Portable Edition | Book 3 **Fifth Edition**

ART HISTORY

A View of the World: Part One

MARILYN STOKSTAD

Judith Harris Murphy Distinguished Professor of Art History Emerita
The University of Kansas

MICHAEL W. COTHREN

Scheuer Family Professor of Humanities
Department of Art, Swarthmore College

Boston Columbus Indianapolis New York San Francisco Upper Saddle River
Amsterdam Cape Town Dubai London Madrid Milan Munich Paris Montréal Toronto
Delhi Mexico City São Paulo Sydney Hong Kong Seoul Singapore Taipei Tokyo

Editorial Director: Craig Campanella
Editor in Chief: Sarah Touborg
Senior Sponsoring Editor: Helen Ronan
Editorial Assistant: Victoria Engros
Vice-President, Director of Marketing: Brandy Dawson
Executive Marketing Manager: Kate Mitchell
Marketing Assistant: Paige Patunas
Managing Editor: Melissa Feimer
Project Managers: Barbara Cappuccio and Marlene Gassler
Senior Operations Supervisor: Mary Fischer
Operations Specialist: Diane Peirano
Media Director: Brian Hyland
Senior Media Editor: David Alick
Media Project Manager: Rich Barnes
Pearson Imaging Center: Corin Skidds
Printer/Binder: Courier / Kendallville
Cover Printer: Lehigh-Phoenix Color / Hagerstown

This book was designed by
Laurence King Publishing Ltd, London
www.laurenceking.com

Editorial Manager: Kara Hattersley-Smith
Senior Editor: Clare Double
Production Manager: Simon Walsh
Page Design: Nick Newton
Cover Design: Jo Fernandes
Picture Researcher: Evi Peroulaki
Copy Editor: Jennifer Speake
Indexer: Vicki Robinson

Cover image: Sultan Muhammad, The "Court of Gayumars," from the *Shahnama* of Shah Tahmasp (fol. 20v). Tabriz, Iran. c. 1525–1535. Ink, pigments, and gold on paper, page size 18½″ × 12½″ (47 × 31.8 cm). Aga Khan Museum, Toronto.

Credits and acknowledgments borrowed from other sources and reproduced, with permission, in this textbook appear on the appropriate page within text or on the credit pages in the back of this book.

Library of Congress Cataloging-in-Publication Data
Stokstad, Marilyn
 Art history / Marilyn Stokstad, Judith Harris Murphy Distinguished Professor of Art History Emerita, The University of Kansas, Michael W. Cothren, Scheuer Family Professor of Humanities, Department of Art, Swarthmore College. -- Fifth edition.
 pages cm
 Includes bibliographical references and index.
 ISBN-13: 978-0-205-87347-0 (hardcover)
 ISBN-10: 0-205-87347-2 (hardcover)
 1. Art--History--Textbooks. I. Cothren, Michael Watt. II. Title.
 N5300.S923 2013
 709--dc23
 2012027450

10 9 8 7 6 5 4 3 2 1

Prentice Hall
is an imprint of

www.pearsonhighered.com

ISBN 10: 0-205-87378-2
ISBN 13: 978-0-205-87378-4

Contents

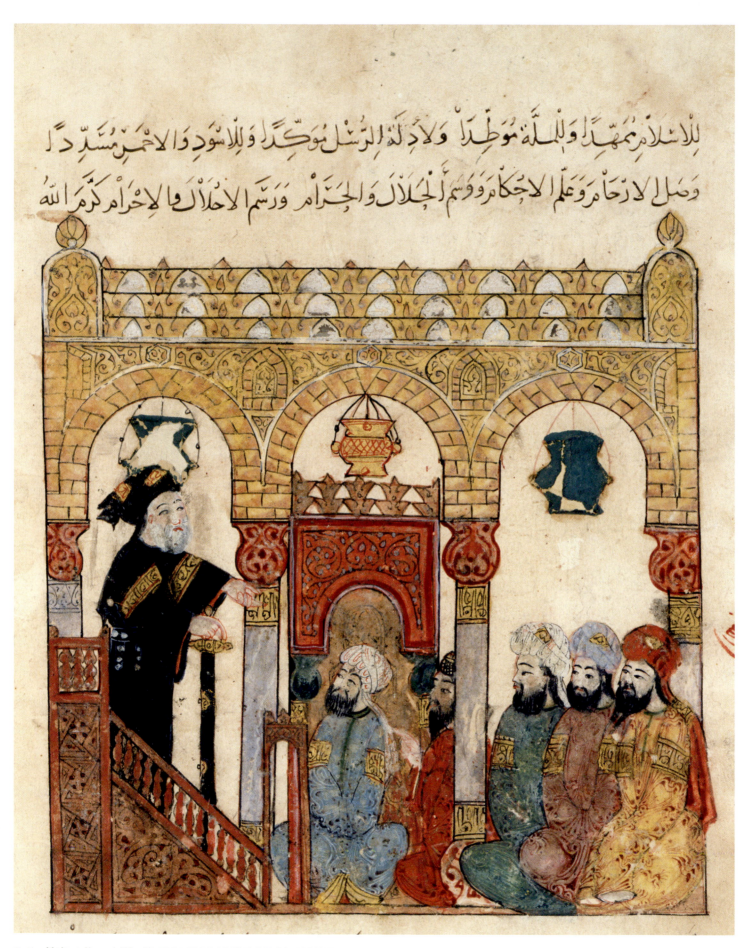

للاسلام ممهدا وللملة موطدا ولأدلة الرسل موكدا وللاسود والاحمر مسددا
وصل الارحام وعلم الاحكام وسم الجلال والحرام ورسم الاحلال والاحرام كرم الله

9-1 • Yahya Ibn al-Wasiti THE MAQAMAT OF AL-HARIRI
From Baghdad, Iraq. 1237. Ink, pigments, and gold on paper, 13¾″ × 10¼″ (35 × 25 cm). Bibliothèque Nationale, Paris. Arabic MS. 5847, fol. 18v

Islamic Art

The *Maqamat* ("*Assemblies*"), by al-Hariri (1054–1122), belongs to a popular Islamic literary genre of cautionary tales. Al-Hariri's stories revolve around a silver-tongued scoundrel named Abu Zayd, whose cunning inevitably triumphs over other people's naivety. His exploits take place in a world of colorful settings—desert camps, ships, pilgrim caravans, apothecary shops, mosques, gardens, libraries, cemeteries, and courts of law. In such settings, these comic stories of trickery and theft would seem perfectly suited for illustration, and that is the case in this engaging manuscript, made in Baghdad during the thirteenth century. Human activity permeates the compositions—pointing fingers, arguing with adversaries, riding horses, stirring pots, and strumming musical instruments. And these vivid visualizations of Abu Zayd's adventures provide us with rare windows into ordinary Muslim life, here prayer in the congregational **mosque** (**FIG. 9-1**), a religious and social institution at the center of Islamic culture.

The congregation has gathered to hear a sermon preached by the deceitful Abu Zayd, who plans to make off with the alms collection. The men sit directly on the ground, as is customary not only in mosques, but in traditional dwellings. The listener in the front row tilts his chin upward to focus his gaze directly upon the speaker. He is framed and centered by the arch of the **mihrab** (the niche indicating the direction of Mecca) on the rear wall; his white turban contrasts noticeably with the darker gold background. Perhaps he stands in for the manuscript's reader who, perusing the illustrations of these captivating stories, pauses to project him- or herself into the scene.

The columns of the mosque's arcades have ornamental capitals from which spring half-round arches. Glass mosque lamps hang from the center of each arch. Figures wear turbans and flowing, loose-sleeved robes with epigraphic borders (*tiraz*) embroidered in gold. Abu Zayd delivers his sermon from the steps of a **minbar** (pulpit) with an arched gateway opening at the lowest level. This *minbar* and the arcades that form the backdrop of the scene are reduced in scale so the painter can describe the entire setting and still make the figures the main focus of the composition. Likewise, although in an actual mosque the *minbar* would share the same wall as the *mihrab*, here they have been separated, perhaps to keep the *minbar* from hiding the *mihrab*, and to rivet our attention on what is most important—the rapt attention Abu Zayd commands from his captive audience, a group we ourselves join as we relish the anecdotal and pictorial delights of this splendid example of Islamic visual narrative.

LEARN ABOUT IT

9.1 Explore the stylistic variety of art and architecture created in the disparate areas of the Islamic world.

9.2 Explore the use of ornament and inscription in Islamic art.

9.3 Interpret Islamic art as a reflection of both religion and secular society.

9.4 Recognize the role of political transformation in the creation of Islamic artistic eclecticism as well as its unification around a shared cultural and religious viewpoint.

((•— **Listen** to the chapter audio on myartslab.com

ISLAM AND EARLY ISLAMIC SOCIETY

Islam arose in seventh-century Arabia, a land of desert oases with no cities of great size and sparsely inhabited by tribal nomads. Yet, under the leadership of its founder, the Prophet Muhammad (c. 570–632 CE), and his successors, Islam spread rapidly throughout northern Africa, southern and eastern Europe, and into Asia, gaining territory and converts with astonishing speed. Because Islam encompassed geographical areas with a variety of long-established cultural traditions, and because it admitted diverse peoples among its converts, it absorbed and combined many different techniques and ideas about art and architecture. The result was a remarkably sophisticated artistic eclecticism.

Muslims ("those who have submitted to God") believe that in the desert outside of Mecca in 610, Muhammad received revelations that led him to found the religion called Islam ("submission to God's will"). Many powerful Meccans were hostile to the message preached by the young visionary, and in 622 he and his companions fled to Medina. There Muhammad built a house that became a gathering place for the converted and thus the first mosque. Muslims date their history as beginning with this *hijira* ("emigration").

In 630, Muhammad returned to Mecca with an army of 10,000, routed his enemies, and established the city as the spiritual capital of Islam. After his triumph, he went to the **KAABA** (FIG. **9-2**), a cubelike, textile-draped shrine said to have been built for God by Ibrahim (Abraham) and Isma'il (Ishmael) and long the focus of pilgrimage and polytheistic worship. He emptied the shrine, repudiating its accumulated pagan idols, while preserving the enigmatic structure itself and dedicating it to God.

The Kaaba is the symbolic center of the Islamic world, the place to which all Muslim prayer is directed and the ultimate destination of Islam's obligatory pilgrimage, the *hajj*. Each year, huge numbers of Muslims from all over the world travel to Mecca to circumambulate the Kaaba during the month of pilgrimage. The exchange of ideas that occurs during the intermingling of these diverse groups of pilgrims has contributed to Islam's cultural eclecticism.

Muhammad's act of emptying the Kaaba of its pagan idols instituted the fundamental practice of avoiding figural imagery in Islamic religious architecture. This did not, however, lead to a ban

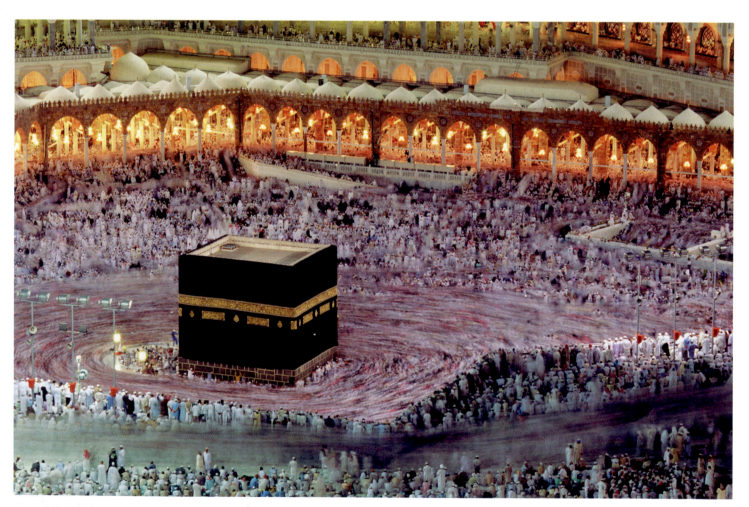

9-2 • THE KAABA, MECCA
The Kaaba represents the center of the Islamic world. Its cubelike form is draped with a black textile that is embroidered with a few Qur'anic verses in gold.

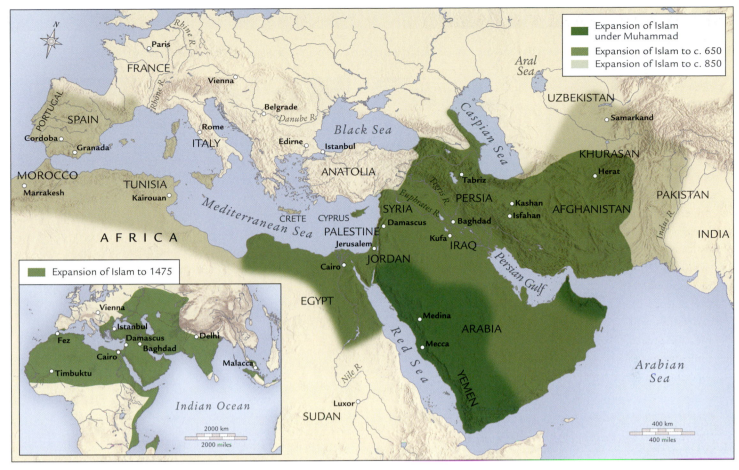

MAP 9–1 • THE ISLAMIC WORLD

Within 200 years after 622 CE, the Islamic world expanded from Mecca to India in the east, and to Morocco and Spain in the west.

on art. Figural imagery is frequent in palaces and illustrated manuscripts, and Islamic artists elaborated a rich vocabulary of nonfigural ornament, including complex geometric designs and scrolling foliate vines (that Europeans labeled **arabesques**), which were appropriate in all contexts. Islamic art revels in surface decoration, in manipulating line, color, and especially pattern, often highlighting the interplay of pure abstraction, organic form, and script.

According to tradition, the Qur'an assumed its final form during the time of the third caliph (successor to the Prophet), Uthman (r. 644–56). As the language of the Qur'an, Arabic and its script have been a powerful unifying force within Islam. From the eighth through the eleventh centuries, it was the universal language among scholars in the Islamic world and in some Christian lands as well. Inscriptions frequently ornament works of art, sometimes written clearly to provide a readable message, but in other cases written as complex patterns also to delight the eye.

The Prophet was succeeded by a series of caliphs. The accession of Ali as the fourth caliph (r. 656–61) provoked a power struggle that led to his assassination and resulted in enduring divisions within Islam. Followers of Ali, known as Shi'ites (referring to the party or *shi'a* of Ali), regard him alone as the Prophet's

rightful successor. Sunni Muslims, in contrast, recognize all of the first four caliphs as "rightly guided." Ali was succeeded by his rival Muawiya (r. 661–80), a close relative of Uthman and the founder of the first Muslim dynasty, the Umayyad (661–750).

Islam expanded dramatically. Within two decades, seemingly unstoppable Muslim armies conquered the Sasanian Persian Empire, Egypt, and the Byzantine provinces of Syria and Palestine. By the early eighth century, the Umayyads had reached India, conquered northern Africa and Spain, and penetrated France before being turned back (**MAP 9–1**). In these newly conquered lands, the treatment of Christians and Jews who did not convert to Islam was not consistent, but in general, as "People of the Book"—followers of a monotheistic religion based on a revealed scripture—they enjoyed a protected status, though they were subject to a special tax and restrictions on dress and employment.

Muslims participate in congregational worship at a mosque (*masjid*, "place of prostration"). The Prophet Muhammad himself lived simply and instructed his followers in prayer at his house, now known as the Mosque of the Prophet, where he resided in Medina. This was a square enclosure that framed a large courtyard with rooms along the east wall where he and his family lived. Along

Islamic art delights in complex ornament that sheathes surfaces, distracting the eye from the underlying structure or physical form.

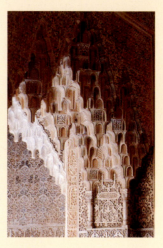

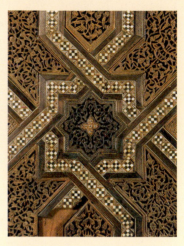

ablaq masonry (*Madrasa*-Mausoleum-Mosque of Sultan Hasan, Cairo; see FIG. 9–14) juxtaposes stone of contrasting colors. The ornamental effect is enhanced here by the interlocking jigsaw shape of the blocks, called **joggled voussoirs**.

cut tile (Shah-i Zinda, Samarkand; see FIG. 9–18), made up of dozens of individually cut ceramic tile pieces fitted precisely together, emphasizes the clarity of the colored shapes.

muqarna (Palace of the Lions, Alhambra, Granada; see FIG. 9–16) consist of small nichelike components, usually stacked in multiples as successive, nonload-bearing units in arches, cornices, and domes, hiding the transition from the vertical to the horizontal plane.

wooden strapwork (Kutubiya *minbar*, Marrakesh; see FIG. 9–9) assembles finely cut wooden pieces to create the appearance of geometrically interlacing ribbons, often framing smaller panels of carved wood and inlaid ivory or mother-of-pearl (shell).

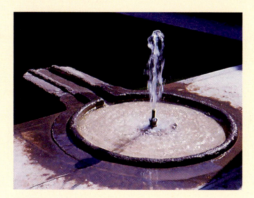

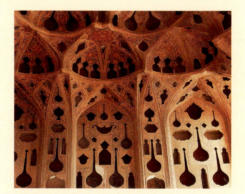

mosaic (Dome of the Rock, Jerusalem; see FIG. 9–4) is comprised of thousands of small glass or glazed ceramic *tesserae* set on a plaster ground. Here the luminous white circular shapes are mother-of-pearl.

water (Court of the Myrtles, Alhambra, Granada) as a fluid architectural element reflects surrounding architecture, adds visual dynamism and sound, and, running in channels between areas to unite disparate spaces.

chini khana (Ali Qapu Pavilion, Isfahan)—literally "china cabinet"—is a panel of niches, sometimes providing actual shelving, but used here for its contrast of material and void which reverses the typical figure-ground relationship.

the south wall, a thatched portico supported by palm-tree trunks sheltered both the faithful as they prayed and Muhammad as he spoke from a low platform. This simple arrangement inspired the design of later mosques. Without the architectural focus provided by chancels, altars, naves, or domes, the space of this prototypical hypostyle (multicolumned) mosque reflected the founding spirit of Islam in which the faithful pray as equals directly to God, led by an imam, but without the intermediary of a priesthood.

THE EARLY PERIOD: NINTH THROUGH TWELFTH CENTURIES

The caliphs of the Umayyad dynasty (661–750) ruled from Damascus in Syria, and throughout the Islamic empire they built mosques and palaces that projected the authority of the new rulers and reflected the growing acceptance of Islam. In 750 the Abbasid

clan replaced the Umayyads in a coup d'état, ruling as caliphs until 1258 from Baghdad, in Iraq. Their long and cosmopolitan reign saw achievements in medicine, mathematics, the natural sciences, philosophy, literature, music, and art. They were generally tolerant of the ethnically diverse populations in the territories they subjugated, and they admired the past achievements of Roman civilization as well as the living traditions of Byzantium, Persia, India, and China, freely borrowing artistic techniques and styles from all of them.

In the tenth century, the Islamic world split into separate kingdoms ruled by independent caliphs. In addition to the Abbasids of Iraq, there was a Fatimid Shi'ite caliph ruling Tunisia and Egypt, and a descendant of the Umayyads ruling Spain and Portugal (together then known as al-Andalus). The Islamic world did not reunite under the myriad dynasties who thereafter ruled from northern Africa to Asia, but loss in unity was gain to artistic diversity.

ARCHITECTURE

While Mecca and Medina remained the holiest Muslim cities, the political center under the Umayyads shifted to the Syrian city of Damascus in 656. In the eastern Mediterranean, inspired by Roman and Byzantine architecture, the early Muslims became enthusiastic builders of shrines, mosques, and palaces. Although tombs were officially discouraged in Islam, they proliferated from the eleventh century onward, in part due to funerary practices imported from the Turkic northeast, and in part due to the rise of Shi'ism with its emphasis on genealogy and particularly ancestry through Muhammad's daughter, Fatima.

THE DOME OF THE ROCK In the center of Jerusalem rises the Haram al-Sharif ("Noble Sanctuary"), a rocky outcrop from which Muslims believe Muhammad ascended to the presence of God on the "Night Journey" described in the Qur'an, as well as the site of the First and Second Jewish Temples. Jews and Christians variously associate this place with Solomon, the site of the creation of Adam, and the place where the patriarch Abraham prepared to sacrifice his son Isaac at the command of God. In 691–92, a domed shrine was built over the rock (**FIG. 9-3**), employing artists

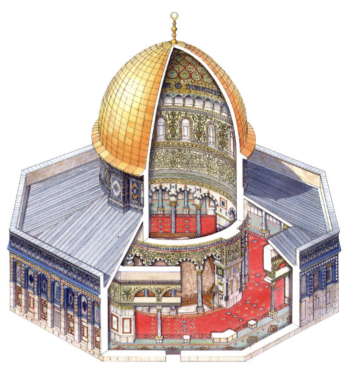

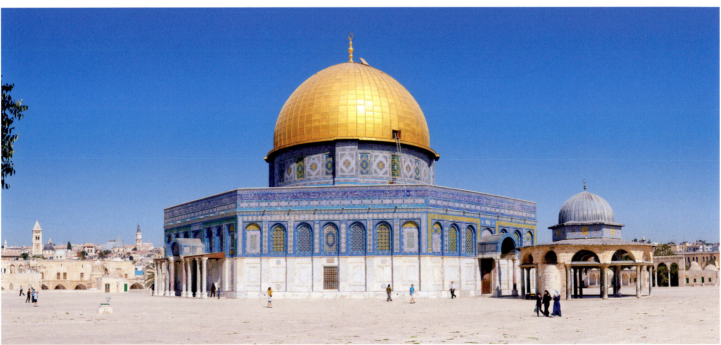

9-3 • EXTERIOR VIEW (A) AND CUTAWAY DRAWING (B) OF THE DOME OF THE ROCK, JERUSALEM
Israel. Begun 691.

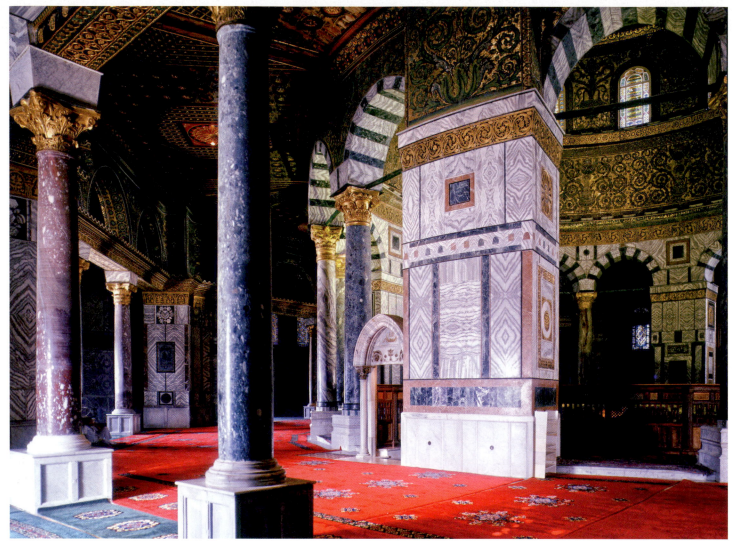

9-4 • INTERIOR, DOME OF THE ROCK
Israel. Begun 691.

The arches of the inner and outer face of the central arcade are encrusted with golden mosaics, a Byzantine technique adapted for Islamic use to create ornament and inscriptions. The pilgrim must walk around the central space first clockwise and then counterclockwise to read the inscriptions. The carpets and ceilings are modern but probably reflect the original intent.

trained in the Byzantine tradition to create the first great monument of Islamic art. By assertively appropriating a site holy to Jews and Christians, the Dome of the Rock manifested Islam's view of itself as completing and superseding the prophecies of those faiths.

Structurally, the Dome of the Rock imitates the centrally planned form of Early Christian and Byzantine martyria (see FIGS. 7–15, 8–5). However, unlike the plain exteriors of its models, it is crowned by a golden dome that dominates the skyline. The ceramic tiles on the lower portion of the exterior were added later, but the opulent marble veneer and mosaics of the interior are original (see "Ornament," page 268). The dome, surmounting a circular drum pierced with windows and supported by arcades of alternating **piers** and columns, covers the central space containing the rock (FIG. 9–4), and concentric aisles (ambulatories) permit devout visitors to circumambulate it.

Inscriptions from the Qur'an interspersed with passages from other texts, including information about the building itself, form a frieze around the inner and outer arcades. As pilgrims walk around the central space to read the inscriptions in brilliant gold mosaic on turquoise green ground, the building communicates both as a text and as a dazzling visual display. These inscriptions are especially notable because they are the oldest surviving written verses from the Qur'an and the first use of Qur'anic inscriptions in architecture. Below, walls are faced with marble—the veining of which creates abstract symmetrical patterns—and the rotunda is surrounded by columns of gray marble with gilded capitals. Above the calligraphic frieze is another mosaic frieze depicting symmetrical vine scrolls and trees in turquoise, blue, and green, embellished with imitation jewels, over a gold ground. The mosaics are variously thought to represent the gardens of Paradise and trophies of

Islam emphasizes a direct personal relationship with God. The Pillars of Islam, sometimes symbolized by an open hand with the five fingers extended, enumerate the duties required of Muslims by their faith.

- The first pillar (*shahadah*) is to proclaim that there is only one God and that Muhammad is his messenger. While monotheism is common to Judaism, Christianity, and Islam, and Muslims worship the God of Abraham, and also acknowledge Hebrew and Christian prophets such as Musa (Moses) and Isa (Jesus), Muslims deem the Christian Trinity polytheistic and assert that God was not born and did not give birth.

- The second pillar requires prayer (*salat*) to be performed by turning to face the Kaaba in Mecca five times daily: at dawn, noon, late afternoon, sunset, and nightfall. Prayer can occur almost anywhere, although the prayer on Fridays takes place in the congregational mosque. Because ritual ablutions are required for purity, mosque courtyards usually have fountains.

- The third pillar is the voluntary payment of annual tax or alms (*zakah*), equivalent to one-fortieth of one's assets. *Zakah* is used for charities such as feeding the poor, housing travelers, and paying the dowries of orphan girls. Among Shi'ites, an additional tithe is required to support the Shi'ite community specifically.

- The fourth pillar is the dawn-to-dusk fast (*sawm*) during Ramadan, the month when Muslims believe Muhammad received the revelations set down in the Qur'an. The fast of Ramadan is a communally shared sacrifice that imparts purification, self-control, and fellowship with others. The end of Ramadan is celebrated with the feast day 'Id al-Fitr (Festival of the Breaking of the Fast).

- For those physically and financially able to do so, the fifth pillar is the pilgrimage to Mecca (*hajj*), which ideally is undertaken at least once in the life of each Muslim. Among the extensive pilgrimage rites are donning simple garments to remove distinctions of class and culture; collective circumambulations of the Kaaba; kissing the Black Stone inside the Kaaba (probably a meteorite that fell in pre-Islamic times); and the sacrificing of an animal, usually a sheep, in memory of Abraham's readiness to sacrifice his son at God's command. The end of the *hajj* is celebrated by the festival 'Id al-Adha (Festival of Sacrifice).

The directness and simplicity of Islam have made the Muslim religion readily adaptable to numerous varied cultural contexts throughout history. The Five Pillars instill not only faith and a sense of belonging, but also a commitment to Islam in the form of actual practice.

Muslim victories offered to God. Though the decorative program is extraordinarily rich, the focus of the building is neither art nor architecture but the plain rock it shelters.

THE GREAT MOSQUE OF KAIROUAN Muslim congregations gather on Fridays for regular worship in a mosque. The earliest mosque type followed the model of the Prophet's own house. The **GREAT MOSQUE** of Kairouan, Tunisia (**FIG. 9-5**), built in the ninth century, reflects the early form of the mosque but is elaborated with later additions. The large rectangular space is divided between a courtyard and a flat-roofed hypostyle prayer hall oriented toward Mecca. The system of repeated bays and aisles can easily be extended as the congregation grows in size— one of the hallmarks of the hypostyle plan. New is the large

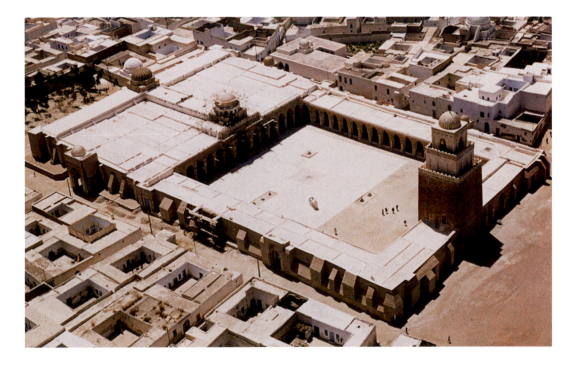

9-5 • THE GREAT MOSQUE, KAIROUAN
Tunisia. 836–875.

When the Umayyads were toppled in 750, a survivor of the dynasty, Abd al-Rahman I (r. 756–788), fled across north Africa into southern Spain (al-Andalus) where, with the support of Muslim settlers, he established himself as the provincial ruler, or emir. This newly transplanted Umayyad dynasty ruled in Spain from its capital in Cordoba (756–1031). The Hispano-Umayyads were noted patrons of the arts, and one of the finest surviving examples of Umayyad architecture is the Great Mosque of Cordoba (FIGS. 9–6, 9–7).

In 785, the Umayyad conquerors began building the Cordoba mosque on the site of a Christian church built by the Visigoths, the pre-Islamic rulers of Spain. The choice of site was both practical—for the Muslims had already been renting space within the church—and symbolic, an appropriation of place (similar to the Dome of the Rock) that affirmed their presence. Later rulers expanded the building three times, and today the walls enclose an area of about 620 by 460 feet, about a third of which is the courtyard. This patio was planted with fruit trees, beginning in the early ninth century; today orange trees seasonally fill the space with color and sweet scent. Inside, the proliferation of pattern in the repeated columns and double flying arches is both colorful and dramatic. The marble columns and capitals in the hypostyle prayer hall were recycled from the Christian church that had formerly occupied the site, as well as from classical buildings in the region, which had been a wealthy Roman province. The mosque's interior incorporates *spolia* (reused) columns of slightly varying heights. Two tiers of arches, one over the other, surmount these columns, the upper tier springing from rectangular

piers that rise from the columns. This double-tiered design dramatically increases the height of the interior space, inspiring a sense of monumentality and awe. The distinctively shaped **horseshoe arches**—a form known from Roman times and favored by the Visigoths—came to be closely associated with Islamic architecture in the West (see "Arches," page 274). Another distinctive feature of these arches, adopted from Roman and Byzantine precedents, is the alternation of white stone and red-brick voussoirs forming the curved arch. This mixture of materials may have helped the building withstand earthquakes.

In the final century of Umayyad rule, Cordoba emerged as a major commercial and intellectual hub and a flourishing center

for the arts, surpassing Christian European cities in science, literature, and philosophy. As a sign of this new wealth, prestige, and power, Abd al-Rahman III (r. 912–961) boldly reclaimed the title of caliph in 929. He and his son al-Hakam II (r. 961–976) made the Great Mosque a focus of patronage, commissioning costly and luxurious renovations such as a new *mihrab* with three bays in front of it (FIG. 9–8). These capped the **maqsura**, an enclosure in front of the *mihrab* reserved for the ruler and other dignitaries, which became a feature of congregational mosques after an assassination attempt on one of the Umayyad rulers. A *minbar* formerly stood by the *mihrab* as the place for the prayer leader and as a symbol of authority. The melon-shaped, ribbed dome

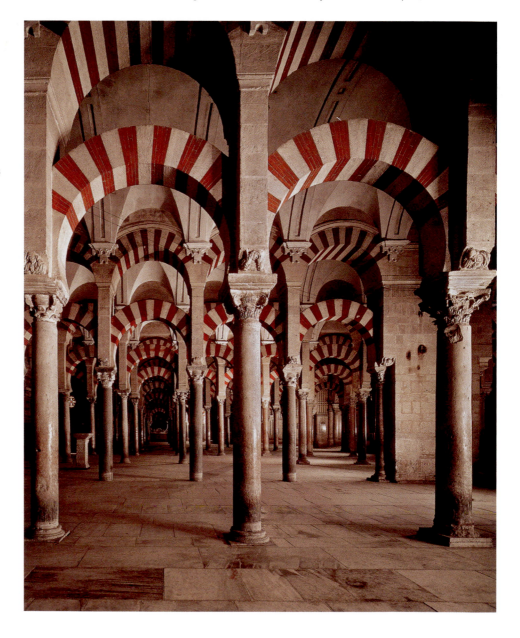

9–6 • PRAYER HALL, GREAT MOSQUE, CORDOBA
Spain. Begun 785/786.

over the central bay may be a metaphor for the celestial canopy. It seems to float upon a web of crisscrossing arches, the complexity of the design reflecting the Islamic interest in mathematics and geometry, not purely as abstract concepts but as sources for artistic inspiration. Lushly patterned mosaics with inscriptions, geometric motifs, and stylized vegetation clothe both this dome and the *mihrab* below in brilliant color and gold. These were installed by a Byzantine master sent by the emperor in Constantinople, who brought with him boxes of small glazed ceramic and glass pieces (*tesserae*). Such artistic exchange is emblematic of the interconnectedness of the medieval Mediterranean—through trade, diplomacy, and competition.

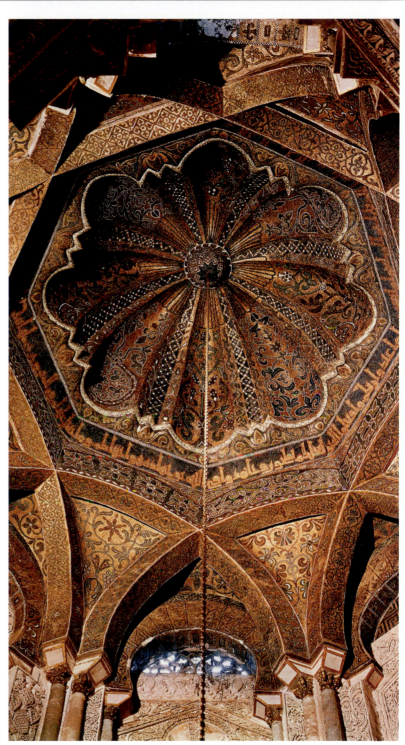

9-8 • DOME IN FRONT OF THE MIHRAB, GREAT MOSQUE
965.

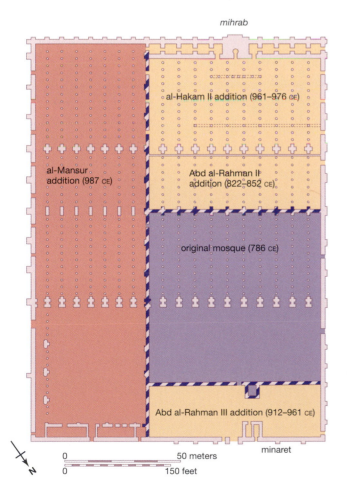

mihrab

al-Hakam II addition (961–976 CE)

al-Mansur addition (987 CE)

Abd al-Rahman II addition (822–852 CE)

original mosque (786 CE)

Abd al-Rahman III addition (912–961 CE)

minaret

| 0 | | 50 meters |
| 0 | | 150 feet |

9-7 • PLAN OF THE GREAT MOSQUE
Begun 785/786.

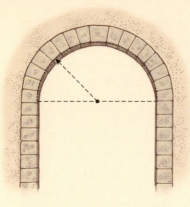
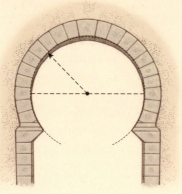
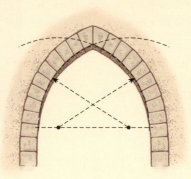
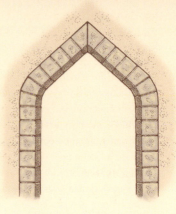

The simple **semicircular arch**, inherited from the Romans and Byzantines, has a single center point that is level with the points from which the arch springs.

The **horseshoe arch** predates Islam but became the prevalent arch form in the Maghreb (see FIG. 9–6). The center point is above the level of the arch's springing point, so that it pinches inward above the capital.

The **pointed arch**, introduced after the beginning of Islam, has two (sometimes four) center points, the points generating different circles that overlap (see FIG. 9–28).

A **keel arch** has flat sides, and slopes where other arches are curved. It culminates at a pointed apex (see "Ornament," cut tile, page 268).

Watch an architectural simulation about Islamic arches on myartslab.com

minaret (a tower from which the faithful are called to prayer) that rises from one end of the courtyard, standing as a powerful sign of Islam's presence in the city.

The **qibla** wall, marked by a centrally positioned *mihrab* niche, is the wall of the prayer hall that is closest to Mecca. Prayer is oriented toward this wall. In the Great Mosque of Kairouan, the *qibla* wall is given heightened importance by a raised roof, a dome over the *mihrab*, and a central aisle that marks the axis that extends from the minaret to the *mihrab* (for a fourteenth-century example of a *mihrab*, see FIG. 9–17). The *mihrab* belongs to the historical tradition of niches that signify a holy place—the Torah shrine in a synagogue, the frame for sculptures of gods or ancestors in Roman architecture, the apse in a church.

THE KUTUBIYA MOSQUE In the Kutubiya Mosque, the principal mosque of Marrakesh, Morocco, survives an exceptionally exquisite, twelfth-century wooden *minbar*—made originally for the Booksellers' Mosque in Marrakesh (**FIG. 9–9**). It consists of a staircase from which the weekly sermon was delivered to the congregation (see FIG. 9–1). The sides are paneled in wooden marquetry with strapwork in a geometric pattern of eight-pointed stars and

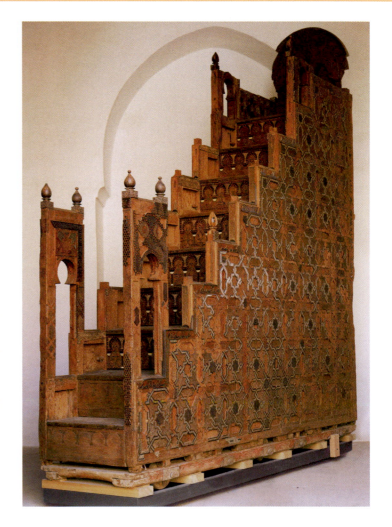

9–9 • MINBAR
From the Kutubiya Mosque, Marrakesh, Morocco. 1125–1130. Wood and ivory, 12'8" × 11'4" × 2'10" (3.86 × 3.46 × 0.87 m). Badi Palace Museum, Marrakesh.

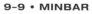

elongated hexagons inlaid with ivory (see "Ornament," page 268). The areas between the strapwork are filled with wood carved in swirling vines. Reflecting the arcades of its original architectural context, the risers of the stairs represent horseshoe arches (see "Arches," opposite) resting on columns with ivory capitals and bases. This *minbar* is much like others across the Islamic world, but those at the Kutubiya Mosque and the Great Mosque of Cordoba (see "the Great Mosque of Cordoba, page 272) were the finest, according to Ibn Marzuq (1311–1379), a distinguished preacher who had given sermons from 48 *minbars*.

CALLIGRAPHY

From the beginning, Arabic script was held in high esteem in Islamic society. Reverence for the Qur'an as the word of God extended—and continues to extend—by association to the act of writing itself, and **calligraphy** (the art of the finely written word) became one of the glories of Islamic art. Writing was not limited to books and documents but—as we have seen—was displayed on the walls of buildings and will appear on works in many media throughout the history of Islamic art. The written word played two roles: It could convey information about a building or object, describing its beauty or naming its patron, and it could delight the eye as a manifestation of beauty.

Arabic script is written from right to left, and a letter's form varies depending on its position in a word. With its rhythmic interplay between verticals and horizontals, Arabic lends itself to many variations. Calligraphers enjoyed the highest status of all

artists in Islamic society. Apprentice scribes had to learn secret formulas for inks and paints, and become skilled in the proper ways to sit, breathe, and manipulate their tools. They also had to absorb the complex literary traditions and number symbolism that had developed in Islamic culture. Their training was long and arduous, but unlike other artists who were generally anonymous in the early centuries of Islam, outstanding calligraphers received public recognition.

Formal **Kufic** script (after Kufa, a city in Iraq) is blocky and angular, with strong upright strokes and long horizontals. It may have developed first for carved or woven inscriptions where clarity and practicality of execution were important. Most early Qur'ans were horizontal in orientation and had large Kufic letters creating only three to five lines per page. Visual clarity was essential because one book was often shared simultaneously by multiple readers. A page from a ninth-century Syrian Qur'an exemplifies the style common from the eighth to the tenth century (**FIG. 9–10**). Red diacritical marks (pronunciation guides) accent the dark brown ink; the surah ("chapter") title is embedded in the burnished ornament at the bottom of the sheet. Instead of page numbers, the brilliant gold of the framed words and the knoblike projection in the left-hand margin mark chapter breaks.

By the tenth century, more than 20 cursive scripts had come into use. They were standardized by Ibn Muqla (d. 940), an Abbasid official who fixed the proportions of the letters in each script and devised a method for teaching calligraphy that is still in use today. The Qur'an was usually written on parchment (treated

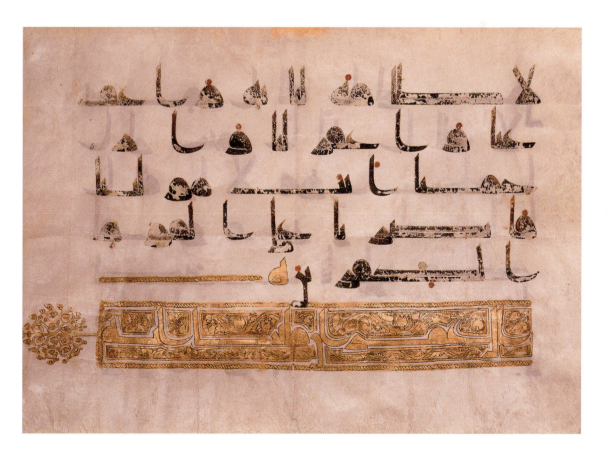

9-10 • PAGE FROM THE QUR'AN
Surah 2:286 and title of surah 3 in Kufic script. Syria. 9th century. Black ink, pigments, and gold on vellum, 8⅜″ × 11⅛″ (21.8 × 29.2 cm). Metropolitan Museum of Art, New York. Rogers Fund, 1937. (37.99.2)

Read the document related to the Qur'an on myartslab.com

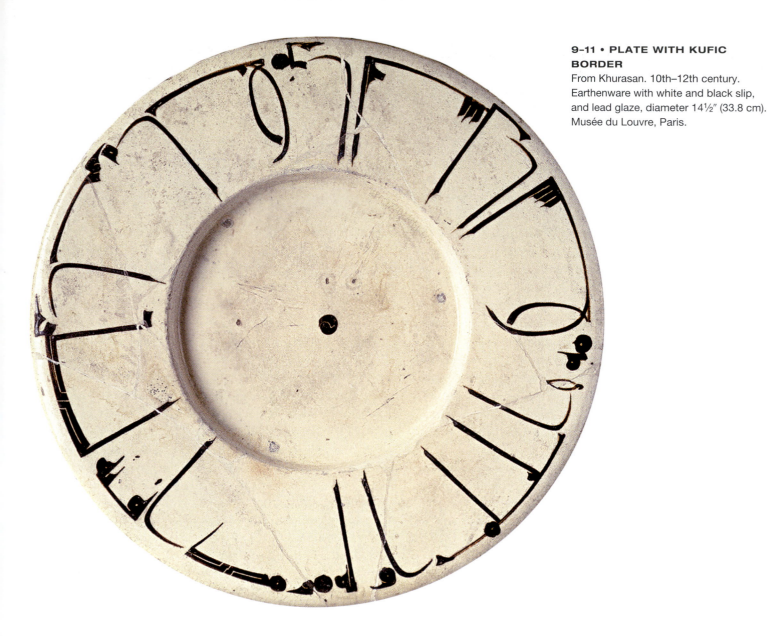

9–11 • PLATE WITH KUFIC BORDER
From Khurasan. 10th–12th century. Earthenware with white and black slip, and lead glaze, diameter 14½″ (33.8 cm). Musée du Louvre, Paris.

animal skin) and vellum (calfskin or a fine parchment). Paper was first manufactured in Central Asia during the mid eighth century, having been introduced earlier by Buddhist monks. Muslims learned how to make high-quality, rag-based paper, and eventually established their own paper mills. By about 1000, paper had largely replaced the more costly parchment for everything but Qur'an manuscripts, which adopted the new medium much later. It was a change as momentous as that brought about by movable type or the Internet, affecting not only the appearance of books but also their content. The inexpensive new medium sparked a surge in book production and the proliferation of increasingly elaborate and decorative cursive scripts which had generally superseded Kufic by the thirteenth century.

Kufic script remained popular, however, in other media. It was the sole decoration on a type of white pottery made from the tenth century onward in and around the region of Nishapur (in Khurasan, in present-day Iran) and Samarkand (in present-day Uzbekistan) known as epigraphic ware. These elegant earthenware bowls and plates employ a clear lead glaze over a painted black inscription on a white slip ground (**FIG. 9–11**). Here the script's horizontals and verticals have been elongated to fill the plate's rim, stressing the letters' verticality in such a way that they seem to radiate from the bold spot at the center of the circle. The fine quality of the lettering indicates that a calligrapher furnished the model. The inscription translates: "Knowledge [or magnanimity]: the beginning of it is bitter to taste, but the end is sweeter than honey," an apt choice for tableware made to appeal to an educated patron. Inscriptions on Islamic ceramics provide a storehouse of such popular aphorisms.

LUSTERWARE

In the ninth century, Islamic potters developed a means of producing a lustrous metallic surface on their ceramics. They may have learned the technique from Islamic glassmakers in Syria and Egypt, who had produced luster-painted vessels a century earlier. First the potters applied a paint laced with silver, copper, or gold oxides to the surface of already fired and glazed tiles or vessels. In a second firing with relatively low heat and less oxygen, these oxides burned

away to produce a reflective, metallic sheen. The finished **lusterware** resembled precious metal. Lusterware tiles, dated 862/863, decorated the *mihrab* of the Great Mosque at Kairouan. At first a carefully guarded secret of Abbasid potters in Iraq, lusterware soon spread throughout the Islamic world, to North Africa, Egypt, Iran, Syria, and Spain.

Early potters covered the entire surface with luster, but soon they began to use luster to paint patterns using geometric design, foliate motifs, animals, and human figures, in brown, red, purple, and/or green. Most common was monochrome lusterware in shades of brown, as in this tenth-century jar from Iraq (**FIG. 9-12**). The form of the vessel is emphasized by the distribution of decorative motifs—the lip and neck are outlined with a framed horizontal band of scalloped motifs, the shoulder singled out with dots within circles (known as the "peacock's eye" motif), and the height emphasized by boldly ornamented vertical strips with undulating outlines moving up toward pointed tops and dividing the surface of the jar into quadrants. Emphasis, however, is placed on representations of enigmatic human figures dressed in dark, hooded garments. They stand in bended postures and hold beaded strands while looked directly out toward viewers, engaged in an activity whose meaning and significance remains a mystery.

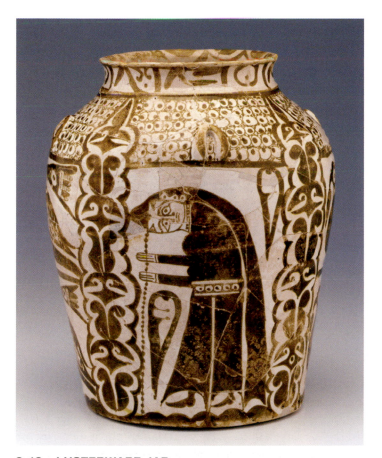

9-12 • LUSTERWARE JAR
Iraq. 10th century. Glazed earthenware with luster, 11⅛″ × 9⅛″ (28.2 × 23.2 cm). Freer Gallery of Art, Smithsonian Institution, Washington, DC.

THE LATER PERIOD: THIRTEENTH THROUGH FIFTEENTH CENTURIES

The Abbasid caliphate began a slow disintegration in the ninth century, and power in the Islamic world became distributed among more or less independent regional rulers. During the eleventh century, the Saljuqs, a Turkic people, swept from north of the Caspian Sea into Khurasan and took Baghdad in 1055, becoming the virtual rulers of the Abbasid lands. The Saljuqs united most of Iran and Iraq, establishing a dynasty that endured from 1037/38 to 1194. A branch of the dynasty, the Saljuqs of Rum, ruled much of Anatolia (Turkey) from the late eleventh to the beginning of the fourteenth century. The central and eastern Islamic world suffered a dramatic rift in the early thirteenth century when the nomadic Mongols—non-Muslims led by Genghiz Khan (r. 1206–1227) and his successors—attacked northern China, Central Asia, and ultimately Iran. The Mongols captured Baghdad in 1258 and encountered weak resistance until they reached Egypt, where they were firmly defeated by the new ruler of the Mamluk dynasty (1250–1517). In Spain, the borders of Islamic territory were gradually pushed southward by Christian forces until the rule of the last Muslim dynasty there, the Nasrids (1230–1492), was ended. Morocco was ruled by the Berber Marinids (from the mid thirteenth century until 1465).

Although the religion of Islam remained a dominant and unifying force throughout these developments, the history of later Islamic society and culture reflects largely regional phenomena. Only a few works have been selected here and in Chapter 24 to characterize Islamic art, and they by no means provide a comprehensive history.

ARCHITECTURE

The new dynasties built on a grand scale, expanding their patronage from mosques and palaces to include new functional buildings, such as tombs, **madrasas** (colleges for religious and legal studies), public fountains, and urban hostels. To encourage long-distance trade, remote caravanserais (inns) were constructed for traveling merchants. A distinguishing characteristic of architecture in the later period is its complexity. Multiple building types were now combined in large and diverse complexes, supported by perpetual endowments (called *waqf*) that funded not only the building, but its administration and maintenance. Increasingly, these complexes included the patron's own tomb, thus giving visual prominence to the act of individual patronage and expressing personal identity through commemoration. A new plan emerged, organized around a central courtyard framed by four large **iwans** (large vaulted halls with rectangular plans and monumental arched openings); this four-*iwan* plan was used for schools, palaces, and especially mosques.

THE MAMLUKS IN EGYPT Beginning in the eleventh century, Muslim rulers and wealthy individuals endowed hundreds of charitable complexes that displayed piety as well as personal

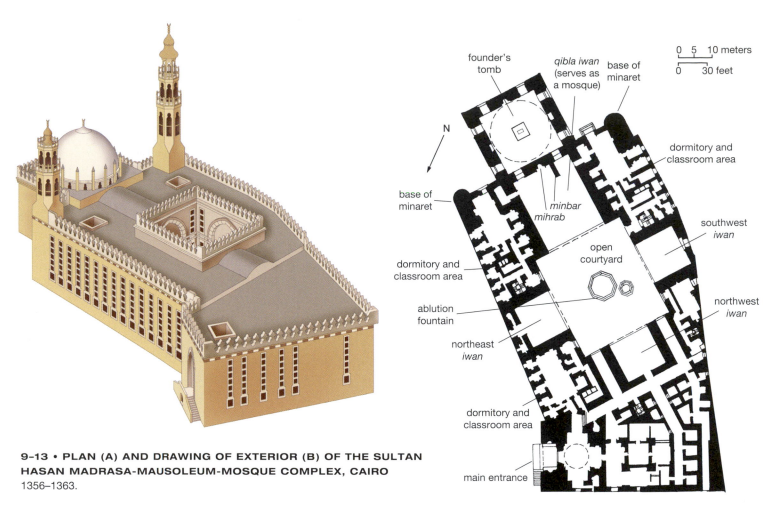

founder's tomb

qibla iwan (serves as a mosque)

base of minaret

0 5 10 meters
0 30 feet

N

base of minaret

dormitory and classroom area

minbar *mihrab*

southwest *iwan*

dormitory and classroom area

open courtyard

northwest *iwan*

ablution fountain

northeast *iwan*

dormitory and classroom area

main entrance

9–13 • PLAN (A) AND DRAWING OF EXTERIOR (B) OF THE SULTAN HASAN MADRASA-MAUSOLEUM-MOSQUE COMPLEX, CAIRO
1356–1363.

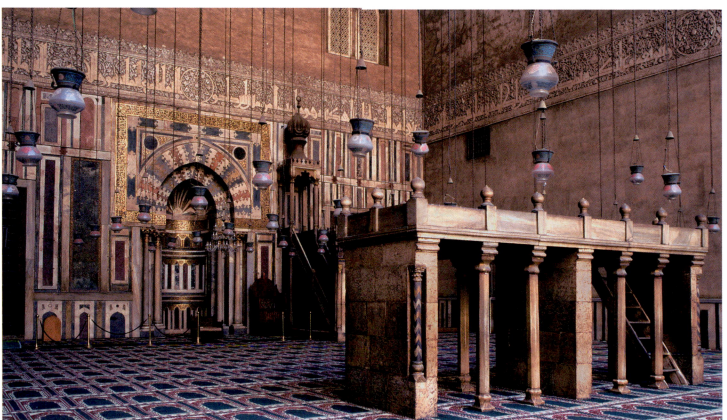

9–14 • QIBLA WALL WITH MIHRAB AND MINBAR
Sultan Hasan Madrasa-Mausoleum-Mosque Complex, Cairo. 1356–1363.

A CLOSER LOOK | A Mamluk Glass Oil Lamp

by ʻAli ibn Muhammad al-Barmaki. Cairo, Egypt. c. 1329–1335.
Blown glass, polychrome enamel, and gold. Diameter 9⅜″ (23.89 cm), height 14″ (35.56 cm).
Metropolitan Museum of Art, New York.

During the thirteenth and fourteenth centuries, Mamluk glassmakers in Egypt and Syria imparted an elegant thinness to their vessels through refined glass-blowing and molding techniques. The blue, red, and gold enamel used to decorate the lamp was affixed to the glass surface by reheating the painted vessel.

The inscription on the lamp's flared neck is a quotation from the Qur'an (Surah 24:35): "God is the light of the heavens and the earth. His light might be compared to a niche that enshrines a lamp, the lamp within a crystal of star-like brilliance."

This inscription around the body of the lamp identifies the patron, Sayf al-Din Qawsun (d. 1342), emir and cup-bearer of the Mamluk Sultan al-Nasir Muhammad (r. 1293–1341). It was probably intended for one of the patron's architectural commissions in Cairo.

This emblem of a cup in a medallion is called a blazon. It identifies the commissioner of the lamp as a cup-bearer to the sultan. The use of blazons traveled to western Europe during the crusades, where it evolved into the system we know as heraldry.

The artist, ʻAli ibn Muhammad al-Barmaki, signed this work discreetly on the upper band of the foot, asking for God's protection.

View the Closer Look for the Mamluk glass oil lamp on myartslab.com

wealth and status. The combined *madrasa*-mausoleum-mosque complex established in mid-fourteenth-century Cairo by the Mamluk Sultan Hasan (**FIG. 9–13**) is a splendid example. A deflected entrance—askew from the building's orientation—leads from the street, through a dark corridor, into a central, well-lit courtyard of majestic proportions. The complex has a classic four-*iwan* plan, each *iwan* serving as a classroom for students following a different branch of study, who are housed in a surrounding, multi-storied cluster of tiny rooms. The sumptuous *qibla iwan* served as the prayer hall for the complex (**FIG. 9–14**). Its walls are ornamented with typically Mamluk panels of sharply contrasting marbles (*ablaq* masonry, see "Ornament," page 268) that culminate in a doubly recessed *mihrab* framed by slightly pointed arches on columns. The marble blocks of the arches are ingeniously joined in interlocking pieces called joggled voussoirs. The paneling is surmounted by a wide band of Kufic script in stucco set against a background of scrolling vines, both the text and the abundant foliage referring to the paradise that is

promised to the faithful. Next to the *mihrab,* an elaborate *minbar* stands behind a platform for reading the Qur'an. Just beyond the *qibla iwan* is the patron's monumental domed tomb, ostentatiously asserting his identity with the architectural complex. The Sultan Hasan complex is vast in scale and opulent in decoration, but money was not an object: The project was financed by the estates of victims of the bubonic plague that had raged in Cairo from 1348 to 1350.

Partly because the mosque in the Sultan Hasan complex—and many smaller establishments—required hundreds of lamps, glassmaking was a booming industry in Egypt and Syria. Made of ordinary sand and ash, glass is the most ethereal of materials. The ancient Egyptians were producing glassware by the second millennium BCE (see "Glassmaking," page 76), and the tools and techniques for making it have changed little since then. Islamic artists also used glass for beakers and bottles, but lamps, lit from within by oil and wick, glowed with special brilliance (see "A Closer Look," above).

THE NASRIDS IN SPAIN Muslim patrons also spent lavishly on luxurious palaces set in gardens. The Alhambra in Granada, in southeastern Spain, is an outstanding and sumptuous example. Built on the hilltop site of an early Islamic fortress, this palace complex was the seat of the Nasrids (1232–1492), the last Spanish Muslim dynasty, by which time Islamic territory had shrunk from covering most of the Iberian peninsula to the region around Granada. To the conquering Christians at the end of the fifteenth century, the Alhambra represented the epitome of luxury. Thereafter, they preserved the complex as much to commemorate the defeat of Islam as for its beauty. Essentially a small town extending for about half a mile along the crest of a high hill overlooking Granada, it included government buildings, royal residences, gates, mosques, baths, servants' quarters, barracks, stables, a mint, workshops, and gardens. Much of what one sees at the site today was built in the fourteenth century or by Christian patrons in later centuries.

The Alhambra offered dramatic views to the settled valley and snowcapped mountains around it, while enclosing gardens within its courtyards. One of these is the Court of the Lions, which stood at the heart of the so-called Palace of the Lions, the private retreat of Sultan Muhammad V (r. 1354–1359 and 1362–1391). The **COURT OF THE LIONS** is divided into quadrants by cross-axial walkways—a garden form called a *chahar bagh*. The walkways carry channels that meet at a central marble fountain held aloft on the backs of 12 stone lions (**FIG. 9–15**). Water animates the fountain, filling the courtyard with the sound of its life-giving abundance. In an adjacent courtyard, the Court of the Myrtles, a basin's round shape responds to the naturally concentric ripples of the water that spouts from a central jet (see "Ornament," page 268). Water has a practical role in the irrigation of gardens, but here it is raised to the level of an art form.

The Court of the Lions is encircled by an arcade of stucco arches embellished with **muqarnas** (nichelike components stacked in tiers, see "Ornament," page 268) and supported on single columns or clusters of two and three. Second-floor **miradors**—windows that frame intentional views—look over the courtyard, which was originally either gardened or more likely paved, with aromatic citrus confined to corner plantings. From these windows, protected by latticework screens, the women of the court, who did not appear in public, would watch the activities of the men below. At one end of the Palace of the Lions, a particularly magnificent *mirador* looks out onto a large, lower garden and the plain below. From here, the sultan literally oversaw the fertile valley that was his kingdom.

Pavilions used for dining and musical performances open off the Court of the Lions. One of these, the so-called Hall of the Abencerrajes, in addition to having excellent acoustics, is covered by a ceiling of dazzling geometrical complexity and exquisitely carved stucco (**FIG. 9–16**). The star-shaped vault is formed by a honeycomb of clustered *muqarnas* arches that alternate with corner squinches themselves filled with more *muqarnas*. The square room thus rises to an eight-pointed star, pierced by 16 windows, that culminates in a burst of *muqarnas* floating high overhead—a dematerialized architectural form, perceived and yet ultimately unknowable, like the heavens themselves.

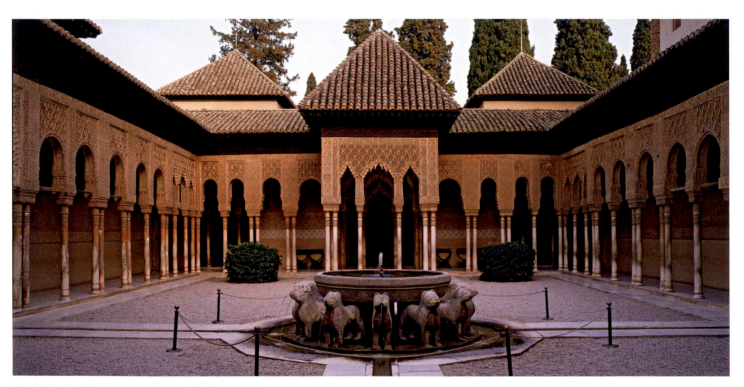

9-15 • COURT OF THE LIONS, ALHAMBRA
Granada, Spain. 1354–1391.

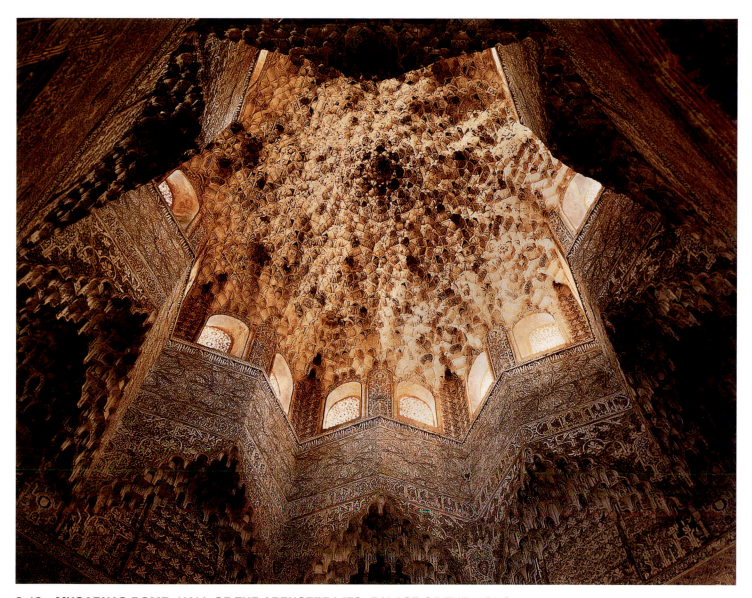

9-16 • MUQARNAS DOME, HALL OF THE ABENCERRAJES, PALACE OF THE LIONS, ALHAMBRA

Granada, Spain. 1354–1391.

The stucco *muqarnas* (stalactite) ornament does not support the dome but is actually suspended from it, composed of some 5,000 individual plaster pieces. Of mesmerizing complexity, the vault's effect can be perceived but its structure cannot be fully comprehended.

◉ **Watch** a video about the Alhambra on myartslab.com

THE TIMURIDS IN IRAN, UZBEKISTAN, AND AFGHANI-STAN The Mongol invasions brought devastation and political instability but also renewal and artistic exchange that provided the foundation for successor dynasties with a decidedly eastern identity. One of the empires to emerge after the Mongols was the vast Timurid empire (1370–1506), which conquered Iran, Central Asia, and the northern part of South Asia. Its founder, Timur (known in the West as Tamerlane), was a Mongol descendant, a lineage strengthened through marriage to a descendant of Genghiz Khan. Timur made his capital at Samarkand (in present-day Uzbekistan), which he embellished by means of the forcible relocation of expert artists from the areas he conquered. Because the empire's compass was vast, Timurid art could integrate Chinese, Persian, Turkic, and Mediterranean artistic ideas into a Mongol base. Its architecture is characterized by axial symmetry, tall double-shelled domes (an inner dome capped by an outer shell of much larger proportions), modular planning with rhythmically repeated elements, and brilliant cobalt blue, turquoise, and white glazed ceramics. Although the empire itself lasted only 100 years after the death of Timur, its legacy endured in the art of the later Safavid dynasty in Iran and the Mughals of South Asia.

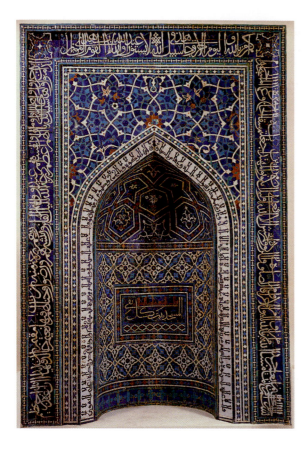

9–17 • TILE MOSAIC MIHRAB
From the Madrasa Imami, Isfahan, Iran. Founded 1354. Glazed and cut tiles, 11′3″ × 9′5¹¹⁄₁₆″ (3.43 × 2.89 m). Metropolitan Museum of Art, New York. Harris Brisbane Dick Fund. (39.20)

This *mihrab* has three inscriptions: the outer inscription, in cursive, contains Qur'anic verses (surah 9) that describe the duties of believers and the Five Pillars of Islam. Framing the niche's pointed arch, a Kufic inscription contains sayings of the Prophet. In the center, a panel with a line in Kufic and another in cursive states: "The mosque is the house of every pious person."

Made during a period of uncertainty as Iran shifted from Mongol to Timurid rule, this *mihrab* (1354), originally from a *madrasa* in Isfahan, is one of the finest examples of architectural ceramic decoration from this era (**FIG. 9–17**). More than 11 feet tall, it was made by painstakingly cutting each individual piece of tile, including the pieces making up the letters on the curving surface of the keel-profiled niche. The color scheme—white against turquoise and cobalt blue with accents of dark yellow and green—was typical of this type of decoration, as were the harmonious, dense, contrasting patterns of organic and geometric forms. The cursive inscription of the outer frame is rendered in elegant white lettering on a blue ground, while the Kufic inscription bordering the pointed arch reverses these colors for a striking contrast.

Near Samarkand, the preexisting Shah-i Zinda ("Living King") **FUNERARY COMPLEX** was adopted for the tombs of Timurid family members, especially princesses, in the late fourteenth and fifteenth centuries (**FIG. 9–18**). The mausolea are arrayed along a central avenue that descends from the tomb

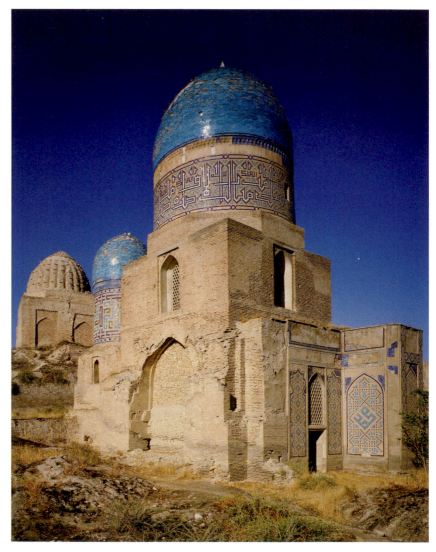

9–18 • SHAH-I ZINDA FUNERARY COMPLEX
Samarkand, Uzbekistan. Late 14th–15th century.

Timurid princesses were buried here and built many of the tombs. The lively experimentation in varied artistic motifs indicates that women were well versed in the arts and empowered to exercise personal taste.

of Qutham b. Abbas (a cousin of the Prophet and a saint). The women sought burial in the vicinity of the holy man in order to gain *baraka* (blessing) from his presence. Like all Timurid architecture, the tombs reflect modular planning—noticeable in the repeated dome-on-square unit—and a preference for blue glazed tiles. The domes of the individual structures were double-shelled and, for exaggerated effect, stood on high drums inscribed with Qur'anic verses in interwoven Kufic calligraphy. The ornament adorning the exterior façades consists of an unusually exuberant array of patterns and techniques, from geometry to chinoiserie, and both painted and cut tiles (see "Ornament," page 268). The tombs reflect a range of individual taste and artistic experimentation that was possible precisely because they were private commissions that served the patrons themselves, rather than the city or state (as in a congregational mosque).

LUXURY ARTS

Islamic society was cosmopolitan, with pilgrimage, trade, and a well-defined road network fostering the circulation of marketable goods. In addition to the import and export of basic and practical commodities, luxury arts brought particular pleasure and status to wealthy owners and were visible signs of cultural refinement. On objects made of ceramics, ivory, glass (see "A Closer Look," page 279), metal, and textiles, calligraphy was prominently displayed. These precious art objects were eagerly exchanged and collected from one end of the Islamic world to the other, and despite their Arabic lettering—or perhaps precisely because of its exotic artistic cachet—they were sought by European patrons as well.

CERAMICS From the beginning, Islamic civilization in Iran was characterized by the production of exceptionally sophisticated and strikingly beautiful luxury ceramic ware. During the twelfth century, Persian potters developed a technique of multicolor ceramic overglaze painting known as *mina'i* ware, the Persian word for "enamel" (**FIG. 9-19**). The decoration of *mina'i* bowls, plates, and beakers often reference or portray stories and subjects popular with potential owners. The circular scene at the bottom of this bowl is drawn from the royal life of Bahram Gur (Sasanian king Bahram V, r. 420–438), legendary in the Islamic world for his prowess in love and hunting; this episode combines both. Bahram Gur rides proudly atop a large camel next to his favorite, the ill-fated lute player Azada, who has foolishly belittled his skills as

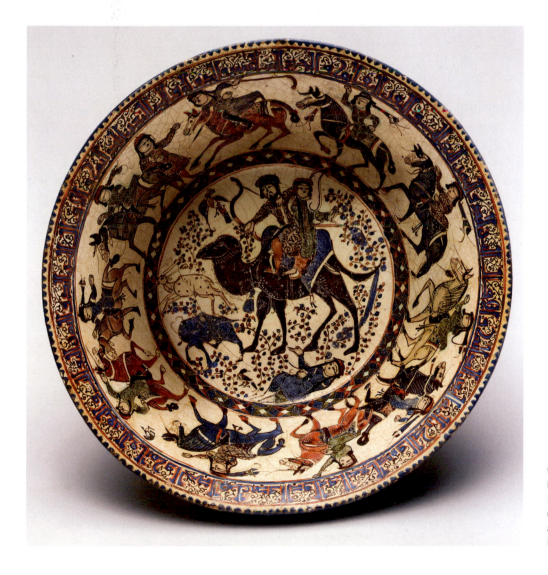

9-19 • MINA'I BOWL WITH BAHRAM GUR AND AZADA
Iran. 12th–13th century. *Mina'i* ware (stoneware with polychrome in-glaze and overglaze), diameter 8½″ (21.6 cm). Metropolitan Museum of Art, New York.

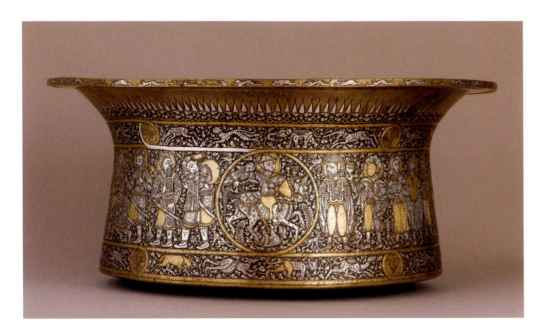

a hunter. To prove his peerless marksmanship, the king pins with his arrow the hoof and ear of a gazelle who had lifted its hind leg to scratch an itch. In this continuous narrative (representing multiple scenes from the same story within a single composition), the subsequent action is also portrayed: Azada trampled to death under the camel after Bahram Gur had pushed her from her mount as punishment for mocking him.

METALWORK Islamic metalsmiths enlivened the surface of vessels with scrolls, interlacing designs, human and animal figures, and calligraphic inscriptions. A shortage of silver in the mid twelfth century prompted the development of inlaid brasswork that used the more precious metal sparingly, as in **FIGURE 9-20**. This basin, made in Mamluk Egypt in the late thirteenth or early fourteenth century by Muhammad Ibn al-Zain (who signed it in six places), is among the finest works of metal produced by a Muslim artist. The dynamic surface is crowded with overlapping figures in vigorous poses that nevertheless remain distinct by means of hatching, modeling, and framing. The exterior face is divided into three bands. The upper and lower depict running animals, and the center shows scenes of horsemen flanked by attendants, soldiers, and falcons—scenes of the princely arts of horsemanship and hunting. In later metalwork, such pictorial cycles were replaced by elegant large-scale inscriptions.

THE ARTS OF THE BOOK

The art of book production had flourished from the first century of Islam because an emphasis on the study of the Qur'an promoted a high level of literacy among both men and women. With the availability of paper, books on a wide range of religious as well as secular subjects became available, although since they were hand-copied, books always remained fairly costly. (Muslims did not adopt the printing press until the eighteenth and nineteenth centuries.)

9-21 • QUR'AN FRONTISPIECE
Cairo. c. 1368. Ink, pigments, and gold on paper, 24" × 18" (61 × 45.7 cm). National Library, Cairo. MS. 7

The Qur'an to which this page belonged was donated in 1369 by Sultan Shaban to the *madrasa* established by his mother. A close collaboration between illuminator and scribe can be seen here and throughout the manuscript.

Libraries, often associated with *madrasas*, were endowed by members of the educated elite. Books made for royal patrons had luxurious bindings and highly embellished pages, the result of workshop collaboration between noted calligraphers and illustrators.

The manuscript illustrators of Mamluk Egypt (1250–1517) executed intricate nonfigural designs filled with sumptuous botanical ornamentation for Qur'ans. As in architectural decoration, the exuberant ornament adheres to a strict geometric organization. In an impressive frontispiece, the design radiates on each page from a 16-pointed starburst, filling the central square (FIG. 9-21). The surrounding frames contain interlacing foliage and stylized flowers that embellish the holy scripture. The page's resemblance to court carpets was not coincidental. Designers often worked in more than one medium, leaving the execution of their efforts to specialized artisans. In addition to religious works, scribes copied and recopied famous secular texts—scientific treatises, manuals of all kinds, stories, and especially poetry. Painters supplied illustrations for these books and also created individual small-scale paintings—miniatures—that were collected by the wealthy and placed in albums.

BIHZAD One of the great royal centers of Islamic miniature painting was at Herat in western Afghanistan, where a Persian **school of painting** and calligraphy was founded in the early fifteenth century under the highly cultured patronage of the Timurid dynasty (1370–1507). In the second half of the fifteenth century, the most famous painter of the Herat School was Kamal al-Din Bihzad (c. 1450–1536/37), who worked under the patronage of Sultan Husayn Bayqara (r. 1470–1506). When the Safavids supplanted the Timurids in 1506/07 and established their capital at Tabriz in northwestern Iran, Bihzad moved to Tabriz, where he headed the Safavid royal workshop.

Bihzad's key paintings, including his only signed works, appear in a manuscript

of the thirteenth-century Persian poet Sa'di's *Bustan* ("Orchard"), made for the royal library in 1488. Sa'di's narrative anthology in verse includes the story of Yusuf and Zulayhka—the biblical Joseph whose virtue was proven by resisting seduction by his master Potiphar's wife, named Zulayhka in the Islamic tradition (Genesis 39:6–12; Qur'an 12:23–25). Bihzad's vizualization of this event (FIG. 9-22) is one of the masterpieces of Persian narrative painting. The dazzling and elaborate architectural setting is inspired not by Sa'di's account, but visualizes Timurid poet Jami's more mystical version of the story (quoted in an architectural frame around the central *iwan* under the two figures), written only five years before Bihzad's painting. Jami sets his story in a seduction palace that Zulayhka had built specifically for this encounter, and into which

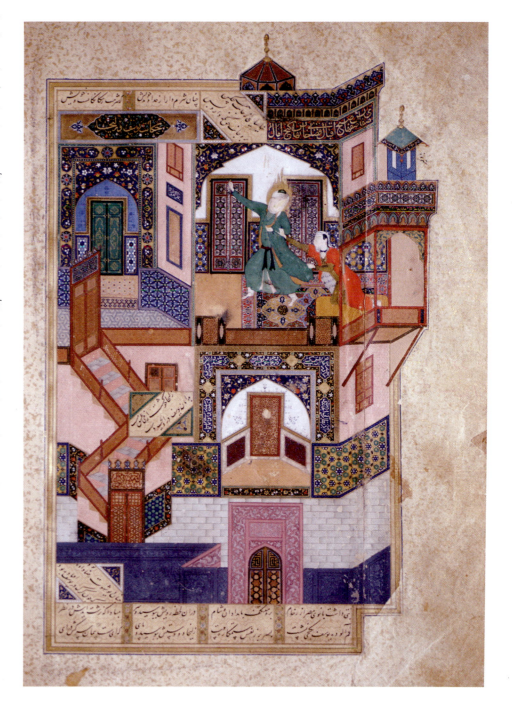

9-22 • Kamal al-Din Bihzad YUSUF FLEEING ZULAYHKA

From a copy of the *Bustan* of Sa'di. Herat, Afghanistan. 1488. Ink and pigments on paper, approx. 12″ × 8½″ (30.5 × 21.5 cm). Cairo, National Library. (MS Adab Farsi 908, f. 52v)

she leads Joseph ever inward from room to room, with entrance doors locked as they pass from one room to the next. As the scarlet-garbed Zulayhka lunges to possess him, the fire-haloed Joseph flees her advances as the doors miraculously open in front of him.

The brilliant, jewel-like color of Bihzad's architectural forms, and the exquisite detail with which each is rendered are salient characteristics of his style, as is the dramatic lunge of Zulayhka and Yusuf's balletic escape. The asymmetrical composition depends on a delicately balanced placement of flat screens of colorful ornament and two emphatically three-dimensional architectural features—a projecting balcony to the right and a zigzagging staircase to the left. Bihzad signed this work in a calligraphic panel over a window at upper left.

ART AND ARCHITECTURE OF LATER EMPIRES

In the pre-modern era, three great powers emerged in the Islamic world. The introduction of gunpowder for use in cannons and guns caused a shift in military strategy; isolated lords in lone castles could not withstand gunpowder sieges. Power lay not in thick walls but in strong centralized governments that could invest in firepower and train armies in its use. To the west was the Ottoman Empire (1342–1918), which grew from a small principality in Asia Minor. In spite of setbacks inflicted by the Mongols, the Ottomans ultimately controlled Anatolia, western Iran, Iraq, Syria, Palestine, western Arabia (including Mecca and Medina), northern Africa (excepting Morocco), and part of eastern Europe. In 1453, their stunning capture of Constantinople (ultimately renamed Istanbul) brought the Byzantine Empire to an end. To the east of the Ottomans, Iran was ruled by the Safavid dynasty (1501–1732), distinguished for their Shi'ite branch of Islam. Their patronage of art and architecture brought a new refinement to artistic ideas and techniques drawn from the Timurid period. The other heirs to the Timurids were the Mughals of South Asia (1526–1858). The first Mughal emperor, Babur, invaded Hindustan (India and Pakistan) from Afghanistan, bringing with him a taste for Timurid gardens, architectural symmetry, and modular planning. The Mughals will be discussed in Chapter 24. Here we will focus on the Ottomans and the Safavids.

THE OTTOMAN EMPIRE

Imperial Ottoman mosques were strongly influenced by Byzantine church plans. Prayer-hall interiors are dominated by ever-larger domed spaces uninterrupted by structural supports. Worship is directed, as in other mosques, toward a qibla wall and mihrab opposite the entrance.

Upon conquering Constantinople, Ottoman rulers converted the great Byzantine church of Hagia Sophia into a mosque, framing it with two graceful Turkish-style minarets in the fifteenth century and two more in the sixteenth century (see FIG. 8-2). In conformance with Islamic practice, the church's figural mosaics were destroyed or whitewashed. Huge calligraphic disks with the names of God (Allah), Muhammad, and the early caliphs were added to the interior in the mid nineteenth century (see FIG. 8-4). At present, Hagia Sophia is neither a church nor a mosque but a state museum.

SINAN Ottoman architects had already developed the domed, centrally planned mosque, but the vast open interior and structural clarity of Hagia Sophia inspired them to strive for a more ambitious scale. For the architect Sinan (c. 1489–1588) the development of a monumental, centrally planned mosque was a personal quest. Sinan began his career in the army, serving as engineer in the Ottoman campaigns at Belgrade, Vienna, and Baghdad. He rose through the ranks to become, in 1528, chief architect for Suleyman "the Magnificent," the tenth Ottoman sultan (r. 1520–1566). Suleyman's reign marked the height of Ottoman power, and the sultan sponsored an ambitious building program on a scale not seen since the days of the Roman Empire. Serving Suleyman and his successor, Sinan is credited with more than 300 imperial commissions, including palaces, *madrasas* and Qur'an schools, tombs, public kitchens, hospitals, caravanserais, treasure houses, baths, bridges, viaducts, and 124 large and small mosques.

Sinan's crowning accomplishment, completed about 1579, when he was over 80, was a mosque he designed in the provincial capital of Edirne for Suleyman's son, Selim II (r. 1566–1574) (**FIG. 9-23**). The gigantic hemispheric dome that tops the Selimiye Mosque is more than 102 feet in diameter—larger than the dome of Hagia Sophia, as Sinan proudly pointed out. It crowns a building of extraordinary architectural coherence. The transition from square base to the central dome is accomplished by corner half-domes that enhance the spatial plasticity and openness of the prayer hall's airy interior (**FIG. 9-24**). The eight massive piers that bear the dome's weight are visible both within and without—on the exterior they resolve in pointed towers that encircle the main dome—revealing the structural logic of the building and clarifying its form. In the arches that support the dome and span from one pier to the next—indeed at every level—light pours through windows into the interior, a space at once soaring and serene.

The interior was clearly influenced by Hagia Sophia—an open expanse under a vast dome floating on a ring of light—but it rejects Hagia Sophia's longitudinal pull from entrance to sanctuary. The Selimiye Mosque is truly a centrally planned structure. In addition to the mosque, the complex housed a *madrasa* and other educational buildings, a cemetery, a hospital, and charity kitchens, as well as the income-producing covered market and baths. Framed by the vertical lines of four minarets and raised on a platform at the city's edge, the Selimiye Mosque dominates the skyline.

The Topkapi, the Ottomans' enormous palace in Istanbul, was a city unto itself. Built and inhabited from 1473 to 1853, it

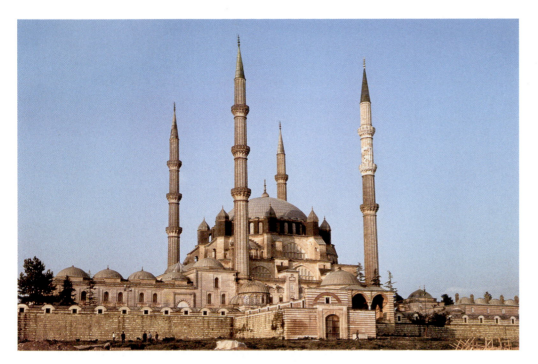

9-23 • PLAN (A) AND EXTERIOR VIEW (B) OF THE MOSQUE OF SULTAN SELIM, EDIRNE

Western Turkey. 1568–1575.

The minarets that pierce the sky around the prayer hall of this mosque, their sleek, fluted walls and needle-nosed spires soaring to more than 295 feet, are only 12½ feet in diameter at the base, an impressive feat of engineering. Only royal Ottoman mosques were permitted multiple minarets, and having more than two was unusual.

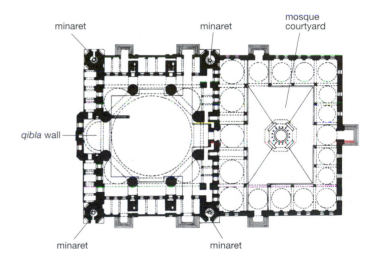

minaret minaret mosque courtyard

qibla wall

minaret minaret

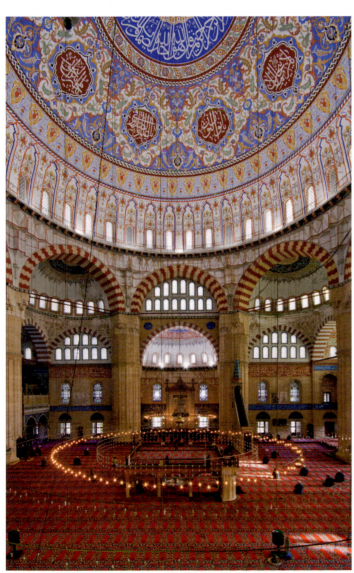

9-24 • INTERIOR, MOSQUE OF SULTAN SELIM

consisted of enclosures within walled enclosures, mirroring the immense political bureaucracy of the state. Inside, the sultan was removed from virtually all contact with the public. At the end of the inner palace, a free-standing pavilion, the Baghdad Kiosk (1638), provided him with a sumptuous retreat (**FIG. 9-25**). The kiosk consists of a low dome set above a cruciform hall with four alcoves. Each recess contains a low sofa (a Turkish word) laid with cushions and flanked by cabinets of wood inlaid with ivory and shell. Alternating with the cabinets are niches with ornate profiles: When stacked in profusion such niches—called *chini khana*—form decorative panels. On the walls, the blue and turquoise glazed tiles contain an inscription of the Throne Verse (Qur'an 2:255) which proclaims God's dominion "over the heavens and the earth," a reference to divine power that appears in many throne rooms and places associated with Muslim sovereigns. Sparkling light glows in the **stained glass** above.

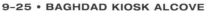

9-25 • BAGHDAD KIOSK ALCOVE

Topkapi Palace, Istanbul. 1638.

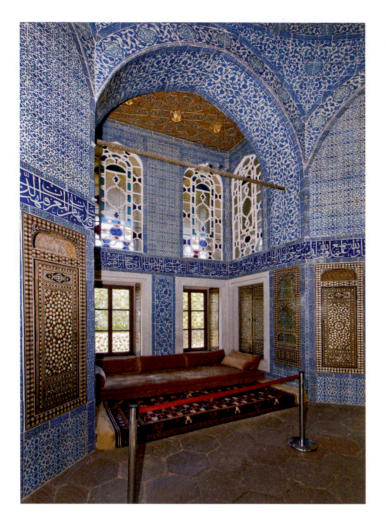

TUGRAS Following a practice begun by the Saljuqs and Mamluks, the Ottomans put calligraphy to political use, developing the design of imperial ciphers—**tugras**—into a specialized art form. Ottoman *tugras* combined the ruler's name and title with the motto "Eternally Victorious" into a monogram denoting the authority of the sultan and of those select officials who were also granted an emblem. *Tugras* appeared on seals, coins, and buildings, as well as on official documents called *firmans*, imperial edicts supplementing Muslim law. Suleyman issued hundreds of edicts, and a high court official supervised specialist calligraphers and illuminators who produced the documents with fancy *tugras* (**FIG. 9-26**).

Tugras were drawn in black or blue with three long, vertical strokes to the right of two concentric horizontal teardrops. Decorative foliage patterns fill the area within the script. By the 1550s, this fill decoration became more naturalistic, and in later centuries it spilled outside the emblems' boundary lines. This rare, oversized *tugra* has a sweeping, fluid but controlled line, drawn to set proportions. The color scheme of delicate floral interlace enclosed in the body of the *tugra* may have been inspired by Chinese blue-and-white porcelain; similar designs appear on Ottoman ceramics and textiles.

9-26 • ILLUMINATED TUGRA OF SULTAN SULEYMAN

From Istanbul, Turkey. c. 1555–1560. Ink, paint, and gold on paper, removed from a *firman* and trimmed to 20½″ × 25⅜″ (52 × 64.5 cm). Metropolitan Museum of Art, New York. Rogers Fund, 1938. (38.149.1)

The *tugra* shown here is from a document endowing an institution in Jerusalem that had been established by Suleyman's powerful wife, Hurrem.

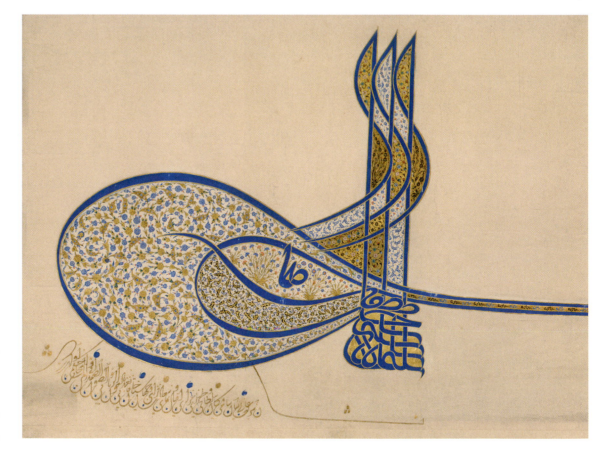

THE SAFAVID DYNASTY

When Shah Isma'il (r. 1501–1524) solidified Safavid rule over the land of the Timurids in the early years of the sixteenth century, he called Bihzad, the most distinguished member of the Herat School, to the capital city of Tabriz to supervise the Safavid royal workshop that established a new golden age of book production by blending the Herat style with that of other regional Persian traditions. But it was Isma'il's son and successor Shah Tahmasp (r. 1524–1576) who emerged as the most important early patron.

SULTAN MUHAMMAD As a child, Tahmasp was trained in the art of calligraphy and drawing in Herat, where Shah Isma'il had dispatched him to serve as titular governor. Shortly after succeeding his father, the youthful Tahmasp commissioned from the royal workshop in Tabriz a spectacular manuscript copy of the *Shahnama* ("Book of Kings"), Firdawsi's poetic history of Persian rulers written in the late tenth and early eleventh centuries. Tahmasp's monumental volume—with pages 18½ inches tall, larger than any book produced during the Timurid period—consists of 742 folios whose margins are embellished with pure gold; 258 full-page pictures highlight the important kings and heroes of Persian royal history. The paintings were produced by a series of artists over an extended period during the 1520s and into the 1530s. This was the most important royal artistic project of the early Safavid period.

Among the most impressive paintings—indeed, a work many consider the greatest of all Persian manuscript paintings—is a rendering of **THE "COURT OF GAYUMARS"** (**FIG. 9-27**) painted by Sultan Muhammad, the most renowned artist in the royal workshop. This assessment is not only modern. In 1544, Dust Muhammad—painter, chronicler, and **connoisseur**—cited this painting in particular when singling out Sultan Muhammad as the premier painter participating in the project, claiming that "although it has a thousand eyes, the celestial sphere has not seen his like" (Blair and Bloom, page 168). Sultan Muhammad portrayed the idyllic reign of the legendary

first Shah, Gayumars, who ruled from a mountaintop over a people who were the first to make clothing from leopard skins and develop the skill of cooking. The elevated and central figure of the king is surrounded by the members of his family and court, each rendered with individual facial features and varying body proportions to add a sense of naturalism to the unleashed fantasy characterizing the surrounding world. The landscape sparkles with brilliant color, encompassing the detailed delineation of lavish plant life as well as melting renderings of pastel rock formations, into which are tucked the faces of the spirits and demons animating this primitive paradise. This is a painting meant to be savored slowly by an intimate, elite audience within the Safavid court. It is packed with surprises and unexpected delights.

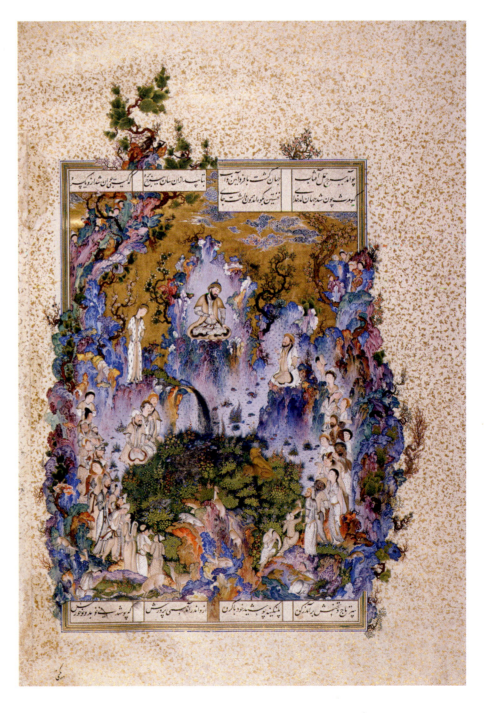

9-27 • Sultan Muhammad THE "COURT OF GAYUMARS"
From the Shahnama of Shah Tahmasp (fol. 20v). Tabriz, Iran. c. 1525–1535. Ink, pigments, and gold on paper, page size 18½″ × 12½″ (47 × 31.8 cm). Aga Khan Museum, Toronto. (AKM165)

ARCHITECTURE Whereas the Ottomans took their inspiration from works of the Byzantine Empire, the Safavids looked to Timurid architecture with its tall, double-shell domes, sheathed in blue tiles. In the later Safavid capital of Isfahan, the typically Timurid taste for modular construction re-emerged on a grand scale that extended well beyond buildings to include avenues, bridges, public plazas, and gardens. To the preexisting city of Isfahan, Safavid Shah Abbas I (1588–1629) added an entirely new extension, planned around an immense central plaza (*maydan*) and a broad avenue, called the Chahar Bagh, that ran through a zone of imperial palace pavilions and gardens down to the river. The city's prosperity and beauty so amazed visitors who flocked from around the world to conduct trade and diplomacy that it led to the popular saying, "Isfahan is half the world."

With Isfahan's **MASJID-I SHAH** or Royal Mosque (1611–1638), the four-*iwan* mosque plan reached its apogee (**FIG. 9-28**). Stately and huge, it anchors the south end of the city's *maydan*. Its 90-foot portal and the passageway through it aligns with the *maydan*, which is oriented astrologically, but the entrance corridor soon turns to conform to the prayer hall's orientation to Mecca. The portal's great *iwan* is framed by a *pishtaq* (a rectangular panel framing an *iwan*) that rises above the surrounding walls and is enhanced by the soaring verticality of its minarets. The *iwan*'s profile is reflected in the repeated, double-tiered *iwans* that parade across the façade of the mosque courtyard and around the *maydan* as a whole. Achieving unity through the regular replication of a single element—here the arch—is a hallmark of Safavid architecture, inherited from Timurid aesthetics, but achieved on an unprecedented scale and integrated within a well-planned urban setting.

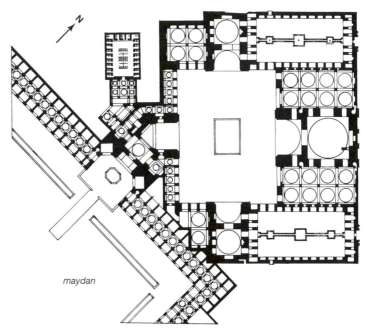

maydan

9-28 • PLAN (A) AND EXTERIOR VIEW (B) OF THE MASJID-I SHAH, ISFAHAN
Iran. 1611–1638.

The tall bulbous dome behind the *qibla iwan* and the large *pishtaqs* with minarets are pronounced vertical elements that made royal patronage visible not only from the far end of the *maydan* but throughout the city and beyond.

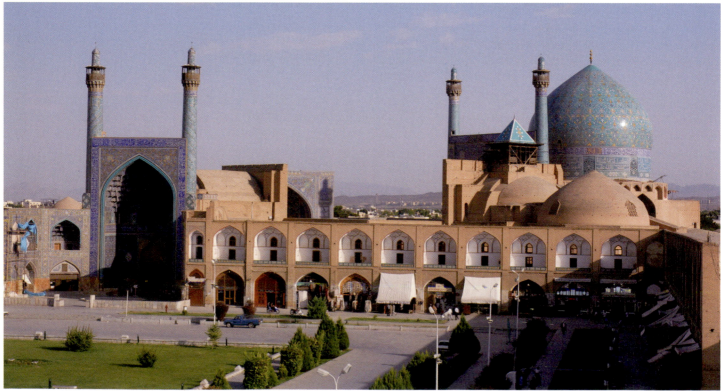

9-29 • GARDEN CARPET

The so-called Wagner Carpet. Iran. 17th century. Wool pile, cotton warp, cotton and wool weft, 17′5″ × 13′11″ (5.31 × 4.25 m). Burrell Collection, Glasgow.

The carpet fascinates not only for the fact that so simple a technique as a knotted yarn can produce such complex, layered designs, but also for the combination of perspectives: From above, the carpet resembles a plan, but the trees are shown in profile, as if from ground level.

CARPETS The Safavid period was a golden age of carpet making (see "Carpet Making," page 292). Shah Abbas built workshops in Isfahan and Kashan that produced large, costly carpets that were often signed—indicating the weaver's growing prestige. Among the types produced were medallion carpets, centered around a sun or star, and garden carpets, representing Paradise as a shady garden with four rivers. The seventeenth-century **GARDEN CARPET** in **FIGURE 9-29** represents a dense field of trees (including cypresses) and flowers, populated with birds, animals, and even fish, and traversed by three large water channels that form an H with a central pool at the center. Laid out on the floor of an open-air hall, and perhaps set with bowls of ripe fruit and other delicacies, such carpets brought the beauty of nature indoors.

Rugs have long been used for Muslim prayer, which involves repeatedly kneeling and touching the forehead to the floor before God. While individuals often had their own small prayer rugs, with representations of mihrab niches to orient them in prayer, many mosques were furnished with wool-pile rugs received as pious donations. In Islamic houses, people sat and slept on cushions, carpets, and thick mats laid directly on the floor, so cushions took the place of the fixed furnishings of Western domestic environments. Historically, rugs from Iran, Turkey, and elsewhere were highly valued by Westerners, who often displayed them on tables rather than floors. They remain one of the predominant forms of Islamic art known in the West.

THE MODERN ERA

Islamic art is not restricted to the distant past. But with the dissolution of the great Islamic empires and the formation of smaller nation-states during the twentieth century, questions of identity and its expression in art changed significantly. Muslim artists and

Because textiles are made of organic materials that are destroyed through use, very few carpets from before the sixteenth century have survived. Carpets fall into two basic types: flat-weave carpets and pile, or knotted, carpets. Both can be made on either vertical or horizontal looms.

The best-known flat-weaves today are kilims, which are typically woven in wool with bold, geometric patterns and sometimes with brocaded details. Kilim weaving is done with a **tapestry** technique called slit tapestry (see A).

Knotted carpets are an ancient invention. The oldest known example, excavated in Siberia and dating to the fourth or fifth century BCE, has designs evocative of Achaemenid art, suggesting that the technique may have originated in Central Asia. In knotted carpets, the pile—the plush, thickly tufted surface—is made by tying colored strands of yarn, usually wool but occasionally silk for deluxe carpets, onto the vertical elements

(the **warp**) of a yarn grid (see B and C). These knotted loops are later trimmed and sheared to form the plush pile surface of the carpet. The **weft** strands (crosswise threads) are shot horizontally, usually twice, after each row of knots is tied, to hold the knots in place and to form the horizontal element common to all woven structures. The weft is usually an undyed yarn and is hidden by the colored knots of the warp. Two common knot tying techniques are the asymmetrical knot, used in many carpets from Iran, Egypt, and Central Asia (formerly termed the Sehna knot), and the symmetrical knot (formerly called the Gördes knot) more commonly used in Anatolian Turkish carpet weaving. The greater the number of knots, the shorter the pile. The finest carpets can have as many as 2,400 knots per square inch, each one tied separately by hand.

Although royal workshops produced luxurious carpets (see FIG. 9–29), most knotted rugs have traditionally been made in tents and homes, woven, depending on local custom, either by women or by men.

A Kilim weaving pattern used in flat-weaving

B Symmetrical knot, used extensively in Turkey

C Asymmetrical knot, used extensively in Iran

9-30 • Hasan Fathy MOSQUE AT NEW GOURNA
Luxor, Egypt. 1945–1947. Gouache on paper, 22½″ × 17⅞″ (52.8 × 45.2 cm). Collection of the Aga Khan Award for Architecture, Geneva, Switzerland.

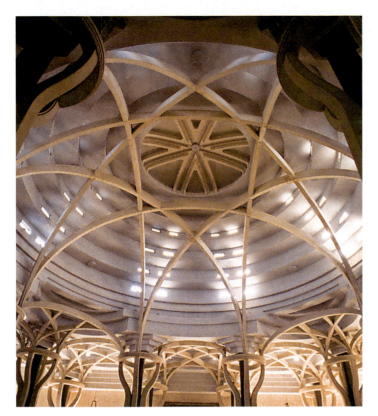

9-31 • Paolo Portoghesi, Vittorio Gigliotti, and Sami Mousawi **ISLAMIC MOSQUE AND CULTURAL CENTER, ROME** 1984–1992.

The prayer hall, 197' × 131' (60 × 40 m), which has an ablution area on the floor below, can accommodate a congregation of 2,500 on its main floor and balconies. The large central dome (65½'; 20 m in diameter) is surrounded by 16 smaller domes, all similarly articulated with concrete ribs.

architects began to participate in international movements that swept away many of the visible signs that formerly expressed their cultural character and difference. When architects in Islamic countries were debating whether modernity promised opportunities for new expression or simply another form of Western domination, the Egyptian Hasan Fathy (1900–1989) questioned whether abstraction could serve the cause of social justice. He revived traditional, inexpensive, and locally obtainable materials such as mud brick and forms such as wind scoops (an inexpensive means of catching breezes to cool a building's interior) to build affordable housing for the poor. Fathy's New Gourna Village (designed 1945–1947) in Luxor, Egypt, became a model of environmental sustainability realized in pure geometric forms that resonated with references to Egypt's architectural past (**FIG. 9–30**). In their simplicity, his watercolor paintings are as beautiful as his buildings.

More recently, Islamic architects have sought to reconcile modernity with an Islamic cultural identity distinct from the West. In this spirit Iraqi architect Sami Mousawi and the Italian firm of Portoghesi-Gigliotti designed the **ISLAMIC CULTURAL CENTER** in Rome (completed 1992) with clean modern lines, exposing the structure while at the same time taking full advantage of opportunities for ornament (**FIG. 9–31**). The structural logic appears in the prayer hall's concrete columns that rise to meet abstract capitals in the form of plain rings, then spring upward to make a geometrically dazzling eight-pointed star supporting a dome of concentric circles. There are references here to the interlacing ribs of the *mihrab* dome in the Great Mosque of Cordoba, to the great domed spans of Sinan's prayer halls, and to the simple palm-tree trunks that supported the roof of the Mosque of the Prophet in Medina.

THINK ABOUT IT

9.1 Explain how the design of the mosque varies across the Islamic world with reference to three examples. Despite the differences, what features do mosques typically have in common?

9.2 Images of people are not allowed in Islamic religious contexts, but mosques and other religious buildings are lavishly decorated. What artistic motifs and techniques are used and why?

9.3 Compare the painted pages from sumptuous manuscripts in FIGURES 9–21 and 9–27. How does the comparison reveal the distinctive aspirations of religious and secular art in Islamic society? How are they different, and what features do they share?

9.4 Select an Islamic structure that is influenced by Roman or Byzantine architecture. Which forms are borrowed? Why and how, in their new Islamic context, are they transformed?

CROSSCURRENTS

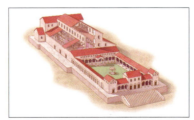

FIG. 7–13B

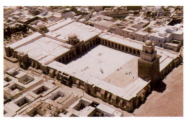

FIG. 9–5

These buildings were constructed for worship during the formative years of Christianity and Islam. Explain why they appear similar and discuss the ways in which their designs are consistent with the religious and cultural contexts.

✔●—[**Study** and review on myartslab.com

10–1 • ASHOKAN PILLAR
Lauriya Nandangarh, Bihar, India. Maurya period, c. 246 BCE.

Art of South and Southeast Asia before 1200

In 1837, when examining inscriptions on a series of massive monolithic pillars (**FIG. 10–1**) in northern India, amateur scholar James Princep realized that the designation "Beloved of the Gods" was one of the great ruler Ashoka Maurya's personal epithets. This realization made clear that the pillars dated to the time of King Ashoka (273–232 BCE) and lifted some of the mystery surrounding this renowned figure. The heroic qualities of Ashoka are well recorded in the Indian cultural tradition. His accomplishments served as inspiration for later kings, like those of the Gupta dynasty, and Buddhist literary sources credit him with a wide range of miraculous deeds. But in spite of this fame, early historians had great difficulty distinguishing the historical man from the legend. Once properly identified, his name appeared in numerous Maurya-dynasty inscriptions and what they reveal about the humanity of this man is in many ways more captivating than the larger-than-life figure encountered in the legends.

Notably, in his Thirteenth Rock Edict, Ashoka presents himself as a man weary of battle and intensely remorseful for the death and suffering generated by his political ambitions. In it, he recalls a horrific battle in the region of Kalinga that took place eight years into his reign. By his estimation 100,000 died and many thousands more were dispossessed or left in despair from the conflict. In surveying this carnage, Ashoka admits to being deeply pained and resolves henceforth to seek conquest through moral teachings (*dharma*) rather than by the sword. His profound change of heart also proved to be a sound policy for establishing legal consistency over his vast empire, and this stability stimulated a rich period of artistic production.

As part of this conversion, Ashoka supported religious institutions and gave special attention to the nascent Buddhist community. He also widely distributed royal inscriptions by having them carved directly onto boulders and mountainsides. These rock edicts were far more plentiful than the inscribed columns, commonly called Ashokan pillars, which are few in number and appear to have been concentrated in the heart of the Maurya empire. The remains of about 19 such pillars exist, but not all bear inscriptions that can be attributed with certainty to Ashoka. Most were placed at the sites of Buddhist monasteries along a route leading from Punjab in the northwest to Ashoka's capital, Pataliputra, in the northeast.

Pillars and pillared halls had been used as emblems of kingship in the Persian Achaemenid empire (Chapter 2, pages 45–46) and it is possible that Ashoka was inspired by their precedent when he decided to display his words on columns detached from an architectural setting. Most of these edicts are inscribed in Prakrit, a language closely related to classical Sanskrit, but others were written in the languages spoken locally, like Greek and Aramaic. These observations are indicative of the size and reach of Ashoka's empire, which set the model for South Asian kingship over the centuries to come.

LEARN ABOUT IT

10.1 Recognize the stylistic differences in regional art and architecture from South and Southeast Asia.

10.2 Understand the significance of iconography and narrative in the religious art of South and Southeast Asia.

10.3 Explore the correlation between Hindu and Buddhist religious worldviews and architectural form.

10.4 Identify the ways in which patronage benefited royal donors such as Ashoka Maurya, Sembiyan Mahadevi, Kyanzittha, and Suryavarman II.

((•—[**Listen** to the chapter audio on myartslab.com

GEOGRAPHY

It is difficult to make inclusive claims about South and Southeast Asia because the two areas were and are home to a broad range of diverse ethnic communities, political units, language groups, and cultural traditions. One of the few things both regions share is a historical importance to trade networks and, consequently, an exposure to similar ideological and religious ideas, most notably Hinduism, Buddhism, and Islam. The same proximity to the sea that played a role in trade also ensured exposure to the monsoon rains which pull moisture from the oceans each summer and have traditionally enabled vigorous agricultural production. Due to their wealth and accessibility, both regions have historically been subject to periods of invasion, immigration, and colonization. This sporadic influx of new peoples has, at times, been a source of great hardship, but each wave added to the rich diversity of these regions and contributed new layers to their remarkable artistic heritage.

The South Asian subcontinent, or Indian subcontinent, as it is commonly called, is a peninsular region that includes the present-day countries of India, Afghanistan, Pakistan, Nepal, Bhutan, Bangladesh, and Sri Lanka (**MAP 10–1**). This land mass is slowly pressing into the rest of Asia and the collision has given rise to the Himalayas, the world's highest mountains, which form a protective barrier to the north. Southeast Asia, by contrast, is part of the Asian continental plate and can be divided into two geographic regions. The first part is its peninsular or mainland portion which emerges from the southern edge of Asia and includes Myanmar, Cambodia, Laos, Malaysia, Singapore, Thailand, and Vietnam. The second region is comprised of a vast archipelago of islands that spreads out into the Pacific and Indian oceans. This maritime region includes the states of Brunei, East Timor, Indonesia, and the Philippines.

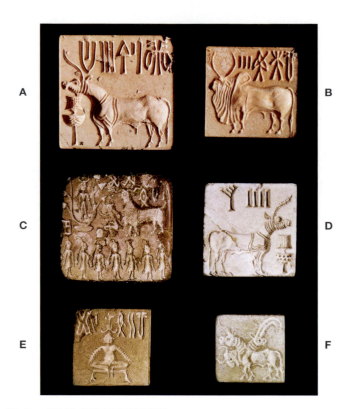

10–2 • SEAL IMPRESSIONS
A, D horned animal; B buffalo; C sacrificial rite to a goddess (?); E yogi; F three-headed animal. Indus Valley civilization, c. 2500–1500 BCE. Seals steatite, each approx. 1¼″ × 1¼″ (3.2 × 3.2 cm).

The more than 2,000 small seals and impressions that have been found offer an intriguing window on the Indus Valley civilization. Usually carved from steatite stone, the seals were coated with alkali and then fired to produce a lustrous, white surface. A perforated knob on the back of each may have been for suspending them. The most popular subjects are animals, most commonly a one-horned bovine standing before an altarlike object (A, D). The function of the seals may relate to trade but this remains uncertain since the script that is so prominent in the impressions has yet to be deciphered.

ART OF SOUTH ASIA

The earliest civilization of South Asia was nurtured in the lower reaches of the Indus River, in present-day Pakistan and north-western India. Known as the Indus or Harappan civilization (after Harappa, the first-discovered site), it flourished from approximately 2600 to 1900 BCE, or during roughly the same time as the Old Kingdom period of Egypt, the Minoan civilization of the Aegean, and the dynasties of Ur and Babylon in Mesopotamia. Indeed, it is considered, to be one of the world's earliest urban river-valley civilizations.

A chance late nineteenth-century discovery of some small **SEALS** (such as those whose impressions are shown in **FIGURE 10–2**), provided the first clue that an ancient civilization had existed in the Indus River Valley. This discovery prompted further excavations, beginning in the 1920s and continuing to the present, that subsequently uncovered a number of major urban areas at points along the lower Indus River, including Harappa, Mohenjo-Daro, and Chanhu-Daro.

THE INDUS CIVILIZATION

MOHENJO-DARO The ancient cities of the Indus Valley resemble each other in design and construction, suggesting a coherent culture. At Mohenjo-Daro, the best preserved of the sites, archaeologists discovered an elevated citadel area about 50 feet high, surrounded by a wall. Among the citadel's buildings is a remarkable **WATER TANK**, a large watertight pool that may have been a public bath but could also have had a ritual use (**FIG. 10–3**). Stretching out below the elevated area was the city, arranged in a gridlike plan with wide avenues and narrow side streets. Its houses, often two stories high, were generally built around a central courtyard. Like other Indus Valley cities, Mohenjo-Daro was constructed of fired brick, in contrast to the less durable sun-dried brick used in other cultures of the time. The city included a network of covered drainage systems that channeled away waste and rainwater. Clearly the technical and engineering skills of this civilization were highly advanced. At its peak, about 2500 to 2000 BCE, Mohenjo-Daro

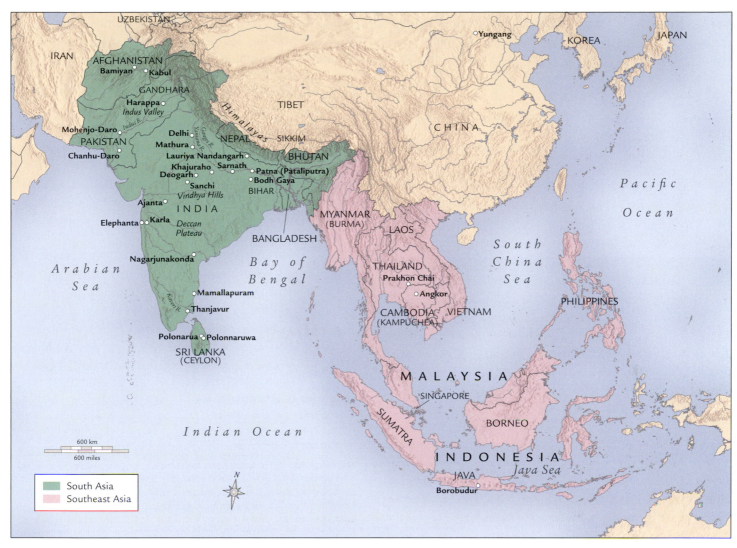

MAP 10-1 • SOUTH AND SOUTHEAST ASIA

As the deserts in western China heat during the summer months, the hot air rises and pulls cool air north off the oceans. As this water-laden air hits the Himalayas and the Tibetan plateau, it drops the torrential monsoon rains over much of South and Southeast Asia.

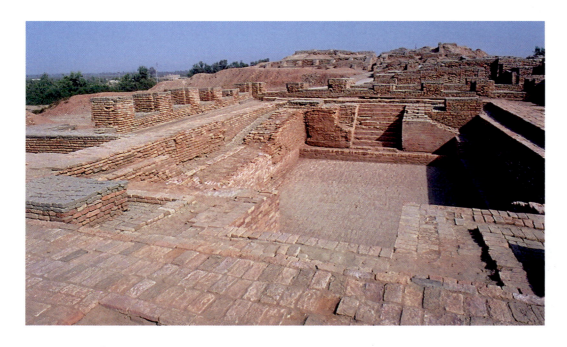

10-3 • LARGE WATER TANK, MOHENJO-DARO

Indus Valley (Harappan) civilization, c. 2600–1900 BCE.

Possibly a public or ritual bathing area.

was approximately 6–7 square miles in size and had a population of about 20,000–50,000. This uniformity suggests some form of central political control, but in the absence of any clear political or religious structures we can say very little about how these cities were governed.

INDUS VALLEY SEALS Although our knowledge of the Indus civilization is limited by the fact that we cannot read its writing, motifs on seals as well as the few discovered artworks strongly suggest continuities with later South Asian cultures. The seal in FIGURE 10-2E, for example, depicts a man in a meditative posture that resembles later forms of yoga, traditional physical and mental exercises usually undertaken for spiritual purposes. In FIGURE 10-2C, people with elaborate headgear stand in a row or procession observing a figure standing in a tree—possibly a goddess—and a kneeling worshiper. This scene may offer some insight into the religious or ritual customs of Indus people, whose deities may have been ancient prototypes of later Indian gods and goddesses.

Numerous terra-cotta figurines and a few stone and bronze statuettes have been found at Indus sites. They reveal a confident maturity of artistic conception and technique. Both the terra-cotta and the stone figures foreshadow the later Indian artistic tradition in their sensuous naturalism.

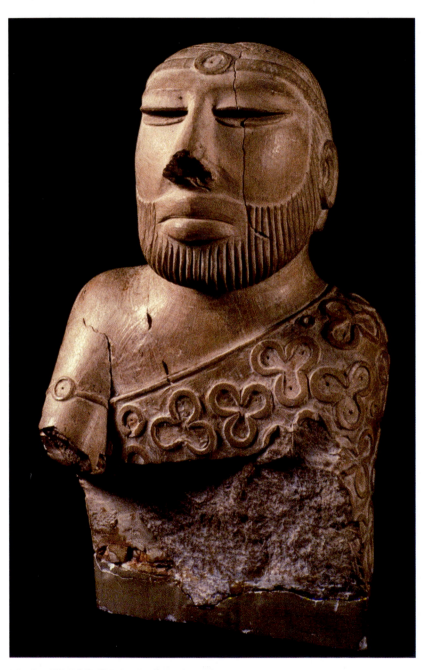

10-4 • TORSO OF A "PRIEST-KING"
From Mohenjo-Daro. Indus Valley civilization, c. 2600–1900 BCE. Steatite, height 6⅞" (17.5 cm). National Museum of Pakistan, Karachi.

"PRIEST-KING" FROM MOHENJO-DARO The male torso sometimes called the "priest-king" (FIG. 10-4) suggests by this name a structure of society where priests functioned as kings—for which we have no evidence at all. Several features of this figure, including a low forehead, a broad nose, thick lips, and long slit eyes, are seen on other works from Mohenjo-Daro. The man's garment is patterned with a **trefoil** (three-lobed) motif. The depressions of the trefoil pattern were originally filled with red pigment, and the eyes were inlaid with colored shell or stone. Narrow bands with circular ornaments adorn the upper arm and the head. The headband falls in back into two long strands, and they may be an indication of rank. Certainly, with its formal pose and simplified, geometric form, the statue conveys a commanding human presence.

NUDE TORSO FROM HARAPPA Although its date is disputed by some, a nude **MALE TORSO** (FIG. 10-5) found at Harappa is an example of a contrasting naturalistic style of ancient Indus origin. Less than 4 inches tall, it is one of the most extraordinary portrayals of the human form to survive from any early civilization. Its lifelike rendering emphasizes the soft texture of the human body and the subtle nuances of muscular form. With these characteristics the Harappa torso forecasts the essential aesthetic attributes of later Indian sculpture.

The reasons for the demise of this flourishing civilization are not yet understood. Recent research has suggested that between 2000 and 1750 there was a gradual breakdown of the architectural regularity characteristic of earlier periods. Many now think this was due to climate change and a dramatic shift in the course of local rivers. These changes made it impossible to practice the agriculture and river trade on which these cities depended. The cities of the Indus civilization declined, and predominantly rural and nomadic societies emerged.

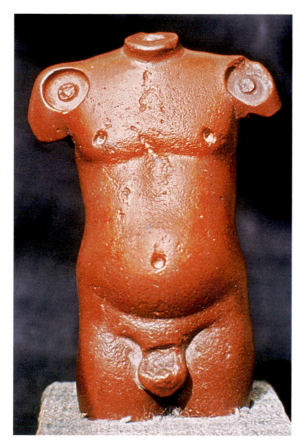

10-5 • MALE TORSO
From Harappa. Indus Valley civilization, c. 2600–1900 BCE.
Red sandstone, height 3¾″ (9.5 cm). National Museum,
New Delhi.

THE VEDIC PERIOD

About 2000 BCE nomadic herdsmen, the Aryans, entered India from Central Asia and the Russian steppes. Gradually they blended with the indigenous populations and introduced the horse and chariot, the Sanskrit language, a hierarchical social order, and religious practices that centered on the propitiation of gods through fire sacrifice. The earliest of their sacred writings, known as the Vedas, contain hymns to various gods including the divine king Indra. The importance of the fire sacrifice, overseen by a powerful priesthood—the Brahmins—and religiously sanctioned social classes, persisted through the Vedic period. At some point, the class structure became hereditary and immutable, with lasting consequences for Indian society.

During the latter part of this period, from about 800 BCE, the Upanishads were composed. These texts, written primarily by Brahmins, attempted to reform the Vedic ritual by emphasizing the unity between the individual and the divine. Some authors asserted that the material world is illusory and that only the universal divine (Brahman) is real and eternal. Others held that our existence is cyclical and that beings are caught in *samsara*, a relentless cycle of birth, life, death, and rebirth. Believers aspire to attain liberation from *samsara* and to unite the individual soul with the eternal, universal Brahman.

The latter portion of the Vedic period also saw the flowering of India's epic literature, written in the melodious and complex Sanskrit language. By around 400 BCE, the *Mahabharata*, the longest epic in world literature, and the *Ramayana*, the most popular and enduring religious epic in India and Southeast Asia, were taking shape. These texts relate histories of gods and humans, bringing profound philosophical ideas to a more accessible and popular level. In this way, the Vedic tradition continued to evolve, emerging later as Hinduism, a loose term that encompasses the many religious forms that resulted from the mingling of Vedic culture with indigenous beliefs (see "Hinduism," page 309).

In this stimulating religious, philosophical, and literary climate, numerous religious communities arose, some of which did not accept the primacy of the Brahmins. Among these heterodox groups the Jains and the Buddhists were the most successful. The last of the 24 Jain spiritual pathfinders (*tirthankara*), Mahavira, is believed to have taught in the sixth century BCE. His were the earliest teachings ever to recognize non-violence as a central moral principle. The Buddha Shakyamuni is thought to have lived shortly thereafter in the fifth century BCE (see "Buddhism," page 301). Both traditions espoused some basic Upanishadic tenets, such as the cyclical nature of existence and the need for liberation from the material world. However, they rejected the authority of the Vedas, and with it the legitimacy of the fire sacrifice and the hereditary class structure of Vedic society, with its powerful, exclusive priesthood. In further contrast with the Brahmins, who often held important positions in society, both Jainism and Buddhism were renunciate (*shramana*) traditions, centered on communities of monks and nuns who chose to separate themselves from worldly concerns. Over time, however, even these communities began to play important social roles. Nevertheless, asceticism held, and continues to hold, an important place within most South Asian religious traditions.

THE MAURYA PERIOD

In about 700 BCE, hundreds of years after their decline along the Indus, cities began to reappear on the subcontinent, particularly in the north, where numerous kingdoms arose. For most of its subsequent history, India was a shifting mosaic of regional kingdoms. From time to time, however, a particularly powerful dynasty formed an empire. The first of these was the Maurya dynasty (c. 322–185 BCE), which extended its rule over all but the southernmost portion of the subcontinent.

During the reign of the third Maurya king, Ashoka (r. c. 273–232 BCE), Buddhism expanded from a religion largely localized in the Maurya heartland, a region known as Magadha, to one extending across the entire empire. Among the monuments he erected were monolithic pillars set up primarily at the sites of Buddhist monasteries. The fully developed Ashokan pillar—a slightly tapered sandstone shaft that usually rested on a stone foundation slab sunk more than 10 feet into the ground—rose to a height of around 50 feet (see FIG. 10–1). On it were often carved inscriptions relating to rules of *dharma,* the divinely ordained moral law

believed to keep the universe from falling into chaos. Ideal kings were enjoined to uphold this law, and many later Buddhists interpreted the rules as also referring to Buddhist teachings. At the top were placed elaborate animal-shaped capitals carved from separate blocks of sandstone. Both shaft and capital were given the high polish characteristic of Maurya stonework. Scholars believe that the pillars, which served as royal standards, symbolized the **axis mundi** ("axis of the world"), joining earth with the cosmos and representing the vital link between the human and celestial realms.

LION CAPITAL FROM SARNATH This capital (**FIG. 10–6**) originally crowned the pillar erected at Sarnath, the site of the Buddha's first sermon. It represents four addorsed, or back-to-back, Asiatic lions with open mouths standing atop a circular platform depicting a bull, horse, lion, and elephant separated by large chariot wheels. The base is an inverted lotus blossom whose

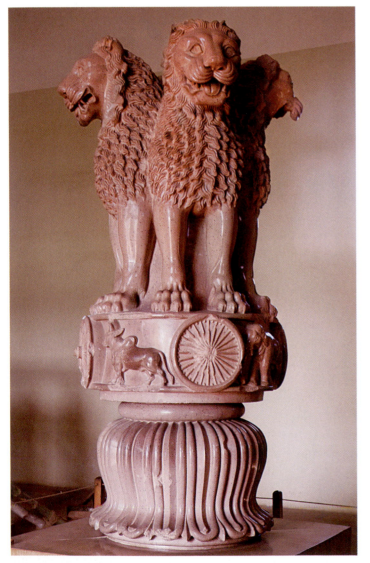

10–6 • LION CAPITAL
From Ashokan pillar at Sarnath, Uttar Pradesh, India. Maurya period, c. 250 BCE. Polished sandstone, height 7′ (2.13 m). Archaeological Museum, Sarnath.

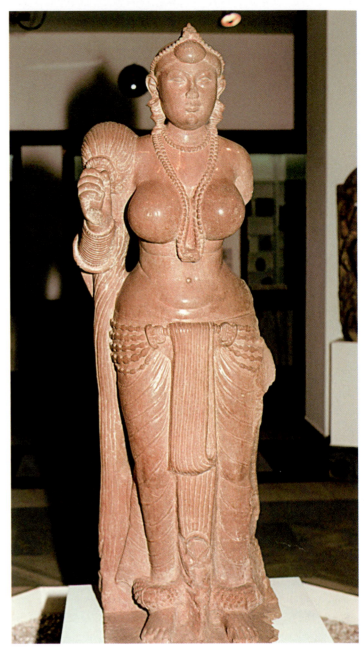

10–7 • FEMALE FIGURE HOLDING A FLY-WHISK
From Didarganj, Patna, Bihar, India. Probably Maurya period, c. 250 BCE. Polished sandstone, height 5′4¼″ (1.63 m). Patna Museum, Patna.

Commonly identified as a *yakshi*, this sculpture has become one of the most famous works of Indian art. Holding a fly-whisk in her raised right hand, the figure wears only a long shawl and a skirtlike cloth. The nubbled tubes about her ankles probably represent anklets made of beaten gold. Her hair is bound behind in a large bun, and a small bun sits on her forehead. This hairstyle appears again in Indian sculpture of the later Kushan period (c. second century CE).

bell-shape formed a transition to the column. The deeply cut carving promotes an active play of light and shadow and results in details that are readily visible even when this image was placed high atop its perch.

Some poetic references allude to the Buddha's sermon as the "Lion's Roar," whereas, others refer to it as the turning of the

The Buddhist religion developed from the teachings of Shakyamuni Buddha, who lived during the fifth century BCE in the present-day regions of southern Nepal and northern India. At his birth, it is believed, seers foretold that the infant prince, named Siddhartha Gautama, would become either a *chakravartin* (world-conquering ruler) or a *buddha* (fully enlightened being). Hoping for a ruler like himself, Siddhartha's father tried to surround his son with pleasure and shield him from pain. Yet the prince was eventually exposed to the sufferings of old age, sickness, and death—the inevitable fate of all mortal beings. Deeply troubled by the human condition, Siddhartha at age 29 left the palace, his family, and his inheritance to live as an ascetic in the wilderness. After six years of meditation, he attained complete enlightenment at a site in India now called Bodh Gaya.

Following his enlightenment, the Buddha ("Awakened One") gave his first teaching in the Deer Park at Sarnath. Here he expounded the Four Noble Truths that are the foundation of Buddhism: (1) life is suffering; (2) this suffering has a cause, which is ignorance and desire; (3) this ignorance and desire can be overcome and extinguished; (4) the way to overcome them is by following the eightfold path of right view, right resolve, right speech, right action, right livelihood, right effort, right mindfulness, and right concentration. After the Buddha's death at age 80, his many disciples developed his teachings and established the world's oldest monastic institutions.

A buddha is not a god but rather one who sees the ultimate nature of the world and is therefore no longer subject to *samsara*, the cycle of birth, death, and rebirth that otherwise holds us in its grip, whether we are born into the world of the gods, humans, animals, demons, tortured spirits, or hellish beings.

The early form of Buddhism, known as Theravada or Nikaya, stresses self-cultivation for the purpose of attaining *nirvana*, which is the extinction of *samsara* for oneself. Theravada Buddhism has continued mainly in Sri Lanka and Southeast Asia. Almost equally old is another form of Buddhism, known as Mahayana, which became popular mainly in northern India; it eventually flourished in China, Korea, Japan, and in Tibet (as Vajrayana). Compassion for all beings is the foundation of Mahayana Buddhism, whose goal is not only *nirvana* for oneself but buddhahood (enlightenment) for every being throughout the universe. Many schools of Buddhism recognize buddhas other than Shakyamuni from the past, present, and future. One such is Maitreya, the next buddha destined to appear on earth. Several Buddhist schools also accept the existence of bodhisattvas ("those whose essence is wisdom"), saintly beings who are on the brink of achieving buddhahood but have vowed to help others achieve buddhahood before crossing over themselves. In art, bodhisattvas and buddhas are most clearly distinguished by their clothing and adornments: bodhisattvas wear the princely garb of India, while buddhas wear monks' robes.

Read the document related to the Buddha on myartslab.com

"Wheel of the Law" (*dharmachakra*). This designation likens the Buddha's teachings to a chariot wheel and the sermon to the first push that set the wheel rolling across the world. The four lions and spoked wheels on the capital face the cardinal directions, thus referencing these descriptive titles.

However, the imagery works on two levels and also holds important political associations. The lion may have served as a metaphor for the Buddha's preaching but prior to that is was a symbol of kingship, and the elephant, horse, and bull were similarly potent as emblems of worldly and military power. When considered in conjunction with the wheel motifs, this imagery almost certainly also references the king as a *chakravartin*. This term refers to a universal king of such power that the wheels of his chariot pass everywhere unimpeded. The designation held great significance in South Asia, and Ashoka is here associating the worldly might of his empire with the moral authority of Buddhism. This relationship would have been further reinforced by the large wheel, now lost, that is believed to have rested atop the lions.

FEMALE FIGURE FROM DIDARGANJ Alongside the formal religious institutions of the Brahmins, Buddhists, and Jains, there existed a host of popular religious practices centered on local gods of villages and fields who were believed to oversee worldly matters such as health, wealth, and fertility. A spectacular **FEMALE**

FIGURE HOLDING A FLY-WHISK, or *chauri* (**FIG. 10-7**), found at Didarganj, near the Maurya capital of Pataliputra may represent one such deity. The statue, dated by most scholars to the Maurya period, probably represents a **yakshi**, a spirit associated with the productive and reproductive forces of nature. With its large breasts and pelvis, the figure embodies the association of female beauty with procreative abundance, bounty, and auspiciousness.

Sculpted from fine-grained sandstone, the statue conveys the *yakshi*'s authority through the frontal rigor of her pose, the massive volumes of her form, and the strong, linear patterning of her ornaments and dress. Alleviating and counterbalancing this hierarchical formality are her soft, youthful face, the precise definition of prominent features such as the stomach muscles, and the polished sheen of her exposed flesh. As noted above, this lustrous polish is a special feature of Maurya sculpture.

THE PERIOD OF THE SHUNGA AND EARLY SATAVAHANA

With the demise of the Maurya empire, India returned to rule by regional dynasties. Between the second century BCE and the early centuries CE, two of the most important of these dynasties were the Shunga dynasty (185–72 BCE) in central India and the Satavahana dynasty (third century BCE–third century CE), who initially ruled in central India and after the first century in the south. During this

Buddhist architecture in South Asia consists mainly of stupas and temples, often at monastic complexes containing *viharas* (monks' cells and common areas). These monuments may be either structural—built up from the ground—or rock-cut—hewn out of a mountainside. Stupas derive from burial mounds and contain relics beneath a solid, dome-shaped core. A major stupa is surrounded by a railing that creates a sacred path for ritual circumambulation at ground level. This railing is punctuated by gateways, called **toranas** in Sanskrit, aligned with the cardinal points. The stupa sits on a round or square terrace; and stairs may lead to an upper circumambulatory path around the platform's edge. On top of the stupa a railing defines a square, from the center of which rises a mast supporting tiers of disk-shaped "umbrellas."

Hindu architecture in South Asia consists mainly of temples, either structural or rock-cut, executed in a number of styles and dedicated to diverse deities. The two general Hindu temple types are the northern and southern styles, prevalent in northern India and southern India

respectively. Within these broad categories is great stylistic diversity, though all are raised on plinths and dominated by their superstructures. In north India, the term **shikhara** is used to refer to the entire towerlike superstructure which often curves inward, sloping more steeply near its peak. In the south, by contrast, the southern superstructure is comprised of angular, steplike terraces and the term *shikhara* refers only to the finial, that is, the uppermost member of the superstructure. North Indian *shikharas* are crowned by **amalakas**. Inside, a series of **mandapas** (halls) leads to an inner sanctuary, the **garbhagriha**, which contains a sacred image. An axis mundi is imagined to run vertically up from the Cosmic Waters below the earth, through the *garbhagriha*'s image, and out through the top of the tower.

Jain architecture consists mainly of structural and rock-cut monasteries and temples that have much in common with their Buddhist and Hindu counterparts.

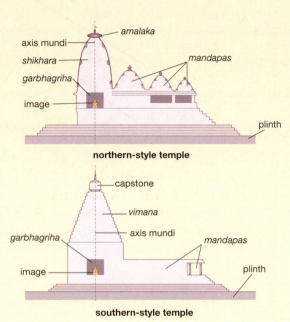

northern-style temple

southern-style temple

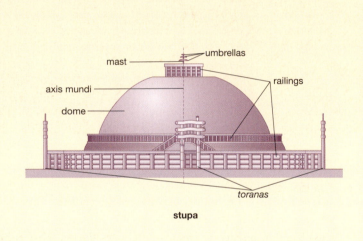

stupa

⊙ **Watch** an architectural simulation about stupas and temples on myartslab.com

period, some of the most magnificent early Buddhist structures were created.

Religious monuments called **stupas**, solid mounds enclosing a relic, are fundamental to Buddhism (see "Stupas and Temples," above). In practice, the exact nature of the relic varies, but in ideal cases they are connected directly with the Buddha himself or to one of his important disciples. The form, size, and decoration of stupas differ from region to region, but their symbolic meaning remains virtually the same, and their plan is a carefully calculated **mandala**, or diagram of the cosmos as envisioned in Buddhism. Stupas are open to all for private worship.

The first stupas were constructed to house the Buddha's remains after his cremation. According to tradition, these relics

were divided into eight portions and given to important kings, who then further divided and encased the remains in burial mounds. Since the early stupas held actual remains of the Buddha, they were venerated as his body and, by extension, his enlightenment and attainment of *nirvana* (liberation from rebirth). The method of veneration was, and still is, to circumambulate, or walk around, the stupa in a clockwise direction.

THE GREAT STUPA AT SANCHI Probably no early Buddhist structure is more famous than the **GREAT STUPA** at Sanchi in central India (**FIG. 10–8**). Most likely dating to the time of Ashoka, the Great Stupa originally formed part of a large monastery complex crowning a hill. During the mid second century BCE, it was

10-8 • STUPA 1 (THE GREAT STUPA) AT SANCHI
Madhya Pradesh, India. Founded 3rd century BCE; enlarged c. 150–50 BCE.

View the Closer Look for Stupa 1 (The Great Stupa) at Sanchi on myartslab.com

enlarged to its present size, and the surrounding stone railing was constructed. About 100 years later, elaborately carved stone gateways were added to the railing.

Representative of the early central Indian stupa type, the solid, hemispherical mound of the Great Stupa at Sanchi was built up from rubble and dirt, faced with dressed stone, then covered with a shining white plaster made from lime and powdered seashells. A 10-foot-tall stone railing demarcates a circumambulatory path at ground level. Another walkway, approached by a staircase on the south side, creates a second raised level for circumambulation. On top of the mound a square enclosure, designated by another railing, contains the top of a mast bearing three stone disks, or "umbrellas," of decreasing size. Interpreted in various ways, these disks are probably an architectural form derived from the parasols used to shade kings and indicate people of importance. They may also correspond to the "Three Jewels of Buddhism"—the Buddha, the Law, and the Monastic Order.

As is often true in religious architecture, the railing provides a physical and symbolic boundary between an inner, sacred area and the outer, profane world. Carved with octagonal uprights and lens-shaped crossbars, it probably simulates the wooden railings of the time. Aligned with the four cardinal directions, four stone gateways, or *toranas*, punctuate the railing. An inscription on the south gateway indicates that it was provided by ivory carvers from the nearby town of Vidisha, while another inscription, also on the south *torana*, specifies a gift during the reign of King Satakarni of the Satavahana dynasty, providing the first-century BCE date for the gateways. The vast majority of the inscriptions at Sanchi, however, record modest donations by individual devotees from all walks of life. This collaborative patronage points to Buddhism's expanding popularity.

Rising to a height of 35 feet, the gateways are the only elements of the Great Stupa at Sanchi to be ornamented with sculpture.

The four gates support a three-tiered array of architraves in which posts and crossbars are elaborately carved with symbols and scenes drawn mostly from the Buddha's life and the **Jataka tales**, stories of the Buddha's past lives. These relief sculptures employ two distinctive features of early South Asian visual narrative. The first is that the Buddha himself is not shown in human form prior to the late first century BCE. Instead, he is represented by symbols

A CLOSER LOOK | The Great Departure

East torana (exterior middle architrave) of Stupa 1 (The Great Stupa) at Sanchi.
1st century BCE. Sandstone.

Before he became the Buddha, Prince Siddhartha resolved to give up his royal comforts in order to pursue the life of an ascetic. Confiding only in his charioteer Channa, the prince slipped out of his palace in the dead of night, and, mounting his horse, headed for the gates. The local gods, *yakshas*, were eager for the prince to succeed on his spiritual quest and cupped their hands under the horse's hooves so that no one would awaken from the noise. Indeed, in some versions, they carry the horse and its rider right over the palace walls. This story is depicted, using some distinctive forms of visual narrative, on the middle architrave of the east gate of the Great Stupa at Sanchi.

The presence of the prince is indicated by the riderless horses shaded by a royal parasol and fly-whisk. This is the same horse shown at various moments in the story.

All the action is organized geographically in the scene as it plays out between the palace and the forest. This tree indicates the transition into the forest setting.

The *yakshas* accompany the creature only when ridden by the prince. In the lower right, the horse and charioteer turn back on their own, unaccompanied by the local gods and leaving Shakyamuni to begin his life as an ascetic.

The footprints on the far right of the relief indicate the place Prince Siddhartha dismounted.

 View the Closer Look for The Great Departure on myartslab.com

such as his footprints, an empty "enlightenment" seat, or a plank. The reasons for this absence are still widely debated but, since Vedic gods and Jinas are very rarely depicted in this period, it seems likely that this was the result of a wider cultural practice rather than a uniquely Buddhist prohibition. The second is that South Asian sculpture frequently employs continuous narrative. This means that several moments in time are represented in the same visual frame. For an example see "A Closer Look," above. The *toranas* are further decorated with free-standing sculptures depicting such subjects as *yakshis* and their male counterparts, *yakshas*, riders on real and mythical animals, and the Buddhist wheel.

Forming a bracket between each capital and the lowest crossbar on the east gate is a sculpture of a **YAKSHI** (**FIG. 10–9**). These *yakshis* are some of the finest female figures in Indian art, and they make an instructive comparison with the Didarganj image of the Maurya period (see FIG. 10–7). The earlier figure was distinguished by a formal, somewhat rigid pose, an emphasis on realistic details, and a clear distinction between clothed and nude parts of the body. In contrast, the Sanchi *yakshi* leans daringly into space with casual abandon, supported by one leg as the other charmingly crosses behind. Her thin, diaphanous garment is noticeable only by its hems, and so she appears almost nude, which emphasizes her form. The mango tree on which she hangs is heavy with fruit, reasserting the fecundity and bounty associated with these mercurial deities. This semidivine figure's presence on a Buddhist gateway implies her role as a guardian or devotee, which, in turn, speaks to Buddhism's inclusiveness. Even deities were understood to benefit from the Buddha's teachings.

THE CHAITYA HALL AT KARLE From ancient times, caves have been considered hallowed places in India, because they were frequently the abodes of holy men and ascetics. Around the second century BCE, cavelike sanctuaries were hewn out of the stone plateaus in the region of south-central India known as the Deccan. Made for the use of Jain and Buddhist monks, these sanctuaries were carved from top to bottom like great pieces of sculpture, with all details completely finished in stone. Entering these remarkable halls transports one to an otherworldly sacred

10-9 • YAKSHI BRACKET FIGURE
East *torana* of the Great Stupa at Sanchi. Sandstone, height approx. 60″ (152.4 cm).

10-10 • CHAITYA HALL, KARLE
Maharashtra, India. 1st century BCE–1st century CE.

space. The atmosphere created by the cool, dark interior and the echo that magnifies the smallest sound combine to promote a state of heightened awareness.

The monastic community utilized two types of rock-cut halls. The **vihara** functioned as the monks' living quarters, and the **chaitya** ("sanctuary") usually enshrined a stupa. A **CHAITYA HALL** at Karle (**FIG. 10-10**), dating from the first century BCE to the first century CE, is one of the largest and most fully developed examples of these early Buddhist works. At the entrance, columns once supported a wooden façade, in front of which stands a pillar, inspired by Ashokan precedents. The walls of the vestibule are carved in relief with rows of small balcony railings and arched windows, simulating the appearance of a great multi-storied palace. At the base of the side walls, enormous statues of elephants seem to support the entire structure on their backs. Dominating the upper portion of the main façade is a large horseshoe-shaped opening, which

provides the hall's main source of light. The window was originally fitted with a carved wooden screen, some of which remains, that filtered the light streaming inside.

Three entrances allow access to the interior. Flanking the doorways are sculpted panels of **mithuna** couples, amorous male and female figures that evoke the auspicious qualities of harmony and fertility in life. The interior hall, 123 feet long, has a 46-foot-high ceiling carved in the form of a barrel vault ornamented with arching wooden ribs. Both the interior and exterior of the hall were once brightly painted. Pillars demarcate a pathway for circumambulation around the stupa in the apse at the far end.

The side aisles are separated from the main aisle by closely spaced columns whose bases resemble a large pot set on a stepped pyramid of planks. The statues that comprise the upper capitals of these columns depict pairs of kneeling elephants, each bearing a *mithuna* couple. These figures, the only sculpture within this austere hall, may represent the nobility coming to pay homage at the temple. The pillars around the apse are plain, and the stupa is simple. A railing motif ornaments its base. The stupa was once topped with wooden umbrellas, only one of which remains. As with nearly everything in the cave, the stupa is carved from the rock of the cliff.

THE KUSHAN PERIOD

Around the first century CE, the regions of present-day Afghanistan, Pakistan, and north India came under the control of the Kushans, originally a nomadic people forced out of northwest China by the Han. Exact dates are uncertain, but they ruled from the first to the third century CE.

These heavily-bearded warrior kings made widespread use of royal portraiture on coins and in sculptural form. An image of **KING KANISHKA** (**FIG. 10–11**), whose reign is thought to have begun in 127 CE, represents one of the Kushan's most illustrious rulers. This boldly frontal work stands over 5 feet tall even with the head missing. The fact that his hands rest on his sword and massive club makes his martial authority clear even before reading the inscription which identifies him as "The great king, king of kings." Attired in a coat and heavy felt riding boots, he is ill-suited for the warm South Asian climate and his garments reflect his Central Asian heritage. The hundreds of pearls that line the hem of his outfit are indicative of his great wealth and were particularly rare in the inland territories from which the Kushan migrated.

10–11 • KING KANISHKA
Uttar Pradesh, India. c. 2nd–3rd century CE. Sandstone, height 5′3″ (1.6 m). Government Museum, Mathura.

These rulers were remarkably eclectic in their religious views and, judging from their coins, supported a wide range of religious institutions. In this tolerant climate, and perhaps spurred on by Kushan royal images, innovative figural art began to blossom in the Jain, Brahmanic, and Buddhist traditions.

Among these innovations are the first depictions of the Buddha himself in art. (Previously, as in the Great Stupa at Sanchi, the Buddha had been indicated solely by symbols.) Distinctive styles arose in the Gandhara region in the northwest (present-day Pakistan and Afghanistan) and in the important religious center of Mathura in central India. While the images from these Kushan-controlled regions are stylistically quite distinct, they shared a basic visual language, or iconography, in which the Buddha is readily recognized by specific characteristics. For instance, he wears a monk's robe, a long length of cloth draped over the left shoulder and around the body. The Buddha also is said to have had 32 major distinguishing marks, called **lakshanas**, some of which are reflected in the iconography (see "Buddhist Symbols," page 368). These include a golden-colored body, long arms that reached to his knees, the impression of a wheel (*chakra*) on the palms of his hands and the soles of his feet, and the **urna**—a mark between his eyebrows. A prince in his youth, he had worn the customary heavy earrings, and so his earlobes are usually shown elongated. The top of his head is said to have had a protuberance called an **ushnisha**, which in images often resembles a bun or topknot and symbolizes his enlightenment.

THE GANDHARA STYLE Combining elements of Hellenistic, Persian, and Indian styles, Gandhara sculptors typically portrayed the Buddha as an athletic figure, more powerful and heroic than an ordinary human. Carved from schist, a fine-grained dark stone, this over-life-size **STANDING BUDDHA** (**FIG. 10-12**) may date to the fully developed stage of the Gandhara style, possibly around the third century CE. The Buddha's body, revealed through the folds of the garment, is broad and massive, with heavy shoulders and limbs and a well-defined torso. His left knee bends gently, suggesting a slightly relaxed posture.

The treatment of the robe is especially characteristic of the Gandhara manner. Tight, naturalistic folds alternate with delicate creases, setting up a clear, rhythmic pattern of heavy and shallow lines. On the upper part of the figure, the folds break asymmetrically along the left arm; on the lower part, they drape in a symmetric U shape. The strong tension of the folds suggests life and power within the image. This complex fold pattern resembles the treatment of togas on certain Roman statues (see FIG. 6-22), and it exerted a strong influence on portrayals of the Buddha in Central and East Asia. The Gandhara region's relations with the Hellenistic world may have led to this strongly Western style in its art. Pockets of Hellenistic culture had thrived in neighboring Bactria (present-day northern Afghanistan and southern Uzbekistan) since the fourth century BCE, when the Greeks under Alexander the Great had reached the borders of India. Also, Gandhara's position

draw on this sculptural tradition, often portraying him in a frontal stance with broad shoulders and wide eyes.

The stele in **FIGURE 10-13** is one of the finest of the early Mathura images. The sculptors worked in a distinctive red sandstone flecked with cream-colored spots. Carved in **high relief** (forms projecting strongly from the background), it depicts a seated Buddha with two attendants. His right hand is raised in a symbolic gesture meaning "have no fear." Images of the Buddha rely on a repertoire of such gestures, called **mudras**, to communicate certain ideas, such as teaching, meditation, or the attaining of enlightenment (see "Mudras," page 308). The Buddha's *urna*, his *ushnisha*, and the impressions of wheels on his palms and soles are all clearly visible in this figure. Behind his head is a large, circular halo; the scallop points of its border represent radiating light. Behind the halo are branches of the pipal tree, the tree under which the Buddha was seated when he achieved enlightenment. Two celestial beings hover above.

As in Gandhara sculptures, the Mathura work gives a powerful impression of the Buddha. The robe is pulled tightly over the body,

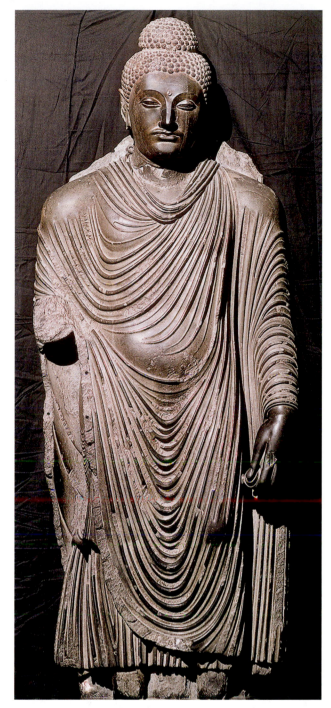

10-12 • STANDING BUDDHA
From Gandhara, Pakistan. Kushan period, c. 2nd–3rd century CE. Schist, height 7′6″ (2.28 m). Lahore Museum, Lahore.

near the east–west trade routes appears to have stimulated contact with Roman culture in the Near East during the early centuries of the first millennium CE.

THE MATHURA STYLE The second major style of Buddhist art in the Kushan period—that found at Mathura—was not allied with the Hellenistic-Roman tradition. Instead, the Mathura style evolved from representations of *yakshas*, the indigenous male nature deities. Early images of the Buddha produced at Mathura

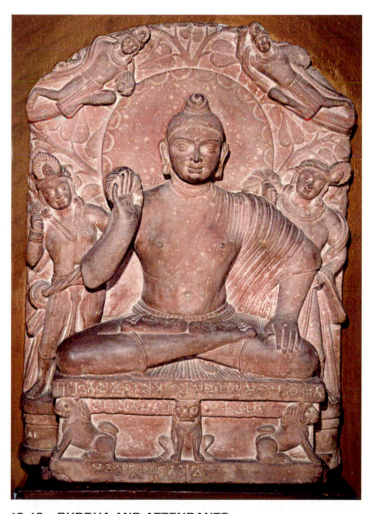

10-13 • BUDDHA AND ATTENDANTS
From Katra Keshavdev, Mathura, Madhya Pradesh, India. Kushan period, c. late 1st–early 2nd century CE. Red sandstone, height 27¼″ (69.2 cm). Government Museum, Mathura.

Mudras (Sanskrit for "sign") are ancient symbolic hand gestures that first appeared in a manual on dance, but came to be regarded as physical expressions of a particular action or state of being. In Buddhist art, they function iconographically. *Mudras* are also used during meditation to invoke specific states of mind. The following are the most common *mudras* in Asian art.

Dharmachakra *mudra*

Appears as if the subject is counting on his fingers, The gesture of teaching, setting the *chakra* (wheel) of the *dharma* (law or doctrine) in motion. Hands are at chest level.

Dhyana *mudra*

A gesture of meditation and balance, symbolizing the path toward enlightenment. Hands are in the lap, the lower representing *maya*, the physical world of illusion, the upper representing *nirvana*, enlightenment and release from the world.

Vitarka *mudra*

This variant of *dharmachakra mudra* stands for intellectual debate. The right and/or left hand is held at shoulder level with thumb and forefinger touching. Resembles counting on the fingers with one hand.

Abhaya *mudra*

The gesture of reassurance, blessing, and protection, this *mudra* means "have no fear." The right hand is at shoulder level, palm outward.

Bhumisparsha *mudra*

This gesture calls upon the earth to witness Shakyamuni Buddha's enlightenment at Bodh Gaya. A seated figure's right hand reaches toward the ground, palm inward.

Varada *mudra*

The gesture of charity, symbolizing the fulfillment of all wishes. Alone, this *mudra* is made with the right hand; but when combined with *abhaya mudra* in standing Buddha figures (as is most common), the left hand is occasionally shown in *varada mudra*.

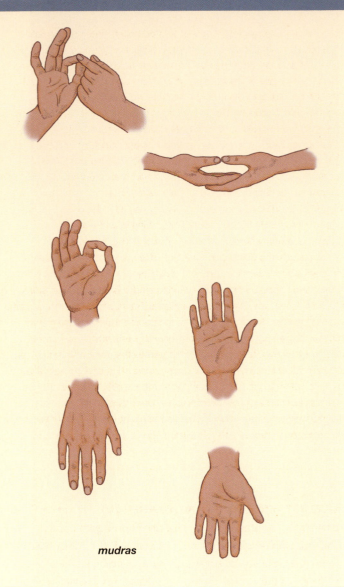

mudras

allowing the fleshy form to be seen as almost nude. Where the pleats of the robe appear, such as over the left arm and fanning out between the legs, they are depicted abstractly through compact parallel formations of ridges with an incised line in the center of each ridge. This characteristic Mathura tendency to abstraction also appears in the face, whose features take on geometric shapes, as in the rounded forms of the widely opened eyes. Nevertheless, the torso with its subtle and soft modeling is strongly naturalistic. This Buddha's riveting outward gaze and alert posture impart a more intense, concentrated energy that draws on imagery associated with nature deities and reveal a spiritual power contained in physical form.

THE GUPTA PERIOD AND ITS SUCCESSORS

The Guptas, who founded a dynasty in the eastern region of central India, expanded their territories during the fourth century CE to form an empire that encompassed northern and much of central India. Although Gupta rule was not long-lasting (ending in 550) or the most expansive, the influence of Gupta culture was tremendous and its impact was felt long after its decline. Renowned for their flourishing artistic, mathematical, and literary culture, the Guptas and their contemporaries brought forth some of India's most widely admired works of art. While Buddhism continued to be a major religion, the earliest surviving Hindu temples also date from this time.

By the fourth century the Vedic sacrifice, in which burnt offerings were ritually sent up to the gods, had given way to temple-based practices that invoked the divine presence into a sanctified architectural setting. These practices, collectively termed Hinduism by later observers, were still presided over by Brahmin priests but often brought new deities into prominence.

Hinduism is not one religion but many related beliefs and innumerable sects. It results from the mingling of Vedic beliefs with indigenous, local beliefs and practices. All three major Hindu sects draw upon the texts of the Vedas, which are believed to be sacred revelations set down about 1200–800 BCE. The gods lie outside the finite world, but they can appear in visible form to believers. Each Hindu sect takes its particular deity as supreme. By worshiping gods with rituals, meditation, and intense love, individuals may be reborn into increasingly higher positions until they escape the cycle of life, death, and rebirth, which is called *samsara*. The most popular deities are Vishnu, Shiva, and the Great Goddess, Devi. Deities are revealed and depicted in multiple aspects.

Vishnu: Vishnu is a benevolent god who works for the order and well-being of the world. He is often represented lying in a trance or asleep on the Cosmic Waters, where he dreams the world into existence. His attributes include the discus, conch shell, mace, and lotus. He usually has four arms and wears a crown and lavish jewelry. He rides a man-bird, Garuda. Vishnu appears in ten different incarnations (*avatara*), including Rama and Krishna, who have their own sects. Rama embodies virtue, and, assisted by the monkey king, he fights the demon Ravana. As Krishna, Vishnu is a supremely beautiful, blue-skinned youth who lives with the cowherds, loves the maiden Radha, and battles the demon Kansa.

Shiva: Shiva is both creative and destructive, light and dark, male and female, ascetic and family man. His symbol is the *linga*, an upright phallus represented as a low pillar, set in a low base, or *yoni*, which represents the feminine. As an expression of his power and creative energy, he is often represented as Lord of the Dance, dancing the

Cosmic Dance, the endless cycle of death and rebirth, destruction and creation (see "Shiva Nataraja of the Chola Dynasty," page 322). He dances within a ring of fire, his four hands holding fire, a drum, and gesturing to the worshipers. Shiva's animal vehicle is the bull. His consort is Parvati; their sons are the elephant-headed Ganesha, the remover of obstacles, and Karttikeya, often associated with war.

Devi: Devi, the Great Goddess, controls material riches and fertility. She has forms indicative of beauty, wealth, and auspiciousness, but also forms of wrath, pestilence, and power. As the embodiment of cosmic energy, she provides the vital force to all the male gods. Her symbol, the *yoni*, is an abstract depiction of female genitals often associated with the *linga* of Shiva. When armed and riding a lion (as the goddess Durga), she personifies righteous fury. As the goddess Lakshmi, she is the goddess of wealth and beauty. She is often represented by the basic geometric forms: squares, circles, triangles.

Brahma: Brahma, who once had his own cult, embodies spiritual wisdom. His four heads symbolize the four cosmic cycles, four earthly directions, and four classes of society: priests (brahmins), warriors, merchants, and laborers.

There are countless other deities, but central to Hindu practice are *puja* (forms of worship) and *darshan* (beholding a deity), generally performed to obtain a deity's favor and in the hope that this favor will lead to liberation from *samsara*. Because desire for the fruits of our actions traps us, the ideal is to consider all earthly endeavors as sacrificial offerings to a god. Pleased with our devotion, he or she may grant us an eternal state of pure being, pure consciousness, and pure bliss.

TEMPLE OF VISHNU AT DEOGARH One of the earliest northern-style temples, dedicated to the Hindu god Vishnu, is at Deogarh in north-central India and dates to 530 CE (**FIG. 10–14**). The entire temple site is patterned on a *mandala*, or sacred diagram. Much of the central tower, or *shikhara*, has crumbled away,

so we cannot determine its original shape with precision. Clearly a massive, solid structure built of large cut stones, it would have given the impression of a mountain, one of several metaphoric meanings of a Hindu temple. The temple has only one chamber, the *garbhagriha*, literally the womb chamber, which corresponds

10–14 • VISHNU TEMPLE, DEOGARH
Uttar Pradesh, India. Gupta dynasty, c. 530 CE.

to the center of a *mandala*. As the deity's residence, the *garbhagriha* is likened to a sacred cavern within the "cosmic mountain" of the temple.

Large panels sculpted in relief with images of Vishnu appear as "windows" on the temple's exterior. These elaborately framed panels do not function literally to let light *into* the temple; they function symbolically to let the light of the deity *out* of the temple to be seen by those outside.

One panel depicts **VISHNU LYING ON THE COSMIC WATERS** at the beginning of creation (**FIG. 10-15**). He sleeps on the serpent of infinity, Ananta, whose body coils endlessly into space. Stirred by his female aspect (*shakti*, or female energy), personified here by the goddess Lakshmi, seen holding his foot,

Vishnu dreams the universe into existence. From his navel springs a lotus (shown in this relief behind Vishnu), from which emerges the god Brahma (not to be confused with Brahman), who appears here as the central, four-headed figure in the row of gods portrayed above the reclining Vishnu. Brahma subsequently turns himself into the universe of space and time by thinking, "May I become Many."

The sculptor has depicted Vishnu as a large, resplendent figure with four arms. His size and his multiple arms denote his omnipotence. He is lightly garbed but richly ornamented. The ideal of the Gupta style is evident in the smooth, perfected shape of the body and in the lavishly detailed jewelry, including Vishnu's characteristic cylindrical crown. The four figures on the right in the frieze below personify Vishnu's four attributes. They stand ready to fight the appearance of evil, represented at the left of the frieze by two demons who threaten to kill Brahma and jeopardize all creation.

The birth of the universe and the appearance of evil are thus portrayed here in three clearly organized registers. Typical of Indian religious and artistic expression, these momentous events are set before our eyes not in terms of abstract symbols, but as a drama acted out by gods in superhuman form.

SEATED BUDDHA FROM SARNATH

Buddhism continued to thrive during the Gupta period. Although the Gandhara style eventually declined in influence, the Mathura style gave rise to the Buddhist visual forms found over much of north India, including at sites like Sarnath.

The seated Buddha in **FIGURE 10-16** embodies the fully developed Sarnath Gupta style. Carved from fine-grained sandstone, the figure sits in a yogic posture making the teaching gesture indicative of the First Sermon. This event is further indicated by the presence of devotees/listeners represented on the pedestal along with a wheel whose outer tread faces toward the viewer. The devotees, who may also represent the donors of this image, are joined in their devotion by two divine beings flying in from above. The plain robe, portrayed with none of the creases and folds so prominent in the Kushan-period images, is distinctive of the Sarnath style. The body, clearly visible through the clinging robe, is graceful and slight, with broad shoulders and

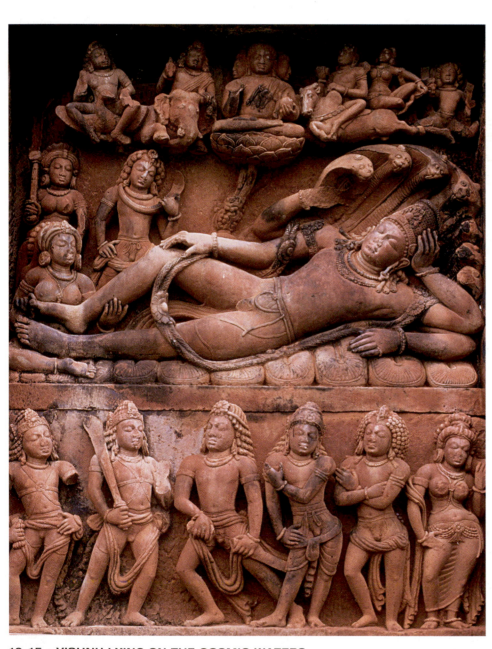

10-15 • VISHNU LYING ON THE COSMIC WATERS
Relief panel in the Vishnu Temple, Deogarh. c. 530 CE. Sandstone, height approx. 5′ (1.5 m).

Watch a video about the process of relief carving on myartslab.com

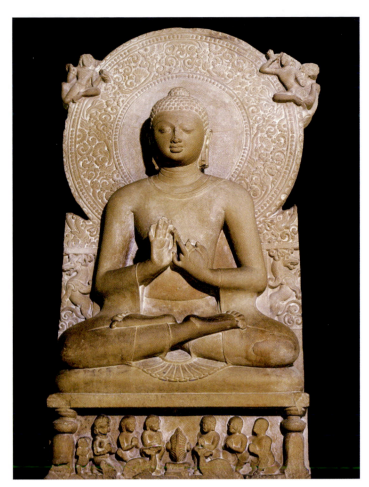

10–16 • BUDDHA PREACHING HIS FIRST SERMON
From Sarnath, Uttar Pradesh, India. Gupta period, c. 465–485 CE.
Sandstone, height 5′3″ (1.6 m). Archaeological Museum, Sarnath.

back, houses some of the finest. Murals painted in mineral pigments on a prepared plaster surface cover the walls of the central court. Some depict episodes from the Buddha's past lives while two large bodhisattvas, one of which is seen in **FIGURE 10–17**, flank the entrance to the shrine chamber.

Bodhisattvas are enlightened beings who postpone *nirvana* and buddhahood to help others achieve enlightenment. They are distinguished from buddhas in art by their princely garments. Lavishly adorned with delicate ornaments, this bodhisattva wears a bejeweled crown, large earrings, a pearl necklace, armbands, and bracelets. A striped cloth covers his lower body. The graceful bending posture and serene gaze impart a sympathetic attitude. His possible identity as the compassionate bodhisattva Avalokiteshvara is indicated by the lotus flower he holds in his right hand.

The naturalistic style balances outline and softly graded color tones. Outline drawing, always a major ingredient of Indian painting, clearly defines shapes; tonal gradations impart the illusion of three-dimensional form, with lighter tones used for protruding parts

a well-proportioned torso. Only a few lines of the garment at the neck, waist, and hems interrupt the purity of its subtly shaped surfaces; the face, smooth and ovoid, has the same refined elegance. The downcast eyes suggest otherworldly introspection, yet the gentle, open posture maintains a human quality. Behind the head is a large, circular halo. Carved in concentric circles of pearls and foliage, the ornate halo contrasts dramatically with the plain surfaces of the figure.

THE AJANTA CAVES Prior to the late fifth century, the Vakataka dynasty had been subject to Gupta rule. Shortly after winning regional control, people affiliated with their court began to sponsor a new phase of construction at the rock-cut monastery of Ajanta. Each of these large caves, over 20 in all, appears to have had its own major patron. Whether inspired by devotion or competition, these caves are among the finest rock-cut architecture found anywhere. Adding to the importance of these caves is the fact that they preserve examples of wall painting, giving us a rare glimpse of a refined art form that has almost entirely been lost to time. Of these examples, Cave I, a large *vihara* hall with monks' chambers around the sides and a Buddha shrine chamber in the

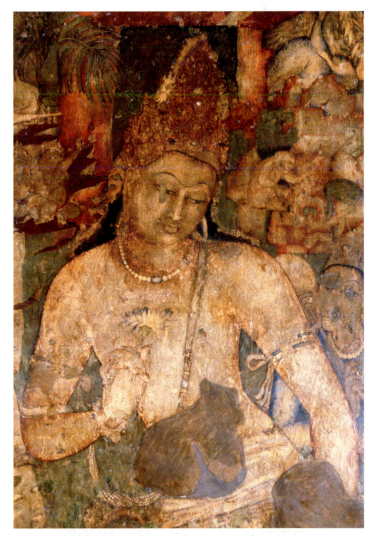

10–17 • BODHISATTVA
Detail of a wall painting in Cave I, Ajanta, Maharashtra, India. Vakataka dynasty, c. 475 CE.

such as the nose, brows, shoulders, and chest muscles. Together with the details of the jewels, these highlighted areas resonate against the subdued tonality of the figure. Sophisticated, realistic detail is balanced by the languorous human form. This particular synthesis is evident also in the Sarnath statue (see FIG. 10–16), which shares much in common as well with the sculpture of Ajanta.

OTHER DEVELOPMENTS, FOURTH–SIXTH CENTURY

THE BAMIYAN BUDDHAS The Gupta and their feudatories were by no means the only kingdoms to flourish in fourth- to sixth-century South Asia. For example, at the site of Bamiyan, about 155 miles northwest of Kabul, Afghanistan, two enormous Buddhas were carved from the rock of a cliff, one some 115 feet in height (**FIG. 10–18**), the other about 165 feet. Located just west of one of the most treacherous portions of the Silk Road, this rich oasis town was a haven and crossroad on the lucrative trade routes that reached from China to the West. Buddhist travelers must have offered gifts of thanks or prayers for safety, depending on their destinations. Recorded by a Chinese pilgrim who came to Bamiyan in the fifth century, these Buddhas must date from before his visit. On the right side of the smaller figure, pilgrims could walk within the cliff up a staircase that ended at the Buddha's shoulder. There they could look into the vault of the niche and see a painted image of the sun god, suggesting a metaphoric pilgrimage to the heavens. They then could circumambulate the figure at the level of the head and return to ground level by a staircase on the figure's left side. These huge figures likely served as the model for those at rock-cut sanctuaries in China, for example, at Yungang. Despite the historical and religious importance of these figures, and ignoring the pleas of world leaders, the Taliban demolished the Bamiyan Buddhas in 2001.

SIGIRIYA, SRI LANKA Far away from Afghanistan, in the south, the palace site of **SIGIRIYA** was built on a dramatic plateau that rises abruptly above the forest canopy in north-central Sri Lanka (**FIG. 10–19**). According to the royal chronicles, this structure was built by King Kassapa in the late 400s CE after usurping the throne from his father and driving off his brother. Visitors to the palace first passed through a broad moat and elaborate terraced gardens before beginning their ascent. At its base, the staircase passes through the chest of a massive sculptural lion, of which only the naturalistically rendered feet currently exist. As visitors climbed higher they were greeted by painted murals depicting elegant, **HEAVENLY MAIDENS** moving among clouds (**FIG. 10–20**), before emerging at the top of the plateau. Only the foundations of the palace buildings, cisterns, and a few sculptures remain, but they are sufficient to get a sense of the site's imposing splendor and spectacular elevation. Kassapa did not have long to enjoy his luxurious and well-fortified home, however, because within approximately 11 years the rightful heir, his brother Moggallana, returned with an army and took back the kingdom. After his victory, Moggallana gave Sigiriya to the Buddhists as a monastery.

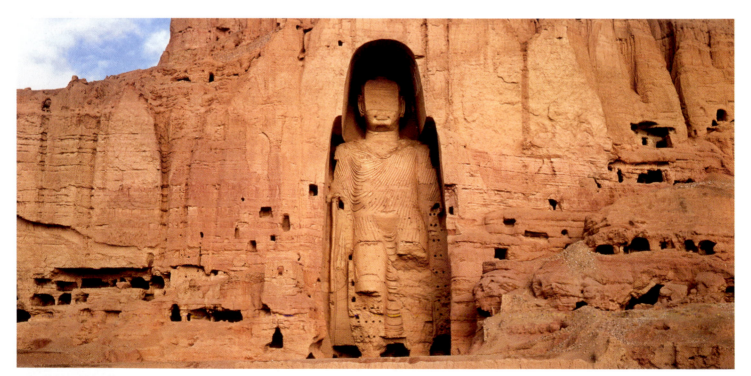

10-18 • STANDING BUDDHA
Bamiyan, Afghanistan. c. 5th century CE. Sandstone coated in stucco, 175′ (54 m).

This photograph pre-dates the destruction of the Buddhas in 2001. Currently their recesses stand empty.

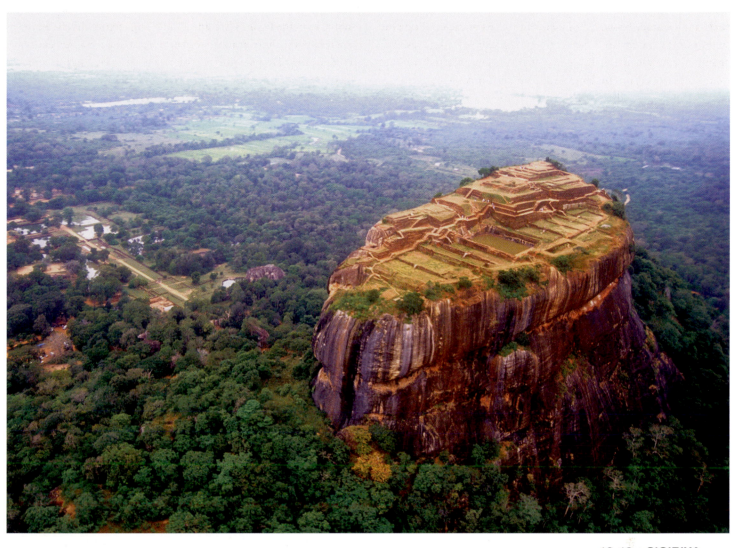

10-19 • SIGIRIYA
Matale District, Central Province, Sri Lanka. 5th century CE. Aerial view.

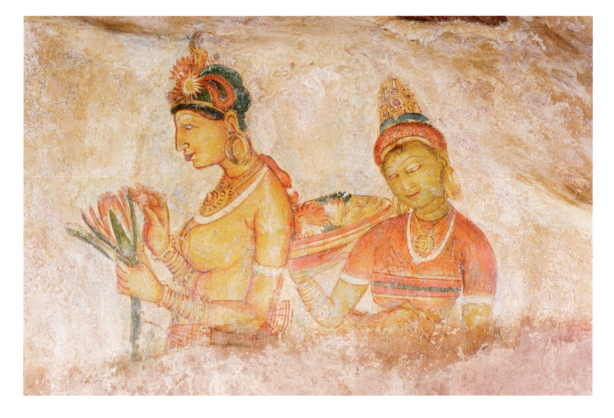

10-20 • HEAVENLY MAIDENS
Detail of wall painting, Sigiriya. 5th century CE.

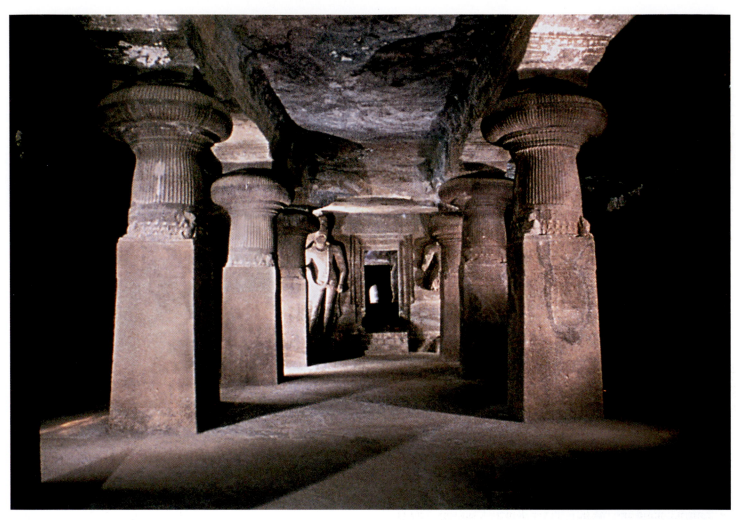

10-21 • CAVE-TEMPLE OF SHIVA, ELEPHANTA
Maharashtra, India. Post-Gupta period, mid 6th century CE. View along the east–west axis to the *linga* shrine.

⊙ **Watch** a video about the Elephanta caves on myartslab.com

TEMPLE OF SHIVA AT ELEPHANTA The Hindu god Shiva exhibits a wide range of aspects or forms, both gentle and wild: He is the Great Yogi who dwells for vast periods of time in meditation in the Himalayas; he is also the husband par excellence who makes love to the goddess Parvati for eons at a time; he is the Slayer of Demons; and he is the Cosmic Dancer who dances the destruction and re-creation of the world. Many of these forms of Shiva appear in the monumental relief panels adorning a cave-temple carved in the mid sixth century on the island of Elephanta off the coast of Mumbai in western India. The cave-temple is complex in layout and conception and is a fine example of Hindu rock-cut architecture. While most temples have one entrance, this

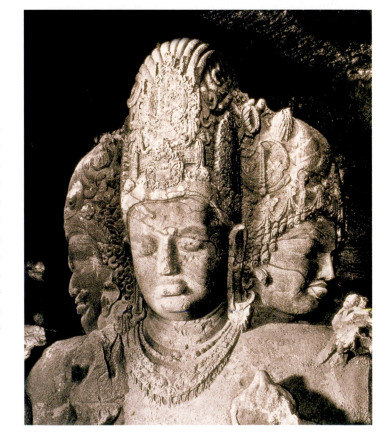

10-22 • ETERNAL SHIVA
Rock-cut relief in the cave-temple of Shiva, Elephanta. Mid 6th century CE. Height approx. 11' (3.4 m).

temple offers three—one facing north, one east, and one west. The interior, impressive in its size and grandeur, is designed along two main axes, one running north–south, the other east–west. The three entrances provide the only source of light, and the resulting cross- and back-lighting effects add to the sense of the cave as a place of mysterious, almost confusing complexity.

Along the east–west axis, large pillars cut from the rock appear to support the low ceiling and its beams, although, as with all architectural elements in a cave-temple, they are not structural (FIG. 10–21). The pillars form orderly rows, but the rows are hard to discern within the framework of the cave shape, which is neither square nor longitudinal, but formed of overlapping *mandalas* that create a symmetric yet irregular space. The pillars each have an unadorned, square base rising to nearly half its total height. Above is a circular column, which has a curved contour and a billowing "cushion" capital. Both column and capital are delicately fluted, adding a surprising refinement to these otherwise sturdy forms. The focus of the east–west axis is a square **linga shrine** (see FIG. 10–21, center). A pair of colossal standing guardian figures flank each of its four entrances. In the center of the shrine is the *linga*, the abstracted symbol of Shiva that represents his presence as the unmanifest Formless One, or Brahman. Synonymous with Shiva, the *linga* is seen in nearly every Shiva temple and shrine.

The focus of the north–south axis, in contrast, is a relief on the south wall with a huge bust of Shiva representing his Sadashiva, or **ETERNAL SHIVA**, aspect (FIG. 10–22). Three heads rest upon the broad shoulders of the upper body, but five heads are implied: the fourth behind and the fifth, never depicted, on top. The head in the front depicts Shiva deep in introspection. The massiveness of the broad head, the large eyes barely delineated, and the mouth with its heavy lower lip suggest the god's serious depths. Lordly and majestic, he easily supports his huge crown, intricately carved with designs and jewels, and the matted, piled-up hair of a yogi. On his left shoulder, his protector nature is depicted as female, with curled hair and a pearl-festooned crown. On his right shoulder, his wrathful, destroyer nature wears a fierce expression, and snakes encircle his neck.

THE PALLAVA PERIOD

Rising to power in the late sixth century, the Pallava dynasty spread from its heartland in southeastern India, drawing wealth from overseas trade. The kingdom grew to its peak during the reigns of King Mahendravarman I (c. 600–630 CE) and his successor Narasimhavarman I (c. 630–668 CE) who was also referred to by his nickname Mamalla (which alludes to his skill at wrestling). Both men sponsored rock-cut shrines and sculpture at the coastal city of Mamallapuram, near Chennai. Often religious in subject matter, the carving is at times infused with a whimsical humor. This good-natured irreverence emerges most clearly in the Pallava literary tradition. One well-known farcical drama, attributed to Mahendravarman himself, pokes fun at Tantric ascetics, Buddhist monks, and Brahmin priests.

At Mamallapuram there are many large boulders and cliffs along the shore from which the Pallava-period stonecutters carved entire temples as well as reliefs. Among the most interesting of these rock-cut temples is a group known as the Five Rathas, which preserve diverse early architectural styles that probably reflect the forms of contemporary wood or brick structures.

DHARMARAJA RATHA AT MAMALLAPURAM One of this group, called today the **DHARMARAJA RATHA** (FIG. 10–23), epitomizes the early southern-style temple. Each story of the superstructure is articulated by a cornice and carries a row of miniature shrines. Both shrines and cornices are decorated with a window motif from which faces peer. The shrines not only demarcate each story, but also provide loftiness for this palace intended to enshrine a god. The temple, square in plan, remains unfinished, and the *garbhagriha* usually found inside was never hollowed out, suggesting that, like cave-temples, Dharmaraja Ratha was executed from the top downward. On the lower portion, only the columns and niches have been carved. The presence of a single deity in each niche forecasts the main trend in temple sculpture in the centuries ahead: The tradition of narrative reliefs declined, and the stories they told became concentrated in statues of individual deities, which conjure up entire mythological episodes

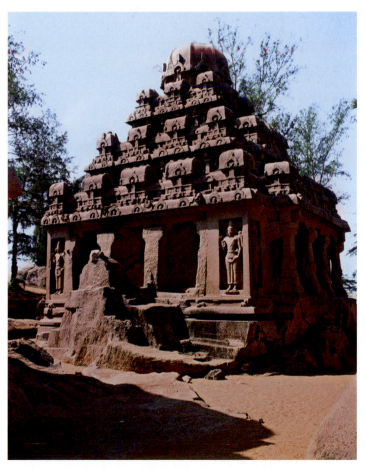

10–23 • DHARMARAJA RATHA, MAMALLAPURAM
Tamil Nadu, India. Pallava period, c. mid 7th century CE.

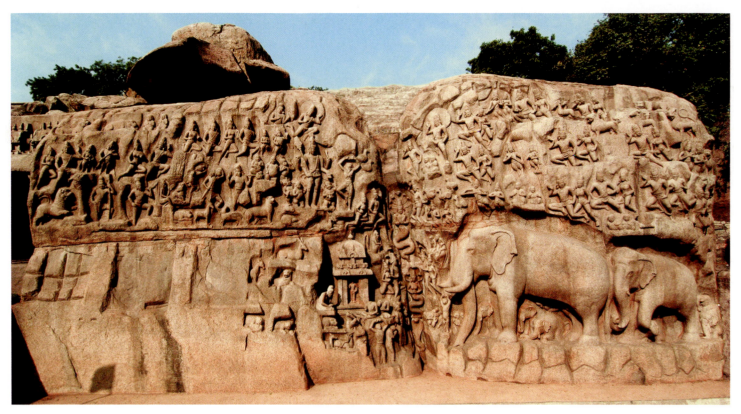

10-24 • DESCENT OF THE GANGES
Rock-cut relief, Mamallapuram, Tamil Nadu, India. Mid 7th century CE. Granite, approx. 20′ (6 m).

View the Closer Look for the *Descent of the Ganges* relief on myartslab.com

through characteristic poses and a few symbolic objects. On the south side of this ratha, among the images of deities, is an unusual two-armed image identified as a representation of King Mamalla who appears to be visually associating himself with Shiva. This practice of depicting royalty in the likeness of divinity became more common over time and was widely practiced in parts of Southeast Asia.

DESCENT OF THE GANGES RELIEF AT MAMALLAPURAM

An enormous relief at Mamallapuram (**FIG. 10-24**) depicts the penance of a king, Bhagiratha, who sought to purify the bones of his deceased relatives by subjecting himself to terrible austerities. In response to his penance, the god Shiva sent the sacred Ganges River, represented by the natural cleft in the rock, to earth, thereby allowing the holy man to ensure his relatives some peace in their next lives. Bhagiratha is shown staring directly at the sun through his parted fingers, standing for interminable periods on one foot, and in deep prayer before a temple. In the upper left part of the relief, Shiva, shown four-armed, appears before Bhagiratha to grant his wish. Elsewhere in the relief, animal families are depicted, generally in mutually protective roles. In a characteristically Pallava twist, this pious scene is mimicked by a cat who does his best to imitate Bhagiratha's pose (**FIG. 10-25**). The reference is to the story of an aging cat who pretends to be an ascetic (who has renounced meat) so as to lure the local mice into compla-

cency, much to their misfortune. This cautionary tale about false ascetics serves as an apt and humorous foil to the upper scene of consummate penance and faith. Both tales are set on the banks of the Ganges.

This richly carved relief was executed under the Pallava dynasty, which continued to flourish in southeastern India until the ninth century CE. The relief must have been visible to anyone

10-25 • CAT IN YOGIC POSTURE
Detail from rock-cut relief, Mamallapuram, Tamil Nadu, India. Mid 7th century CE.

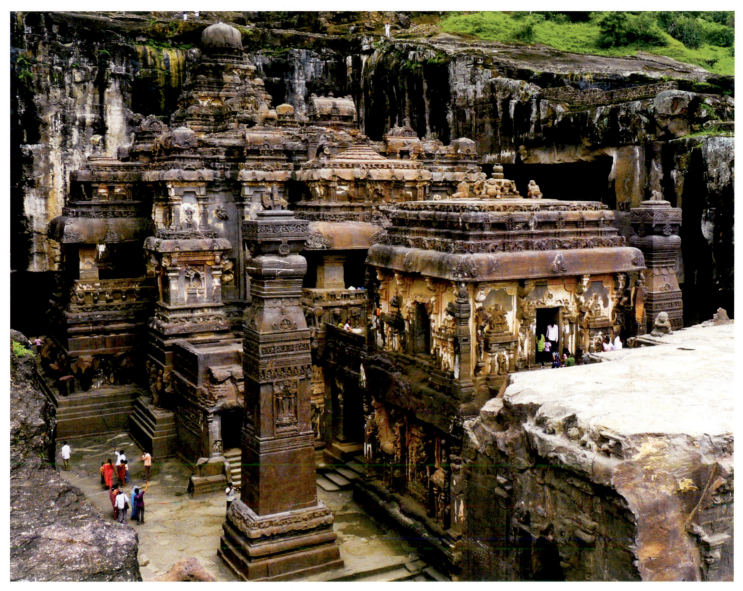

10-26 • KAILASHA TEMPLE, ELLORA
Cave 16, Ellora, Aurangabad District, Maharashtra, India. Mid 8th century CE.

heading inland from the sea and likely served as an allegory for benevolent kingship. It was possibly even an attempt to invoke the presence of the sacred Ganges River right at the heart of the Pallavas' southern empire.

THE SEVENTH THROUGH TWELFTH CENTURIES

During the seventh through twelfth centuries, regional styles developed in ruling kingdoms that were generally smaller than those that had preceded them. Hindu gods Vishnu, Shiva, and the Great Goddess (mainly Durga) grew increasingly popular. Monarchs rivaled each other in the building of temples to their favored deity, and many complicated and subtle variations of the Hindu temple emerged with astounding rapidity in different regions. By around 1000 the Hindu temple reached unparalleled heights of grandeur and engineering.

KAILASHA TEMPLE, ELLORA Occupied and expanded from the fifth to the tenth century, the rock-cut site of Ellora has 34 caves in all, variously dedicated to Buddhism, Jainism, and Hinduism. Among the most spectacular of these is "Cave" 16, the **KAILASHA TEMPLE** (FIG. 10–26), which was most likely started in the reign of the Rashtrakuta king Krishna I (r. 757–83 CE) and completed under his successors. In many ways, this structure marks the apex of the South Asian rock-cut tradition, as the skilled architects and artists managed successfully to sculpt an entire two-story, highly ornamented Shiva temple out of a single mass of stone. The structure is set back in the mountainside, which required cutting straight down 107 feet so that the rock would be high enough to accommodate the stepped, southern-style tower.

Passing the outer gateway, devotees can circumambulate at ground level and admire the narrative sculptural scenes and large elephants that adorn the lower plinth. Alternately, visitors can climb

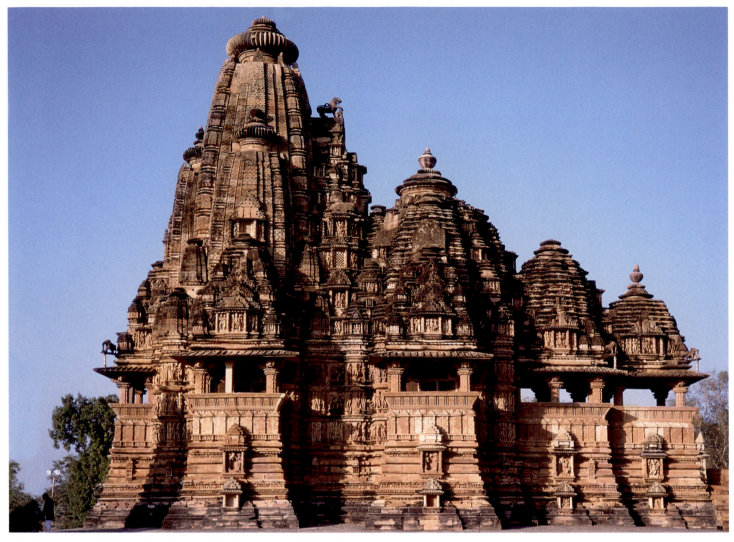

10-27 • KANDARIYA MAHADEVA TEMPLE, KHAJURAHO
Madhya Pradesh, India. Chandella dynasty, c. 1000 CE.

an internal staircase to a second level where a relatively small shrine dedicated to Shiva's bull-mount, Nandi, faces the main temple across a bridge. The interior of the main temple hall (*mandapa*) was originally painted with additional narrative imagery. The *garbhagriha* can be circumambulated from the second story by passing out onto a balcony from which a number of subsidiary shrines radiate. The narrative sculpture throughout the site depict a wide range of deities and events from Hindu literature, many of which feature Shiva.

This site takes the metaphorical association between temples and mountains to an extreme as it is constructed, quite literally, from a mountain. Even the temple itself is named for Shiva's abode on Mount Kailasha in the Himalayas. Despite this association, remote mountainside locations better suited the needs of Buddhist and Jain monastic communities. Such locations proved to fit poorly with the public nature and ritual requirements of Hindu temples. The Kailasha Temple stands as the last of the great rock-cut Hindu temples. From this point on, architects and donors favored built structures placed in or near major urban centers.

KANDARIYA MAHADEVA TEMPLE, KHAJURAHO In 950 CE, the Chandella court moved against the weakened Pratihara dynasty, to whom they were vassals. This rebellion proved successful, and the Chandella marked their new status by undertaking an ambitious project of temple building. The earliest of these structures housed an image of Vishnu taken directly from their previous overlords, but this temple was only the first among many. Khajuraho remained the capital and main temple site for the Chandellas, who constructed more than 80 temples there, about 25 of which are well preserved.

The **KANDARIYA MAHADEVA** (**FIG. 10-27**), a temple dedicated to Shiva at Khajuraho was probably built by a ruler of the Chandella dynasty in the late tenth or early eleventh century. In the northern style, a curvilinear *shikhara* rises over the *garbhagriha* of the temple. Extensively ornamented with additional halls on the front and porches to the sides and back, the temple rests on a stone terrace that sets off a sacred space from the mundane world. A steep flight of stairs at the front (to the right in the illustration) leads to a series of three *mandapas* (distinguished on the outside by

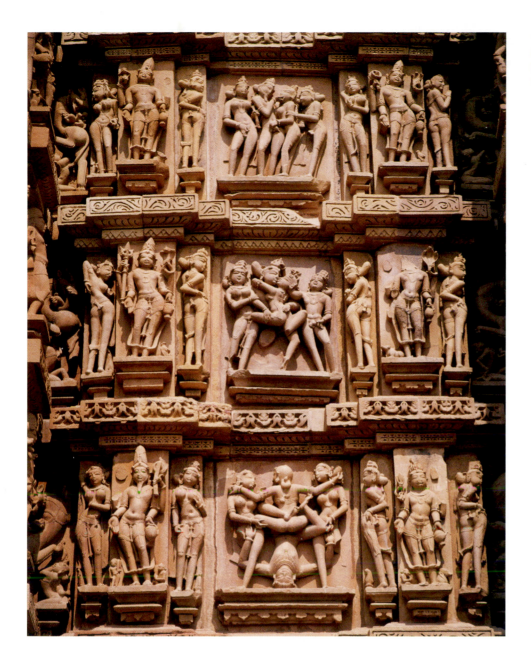

pyramidal roofs), preceding the *garbhagriha*. The *mandapas* serve as spaces for ritual, such as dances performed for the deity, and for the presentation of offerings. The temple is built of stone blocks using only post-and-lintel construction. Despite this architectural challenge, the *shikhara* rises more than 100 feet over the *garbhagriha* and is crowned by a small *amalaka*, or bulbous ornament. The *shikhara* is bolstered by the many smaller subsidiary towers bundled around it. This decorative scheme adds a complex richness to the surface, but it also obscures the shape of the main *shikhara*, which is slender, with a swift and impetuous upward movement. The roofs of the *mandapas* contribute to the impression of rapid ascent by growing progressively taller as they near the *shikhara*.

Despite its apparent complexity, the temple has a clear structure and unified composition. Strong horizontal **moldings** (shaped or sculpted strips) and the open spaces over the *mandapas* and porches separate the towers of the superstructure from the lower portion. Three rows of sculpture—some 600 figures—are integrated into the exterior walls. Approximately 3 feet tall and carved in high relief, the sculptures depict gods and goddesses, as well as figures in erotic postures.

The Khajuraho temples are especially well known for their **EROTIC SCULPTURES** (**FIG. 10-28**). These carvings are not placed haphazardly, but rather in a single vertical line at the juncture of the walls enclosing the *garbhagriha* and the last *mandapa*. Their significance is uncertain; perhaps they derive from the amorous couples (*mithuna*) found at the entrances of many temples and *chaityas*. It is also possible that they relate to two growing traditions within Hinduism: *tantra* and *bhakti*.

Throughout this period, two major religious movements were developing that affected Hindu practice and art: the tantric, or esoteric, and the *bhakti*, or devotional. Although both movements evolved throughout India, the influence of tantric sects appeared

during this period primarily in the art of the north (see Chapter 24 for further discussion), while the *bhakti* movements found artistic expression across South Asia. *Bhakti* revolves around the ideal relationship between humans and deities. Rather than focusing on ritual and the performance of *dharma* according to the Vedas, *bhakti* stresses an intimate, personal, and loving relation with the god, and complete devotion and surrender to the deity. Tantrism, by contrast, is pursued under the guidance of a teacher and employs various techniques designed to help the devotee self-identify with the deity. Ultimately this leads to a profound understanding that there is no separation between oneself and the divine. Although not typical, both traditions have, at times, employed erotic or romantic imagery as a visual means of expressing ideas of devotion and unity.

GAL VIHARA, SRI LANKA During the twelfth century, when Buddhism had all but disappeared from India, it was still thriving in Sri Lanka. This island kingdom played a large role in exporting Buddhist ideas to parts of Southeast Asia, with which it had maintained close economic and cultural ties. Sri Lanka was central to strengthening and maintaining the conservative Theravada Buddhist traditions, especially by preserving scriptures and relics. Sri Lankan sculptors further refined Indian styles and iconography in colossal Buddhist sculptures but rarely initiated further elaboration on traditional Buddhist forms. Because the Buddha's image was believed to have been based on a portrait made during his lifetime, intentional variation was unnecessary and inaccurate.

The construction of the Gal Vihara is linked to an ambitious series of construction projects undertaken by King Parakramabahu in the mid twelfth century. The rock-cut **PARINIRVANA OF THE BUDDHA** at this monastic complex (**FIG. 10-29**) is one of three colossal Buddhas at the site. This serene and dignified image restates one of the early themes of Buddhist art, that of the Buddha's final death and transcendence, with a sophistication of modeling and proportion that updates and localizes the classical Buddhist tradition. Postholes in the rock face reveal that this sculpture was originally housed in a wooden superstructure, that has since decayed. Fortunately granite is more durable, and this fine example of Sri Lankan colossal sculpture has been preserved. This monastery, located north of the capital in Polonnaruwa, was occupied until the capital fell in the late 1200s.

THE CHOLA PERIOD

The Cholas, who succeeded the Pallavas in the mid ninth century, founded a dynasty that governed most of the far south of India well into the late thirteenth century. Its extensive trade networks and powerful navy also made it a potent cultural force in many parts of Southeast Asia over these centuries. The Chola dynasty reached its peak during the reign of Rajaraja I (r. 985–1014). As an expression of gratitude for his many victories in battle, Rajaraja built the Rajarajeshvara Temple to Shiva in his capital, Thanjavur (formerly known as Tanjore). The name Rajarajeshvara means the temple of Rajaraja's Lord, that is, Shiva, which also has the effect of linking the name of the king with that of Shiva. His patronage of the temple was in part a reflection of the fervent Shiva *bhakti* movement which had reached its peak by that time. Now, commonly called the Brihadeshvara (Temple of the Great Lord), this temple is a remarkable achievement of the southern style of Hindu architecture (**FIG. 10-30**). It stands within a huge, walled compound near the banks of the Kaveri River. Although smaller shrines dot the compound, the Rajarajeshvara dominates the area.

Rising to an astonishing height of 216 feet, this temple was probably the tallest structure in India in its time. Each story is decorated with miniature shrines, window motifs, and robust dwarf figures who seem to be holding up the next story. Like the

10-29 • PARINIRVANA OF THE BUDDHA
Gal Vihara, near Polonnaruwa, Sri Lanka. 11th–12th century CE. Granite.

10–30 • RAJARAJESHVARA TEMPLE OF SHIVA, THANJAVUR
Tamil Nadu, India. Chola dynasty, 1003–1010 CE.

contemporaneous Kandariya Mahadeva Temple at Khajuraho (see FIG. 10–27), the Rajarajeshvara has a longitudinal axis and greatly expanded dimensions, especially with regard to its superstructure, a four-sided, hollow pyramid. Typical of the southern style, the *mandapa* at the front of the Rajarajeshvara has a flat roof, as opposed to the pyramidal roofs of the northern style. The walls of the sanctum rise for two stories, with each story emphatically articulated by a large cornice. The interior was originally painted and portions of this decoration have recently been uncovered as sections of the over-painting were removed. The exterior walls are ornamented with niches, each of which holds a single statue, usually depicting a form of Shiva. Because the Rajarajeshvara's superstructure is not obscured by its decorative motifs, it forcefully ascends skyward and is topped by an octagonal dome-shaped capstone. This huge capstone is exactly the same size as the *garbhagriha* housed 13 stories directly below. It thus evokes the shrine a final time before the eye ascends to the point separating the worldly from the cosmic sphere above.

ART OF SOUTHEAST ASIA

With its high mountainous interior and dense vegetation, Southeast Asia's earliest human settlements naturally formed along the rivers and coastlines, facilitating both food production and trade. Additionally, the presence of rich mineral deposits allowed for the development of metallurgy. Bronze casting developed early in the region and the oldest bronze finds, located on the mainland, have been, with some disagreement, dated to 1500 BCE.

EARLY SOUTHEAST ASIA

Archaeological work at sites such as Ban Chiang in northeastern Thailand has uncovered a wide range of bronze tools and jewelry as well as finely decorated ceramics. Because its distinctive bronzework has been found as far afield as Java, the archaeological site of Dongson in northern Vietnam reveals evidence of short range ocean trade having developed shortly after 600 BCE. By the first century CE, these trade networks had expanded, and evidence

Perhaps no sculpture is more representative of Hinduism than the statues of Shiva Nataraja, or Shiva as the Lord of Dance, a form perfected by sculptors under the royal patronage of the south Indian Chola dynasty during the late tenth to eleventh centuries. (For more Chola art, see FIG. 10–30.) The particularly striking Chola version of the Dancing Shiva was introduced and promoted primarily through the efforts of one woman, Queen Sembiyan Mahadevi. Donation records spanning over 60 years reveal that she was a major patron both of temple building and bronze casting and many of her projects involved increasing the prominence of Shiva Nataraja. It was not unusual for Hindu royal families to associate themselves with a particular aspect of a deity, and her efforts were instrumental in forging such a bond between Shiva Nataraja and the Chola state.

The dance of Shiva is a dance of cosmic proportions, signifying the universe's cycle of death and rebirth; it is also a dance for each individual, signifying the liberation of the believer through Shiva's compassion. In the iconography of the Nataraja, this sculpture shows Shiva with four arms dancing on the prostrate body of Apasmara, a dwarf figure who symbolizes "becoming" and whom Shiva controls (FIG. 10–31). Shiva's extended left hand holds a ball of fire; a circle of fire rings the god. The fire is emblematic of the destruction of *samsara* and the physical universe as well as the destruction of *maya* (illusion) and our ego-centered perceptions. Shiva's back right hand holds a drum; its beat represents the irrevocable rhythms of creation and destruction, birth and death. His front right arm shows the *abhaya* "have no fear" *mudra*

(see "Mudras," page 308). The front left arm, gracefully stretched across his body with the hand pointing to his raised foot, signifies the promise of liberation.

The artist has rendered the complex pose with great clarity. The central axis, which aligns the nose, navel, and insole of the weight-bearing foot, maintains the figure's equilibrium while the remaining limbs asymmetrically extend far to each side. Shiva wears a short loincloth, a ribbon tied above his waist, and delicately tooled ornaments. The scant clothing reveals his perfected form with its broad shoulders tapering to a supple waist. The jewelry is restrained and the detail does not detract from the beauty of the body. This work was made using the lost-wax method and is a testament to the extraordinary skill routinely exhibited by Chola artists.

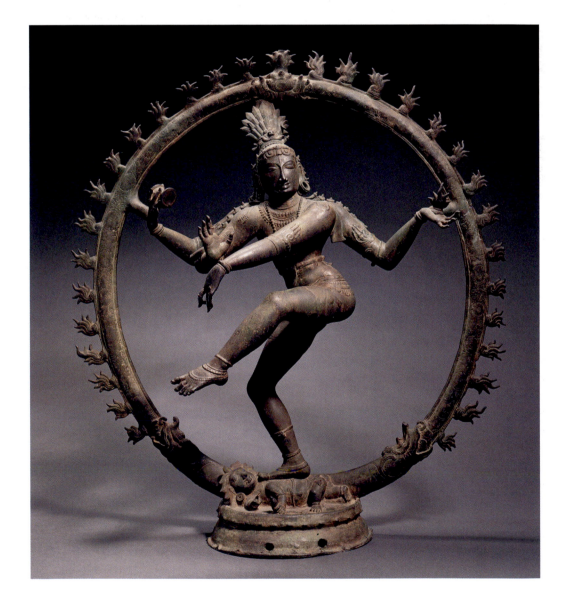

10–31 • SHIVA NATARAJA (SHIVA AS LORD OF THE DANCE)
South India. Chola dynasty, 11th century CE. Bronze, 43⁷⁄₈″ × 40″ (111.5 × 101.65 cm). The Cleveland Museum of Art. Purchase from the J.H. Wade Fund (1930.331)

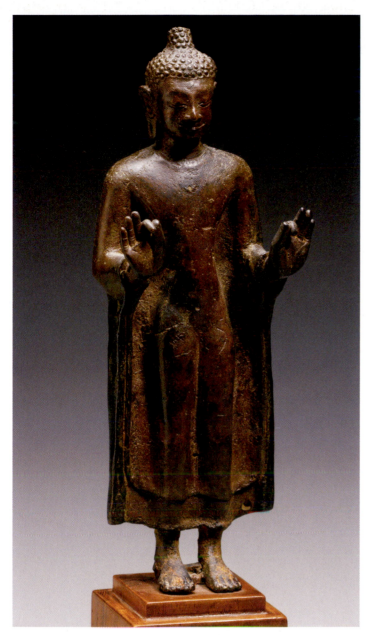

10-32 • STANDING DVARAVATI BUDDHA
Mon Dvaravati style, from Thailand. 8th century CE. Bronze, 52″ (1.3 m).
The Nelson-Atkins Museum of Art, Kansas City, Missouri. Purchase:
William Rockhill Nelson Trust (51-23)

SIXTH TO THE NINTH CENTURY

As trade networks strengthened and expanded, Southeast Asian communities gained increased access to foreign goods and foreign ideas. The South Asian religions of Hinduism and Buddhism were of particular influence and gained popularity just as some of the earliest large-scale kingdoms were emerging. These religions supported and inspired emerging dynasties and became closely intertwined with early Southeast Asian concepts of kingship.

DVARAVATI-STYLE BUDDHA, THAILAND The Mon ethnic group was among the first in Southeast Asia to adopt Buddhism. Starting in the sixth century CE they organized into a kingdom whose name, Dvaravati, is preserved thanks to a cache of ritual coins unearthed from a stupa in Nakhon Pathom, Thailand. The archaeological remains from this kingdom are quite varied in form, media, and subject, which is not surprising, given that the Mon controlled this region until the Khmer gained influence in the tenth century.

Characteristic of the sculpture associated with early Mon sites are the standing Buddha images in bronze, such as this eighth century example (**FIG. 10-32**). Stylistically, this image exhibits the arched brows, outlined facial features, and curled hair reminiscent of the Mathura style; however, the double robe is flattened in a distinctive manner against the body with a capelike angularity at its base. The iconography is consistent with that seen in South Asia, but Dvaravati Buddhas almost invariably display the same *mudra* in both hands, in this case the *vitarka*. The reasons for this insistence on symmetry are not known, but it suggests a local preference. The typically small size of these images may indicate that they were inspired by portable icons carried along the trade routes.

HARIHARA, CAMBODIA Local preferences are exhibited clearly in a late seventh-century CE sculpture from Phnom Da, Cambodia. This pre-Angkorian Khmer work depicts a merged form of the Hindu gods Shiva and Vishnu, known as **HARIHARA** (**FIG. 10-33**). Such images are only rarely encountered in South Asia but in Southeast Asia, in the absence of a long history of sectarian differences between devotees of the two gods, this unified expression of Hindu divinity became extremely popular. Iconographically, the right side of the image depicts Shiva with his trident, matted hair, third eye and animal skins. The left half, correspondingly, represents Vishnu whose cylindrical crown, *chakra* (throwing disk), and fine garments indicate his identity. The artist has rendered this complex subject with great skill but in this early period the Khmer still did not fully trust the strength of the stone, so the sculptor cautiously linked the hands to the head with a supporting arch of stone.

BOROBUDUR, INDONESIA The mainland was not alone in transforming new ideas from abroad. The islands of Southeast Asia, and Java in particular, produced some of the earliest and grandest

for a kingdom, or collection of states, called Funan, in the southern reaches of the Southeast Asian peninsula is provided by third-century CE Chinese sources. As long-distance trade increased, the Southeast Asians found themselves in a strategic and lucrative location for controlling and mediating exchanges between East Asia and points west. Having no shortage of locally produced and highly prized commodities, like hardwoods and spices, regional merchants were also active participants in this trade network. It was perhaps inevitable that over these centuries of trade, new ideas also arrived. By the sixth century CE there is ample evidence that Buddhism and Hinduism had taken firm root in the Mon kingdom of Dvaravati (modern-day Thailand and southern Myanmar) as well as in the Pre-Ankorian art of the Khmer (in modern Cambodia).

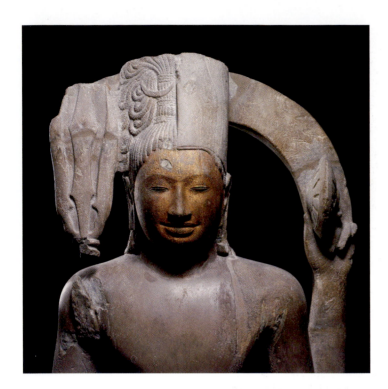

responses to imported Buddhist ideas. The remarkable structure of **BOROBUDUR** (**FIG. 10-34**) was built in its central Java location by the Shailendra dynasty about the year 800. It appears to have been the endpoint of a processional road that linked this site with the Buddhist sacred structures at Mendut and Pawon. Borobudur has characteristics typical of a stupa as well as those suggestive of a three dimensional *mandala*, or cosmic diagram, but many aspects of the structure's use are still poorly understood.

The monument itself rises more than 100 feet from ground level. This stepped pyramid of volcanic-stone blocks has five lower quadrilateral terraces that support three roughly circular terraces surmounted by a large bell-shaped stupa, itself ringed by 72 smaller openwork stupas. Each of the squared terraces is enclosed by a high wall bearing extensive relief sculpture and adorned with Buddha images in niches and small bell-shaped projections. The

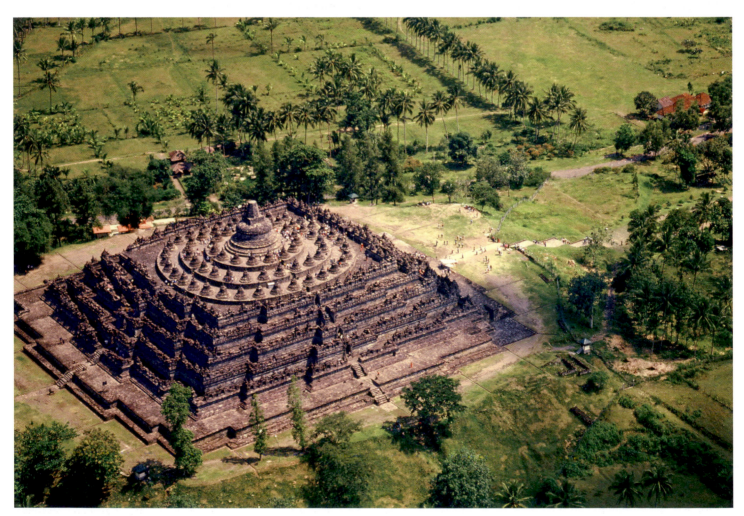

10-34 • BOROBUDUR
Central Java, Magelang District, Indonesia. c. 800 CE. Aerial view.

✳ **Explore** the architectural panoramas of Borobudur on myartslab.com

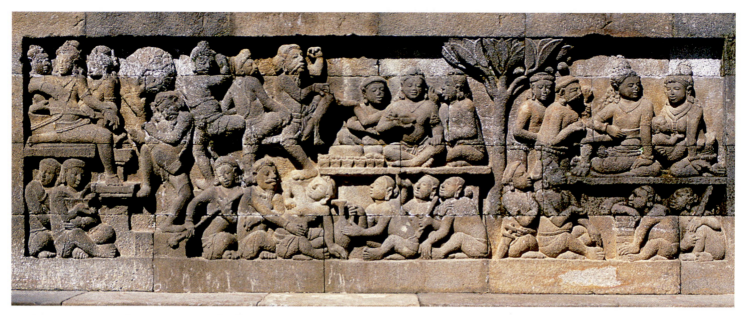

10-35 • SCENE OF DRUNKENNESS AND MODERATION
Borobudur, east side. Central Java, Indonesia. 9th century CE.

This scene depicts a lesson from the Karmavibhanga on the rewards for moderation in food and drink. The figures on the upper right turn away from the scene of debauchery played out in front of them. In reward for this good judgment they are reborn as individuals with few diseases, indicated by the hearty couple surrounded by supplicants on the right side of the panel. The tree divides the cause from the effect.

decoration on the lowest level was hidden for centuries because, shortly after the monument was built, it was bolstered by a heavy architectural foot in order to stop the structure from spreading as the dirt in its core settled under the weight of the stone. These **bas-reliefs** were exposed and carefully photographed during the restoration of the monument begun in 1975. As with all sculpture at the site, the figures are elegant with full rounded bodies whose smooth forms are sporadically accentuated by delicately carved adornments.

The decorative program of these relief carvings displays a carefully calculated arrangement that moves from pragmatic moral lessons at the base up to more abstract religious ideas at the summit. The lowest gallery, which had been covered by the foot, depicts instructive scenes of karmic reward and punishment (**FIG. 10-35**). As one circumambulates to the next set of terraces, scenes of the Buddha's past lives and other moral tales share space with the life story of Shakyamuni Buddha. Moving upward, terraces four and five visually recount the story of Sudhana, an ordinary man who seeks personal enlightenment, eventually achieving it with the guidance of a bodhisattva. At this point visitors exit to the upper three circular terraces whose rows of stupas and wide vista may be a metaphor for the enlightened state. Each of these perforated stupas holds a seated Buddha except for the large, central stupa, whose surface is solid. The placement of Buddha images on the monument and their differing *mudras* corresponds to the arrangement found in some Buddhist *mandalas* and points to another layer of meaning in this exceptionally complex architectural plan.

LORO JONGGRANG, INDONESIA Slightly later than Borobudur, but clearly influenced by its example, is the extensive site of **LORO JONGGRANG** in Prambanan, Java (**FIG. 10-36**). Although not a stepped pyramid, this Hindu monument employs a concentric plan and shares Borobudur's repetition of bell-shaped forms. This temple complex was begun in the mid ninth century by the Sanjaya dynasty, regional rivals to the Shailendra, under the reign of Rakai Pikatan. It was further expanded by later kings.

The buildings in the complex are arranged around the central temple dedicated to Shiva. The central sacred area, housing the biggest temples, is enclosed in an outer wall, beyond which the remains of 224 shrines are arrayed in four concentric squares. Most of these shrines are now badly damaged and their function is not clear, but some have speculated that their locations may reflect the social status of their donors. The towering central structure stands almost 155 feet high and is flanked by two somewhat smaller structures dedicated to Vishnu and Brahma, each just over 108 feet in height. The primary image of Shiva is an anthropomorphic representation rather than a *linga*. Its east-facing chamber is surrounded by subsidiary shrines aligned to the other cardinal directions housing images of deities associated with Shiva. The flanking temples have only one chamber each, which contain beautifully carved images of Vishnu and Brahma respectively. A row of three smaller chambers is located just across from the entrances to the main temples. It is believed that these buildings were dedicated to the mounts (*vahana*) of the three gods, but only the image of Shiva's mount, the bull Nandi, has survived. All the temples are raised on high plinths decorated with narrative scenes in relief.

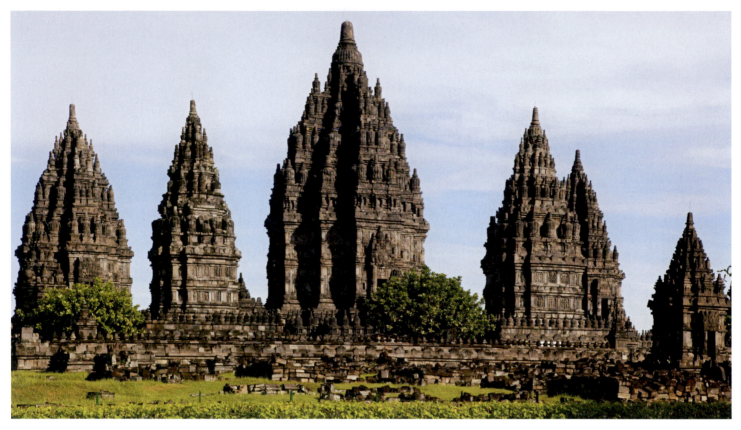

10-36 • LORO JONGGRANG
Prambanan, Central Java, Indonesia. 9th century CE.

A portion of these reliefs depicts scenes from the *Ramayana*. This Hindu epic was known in Indonesia from an early date and aspects of the story were adjusted to better suit the needs and expectations of its Southeast Asian audience. Some of this local influence can be seen in a relief (**FIG. 10-37**) portraying the moment the wicked demon king Ravana (Rawana) abducts Sita, the wife of the hero Rama. Ravana, disguised as a Brahmin, seizes Sita in the midst of a Javanese village and in the process overturns a number of objects as the witnesses to the event react in horror and surprise. The wildlife in this panel exploit the distraction, a dog in the foreground grabs at food fallen from an overturned pot, a rat can be seen sneaking into the storehouse, and a monkey reaches for food held by a seated man. The addition of these details, not mentioned in the text, reinforce the shamefully animalistic nature of Ravana's actions, which ultimately lead to his own destruction. Typical for the art of Java in this period the panel is full of activity as each event is accompanied by a host of attendants, onlookers, and references to the natural world.

10-37 • ABDUCTION OF SITA
Illustration of the *Ramayana*, relief 13, scene 2, Chandi Shiva, Prambanan, Central Java, Indonesia. 9th century CE.

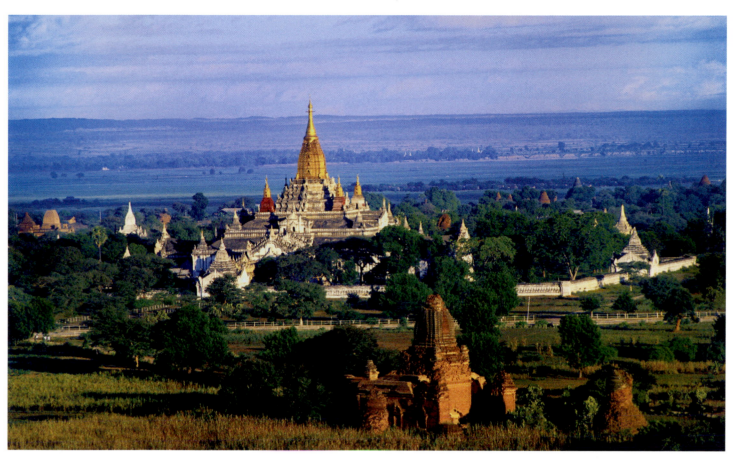

10-38 • ANANDA TEMPLE
Bagan, Mandalay Division, Myanmar. 11th century CE. Height c. 30″ (76 cm).

TENTH THROUGH TWELFTH CENTURIES

By the tenth through twelfth centuries the powerful kingdoms in Angkor and Bagan were reaching their peak. Their great wealth and success found expression in innovative forms of architectural construction whose ambitious design and grand scale took earlier forms of Southeast Asian construction to new heights.

ANANDA TEMPLE, MYANMAR King Anawrahta came to power in 1044, uniting the disparate regional rulers in northern Myanmar under his rule and the local gods (*nats*) under Buddhism. Lavish temple-building projects were not just a means for the king to demonstrate his legitimacy and accrual of good *karma* (the concept that one's deeds, good or bad, eventually produce correspondingly positive or negative consequences), it was also seen as means of ensuring the welfare of state interests and public well-being. The focus of this fervent generosity was the Buddhist monastic order based near the capital in Bagan (also called Pagan). Over the course of generations of public and royal patronage this semiarid valley came to house several thousand spectacular Buddhist structures, large and small, in various states of repair.

Among these, one of the grandest is the **ANANDA TEMPLE** (**FIG. 10–38**), built in 1105 by King Kyanzittha, Anawrahta's adopted son and eventual successor. According to the legends, the head monk at Bagan, Shin Arahan, introduced the king to eight monks from India who were seeking support abroad. The ensuing discussions inspired the king to undertake a major act of patronage, which culminated in the construction of the Ananda Temple. The unique architectural plan of this temple is rather complex but it can be envisioned as four temples placed up against the sides of a massive square-based stupa, which rises to almost 175 feet. The temples each face a cardinal direction and house large Buddha images covered in gold leaf, most of which have been renovated or replaced over the centuries. The walls of these temples have openings that make way for two covered circumambulation pathways. While most of the sculpture, in niches, along these pathways remain, almost none of the painting still exists. The exterior is embellished with rising spires and flamelike decoration over the windows and doors. The central roof rises to the main tower in five tiers. These are decorated with horizontal bands of inset glazed ceramic plaques, many of which display scenes from the Buddha's past lives.

Of particular note are two gilded lacquer images in postures of reverence flanking the Buddha image in the west-facing shrine. These images are believed to depict **KING KYANZITTHA** (**FIG. 10–39**), shown in elaborate attire, and his chief monk Shin Arahan, bald and in simple robes. The details of these figures have been somewhat effaced due to layers of gold leaf, but this accretion may also have protected the lacquer from decay.

10–39 • PORTRAIT OF KING KYANZITTHA
West shrine, Ananda Temple, Bagan. 11th century CE.
Gilded lacquer. Height 30″ (76 cm).

The Ananda is just one grand temple among many in Bagan. Unfortunately, misguided attempts by the government in Myanmar to restore these structures has resulted in conjectural and inaccurate renovations that have hidden or destroyed much of the early material.

ANGKOR WAT, CAMBODIA In 802, the Khmer king Jayavarman II, newly returned from Java, climbed Mount Kulen in what is now northwestern Cambodia. He was accompanied on this trip by a Brahmin who performed a ritual on the mountaintop that marked a special relationship between Jayavarman II and the Hindu god Shiva.

Thereafter, Jayavarman II and subsequent rulers in his lineage claimed the title of "god-king" (*devaraja*). The special religious status indicated by this designation was further solidified through architectural projects that invoked divine symbolism on behalf of the ruler. While Jayavarman II had ascended an actual mountain, his descendants opted to construct elaborate temple mountains near the major urban centers of Roluos and Angkor. These immense structures recalled the sacred mountains on which the gods dwell and marked the political and religious center of the Khmer empire.

Among the grandest and most unusual of these structures is Suryavarman II's temple mountain, known today as **ANGKOR WAT** (FIG. 10–40). Having come to power after a period of turmoil, Suryavarman II (r. 1113–1150), unlike most of his predecessors, chose to devote himself to the god Vishnu rather than to

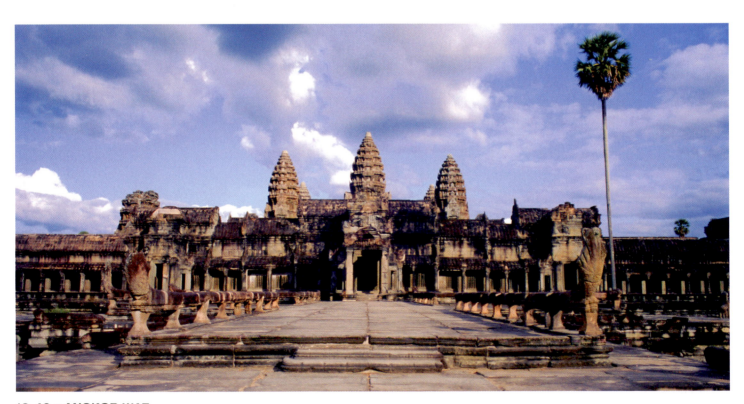

10–40 • ANGKOR WAT
Angkor, Cambodia. 12th century CE.

✳ **Explore** the architectural panoramas of Angkor Wat on myartslab.com

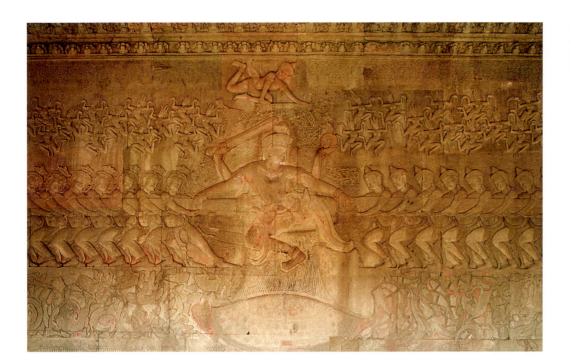

10-41 • VISHNU CHURNING THE OCEAN OF MILK
Detail of relief sculpture, Angkor Wat. 12th century.

Shiva. He further broke with tradition by having his temple face west to the setting sun, a direction which had funerary associations.

The temple is a massive structure, comprised of three concentric galleries that frame a stepped pyramid crowned by five delicately tapered towers. This entire structure is surrounded by lakelike moats over 820 feet wide and crossed by walkways adorned with balustrades shaped like multi-headed serpents. The inner walls of the three outer galleries contain elaborate bas-relief sculptures, many of which depict scenes from the great Hindu epics or glorified depictions of the king.

One relief on the east side of the outer gallery portrays a Hindu story known as the Churning of the Ocean of Milk (FIG. 10–41). In this tale, set in a time before the world was fully formed, Vishnu orchestrates the production of the elixir of immortality. He achieves this by wrapping the cosmic serpent around a great mountain emerging from the sea. Then by pulling on the serpent, the gods, working with their enemies, the *asura*, manage to churn up the elixir of immortality from the ocean's depths. This relief may hold a clue to understanding the monument as a whole. With its mountainlike towers, broad moat, and serpent balustrades, the entire complex at Angkor Wat parallels the setting of the legend and may speak to Suryavarman II's hopes for gaining a sort of immortality through his own special union with Vishnu.

THINK ABOUT IT

10.1 Consider the use of rock-cut architecture. What were the benefits and drawbacks to this architectural technique? How did it influence, and how was it influenced, by built architecture? Give examples.

10.2 Select one architectural work from the chapter and one work of sculpture. Explain how either Buddhist or Hindu ideas are expressed through their decoration, form, or iconography.

10.3 Describe the typical form of Indian temples, northern and southern. Contrast the stupa and the temple directly, paying attention to specific building features and how they are used.

10.4 How do sites like Mamallapuram, the Ananda Temple, and Angkor Wat help legitimize the authority of the ruler?

CROSSCURRENTS

FIG. 10–24

FIG. 10–41

Water symbolism occurs frequently in the art of South and Southeast Asia. Consider the way practical concerns over climate and commerce may have shaped the way this imagery was understood. Why would such symbolism be appropriate for royally sponsored sculpture and what was its significance?

✔ **Study** and review on myartslab.com

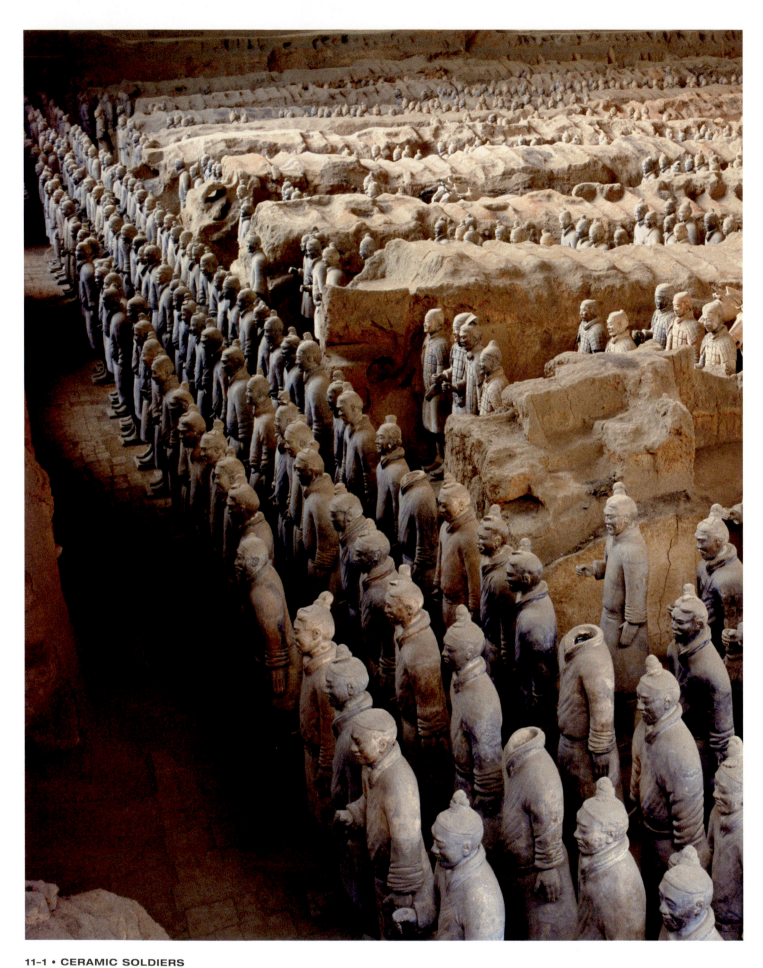

11–1 • CERAMIC SOLDIERS

From the mausoleum of Emperor Shihuangdi, Lintong, Shaanxi. Qin dynasty, c. 210 BCE. Earthenware, life-size.

Chinese and Korean Art before 1279

As long as anyone could remember, the huge mound in Shaanxi Province in northern China had been part of the landscape. No one dreamed that an astonishing treasure lay beneath the surface until one day in 1974 peasants digging a well accidentally brought to light the first hint of riches. When archaeologists began to excavate, they were stunned by what they found: a vast underground army of some 8,000 life-size terra-cotta soldiers with 100 life-size ceramic horses standing in military formation, facing east, supplied with weapons, and ready for battle (FIG. 11–1). For more than 2,000 years, while the tumultuous history of China unfolded overhead, they had guarded the tomb of Emperor Shihuangdi, the ruthless ruler who first united the states of China into an empire, the Qin. In ongoing excavations at the site, additional bronze carriages and horses were found, further evidence of the technology and naturalism achieved by artisans during Qin Shihuangdi's reign. The tomb mound itself has not been excavated.

China has had a long-standing fascination with antiquity, but archaeology is a relatively young discipline there. Only since the 1920s have scholars methodically dug into the layers of history at thousands of sites across the country, yet so much has been unearthed that ancient Chinese history has been rewritten many times. The archaeological record shows that Chinese civilization arose several millennia ago, and was distinctive for its early advances in ceramics and metalwork, as well as for the elaborate working of jade.

Early use of the potter's wheel, mastery of reduction firing, and the early invention of high-fired stoneware and porcelain distinguish the technological advancement of Chinese ceramics. Highly imaginative bronze castings and proficient techniques of mold making characterize early Chinese metalworking. Early attainments in jade reflect a technological competence with rotary tools and abrasion, as well as an aesthetic passion for the subtleties of shape, proportion, and surface texture.

Archaeology has supplemented our understanding of historically appreciated Chinese art forms. These explored human relationships and ethical ideals, exemplifying Confucian values and teaching the standards of conduct that underlie social order. Later, China also came to embrace the Buddhist tradition from India. In princely representations of Buddhist divinities and in sublime and powerful, but often meditative, figures of the Buddha, China's artists presented the divine potential of the human condition. Perhaps the most distinguished Chinese tradition is the presentation of philosophical ideals through the theme of landscape. Paintings simply in black ink, depictions of mountains and water, became the ultimate artistic medium for expressing the vastness, abundance, and endurance of nature.

Chinese civilization radiated its influence throughout East Asia. Chinese learning repeatedly stimulated the growth of culture in Korea, which in turn transmitted influence to Japan.

LEARN ABOUT IT

11.1 Trace the developing period and regional styles in the art of early China and Korea and assess the relationship between Chinese and Korean traditions.

11.2 Explore the principal themes and subjects of the diverse artistic production of China and Korea from the Neolithic period through the thirteenth century CE.

11.3 Probe the relationship between the history of art and the evolving Confucian, Daoist, and Buddhist traditions of China and Korea.

11.4 Discuss the development of traditional Chinese landscape painting and learn the vocabulary and principles that allow us to characterize, interpret, and discuss it.

((•—[Listen to the chapter audio on myartslab.com

THE MIDDLE KINGDOM

Among the cultures of the world, China is distinguished by its long, uninterrupted development, now traced back some 8,000 years. From Qin (pronounced "chin") comes our name for the country that the Chinese call the Middle Kingdom, the country in the center of the world. Present-day China occupies a large landmass in the center of east Asia, covering an area slightly larger than the continental United States. Within its borders lives one-fifth of the human race.

The historical and cultural heart of China is the land watered by its three great rivers, the Yellow (Huang Ho), the Yangzi, and the Xi (MAP 11–1). The Qinling Mountains divide Inner China into north and south, regions with strikingly different climates, cultures, and historical fates. In the south, the Yangzi River flows through lush green hills to the fertile plains of the delta. Along the southern coastline, rich with natural harbors, arose China's port cities, the focus of a vast maritime trading network. The Yellow River, nicknamed "China's Sorrow" because of its disastrous floods, winds through the north. The north country is a dry land of steppe and desert, hot in the summer and lashed by cold winds in the winter. Over its vast and vulnerable frontier have come the nomadic invaders that are a recurring theme in Chinese history, but caravans and emissaries from Central Asia, India, Persia, and, eventually, Europe also crossed this border.

NEOLITHIC CULTURES

Early archaeological evidence had led scholars to believe that agriculture, the cornerstone technology of the Neolithic period, made its way to China from the ancient Near East. More recent findings, however, suggest that agriculture based on rice and millet arose independently in east Asia before 5000 BCE and that knowledge of Near Eastern grains followed some 2,000 years later. One of the clearest archaeological signs of Neolithic culture in China is evidence of the vigorous emergence of towns and cities. At Jiangzhai, near modern Xi'an, for example, the foundations of more than 100 dwellings have been discovered surrounding the remains of a communal center, a cemetery, and a kiln. Dated to about 4000 BCE, the ruins point to the existence of a highly developed early society. Elsewhere, the foundations of the earliest-known Chinese palace have been uncovered and dated to about 2000 BCE.

PAINTED POTTERY CULTURES

In China, as in other places, distinctive forms of Neolithic pottery identify different cultures. One of the most interesting objects thus far recovered is a shallow red **BOWL** with a turned-out rim (FIG. 11–2). Found in the village of Banpo near the Yellow River, it was crafted sometime between 5000 and 4000 BCE. The bowl is an artifact of the Yangshao culture, one of the most important of the so-called Painted Pottery cultures of Neolithic China. Although the potter's wheel had not yet been developed, the bowl is perfectly

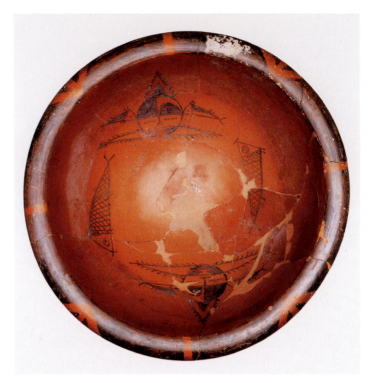

11-2 • BOWL
From Banpo, near Xi'an, Shaanxi. Neolithic period, Yangshao culture, 5000–4000 BCE. Painted pottery, height 7″ (17.8 cm). Banpo Museum.

round and its surfaces are highly polished, bearing witness to a distinctly advanced technology. The decorations are especially intriguing. There are markings on shards from this location that may be evidence of the beginnings of writing in China, which was fully developed by the time the first definitive examples appear during the second millennium BCE, in the later Bronze Age.

Inside the bowl, a pair of stylized fish suggests that fishing was an important activity for the villagers. The images between the two fish represent human faces flanked by fish, one on each side. Although there is no certain interpretation of the image, it may be a depiction of an ancestral figure who could assure an abundant catch, since the worship of ancestors and nature spirits was a fundamental element of later Chinese beliefs.

LIANGZHU CULTURE

Banpo lies near the great bend in the Yellow River, in the area traditionally regarded as the cradle of Chinese civilization, but archaeological finds have revealed that Neolithic cultures spread over a far broader geography. Recent excavations in sites more than 800 miles away, near Hangzhou Bay, in the southeastern coastal region, have uncovered human and animal images—often masks or faces—more than 5,000 years old from the Liangzhu culture (FIG. 11–3). Large, round eyes, a flat nose, and a rectangular mouth protrude slightly from the background pattern of wirelike lines. Above the forehead, a second, smaller face grimaces from under a huge headdress. The upper face may be human, perhaps riding the animal figure below. The drawing reproduces one of

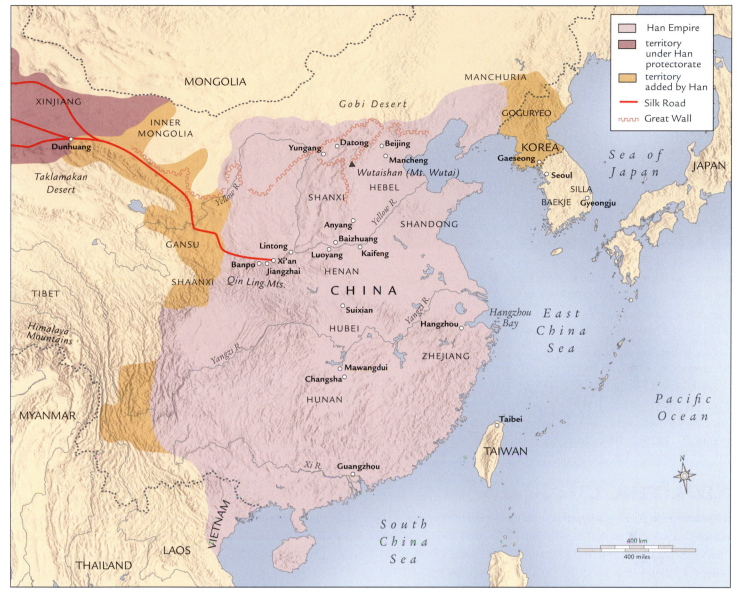

MAP 11–1 • CHINA AND KOREA

The map shows the borders of contemporary China and Korea. Bright-colored areas indicate the extent of China's Han dynasty (206 BCE–220 CE).

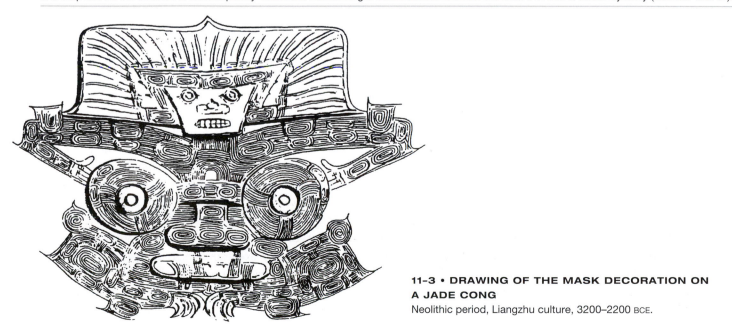

11-3 • DRAWING OF THE MASK DECORATION ON A JADE CONG
Neolithic period, Liangzhu culture, 3200–2200 BCE.

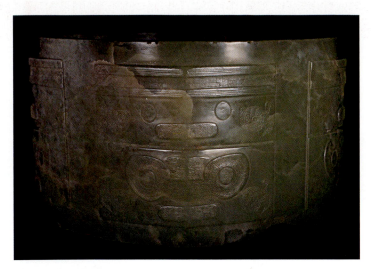

11-4 • CONG
Neolithic period, Liangzhu culture, 3200–2200 BCE. Jade, height 1⅞" × width 2⅝" (5 × 6.6 cm). Shanghai Museum.

The *cong* is one of the most prevalent and mysterious of early Chinese jade shapes. Originating in the Neolithic period, it continued to play a prominent role in burials through the Shang and Zhou dynasties. Many experts believe the *cong* was connected with the practice of contacting the spirit world.

eight masks that were carved in low relief on the outside of a large jade cong, an object resembling a cylindrical tube encased in a rectangular block. Another **CONG** (**FIG. 11-4**), also from Liangzhu, bears a lustrous, smooth finish and similar—if more stylized—mask motifs. Both *congs* were found near the remains of persons buried with what appear to be sets of numerous jade objects.

The intricacy of these carvings documents the technical sophistication of the jade-working Liangzhu culture, which seems to have emerged around 3300 BCE. Jade, a stone cherished by the Chinese throughout their history, is extremely hard and is difficult to carve. Liangzhu artists must have used sand as an abrasive to slowly grind the stone down; modern artisans marvel at the refinement and virtuosity of the work they produced.

The meaning of the masklike image in FIGURE 11-3 is open to interpretation. Its combination of human and animal features seems to show how the ancient Chinese imagined supernatural beings, either deities or dead ancestors. Similar masks later formed the primary decorative motif of Bronze Age ritual objects. Still later, Chinese historians began referring to the ancient mask motif as **taotie**, but the motif's original meaning had already been lost. The jade carving here seems to be a forerunner of this most central and mysterious image.

BRONZE AGE CHINA

China entered its Bronze Age in the second millennium BCE. As with agriculture, scholars at first theorized that the technology had been imported from the Near East. Archaeological evidence now makes clear, however, that bronze casting using the **piece-mold**

casting technique arose independently in China, where it attained an extraordinary level of sophistication (see "Piece-Mold Casting," opposite).

SHANG DYNASTY

Traditional Chinese histories tell of three Bronze Age dynasties: the Xia, the Shang, and the Zhou. Experts at one time tended to dismiss the Xia and Shang as legendary, but twentieth-century archaeological discoveries fully established the historical existence of the Shang (c. 1700–1100 BCE) and point strongly to the historical existence of the Xia as well.

Shang kings ruled from a succession of capitals in the Yellow River Valley, where archaeologists have found walled cities, palaces, and vast royal tombs. The Shang were surrounded by many other states—some rivals, others clients—and their culture spread widely. Society seems to have been highly stratified, with a ruling group that had the bronze technology needed to make weapons and ritual vessels. They maintained their authority in part by claiming power as intermediaries between the supernatural and human realms. The chief Shang deity, Shangdi, may have been a sort of "Great Ancestor." It is thought that nature and fertility spirits were also honored, and that regular sacrifices were thought necessary to keep the spirits of dead ancestors vital so that they might help the living.

Shang priests communicated with the supernatural world through oracle bones. An animal bone or piece of tortoiseshell was inscribed with a question and heated until it cracked; the crack was then interpreted as an answer. Oracle bones, many of which have been recovered and deciphered, contain the earliest known form of Chinese writing, a script fully recognizable as the ancestor of the system still in use today (see "Chinese Characters," page 337).

RITUAL BRONZES Shang tombs reveal a warrior culture of great splendor and violence. Many humans and animals were sacrificed to accompany the deceased into death. In one tomb, for example, chariots were found with the skeletons of their horses and drivers; in another, dozens of human skeletons lined the approaches to the central burial chamber. The tombs contain hundreds of jade, ivory, and lacquer objects, gold and silver ornaments, and bronze vessels. The enormous scale of Shang burials illustrates the great wealth of the civilization and the power of a ruling class able to consign such great quantities of treasure to the earth. It also documents this culture's reverence for the dead.

Bronze vessels are the most admired and studied of Shang artifacts. Like oracle bones and jade objects, they were connected with ritual practices, serving as containers for offerings of food and wine. A basic repertoire of about 30 shapes evolved. Some shapes derive from earlier pottery forms, while others seem to reproduce wooden containers. Still others are highly sculptural and take the form of fantastic composite animals.

One functional shape, the **fang ding**, a rectangular vessel standing on four elongated legs, was used for food offerings. Early

The early piece-mold technique for bronze casting is different from the lost-wax process developed in the ancient Mediterranean and Near East. Although we do not know the exact steps ancient Chinese artists followed, we can deduce the general procedure for casting a vessel.

First, a model of the bronze-to-be was made of clay and dried. Then, to create a mold, damp clay was pressed onto the model; after the clay mold dried, it was cut away in pieces, which were keyed for later reassembly and then fired. The original model itself was shaved down to serve as the core for the mold. After this, the pieces of the mold were reassembled around the core and held in place by bronze spacers, which locked the core in position and ensured an even casting space around the core. The reassembled mold was then covered with another layer of clay, and a sprue, or pouring duct, was cut into the clay to receive the molten metal. A riser duct may also have been cut to allow the hot gases to escape. Molten bronze was then poured into the mold. When the metal cooled, the mold was broken apart to reveal a bronze copy of the original clay model. Finely cast relief decoration could be worked into the model or carved into the sectional molds, or both. Finally, the vessel could be burnished—a long process that involved scouring the surface with increasingly fine abrasives.

The vessel shown here is a *fang ding*. A *ding* is a ceremonial cooking vessel used in Shang rituals and buried in Shang tombs. The Zhou people also made, used, and buried *ding* vessels.

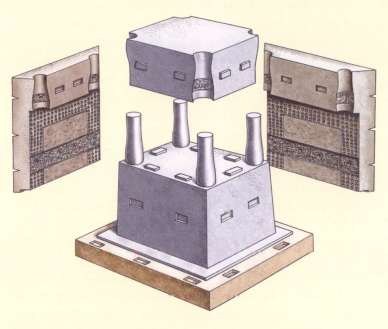

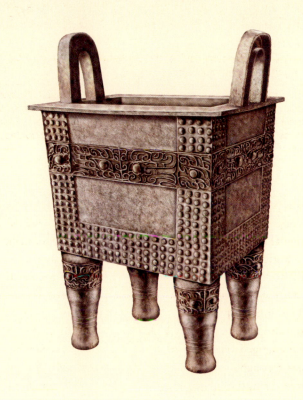

Sectional clay molds for casting bronze vessels. This sketch is based on a vessel in the Zhengzhou Institute of Cultural Relics and Archaeology.

examples (see "Piece-Mold Casting," above) featured decoration of raised bosses and masklike (*taotie*) motifs in horizontal registers on the sides and the legs. This late Shang example, one of hundreds of vessels recovered from the royal tombs near Yin, the last of the Shang capitals (present-day Anyang), is extraordinary for its size. Weighing nearly 2,000 pounds, it is the largest Shang *ding* vessel thus far recovered. A ritual pouring vessel, called a **GUANG** (**FIG. 11-5**), shows a highly sculptural rendition of animal forms. The pouring spout and cover take the form of the head and body of a tiger, while the rear portion of the vessel and cover is conceived as an owl. Overall geometric decoration combines with suggestive zoomorphic forms. Such images seem to be related to the hunting life of the Shang, but their deeper significance is unknown. Sometimes strange, sometimes fearsome, Shang creatures seem always to have a sense of mystery, evoking the Shang attitude toward the supernatural world.

ZHOU DYNASTY

Around 1100 BCE, the Shang were conquered by the Zhou from western China. During the Zhou dynasty (1100–221 BCE) a feudal society developed, with nobles related to the king ruling over numerous small states. (Zhou nobility are customarily ranked in English by such titles as duke and marquis.) The supreme deity became known as Tian, or Heaven, and the king ruled as the Son of Heaven. Later Chinese ruling dynasties continued to follow the belief that imperial rule emanated from a mandate from Heaven.

The first 300 years of this longest-lasting Chinese dynasty were generally stable and peaceful. In 771 BCE, however, the Zhou suffered defeat in the west at the hands of a nomadic tribe. Although they quickly established a new capital to the east, their authority had been crippled, and the later Eastern Zhou period was a troubled one. States grew increasingly independent, giving only nominal allegiance to the Zhou kings. Smaller states were

swallowed up by their larger neighbors. During the time historians call the Spring and Autumn period (722–481 BCE), 10 or 12 states, later reduced to seven, emerged as powers. The ensuing Warring States period (481–221 BCE) saw intrigue, treachery, and increasingly ruthless warfare.

Against this background of social turmoil, China's great philosophers arose—such thinkers as Confucius, Laozi, and Mozi. Traditional histories speak of China's "one hundred schools" of philosophy, indicating a shift of focus from the supernatural to the human world. Nevertheless, elaborate burials on an even larger scale than before reflected the continuation of traditional beliefs.

BRONZE BELLS Ritual bronze objects continued to play an important role during the Zhou dynasty, and new forms developed. One of the most spectacular recent discoveries is a carillon of 65 bronze components, mostly bells arranged in a formation 25 feet long (**FIG. 11–6**), found in the tomb of Marquis Yi of the state of Zeng. Each bell is precisely calibrated to sound two tones—one when struck at the center, another when struck at a corner. They are arranged in scale patterns in a variety of registers, and several musicians would have moved around the carillon, striking the bells in the appointed order.

Music may well have played a part in rituals for communicating with the supernatural, for the *taotie* typically appears on the front and back of each bell. The image is now much more intricate and stylized, a complexity made possible in part by the more refined lost-wax casting process (see "Lost-Wax Casting," page 418), which had replaced the older piece-mold technique. The marquis, who died in 433 BCE, must have considered music important, for among the more than 15,000 objects recovered from his tomb were many musical instruments. Zeng was one of the smallest and shortest-lived states of the Eastern Zhou, but the contents of this tomb, in quantity and quality, attest to its high cultural level.

THE CHINESE EMPIRE: QIN DYNASTY

Toward the middle of the third century BCE, the state of Qin launched military campaigns that led to its triumph over the other states by 221 BCE. For the first time in its history, China was united under a single ruler. This first emperor of Qin, Shihuangdi, a man of exceptional ability, power, and ruthlessness, was fearful of both assassination and rebellion. Throughout his life, he sought ways to attain immortality. Even before uniting China, he began his own mausoleum at Lintong, in Shaanxi Province. This project continued throughout his life and after his death, until rebellion abruptly ended the dynasty in 206 BCE. Since that time, the mound over the mausoleum has always been visible, but not until an accidental discovery in 1974 was its army of terra-cotta soldiers and horses even imagined (see FIG. 11–1). Modeled from clay with individualized

Each word in Chinese is represented by its own unique symbol, called a character. Some characters originated as **pictographs**, images that mean what they depict. Writing reforms over the centuries have often disguised the resemblance, but if we place modern characters next to their ancestors, the pictures come back into focus:

	water	horse	moon	child	tree	mountain
Ancient	〰	馬)	𢘐	𣏟	⛰
Modern	水	馬	月	子	木	山

Other characters are ideographs, pictures that represent abstract concepts or ideas:

sun	+	moon	=	bright
日		月		明

woman	+	child	=	good
女		子		好

Most characters were formed by combining a radical, which gives the field of meaning, with a phonetic, which originally hinted at pronunciation. For example, words that have to do with water have the character for "water" 水 abbreviated to three strokes 氵 as their radical. Thus "to bathe," 沐 pronounced *mu*, consists of the water radical and the phonetic 木, which by itself means "tree" and is also pronounced *mu*. Here are other "water" characters. Notice that the connection to water is not always literal.

river	sea	weep	pure, clear	extinguish, destroy
河	海	泣	清	滅

These phonetic borrowings took place centuries ago. Many words have shifted in pronunciation, and for this and other reasons there is no way to tell how a character is pronounced or what it means just by looking at it. While at first this may seem like a disadvantage, in the case of Chinese it is advantageous. Spoken Chinese has many dialects. Some are so far apart in sound as to be virtually different languages. But while speakers of different dialects cannot understand each other, they can still communicate through writing, for no matter how they say a word, they write it with the same character. Writing has thus played an important role in maintaining the unity of Chinese civilization through the centuries.

faces and meticulously rendered uniforms and armor and then fired, the figures claim a prominent place in the great tradition of Chinese ceramic art. Literary sources suggest that the tomb itself, which has not yet been opened, reproduces the world as it was known to the Qin, with stars overhead and rivers and mountains below. Thus did the tomb's architects try literally to ensure that the underworld—the world of souls and spirits—would match the human world.

11-6 • SET OF BELLS
From the tomb of Marquis Yi of Zeng, Suixian, Hubei. Zhou dynasty, 433 BCE. Bronze, with bronze and timber frame, frame height 9′ (2.74 m), length 25′ (7.62 m). Hubei Provincial Museum, Wuhan.

Daoism is an outlook on life that brings together many ancient ideas regarding humankind and the universe. Its primary text, a slim volume called the *Daodejing* (*The Way and Its Power*), is ascribed to the Chinese philosopher Laozi, who is said to have been a contemporary of Confucius (551–479 BCE). Later, a philosopher named Zhuangzi (369–286 BCE) explored many of the same ideas in a book that is known simply by his name: *Zhuangzi*. Together the two texts formed a body of ideas that crystallized into a school of thought during the Han period.

A *dao* is a way or path. The Dao is the Ultimate Way, the Way of the universe. The Way cannot be named or described, but it can be hinted at. It is like water. Nothing is more flexible and yielding, yet water can wear down the hardest stone. Water flows downward, seeking the lowest ground. Similarly, a Daoist sage seeks a quiet life, humble and hidden, unconcerned with worldly success. The Way is great precisely because it is small. The Way may be nothing, yet nothing turns out to be essential.

To recover the Way, we must unlearn. We must return to a state of nature. To follow the Way, we must practice *wu wei* (nondoing). "Strive for nonstriving," advises the *Daodejing*.

All our attempts at asserting ourselves, at making things happen, are like swimming against a current and are thus ultimately futile, even harmful. If we let the current carry us, however, we will travel far. Similarly, a life that follows the Way will be a life of pure effectiveness, accomplishing much with little effort.

It is often said that the Chinese are Confucians in public and Daoists in private, and the two approaches do seem to balance each other. Confucianism is a rational political philosophy that emphasizes propriety, deference, duty, and self-discipline. Daoism is an intuitive philosophy that emphasizes individualism, nonconformity, and a return to nature. If a Confucian education molded scholars outwardly into responsible, ethical officials, Daoism provided some breathing room for the artist and poet inside.

Qin rule was harsh and repressive. Laws were based on a totalitarian philosophy called legalism, and all other philosophies were banned, their scholars executed, and their books burned. Yet the Qin also established the mechanisms of centralized bureaucracy that molded China both politically and culturally into a single entity. Under the Qin, the country was divided into provinces and prefectures, the writing system and coinage were standardized, roads were built to link different parts of the country with the capital, and battlements on the northern frontier were connected to form the Great Wall. To the present day, China's rulers have followed the administrative framework first laid down by the Qin.

HAN DYNASTY

The commander who overthrew the Qin became the next emperor and founded the Han dynasty (206 BCE–220 CE). During this period China enjoyed peace, prosperity, and stability. Borders were extended and secured, and Chinese control over strategic stretches of Central Asia led to the opening of the Silk Road, a land route that linked China by trade all the way to Rome. One of the precious goods traded, along with spices, was silk, which had been cultivated and woven in China since at least the third millennium BCE, and had been treasured in Greece and Rome since the third century BCE (see "The Silk Road during the Tang Period," page 349).

PAINTED BANNER FROM CHANGSHA The early Han dynasty marks the twilight of China's so-called mythocentric age, when people believed in a close relationship between the human and supernatural worlds. The most elaborate and best-preserved surviving painting from this time is a T-shaped silk **BANNER** that summarizes this early worldview (**FIG. 11-7**). Found in the tomb of a noblewoman on the outskirts of present-day Changsha, the banner dates from the second century BCE and is painted with scenes representing three levels of the universe—heaven, earth, and underworld—and includes a portrait of the deceased.

The heavenly realm appears at the top, in the crossbar of the T. In the upper-right corner is the sun, inhabited by a mythical crow; in the upper left, a mythical toad stands on a crescent moon. Between them is an image of the Torch Dragon, a primordial deity shown as a man with a long serpent's tail. Dragons and other celestial creatures swarm underneath him.

A gate guarded by two seated figures stands where the horizontal of heaven meets the banner's long, vertical stem. Two intertwined dragons loop through a circular jade piece known as a *bi*, itself usually a symbol of heaven, dividing this vertical segment into two areas. The portion above the *bi* represents the first stage of the heavenly realm. Here, the deceased woman and three attendants stand on a platform while two kneeling attendants welcome her. The portion beneath the *bi* represents the earthly world and the underworld. Silk draperies and a stone chime hanging from the *bi* form a canopy for the platform below. Like the bronze bells we saw earlier, stone chimes were ceremonial instruments dating from Zhou times. On the platform, ritual bronze vessels contain food and wine for the deceased, just as they did in Shang tombs. The squat, muscular man holding up the platform stands on a pair of fish whose bodies form another *bi*. The fish and the other strange creatures in this section are inhabitants of the underworld.

PHILOSOPHY AND ART

The Han dynasty marked the beginning of a new age, when the philosophical ideals of Daoism and Confucianism, formulated during the troubled times of the Eastern Zhou, became central to Chinese thought. Since this period, their influence has been continuous and fundamental.

11–7 • PAINTED BANNER
From the tomb of the Marquess of Dai, Mawangdui, Changsha, Hunan. Han dynasty, c. 160 BCE. Colors on silk, height 6′8½″ (2.05 m). Hunan Provincial Museum.

DAOISM AND NATURE Daoism emphasizes the close relationship between humans and nature. It is concerned with bringing the individual life into harmony with the Dao, or the Way, of the universe (see "Daoism," opposite). For some a secular, philosoph-

11–8 • INCENSE BURNER
From the tomb of Prince Liu Sheng, Mancheng, Hebei. Han dynasty, 113 BCE. Bronze with gold inlay, height 10½″ (26 cm). Hebei Provincial Museum, Shijiazhuang.

Technically, this exquisite work represents the ultimate development of the long and distinguished tradition of bronze casting in China.

ical path, Daoism on a popular level developed into an organized religion, absorbing many traditional folk practices and the search for immortality.

Immortality was as intriguing to Han rulers as it had been to the first emperor of Qin. Daoist adepts experimented with diet, physical exercise, and other techniques in the belief that immortal life could be achieved on earth. A popular Daoist legend, which tells of the Land of Immortals in the Eastern Sea, takes form in a bronze **INCENSE BURNER** from the tomb of Prince Liu Sheng, who died in 113 BCE (**FIG. 11–8**). Around the bowl, gold inlay outlines the stylized waves of the sea. Above them rises the mountainous island, crowded with birds, animals, and the immortals themselves, all cast in bronze with highlights of inlaid gold. This visionary world would have been shrouded in the shifting mist of incense when the burner was in use.

A CLOSER LOOK | A Reception in the Palace

Detail from a rubbing of a stone relief in the Wu family shrine (Wuliangci).
Jiaxiang, Shandong. Han dynasty, 151 CE. 27½″ × 66½″ (70 × 169 cm).

Birds and small figures, possibly alluding to mythical creatures or immortals.

Women—and an empress?—receiving visitors on the upper floor.

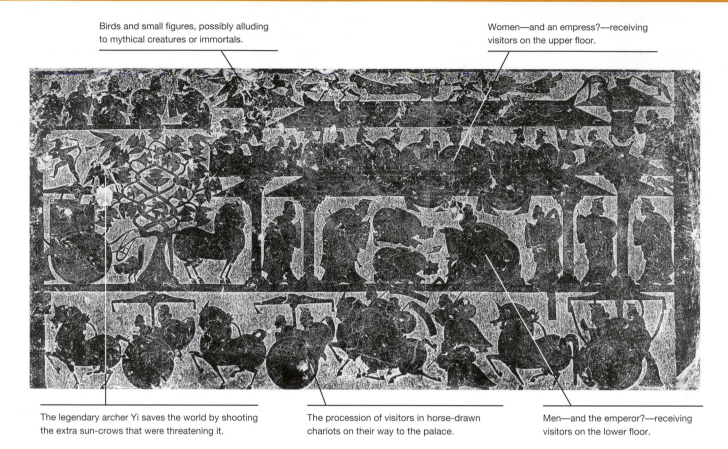

The legendary archer Yi saves the world by shooting the extra sun-crows that were threatening it.

The procession of visitors in horse-drawn chariots on their way to the palace.

Men—and the emperor?—receiving visitors on the lower floor.

View the Closer Look for A Reception in the Palace on myartslab.com

CONFUCIANISM AND THE STATE In contrast to the meta-physical focus of Daoism, Confucianism is concerned with the human world; its goal is the attainment of social harmony. To this end, it proposes a system of ethics based on reverence for ances-tors and correct relationships among people. Beginning with self-discipline in the individual, Confucianism teaches how to rectify relationships within the family, and then, in ever-widening circles, with friends and others, all the way up to the level of the emperor and the state (see "Confucius and Confucianism," page 342).

Emphasis on social order and respect for authority made Confucianism especially attractive to Han rulers, who were eager to distance themselves from the disastrous legalism of the Qin. The Han emperor Wudi (r. 141–87 BCE) made Confucianism the official imperial philosophy, and it remained the state ideology of China for more than 2,000 years, until the end of imperial rule in the twentieth century. Once institutionalized, Confucianism took on so many rituals that it eventually assumed the form and force of a religion. Han philosophers contributed to this process by infusing Confucianism with traditional Chinese cosmology.

They emphasized the Zhou idea, taken up by Confucius, that the emperor ruled by the mandate of Heaven. Heaven itself was reconceived more abstractly as the moral force underlying the universe. Thus the moral system of Confucian society became a reflection of universal order.

Confucian subjects turn up frequently in Han art. Among the most famous examples are the reliefs from the Wu family shrines built in 151 CE in Jiaxiang. Carved and engraved in low relief on stone slabs, the scenes were meant to teach Confucian themes such as respect for the emperor, filial piety, and wifely devotion. Daoist motifs also appear, as do figures from traditional myths and legends in a synchronism characteristic of Han art (see "A Closer Look," above).

When compared with the Han-dynasty banner (see FIG. 11–7), this late Han relief clearly shows the change that took place in the Chinese worldview in the span of 300 years. The banner places equal emphasis on heaven, earth, and the underworld; human beings are dwarfed by a great swarm of supernatural creatures and divine beings. In the relief in the Wu shrine, the focus is clearly

on the human realm and human behavior. The composition conveys the importance of the emperor as the holder of the mandate of Heaven and illustrates fundamental Confucian themes of social order and decorum.

ARCHITECTURE

Contemporary literary sources are eloquent on the wonders of the Han capital. Unfortunately, our only information about Han architecture is in the form of ceramic models of buildings found in tombs, where they were intended to house or support the dead in the afterlife. A particularly elaborate seven-story dwelling, connected by a third-story covered passageway to a tower (**FIG. 11-9**), was excavated in 1993 in a tomb near the village of Baizhuang in Henan Province. The entrance to the main house, flanked by towers, opens into an enclosed courtyard occupied here by a clay figure of the family dog. Pigs and oxen probably occupied the ground floor, with the second level reserved for storage. The family lived in the upper stories, where larger windows provided sufficient light and air.

11-9 • TOMB MODEL OF A HOUSE AND TOWER
From Tomb 6, Baizhuang, Henan Province. Eastern Han dynasty, 1st century CE. Painted earthenware, height of main house 6′3½″ (1.92 m); height of tower 4′2½″ (1.28 m). Henan Museum.

The main house in this ceramic model is assembled from a stack of 13 individual components. Hand-written inscriptions on several of them indicate their specific placement in the assembly process.

Aside from the multi-level construction, the most interesting feature of the house is the **bracketing** system (architectural elements projecting from the wall) that supports the rather broad eaves of its tiled roofs. Bracketing became a standard element of east Asian architecture, not only in private homes but more typically in palaces and temples (see FIG. 11-15). Another interesting aspect of the model is the elaborate painting on the exterior walls, much of it decorative but some of it illustrating structural features such as posts and lintels. Literary sources describe the walls of Han palaces as decorated with paint and lacquer, and also inlaid with precious metals and stones.

SIX DYNASTIES

With the fall of the Han in 220 CE, China splintered into three warring kingdoms. In 280 CE, the empire was briefly reunited, but invasions by nomadic peoples from central Asia, a source of disruption throughout Chinese history, soon forced the court to flee south. For the next three centuries, northern and southern China developed separately. In the north, 16 kingdoms carved out by invaders rose and fell before giving way to a succession of largely foreign dynasties. Warfare was commonplace. Tens of thousands of Chinese fled south, where six short-lived dynasties succeeded each other in an age of almost constant turmoil broadly known as the Six Dynasties period or the period of the Southern and Northern dynasties (265–589 CE).

In this chaotic context, the Confucian system lost influence. In the south especially, many intellectuals—the creators and custodians of China's high culture—turned to Daoism, which contained a strong escapist element. Educated to serve the government, they increasingly withdrew from public life. They wandered the landscape, drank, wrote poems, practiced calligraphy, and expressed their disdain for the social world through willfully eccentric behavior.

The rarefied intellectual escape route of Daoism was available only to the educated elite. Most people sought answers in the magic and superstitions of Daoism in its religious form. Though weak and disorganized, the southern courts remained centers of traditional Chinese culture, and Confucianism survived as official doctrine. Yet ultimately it was a newly arrived religion—Buddhism—that flourished in the troubled China of the Six Dynasties.

PAINTING

Although few paintings survive from the Six Dynasties, abundant literary sources describe the period as an important one for painting. Landscape, later a major theme of Chinese art, first appeared as an independent subject. Daoists wandered through China's countryside seeking spiritual refreshment, and both painters and scholars of the Six Dynasties found that wandering in the mind's eye through a painted landscape could serve the same purpose. This new emphasis on the spiritual value of painting contrasted

Confucius was born in 551 BCE in the state of Lu, roughly present-day Shandong Province, into a declining aristocratic family. While still in his teens he set his heart on becoming a scholar; by his early twenties he had begun to teach.

By this time, wars for supremacy had begun among the various states of China, and the traditional social fabric seemed to be breaking down. Looking back to the early Zhou dynasty as a sort of golden age, Confucius thought about how a just and harmonious society could again emerge. For many years he sought a ruler who would put his ideas into effect, but to no avail. Frustrated, he spent his final years teaching. After his death in 479 BCE, his conversations with his students were collected by his disciples and their followers into a book known in English as the *Analects*, which is the only record of his teaching.

At the heart of Confucian thought is the concept of *ren* (human-heartedness). *Ren* emphasizes morality and empathy as the basic standards for all human interaction. The virtue of *ren* is most fully realized in the Confucian ideal of the *junzi* (gentleman). Originally indicating noble birth, the term was redefined to mean one who through education and self-cultivation had become a superior person, right-thinking and right-acting in all situations. A *junzi* is the opposite of a petty or small-minded person. His characteristics include moderation, integrity, self-control, loyalty, reciprocity, and altruism. His primary concern is justice.

Together with human-heartedness and justice, Confucius emphasized *li* (etiquette). *Li* includes everyday manners as well as ritual, ceremony, and protocol—the formalities of all social conduct and interaction. Such forms, Confucius felt, choreographed life so that an entire society moved in harmony. *Ren* and *li* operate in the realm of the Five Constant Relationships that define Confucian society: parent and child, husband and wife, elder sibling and younger sibling, elder friend and younger friend, ruler and subject. Deference to age is clearly built into this view, as is the deference to authority that made Confucianism attractive to emperors. Yet responsibilities flow the other way as well: The duty of a ruler is to earn the loyalty of subjects, of a husband to earn the respect of his wife, of age to guide youth wisely.

During the early years of the People's Republic of China, and especially during the Great Proletarian Cultural Revolution (1966–1976), Confucius and Confucian thought were denigrated. Recently, however, Confucian temples in Beijing and elsewhere have been restored. Notably, the Chinese government has used the philosopher's name officially in establishing hundreds of Confucius Institutes in more than 80 countries, to promote the learning of the Chinese language abroad.

with the Confucian view, which had emphasized its moral and didactic usefulness.

Reflections on painting traditions also inspired the first works on theory and aesthetics. Some of the earliest and most succinct formulations of the ideals of Chinese painting are the six principles set out by the scholar Xie He (fl. c. 500–535 CE). The first two principles in particular offer valuable insight into the context in which China's painters worked.

The first principle announces that "spirit consonance" imbues a painting with "life's movement." This "spirit" is the Daoist *qi*, the breath that animates all creation, the energy that flows through all things. When a painting has *qi*, it will be alive with inner essence, not merely outward resemblance. Artists must cultivate their own spirit so that this universal energy flows through them and infuses their work. The second principle recognizes that brushstrokes are the "bones" of a picture, its primary structural

11-10 • After Gu Kaizhi **DETAIL OF ADMONITIONS OF THE IMPERIAL INSTRUCTRESS TO COURT LADIES**
Six Dynasties period or later, 5th–8th century CE. Handscroll, ink and colors on silk, 9¾" × 11'6" (24.8 × 348.2 cm). British Museum, London.

element. Traditional Chinese judge a painting above all by the quality of its brushwork. Each brushstroke is a vehicle of expression; it is through the vitality of a painter's brushwork that "spirit consonance" makes itself felt.

We can sense this attitude already in the rapid, confident brushstrokes that outline the figures of the Han banner (see FIG. 11-7) and again in the more controlled, rhythmical lines of one of the most important works associated with the Six Dynasties period, a painted scroll known as **ADMONITIONS OF THE IMPERIAL INSTRUCTRESS TO COURT LADIES**. Attributed to the painter Gu Kaizhi (344–407 CE), it alternates illustrations and text to relate seven Confucian stories of wifely virtue from Chinese history. The first illustration depicts the courage of Lady Feng (**FIG. 11-10**). An escaped circus bear rushes toward her husband, a Han emperor, who is filled with fear. Behind his throne, two female servants have turned to run away. Before him, two male attendants, themselves on the verge of panic, try to fend off the bear with spears. Only Lady Feng is calm as she rushes forward to place herself between the beast and the emperor.

The figures are drawn with a brush in a thin, even-width line, and a few outlined areas are filled with color. Facial features, especially those of the men, are carefully delineated. Movement and emotion are shown through conventions—the scarves flowing from Lady Feng's dress, indicating that she is rushing forward, and the upturned strings on both sides of the emperor's head, suggesting his fear. There is no hint of a setting; the artist's careful placement of figures creates a sense of depth.

The painting is on silk, which was typically woven in bands about 12 inches wide and up to 20 or 30 feet long. Early Chinese painters thus developed the format used here, the **handscroll**—a long, narrow, horizontal composition, compact enough to be held in the hand when rolled up. Handscrolls are intimate works, meant to be viewed by only two or three people at a time. They were not displayed completely unrolled as we commonly see them today in museums. Rather, viewers would open a scroll and savor it slowly from right to left, displaying only an arm's length at a time.

CALLIGRAPHY

The emphasis on the expressive quality and structural importance of brushstrokes finds its purest embodiment in calligraphy. The same brushes are used for both painting and calligraphy, and a relationship between them was recognized as early as Han times. In his teachings, Confucius had extolled the importance of the pursuit of knowledge and the arts. Among the visual arts, painting was felt to reflect moral concerns, while calligraphy was believed to reveal the character of the writer.

Calligraphy is regarded as one of the highest forms of artistic expression in China. For more than 2,000 years, China's literati—Confucian scholars and literary men who also served the government as officials—have been connoisseurs and practitioners of this art. During the fourth century CE, calligraphy came to full maturity. The most important practitioner of the day was Wang Xizhi

11-11 • Wang Xizhi PORTION OF A LETTER FROM THE FENG JU ALBUM
Six Dynasties period, mid 4th century CE. Ink on paper, 9¾″ × 18½″ (24.7 × 46.8 cm). National Palace Museum, Taibei, Taiwan, Republic of China.

The stamped characters that appear on Chinese artworks are seals—personal emblems. The use of seals dates from the Zhou dynasty, and to this day such seals traditionally employ the archaic characters, known appropriately as "seal script," of the Zhou or Qin. Cut in stone, a seal may state a formal, given name, or it may state any of the numerous personal names that China's painters and writers adopted throughout their lives. A treasured work of art often bears not only the seal of its maker, but also those of collectors and admirers through the centuries. In the Chinese view, these do not disfigure the work but add another layer of interest. This sample of Wang Xizhi's calligraphy, for example, bears the seals of two Song-dynasty emperors, a Song official, a famous collector of the sixteenth century, and two Qing-dynasty emperors of the eighteenth and nineteenth centuries.

(c. 307–365), whose works have served as models of excellence for subsequent generations. The example here comes from a letter, now somewhat damaged and mounted as part of an album, known as **FENG JU** (**FIG. 11-11**).

Feng Ju is an example of "running" or semicursive style, neither too formal nor too free but with a relaxed, easygoing manner. Brushstrokes vary in width and length, creating rhythmic vitality. Individual characters remain distinct, yet within each character the strokes are connected and simplified as the brush moves from one to the other without lifting off the page. The effect is fluid and graceful, yet strong and dynamic. Wang Xizhi's running style came to be officially accepted and learned along with other script styles by those who practiced this art.

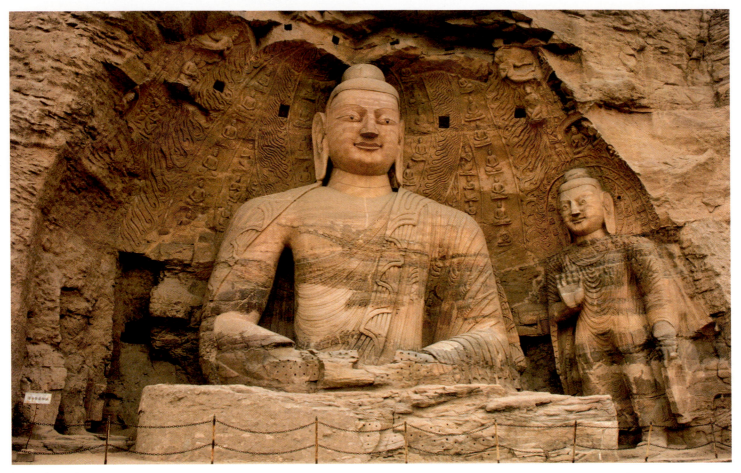

11–12 • SEATED BUDDHA, CAVE 20, YUNGANG
Datong, Shanxi. Northern Wei dynasty, c. 460. Stone, height 45′ (13.7 m).

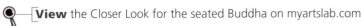 **View** the Closer Look for the seated Buddha on myartslab.com

BUDDHIST ART AND ARCHITECTURE

Buddhism originated in India during the fifth century BCE (see Chapter 10), then gradually spread north into central Asia. With the opening of the Silk Road during the Han dynasty, its influence reached China. To the Chinese of the Six Dynasties, beset by constant warfare and social devastation, Buddhism offered consolation in life and the promise of salvation after death. The faith spread throughout the country across all social levels, first in the north, where many of the invaders promoted it as the official religion, then slightly later in the south, where it found its first great patron in the emperor Liang Wu Di (r. 502–549 CE). Thousands of temples and monasteries were built; many became monks and nuns.

Almost nothing remains in China of the Buddhist architecture of the Six Dynasties, but we can see what it must have looked like in the Japanese Horyuji Temple (see FIG. 12–4), which was based on Chinese models of this period.

ROCK-CUT CAVES OF THE SILK ROAD The most impressive works of Buddhist art surviving from the Six Dynasties are the hundreds of northern rock-cut caves along the trade routes between Xinjiang in Central Asia and the Yellow River Valley.

Both the caves and the sculptures that fill them were carved from the solid rock of the cliffs. Small caves high above the ground were retreats for monks and pilgrims, while larger caves at the base of the cliffs were wayside shrines and temples.

The caves at Yungang, in Shanxi Province in central China, contain many examples of the earliest phase of Buddhist sculpture in China, including the monumental **SEATED BUDDHA** in Cave 20 (**FIG. 11–12**). The figure was carved in the latter part of the fifth century by the imperial decree of a ruler of the Northern Wei dynasty (386–534 CE), the longest-lived and most stable of the northern kingdoms. Most Wei rulers were avid patrons of Buddhism, and under their rule the religion made its greatest advances in the north.

The front part of the cave has crumbled away, and the 45-foot statue, now exposed to the open air, is clearly visible from a distance. The elongated ears, protuberance on the head (*ushnisha*), and monk's robe are traditional attributes of the Buddha. The masklike face, full torso, massive shoulders, and shallow, stylized drapery indicate strong Central Asian influence. The overall effect of this colossus is remote and austere, less human than the more sensuous expression of the early Buddhist traditions in India.

SUI AND TANG DYNASTIES

In 581 CE, a general from the last of the northern dynasties replaced a child emperor and established a dynasty of his own, the Sui. Defeating all opposition, he molded China into a centralized empire as it had been in Han times. The short-lived Sui dynasty fell in 618, but, in reunifying the empire, paved the way for one of the greatest dynasties in Chinese history: the Tang (618–907). Even today many Chinese living abroad still call themselves "Tang people." To them, Tang implies that part of the Chinese character that is strong and vigorous (especially in military power), noble and idealistic, but also realistic and pragmatic.

BUDDHIST ART AND ARCHITECTURE

The new Sui emperor was a devout Buddhist, and his reunification of China coincided with a fusion of the several styles of

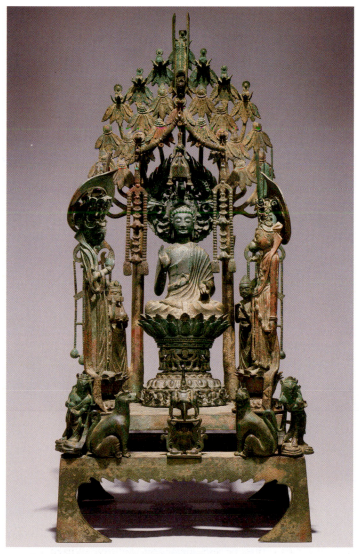

11-13 • ALTAR TO AMITABHA BUDDHA
Sui dynasty, 593. Bronze, height 30⅛″ (76.5 cm). Museum of Fine Arts, Boston. Gift of Mrs. W. Scott Fitz (22.407) and Gift of Edward Holmes Jackson in memory of his mother, Mrs. W. Scott Fitz (47.1407–1412)

Buddhist sculpture that had developed. This new style is seen in a bronze **ALTAR TO AMITABHA BUDDHA** (FIG. 11-13), one of the many Buddhas of Mahayana Buddhism. Amitabha dwelled in the Western Pure Land, a paradise into which his faithful followers were promised rebirth. With its comparatively simple message of salvation, the Pure Land sect eventually became the most popular form of Buddhism in China and one of the most popular in Japan (see Chapter 12).

The altar depicts Amitabha in his paradise, seated on a lotus throne beneath a canopy of trees. Each leaf cluster is set with jewels. Seven celestial figures sit on the topmost clusters, and ropes of "pearls" hang from the tree trunks. Behind Amitabha's head is a halo of flames. To his left, the bodhisattva, a being close to enlightenment but who voluntarily remains on earth to help others achieve this goal, Guanyin holds a pomegranate; to his right, another bodhisattva clasps his hands in prayer. Behind are four disciples who first preached the teachings of the Buddha. On the lower level, an incense burner is flanked by seated lions and two smaller bodhisattvas. Focusing on Amitabha's benign expression and filled with objects symbolizing his power, the altar combines the sensuality of Indian styles, the schematic abstraction of central Asian art, and the Chinese emphasis on linear grace and rhythm into a harmonious new style.

Buddhism reached its greatest development in China during the subsequent Tang dynasty, which for nearly three centuries ruled China and controlled much of Central Asia. From emperors and empresses to common peasants, virtually the entire country adopted the Buddhist faith. A Tang vision of the most popular sect, Pure Land, was expressed in a wall painting from a cave in Dunhuang (FIG. 11-14). A major stop along the Silk Road, Dunhuang has nearly 500 caves carved into its sandy cliffs, all filled with painted clay sculpture and decorated with wall paintings from floor to ceiling. The site was worked on continuously from the fourth to the fourteenth century, a period of almost 1,000 years. In the detail shown here, a seated Amitabha Buddha appears at center, flanked by four bodhisattvas, his messengers to the world. Two other groups of bodhisattvas are clustered at right and left. Great halls and towers rise in the background, representing the Western Paradise in terms of the grandeur of Tang palaces. Indeed, the aura of opulence could just as easily be that of the imperial court. This worldly vision of paradise, recorded with great attention to detail in the architectural setting, provides our best indication of the splendor of Tang civilization at a time when Chang'an (present-day Xi'an) was probably the greatest city in the world.

The early Tang emperors proclaimed a policy of religious tolerance, but during the ninth century a conservative reaction developed. Confucianism was reasserted and Buddhism was briefly suppressed as a "foreign" religion. Thousands of temples, shrines, and monasteries were destroyed and innumerable bronze statues melted down. Fortunately, several Buddhist structures do survive from the Tang dynasty. One of them, the Nanchan Temple, is the earliest important surviving example of Chinese architecture.

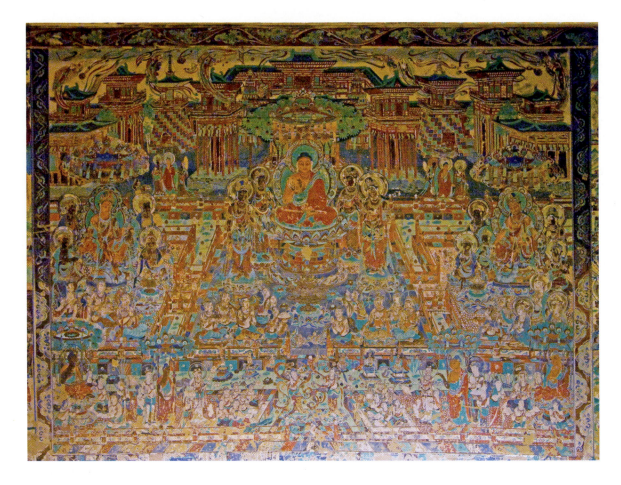

11–14 • THE WESTERN PARADISE OF AMITABHA BUDDHA
Detail of a wall painting in Cave 217, Dunhuang, Gansu. Tang dynasty, c. 750. 10′2″ × 16′ (3.1 × 4.86 m).

NANCHAN TEMPLE The Nanchan Temple shows characteristics of both temples and palaces of the Tang dynasty (**FIG. 11–15**). Located on Mount Wutai (Wutaishan) in the eastern part of Shanxi Province, this small hall was constructed in 782. The tiled roof, seen earlier in the Han tomb model (see FIG. 11–9), has taken on a curved silhouette. Quite subtle here, this curve became increasingly pronounced in later centuries. The very broad overhanging eaves are supported by a correspondingly elaborate bracketing system.

Also typical is the bay system of construction, in which a cubic unit of space, a bay, is formed by four posts and their lintels. The bay functioned in Chinese architecture as a **module**, a basic unit of construction. To create larger structures, an architect multiplied the number of bays. Thus, though modest in scope with only three

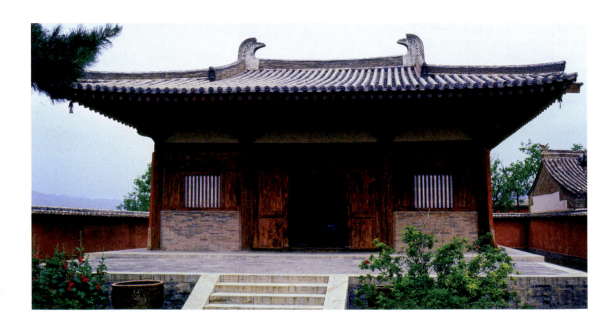

11–15 • NANCHAN TEMPLE, WUTAISHAN
Shanxi. Tang dynasty, 782.

bays, the Nanchan Temple still gives an idea of the vast, multi-storied palaces of the Tang depicted in such paintings as FIGURE 11–14.

GREAT WILD GOOSE PAGODA The Great Wild Goose Pagoda of the Ci'en Temple in the Tang capital of Chang'an also survives (**FIG. 11–16**). The temple, constructed in 645 for the famous monk Xuanzang (600–664) on his return from a 16-year pilgrimage to India, was where he taught and translated the Sanskrit Buddhist scriptures he had brought back with him.

Pagodas—towers associated with East Asian Buddhist temples—originated in the Indian Buddhist stupa, the elaborate burial mound that housed relics of the Buddha (see "Pagodas," page 351). In China this form blended with a traditional Han watchtower to produce the pagoda. Built entirely in brick, the Great Wild Goose Pagoda nevertheless imitates the wooden architecture of the time. The walls are decorated in low relief to resemble bays, and bracket systems are reproduced under the projecting roofs of each story. Although modified and repaired in later times (its seven stories were originally five, and a new finial has been added), the pagoda still preserves the essence of Tang architecture in its simplicity, symmetry, proportions, and grace.

FIGURE PAINTING

Later artists looking back on their heritage recognized the Tang dynasty as China's great age of figure painting. Unfortunately, very few Tang **scroll paintings** still exist. The wall paintings of Dunhuang (see FIG. 11–14) give us some idea of the character of Tang figure painting, and we can look at copies of lost Tang paintings made by later, Song-dynasty artists. **LADIES PREPARING NEWLY WOVEN SILK** is an outstanding example of such copies, this one attributed to Huizong (r. 1101–1126 CE), the last emperor of the Northern Song dynasty (**FIG. 11–17**). An inscription on the scroll identifies the Tang original as a famous work by

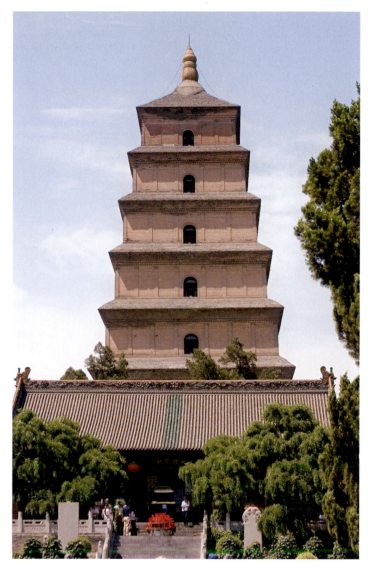

11–16 • GREAT WILD GOOSE PAGODA AT CI'EN TEMPLE, CHANG'AN
Shanxi. Tang dynasty, first erected 645; rebuilt mid 8th century CE.

11–17 • Attributed to Emperor Huizong
DETAIL OF LADIES PREPARING NEWLY WOVEN SILK
Copy after a lost Tang-dynasty painting by Zhang Xuan. Northern Song dynasty, early 12th century CE. Handscroll with ink and colors on silk, 14½″ × 57½″ (36 × 145.3 cm). Museum of Fine Arts, Boston.
Chinese and Japanese Special Fund (12.886)

Confucius said of himself, "I merely transmit, I do not create; I love and revere the ancients." In this spirit, Chinese painters regularly copied paintings of earlier masters. Painters made copies both to absorb the lessons of their great predecessors and to perpetuate the achievements of the past. In later centuries, they took up the practice of regularly executing a work "in the manner of" some particularly revered ancient master. This was at once an act of homage, a declaration of artistic allegiance, and a way of reinforcing a personal connection with the past.

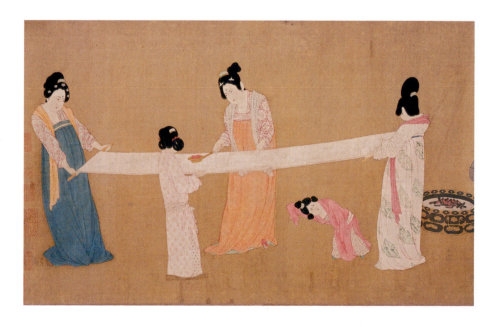

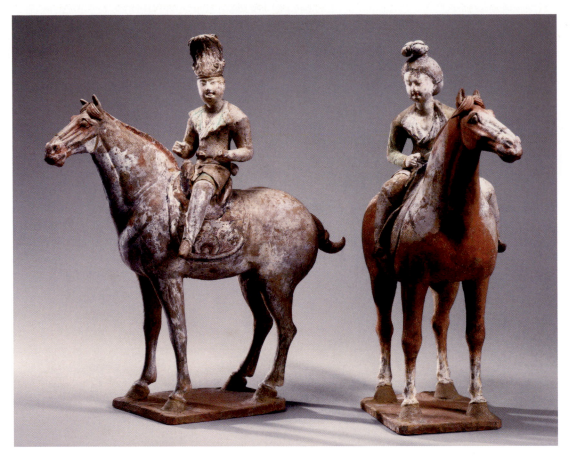

11–18 • TWO EQUESTRIAN FIGURES
Tang dynasty, first half of 8th century CE. Molded, reddish-buff earthenware with cold-painted pigments over white ground, height (male figure) 14½″ (37 cm). Arthur M. Sackler Museum, Harvard Art Museum, Cambridge, Massachusetts. Gift of Anthony M. Solomon (2003.207.1-2)

This pair documents the lively participation of women as well as men in sport and riding. Both have pointed boots and are mounted on a standing saddled and bridled horse; their hands are positioned to hold the reins. The male figure wears a tall, elaborately embellished hat, and the female figure has her hair arranged in a topknot.

Zhang Xuan, an eighth-century painter known for his depictions of women at the Tang court. Since the original no longer exists, we cannot know how faithful the copy is, but its refined lines and bright colors seem to share the grace and dignity of Tang sculpture and architecture.

Two earthenware **EQUESTRIAN FIGURES** (**FIG. 11–18**), a man and a woman, made for use as tomb furnishings, reveal more directly the robust naturalism and exuberance of figural representation during the Tang period. Accurate in proportion and lively in demeanor, the statuettes are not glazed (as is the tomb figure in FIGURE 11–19) but are "cold-painted" using pigments after firing to render details of costume and facial features.

SONG DYNASTY

A brief period of disintegration followed the fall of the Tang, but eventually China was again united, this time under the Song dynasty (960–1279). A new capital was founded at Bianjing (present-day Kaifeng), near the Yellow River. In contrast to the outgoing confidence of the Tang, the mood during the Song was more introspective, a reflection of China's weakened military situation. In 1126, the Jurchen tribes of Manchuria invaded China, sacked the capital, and took possession of much of the northern part of the country. Song forces withdrew south and established a new capital at Hangzhou. From this point on, the dynasty is known as the Southern Song (1127–1179), with the first portion called in retrospect the Northern Song (960–1126).

Although China's territory had diminished, its wealth had increased because of advances in agriculture, commerce, and technology begun under the Tang. Patronage was plentiful, and the arts flourished. Song culture is noted for its refined taste and intellectual grandeur. Where the Tang had reveled in exoticism, eagerly absorbing influences from Persia, India, and Central Asia, Song culture was more self-consciously Chinese. Philosophy experienced its most creative era since the "one hundred schools" of the Zhou. Song scholarship was brilliant, especially in history, and its poetry is noted for its depth. Perhaps the finest expressions of the Song, however, are in art, especially painting and ceramics.

Under a series of ambitious and forceful Tang emperors, Chinese control once again extended over Central Asia. Goods, ideas, and influence flowed along the Silk Road. In the South China Sea, Arab and Persian ships carried on a lively trade with coastal cities. Chinese cultural influence in east Asia was so important that Japan and Korea sent thousands of students to study Chinese civilization.

Cosmopolitan and tolerant, Tang China was confident and curious about the world. Many foreigners came to the splendid new capital Chang'an (present-day Xi'an), and they are often depicted in the art of the period. A ceramic statue of a camel carrying a troupe of musicians (FIG. 11–19) reflects the Tang fascination with the "exotic" Turkic cultures of Central Asia. The three bearded musicians (one with his back to us) are Central Asian, while the two smooth-shaven ones are Han Chinese. Bactrian, or two-humped, camels, themselves exotic Central Asian "visitors," were beasts of burden in the caravans that traversed the Silk Road. The stringed lute (which the Chinese called the *pipa*) came from Central Asia to become a lasting part of Chinese music.

Stylistically, the statue reveals a new interest in naturalism, an important trend in both painting and sculpture. Compared with the rigid, staring ceramic soldiers of the first emperor of Qin, this Tang band is alive with gesture and expression. The majestic camel throws its head back; the musicians are vividly captured in mid-performance. Ceramic figurines such as this, produced by the thousands for Tang tombs, offer glimpses into the gorgeous variety of Tang life. The statue's three-color glaze technique was a specialty of Tang ceramicists. The glazes— usually chosen from a restricted palette of amber-yellow, green, and blue—were splashed freely and allowed to run over the surface during firing to convey a feeling of spontaneity. The technique is emblematic of Tang culture itself in its robust, colorful, and cosmopolitan expressiveness.

The Silk Road had first flourished in the second century CE. A 5,000-mile network of caravan routes from the Han capital (near present-day Luoyang, Henan, on the Yellow River) to Rome, it brought Chinese luxury goods to Western markets.

The journey began at the Jade Gate (Yumen) at the westernmost end of the Great Wall, where Chinese merchants turned their goods over to Central Asian traders. Goods would change hands many more times before reaching the Mediterranean. Caravans headed first for the nearby desert oasis of Dunhuang. Here northern and southern routes diverged to skirt the vast Taklamakan Desert. At Khotan,

in western China, farther west than the area shown in MAP 11–1, travelers on the southern route could turn off toward a mountain pass into Kashmir, in northern India. Or they could continue on, meeting up with the northern route at Kashgar, on the western border of the Taklamakan, before proceeding over the Pamir Mountains into present-day Afghanistan. From there, travelers could head toward present-day Pakistan and India, or travel west through present-day Uzbekistan, Iran, and Iraq, arriving finally at Antioch, in Syria, on the coast of the Mediterranean. After that, land and sea routes led to Rome.

11–19 • CAMEL CARRYING A GROUP OF MUSICIANS

From a tomb near Xi'an, Shanxi. Tang dynasty, c. mid 8th century CE. Earthenware with three-color glazes, height 26⅛" (66.5 cm). National Museum, Beijing.

SEATED GUANYIN BODHISATTVA No hint of political disruption or religious questioning intrudes on the sublime grace and beauty of this **SEATED GUANYIN BODHISATTVA** (**FIG. 11–20**), carved from wood in the eleventh or twelfth century in a territory on the northern border of Song China, a region ruled by the Liao dynasty (907–1125). Bodhisattvas are represented as young princes wearing royal garments and jewelry, their finery indicative of their worldly but virtuous lives. Guanyin is the Bodhisattva of Infinite Compassion, who appears in many guises, in this case as the Water and Moon Guanyin. He sits on rocks by the sea, in the position known as royal ease. His right arm rests on his raised and bent right knee and his left arm and foot hang down, the foot touching a lotus blossom.

PHILOSOPHY: NEO-CONFUCIANISM Song philosophers continued the process, begun during the Tang, of restoring Confucianism to dominance. In strengthening Confucian thought, they drew on Daoist and especially Buddhist ideas, even as they openly rejected Buddhism itself as foreign. These innovations provided Confucianism with a new metaphysical aspect, allowing it

11–20 • SEATED GUANYIN BODHISATTVA
Liao dynasty, 11th–12th century CE (the painting and gilding were restored in the 16th century). Wood with paint and gold, 95″ × 65″ (241.3 × 165.1 cm). The Nelson-Atkins Museum of Art, Kansas City, Missouri. Purchase, William Rockhill Nelson Trust (34–10)

Pagodas developed from Indian stupas as Buddhism spread northeast along the Silk Road. Stupas merged with the watchtowers of Han-dynasty China in multi-storied stone or wood structures with projecting tiled roofs. This transformation culminated in wooden pagodas with upward-curving roofs supported by elaborate bracketing in China, Korea, and Japan. Buddhist pagodas retain the axis mundi masts of stupas. Like their South Asian prototypes, early East Asian pagodas were symbolic rather than enclosing structures. Later examples often provided access to the ground floor and sometimes to upper levels.

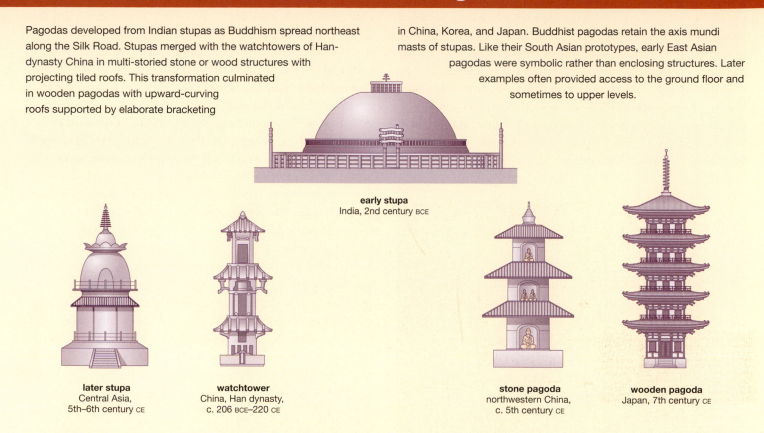

early stupa
India, 2nd century BCE

later stupa
Central Asia,
5th–6th century CE

watchtower
China, Han dynasty,
c. 206 BCE–220 CE

stone pagoda
northwestern China,
c. 5th century CE

wooden pagoda
Japan, 7th century CE

Watch an architectural simulation about pagodas on myartslab.com

to propose a richer, all-embracing explanation of the universe. This new synthesis of China's three main paths of thought is called Neo-Confucianism.

Neo-Confucianism teaches that the universe consists of two interacting forces known as *li* (principle or idea) and *qi* (matter). All pine trees, for example, consist of an underlying *li* we might call "Pine Tree Idea" brought into the material world through *qi*. All the *li* of the universe, including humans, are but aspects of an eternal first principle known as the Great Ultimate (*taiji*), which is completely present in every object. Our task as human beings is to rid our *qi* of impurities through education and self-cultivation so that our *li* may realize its oneness with the Great Ultimate. This lifelong process resembles the striving to attain buddhahood, and, if we persist in our attempts, one day we will be enlightened—the term itself comes directly from Buddhism.

NORTHERN SONG PAINTING

Neo-Confucian ideas found visual expression in art, especially in landscape, which became the most highly esteemed subject for painting. Northern Song artists studied nature closely to master its many appearances: the way each species of tree grows; the distinctive character of each rock formation; the changes of the seasons; the myriad birds, blossoms, and insects. This passion for descriptive detail was the artist's form of self-cultivation; mastering outward forms showed an understanding of the principles behind them.

Yet despite the convincing accumulation of detail, Song landscape paintings do not record a specific site. The artist's goal was to paint the eternal essence of "mountain-ness," for example, not to reproduce the appearance of a particular mountain. Painting landscapes required artists to orchestrate their cumulative understanding of *li* in all its aspects—mountains and rocks, streams and waterfalls, trees and grasses, clouds and mist. A landscape painting thus expressed the desire for the spiritual communion with nature that was the key to enlightenment. As the tradition progressed, landscape also became a vehicle for conveying human emotions, even for speaking indirectly of one's own deepest feelings.

In the earliest times, art had reflected the mythocentric world-view of the ancient Chinese. Later, as religion came to dominate people's lives, the focus of art shifted, and religious images and human actions became important subjects. Subsequently, during the Song dynasty, artists developed landscape as the chief means of expression, preferring to avoid direct depiction of the human condition and to convey ideals in a symbolic manner. Chinese artistic expression thus moved from the mythical, through the religious and ethical, and finally to the philosophical and aesthetic.

11-21 • Fan Kuan TRAVELERS AMONG MOUNTAINS AND STREAMS
Northern Song dynasty, early 11th century CE. Hanging scroll with ink and colors on silk, height 6′9½″ (2.06 m). National Palace Museum, Taibei, Taiwan, Republic of China.

FAN KUAN One of the first great masters of Song landscape was the eleventh-century painter Fan Kuan (active c. 990–1030 CE), whose surviving major work, **TRAVELERS AMONG MOUNTAINS AND STREAMS**, is regarded as one of the great monuments of Chinese art (**FIG. 11-21**). The work is physically large—almost 7 feet high—but the sense of monumentality also

radiates from the composition itself, which makes its impression even when much reduced.

The composition unfolds in three stages, comparable to three acts of a drama. At the bottom a large, low-lying group of rocks, taking up about one-eighth of the picture surface, establishes the extreme foreground. The rest of the landscape pushes back from this point. In anticipating the shape and substance of the mountains to come, the rocks introduce the main theme of the work, much as the first act of a drama introduces the principal characters. In the middle ground, travelers and their mules are coming from the right. Their size confirms our human scale—how small we are, how vast is nature. This middle ground takes up twice as much picture surface as the foreground, and, like the second act of a play, shows variation and development. Instead of a solid mass, the rocks here are separated into two groups by a waterfall that is spanned by a bridge. In the hills to the right, the rooftops of a temple stand out above the trees.

Mist veils the transition to the background, with the result that the mountain looms suddenly. This background area, almost twice as large as the foreground and middle ground combined, is the climactic third act of the drama. As our eyes begin their ascent, the mountain solidifies. Its ponderous weight increases as it billows upward, finally bursting into the sprays of energetic brushstrokes that describe the scrubby growth on top. To the right, a slender waterfall plummets, not to balance the powerful upward thrust of the mountain but simply to enhance it by contrast. The whole painting, then, conveys the feeling of climbing a high mountain, leaving the human world behind to come face to face with the Great Ultimate in a spiritual communion.

All the elements are depicted with precise detail and in proper scale. Jagged brushstrokes describe the contours of rocks and trees and express their rugged character. Layers of short, staccato strokes (translated as "raindrop texture" from the Chinese) accurately mimic the texture of the rock surface. Spatial recession from foreground through middle ground to background is logically and convincingly handled.

Although it contains realistic details, the landscape represents no specific place. In its forms, the artist expresses the ideal forms behind appearances; in the rational, ordered composition, he expresses the intelligence of the universe. The arrangement of the mountains, with the central peak flanked by lesser peaks on each side, seems to reflect both the ancient Confucian notion of social hierarchy, with the emperor flanked by his ministers, and the Buddhist motif of the Buddha with bodhisattvas at his side. The landscape, a view of nature uncorrupted by human habitation, expresses a kind of Daoist ideal. Thus we find the three strains of Chinese thought united, much as they are in Neo-Confucianism itself.

The ability of Chinese landscape painters to take us out of ourselves and to let us wander freely through their sites is closely linked to the avoidance of perspective as it is understood in the West. Fifteenth-century European painters, searching for fidelity to

11–22 • Xu Daoning SECTION OF FISHING IN A MOUNTAIN STREAM
Northern Song dynasty, mid 11th century CE. Handscroll with ink on silk, 19″ × 6′10″ (48.9 cm × 2.09 m).
The Nelson-Atkins Museum of Art, Kansas City, Missouri. Purchase, William Rockhill Nelson Trust (33–1559)

appearances, developed a scientific system for recording exactly the view that could be seen from a single, stable vantage point. The goal of Chinese painting is precisely to avoid such limits and show a totality beyond what we are normally given to see. If the ideal for centuries of Western painters was to render what can be seen from a fixed viewpoint, that of Chinese artists was to reveal nature through a distant, all-seeing, and mobile viewpoint.

XU DAONING This sense of shifting perspective is clearest in the handscroll, where our vantage point changes constantly as we move through the painting. One of the finest handscrolls to survive from the Northern Song is **FISHING IN A MOUNTAIN STREAM** (**FIG. 11-22**), a painting executed in the middle of the eleventh century by Xu Daoning (c. 970–c. 1052). Starting from a thatched hut in the right foreground, we follow a path that leads to a broad, open view of a deep vista dissolving into distant mists and mountain peaks. (Remember that viewers observed only a small section of the scroll at a time. To mimic this effect, use two pieces of paper to frame a small viewing area, then move them slowly leftward.) Crossing over a small footbridge, we are brought back to the foreground with the beginning of a central group of high mountains that show extraordinary shapes. Again our path winds back along the bank, and we have a spectacular view of the highest peaks from another small footbridge the artist has placed for us. At the far side of the bridge, we find ourselves looking up into a deep valley, where a stream lures our eyes far into the distance. We can imagine ourselves resting for a moment in the small pavilion halfway up the valley on the right. Or perhaps we may spend some time with the fishers in their boats as the valley gives way to a second, smaller group of mountains, serving both as an echo of the spectacular central group and as a transition to the painting's finale, a broad, open vista. As we cross the bridge here, we meet travelers coming toward us who will have our experience in reverse. Gazing out into the distance and reflecting on our journey, we again feel that sense of communion with nature that is the goal of Chinese artistic expression.

Such handscrolls have no counterpart in the Western visual arts and are often compared instead to the tradition of Western

music, especially symphonic compositions. Both are generated from opening motifs that are developed and varied, both are revealed over time, and in both our sense of the overall structure relies on memory, for we do not see the scroll or hear the composition all at once.

ZHANG ZEDUAN The Northern Song fascination with precision extended to details within landscape. The emperor Huizong, whose copy of *Ladies Preparing Newly Woven Silk* was seen in FIGURE 11–17, gathered around himself a group of court painters who shared his passion for quiet, exquisitely detailed, delicately colored paintings of birds and flowers. Other painters specialized in domestic and wild animals, still others in palaces and buildings. One of the most spectacular products of this passion for observation is **SPRING FESTIVAL ON THE RIVER**, a long handscroll painted in the late eleventh or early twelfth century by Zhang Zeduan, an artist connected to the court (**FIG. 11-23**). Beyond its considerable visual delights, the painting is also a valuable record of daily life in the Song capital.

The painting depicts a festival day when local inhabitants and visitors from the countryside thronged the streets. One high point is the scene reproduced here, which takes place at the Rainbow Bridge. The large boat to the right is probably bringing goods from the southern part of China up the Grand Canal that ran through the city at that time. The sailors are preparing to pass beneath the bridge by lowering the sail and taking down the mast. Excited figures on ship and shore gesture wildly, shouting orders and advice, while a noisy crowd gathers at the bridge railing to watch. Stalls on the bridge are selling food and other merchandise; wine shops and eating places line the banks of the canal. Everyone is on the move. Some people are busy carrying goods, some are shopping, some are simply enjoying themselves. Each figure is splendidly animated and full of purpose; the depiction of buildings and boats is highly detailed, almost encyclopedic.

Little is known about the painter Zhang Zeduan other than that he was a member of the scholar-official class, the highly educated elite of imperial China. His painting demonstrates skill in the fine-line architectural drawing called *jiehua* ("ruled-line") painting.

11–23 • Zhang Zeduan SECTION OF SPRING FESTIVAL ON THE RIVER
Northern Song dynasty, late 11th–early 12th century CE. Handscroll with ink and colors on silk,
9½″ × 7′4″ (24.8 cm × 2.28 m). The Palace Museum, Beijing.

Interestingly, some of Zhang Zeduan's peers were already begin-ning to cultivate quite a different attitude toward painting as a form of artistic expression, one that placed overt display of technical skill at the lowest end of the scale of values. This emerging scholarly aesthetic, developed by China's literati, later came to dominate Chinese thinking about art.

SOUTHERN SONG PAINTING AND CERAMICS

Landscape painting took a very different course after the fall of the north to the Jurchen in 1127, and the removal of the court to its new southern capital in Hangzhou.

XIA GUI A new sensibility is reflected in the extant portion of **TWELVE VIEWS OF LANDSCAPE** (**FIG. 11-24**) by Xia Gui (fl. c. 1195–1235), a member of the newly established Academy of Painters. In general, academy members continued to favor such subjects as birds and flowers in the highly refined, elegantly colored court style patronized earlier by Huizong (see **FIG. 11-17**). Xia Gui, however, was interested in landscape and cultivated his own style. Only the last four of the 12 views that originally made

up this long handscroll have survived, but they are enough to illustrate the unique quality of his approach.

In contrast to the majestic, austere landscapes of the Northern Song painters, Xia Gui presents an intimate and lyrical view of nature. Subtly modulated, carefully controlled ink washes evoke a landscape veiled in mist, while a few deft brushstrokes suffice to indicate the details showing through the mist—the grasses grow-ing by the bank, the fishers at their work, the trees laden with moisture, the two bent-backed figures carrying their heavy loads along the path that skirts the hill. Simplified forms, stark contrasts of light and dark, asymmetrical composition, and great expanses of blank space suggest a fleeting world that can be captured only in glimpses. The intangible has more presence than the tangible. By limiting himself to a few essential details, the painter evokes a deep feeling for what lies beyond.

This development in Song painting from the rational and intellectual to the emotional and intuitive, from the tangible to the intangible, had a parallel in philosophy. During the late twelfth century, a new school of Neo-Confucianism called School of the Mind insisted that self-cultivation could be achieved through

11–24 • Xia Gui SECTION OF TWELVE VIEWS OF LANDSCAPE
Southern Song dynasty, early 13th century CE. Handscroll with ink on silk, height 11″ (28 cm); length of extant portion 7′7½″ (2.31 m). The Nelson-Atkins Museum of Art, Kansas City, Missouri. Purchase, William Rockhill Nelson Trust (32–159/2)

contemplation, which might lead to sudden enlightenment. The idea of sudden enlightenment may have come from Chan Buddhism, better known in the West by its Japanese name, Zen. Chan Buddhists rejected formal paths to enlightenment such as scripture, knowledge, and ritual, in favor of meditation and techniques designed to "short-circuit" the rational mind. Xia Gui's painting seems to suggest this intuitive approach.

The subtle and sophisticated paintings of the Song were created for a highly cultivated audience who were equally discerning in other arts such as ceramics. Building on the considerable accomplishments of the Tang, Song potters achieved a technical and aesthetic perfection that has made their wares models of excellence throughout the world. Like their painter contemporaries, Song potters turned away from the exuberance of Tang styles to create more quietly beautiful pieces.

GUAN WARE Among the most prized of the many types of Song ceramics is Guan ware, made mainly for imperial use (**FIG. 11-25**). The everted lip, high neck, and rounded body of this simple vessel show a strong sense of harmony. Enhanced by a lustrous grayish-blue glaze, the form flows without break from base to lip, evoking an introspective quality as eloquent as the blank spaces in Xia Gui's painting. The aesthetic of the Song is most evident in the crackle pattern on the glazed surface. The crackle technique was probably discovered accidentally, but came to be used deliberately in some of the most refined Song wares. In the play of irregular, spontaneous crackles over a perfectly regular, perfectly planned form we can sense the same spirit that hovers behind the self-effacing virtuosity and freely intuitive insights of Xia Gui's landscape.

In 1279 the Southern Song dynasty fell to the conquering forces of the Mongol leader Kublai Khan (1215–1294). China was subsumed into the vast Mongol empire. Mongol rulers founded the Yuan dynasty (1279–1368), setting up their capital in the northeast in what is now Beijing. Yet the cultural center of China remained in the south, in the cities that rose to prominence during the Song, especially Hangzhou. This separation of political and cultural centers, coupled with a lasting resentment toward "barbarian" rule, created the climate for later developments in Chinese art.

11-25 • GUAN WARE VESSEL
Southern Song dynasty, 13th century CE. Gray stoneware with crackled grayish-blue glaze, height 6⅝″ (16.8 cm). Percival David Foundation of Chinese Art, British Museum, London.

👁 **Watch** a video about the process of ceramic making on myartslab.com

THE ARTS OF KOREA

Set between China and Japan, Korea occupies a peninsula in northeast Asia. Inhabited for millennia, the peninsula gave rise to a distinctively Korean culture during the Three Kingdoms period.

THE THREE KINGDOMS PERIOD

Traditionally dated 57 BCE–668 CE, the Three Kingdoms period saw the establishment of three independent nation-states: Silla in the southeast, Baekje in the southwest, and Goguryeo in the north. Large tomb mounds built during the fifth and sixth centuries are enduring monuments of this period.

A GOLD HEADDRESS The most spectacular items recovered from these tombs are trappings of royal authority (**FIG. 11-26**). Made expressly for burial, this elaborate crown was assembled from cut pieces of thin gold sheet, held together by gold wire.

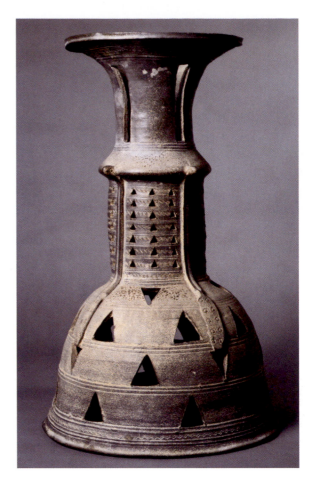

11-27 • CEREMONIAL STAND WITH SNAKE, ABSTRACT, AND OPENWORK DECORATION
Reportedly recovered in Andong, North Gyeongsang Province, Korea. Three Kingdoms period, Silla kingdom, 5th–6th century CE. Gray stoneware with combed, stamped, applied, and openwork decoration and with traces of natural ash glaze, height 23⅛″ (58.7 cm). Arthur M. Sackler Museum, Harvard University, Cambridge, Massachusetts. Partial gift of Maria C. Henderson and partial purchase through the Ernest B. and Helen Pratt Dane Fund for the Acquisition of Oriental Art (1991.501)

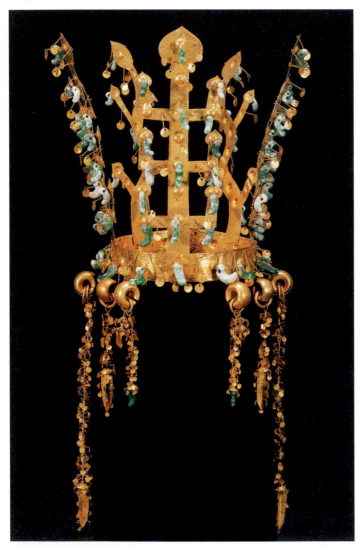

11-26 • CROWN
From the Gold Crown Tomb, Gyeongju, North Gyeongsang Province, Korea. Three Kingdoms period, Silla kingdom, probably 6th century CE. Gold with jadeite ornaments, height 17½″ (44.5 cm). National Museum of Korea, Seoul, Republic of Korea.

Spangles of gold embellish the crown, as do comma-shaped ornaments of green and white jadeite—a form of jade mineralogically distinct from the nephrite prized by the early Chinese. The tall, branching forms rising from the crown's periphery resemble trees and antlers. Within the crown is a conical cap woven of narrow strips of sheet gold and ornamented with appendages that suggest wings or feathers.

HIGH-FIRED CERAMICS The tombs have also yielded ceramics in abundance. Most are containers for offerings of food placed in the tomb to nourish the spirit of the deceased. These items generally are of unglazed stoneware, a high-fired ceramic that is impervious to liquids, even without glaze.

The most imposing ceramic shapes are tall **STANDS** (**FIG. 11-27**), typically designed as a long, cylindrical shaft set on a

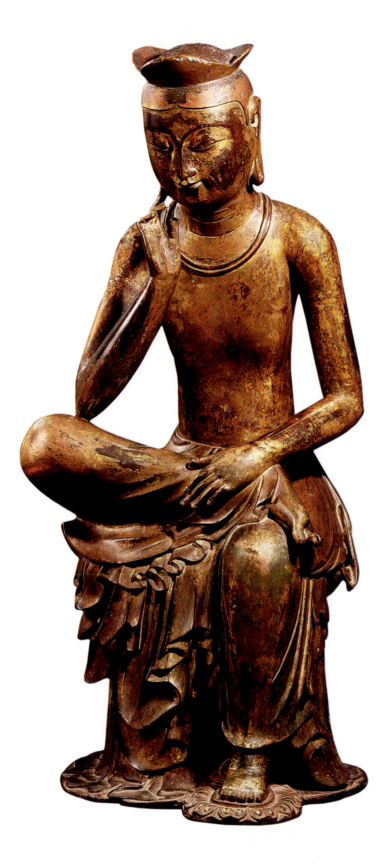

11-28 • BODHISATTVA SEATED IN MEDITATION
Korea. Three Kingdoms period, probably Silla kingdom, early 7th century CE. Gilt bronze, height 35⅞" (91 cm). National Museum of Korea, Seoul, Republic of Korea (formerly in the collection of the Toksu Palace Museum of Fine Arts, Seoul).

bulbous base and used to support round-bottomed jars. Cut into the moist clay before firing, their openwork apertures lighten what otherwise would be rather ponderous forms. Although few examples of Three Kingdoms ceramics exhibit surface ornamentation, other than an occasional combed wave pattern or an incised configuration of circles and **chevrons** (v-shapes), here snakes inch their way up the shaft of the stand.

A BODHISATTVA SEATED IN MEDITATION Buddhism was introduced into the Goguryeo kingdom from China in 372 CE and into Baekje by 384. Although it probably reached Silla in the second half of the fifth century, Buddhism gained recognition as the official religion of the Silla state only in 527.

At first, Buddhist art in Korea imitated Chinese examples. By the late sixth century, however, Korean sculptors had created a distinctive style, exemplified by a magnificent gilt-bronze image of a bodhisattva (probably the bodhisattva Maitreya) seated in meditation that likely dates to the early seventh century (**FIG. 11-28**). Although the pose derives from late sixth-century Chinese sculpture, the slender body, elliptical face, elegant drapery folds, and trilobed crown are distinctly Korean.

Buddhism was introduced to Japan from Korea—from the Baekje kingdom, according to literary accounts. In fact, historical sources indicate that numerous Korean sculptors were active in Japan in the sixth and seventh centuries; several early masterpieces of Buddhist art in Japan show pronounced Korean influence (see FIG. 12-6).

THE UNIFIED SILLA PERIOD

In 660, the Silla kingdom conquered Baekje, and, in 668, through an alliance with Tang-dynasty China, it vanquished Goguryeo, uniting the peninsula under the rule of the Unified Silla dynasty, which lasted until 935. Buddhism prospered under Unified Silla, and many large, important temples were erected in and around Gyeongju, the Silla capital.

SEOKGURAM The greatest monument of the Unified Silla period is Seokguram, an artificial cave-temple constructed under royal patronage atop Mount Toham, near Gyeongju. The temple is modeled after Chinese cave-temples of the fifth, sixth, and seventh centuries, which were in turn inspired by the Buddhist cave-temples of India.

Built in the mid eighth century of cut blocks of granite, Seokguram consists of a small rectangular antechamber joined by a narrow vestibule to a circular main hall with a domed ceiling. More than 11 feet in height, a huge seated Buddha dominates the main hall (**FIG. 11-29**). Seated on a lotus pedestal, the image represents the historical Buddha Shakyamuni at the moment of his enlightenment, as indicated by his earth-touching gesture, or *bhumisparsha mudra*. The full, taut forms, diaphanous drapery, and anatomical details of his chest relate this image to eighth-century Chinese sculptures. Exquisitely carved low-relief images of bodhisattvas

ters began to experiment with such glazes in the eighth and ninth centuries, and soon the finest Goryeo celadons rivaled the best Chinese court ceramics. Although these wares were used by people of various socioeconomic classes during the Goryeo dynasty, the finest examples went to the palace, to nobles, or to powerful Buddhist clergy.

Prized for their classic simplicity, eleventh-century Korean celadons often have little decoration, but during the twelfth century potters added incised, carved, or molded embellishments, either imitating those of contemporary Chinese ceramics or exploring new styles and techniques of ornamentation. Most notable among their inventions was inlaid decoration, in which black and white slips, or finely ground clays, were inlaid into the intaglio lines of decorative elements incised or stamped in the clay body, creating underglaze designs in contrasting colors, as seen in a bottle (**FIG. 11–30**) displaying three different pictorial scenes inlaid in black and

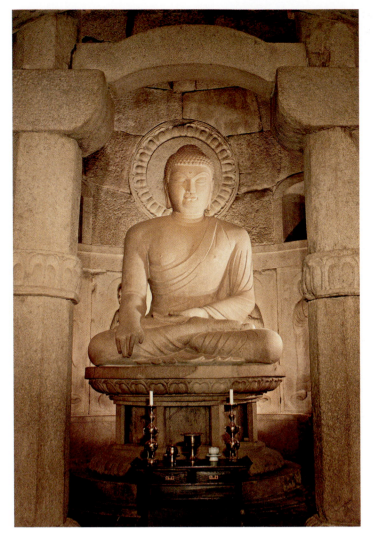

11–29 • SEATED SHAKYAMUNI BUDDHA
Seokguram Grotto, near Gyeongju, North Gyeongsang Province, Korea. Unified Silla period, c. 751 CE. Granite, height of Buddha 11′2½″ (3.42 m).

The Buddha's hands are in the *bhumisparsha mudra*, the earth-touching gesture symbolizing his enlightenment).

and lesser deities grace the walls of the antechamber, vestibule, and main hall.

GORYEO DYNASTY

Established in 918, the Goryeo dynasty eliminated the last vestiges of Unified Silla rule in 935; it would continue until 1392, ruling from its capital at Gaeseong—to the northwest of present-day Seoul and now in North Korea. A period of courtly refinement, the Goryeo dynasty is best known for its celadon-glazed ceramics.

CELADON-GLAZED CERAMICS The term **celadon** refers to a high-fired, transparent glaze of pale bluish-green hue, typically applied over a pale gray stoneware body. Chinese potters invented celadon glazes and had initiated the continuous production of celadon-glazed wares as early as the first century CE. Korean pot-

11–30 • MAEBYEONG BOTTLE WITH DECORATION OF BAMBOO AND BLOSSOMING PLUM TREE
Korea. Goryeo dynasty, late 12th–early 13th century CE. Inlaid celadon ware: light gray stoneware with decoration inlaid with black and white slips under celadon glaze, height 13¼″ (33.7 cm). Tokyo National Museum, Tokyo, Japan. (TG-2171)

11-31 • SEATED WILLOW-BRANCH GWANSE'EUM BOSAL (THE BODHISATTVA AVALOKITESHVARA)
Korea. Goryeo dynasty, late 14th century CE. Hanging scroll with ink, colors, and gold pigment on silk, height 62½″ (159.6 cm). Arthur M. Sackler Museum, Harvard University, Cambridge, Massachusetts. Bequest of Grenville L. Winthrop (1943.57.12)

white slips. The scene shown here depicts a clump of bamboo growing at the edge of a lake, the stalks intertwined with the branches of a blossoming plum tree (which flowers in late winter, before sprouting leaves). Geese swim in the lake and butterflies flutter above, linking the several scenes around the bottle. Called *maebyeong* ("plum bottle"), such broad-shouldered vessels were used as storage jars for wine, vinegar, and other liquids. A small, bell-shaped cover originally capped the bottle, protecting its contents and complementing its curves.

BUDDHIST PAINTING Buddhism, the state religion of Goryeo, enjoyed royal patronage, allowing many temples to commission the very finest architects, sculptors, and painters. The most sumptuous Buddhist works produced during the Goryeo period were paintings. Wrought in ink and colors on silk, a fourteenth-century hanging scroll (**FIG. 11-31**) depicts Gwanse'eum Bosal (whom the Chinese called Guanyin), the bodhisattva of compassion. The rich colors and gold pigment reflect the luxurious taste of the period. Numerous paintings of this type were exported to Japan, where they influenced the course of Buddhist painting.

THINK ABOUT IT

11.1 To what extent is naturalism—the artistic goal of reproducing the visual appearance of the natural world a motivating force in the developing history of early Chinese and Korean art?

11.2 Compare and contrast the Chinese seated Guanyin bodhisattva (FIG. 11-20) and the Korean bodhisattva seated in meditation (FIG. 11-28). Define the meaning of bodhisattva, and examine how the artists gave visual expression to the deity's attributes.

11.3 Summarize the main tenets of Confucianism. Then select a work from the chapter that gives visual form to Confucian philosophy and explain how it does so.

11.4 Select one of the Song-era Chinese landscape paintings included in the chapter. Describe it carefully and explain how it may embody philosophical or religious ideals.

CROSSCURRENTS

FIG. 3–3

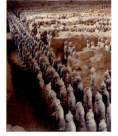

FIG. 11–1

These two imposing complexes from Egypt and China are royal tombs. Explain how they represent the political stature of the entombed and the beliefs of their cultures.

 Study and review on myartslab.com

12–1 • KASUGA SHRINE MANDALA
Kamakura period, early 14th century CE. Hanging scroll with ink, color, and gold on silk, 39½″ × 15⅝″ (100.3 × 39.8 cm). Mary and Jackson Burke Foundation.

Japanese Art before 1333

A group of Buddhist deities hovers across the top of this painting (**FIG. 12–1**), poised in the sky above a vast vertical expanse of verdant hills and meadows filled with blossoming cherry and plum trees, and a diagrammatic, bird's-eye view of a religious compound. The sacred site depicted in idealized but recognizable form is the Kasuga Shrine in Nara, dedicated to deities, known as *kami*, of Japan's native Shinto religion. It served as the family shrine for the most powerful aristocratic clan in ancient Japan, the Fujiwara, who chose the site because of its proximity to their home as well as for its natural beauty. Life in Japan revolved around natural seasonal rhythms and the conceptions of *kami*, who give and protect life and embody the renewable, life-sustaining forces of nature. The *kami* were believed to have descended from mysterious heavens at supremely beautiful places such as majestic mountains, towering waterfalls, old and gnarled trees, or unusual rock formations, thus rendering such locations holy—places where one might seek communion with *kami*. The deer glimpsed scampering about the grounds—prominently silhouetted at the very bottom of the painting—are considered sacred messengers of *kami*. They roam freely in this area even today.

That foreign deities associated with Buddhism preside over a native Shinto shrine presented no anomaly. By the Heian period (794–1185 CE), the interaction of Buddhist and Shinto doctrines in Japan resulted from the belief that *kami* were emanations of Buddhist deities who were their original forms. When Buddhism first entered Japan in the sixth century, efforts began to integrate the foreign faith with the indigenous Japanese religious belief system centered around *kami*, which only later came to be called Shinto. Until the government forcibly separated the two religions in the latter part of the nineteenth century, and elevated Shinto to bolster worship of the emperor, the two religions were intimately intertwined, evolving together as complementary systems. Shinto explains the origins of the Japanese people and its deities protect them, while Buddhism offers salvation after death.

This painting encapsulates various aspects of ancient and early medieval Japanese art and culture. Like all religious art from early Japan, it was created to embody religious teachings and beliefs, and was not considered a work of art in its own time. It represents how reverence for the natural world informed religious practice and visual vocabulary and shows how the foreign religion of Buddhism was integrated with indigenous belief systems, without sacrificing either. We will discover other examples of creative syntheses of disparate traditions as we survey the art of early Japan.

LEARN ABOUT IT

12.1 Recognize the native elements in early Japanese art and assess the influence of outside traditions in tracing its stylistic development.

12.2 Understand the themes and subjects associated with the developing history of Buddhism in Japan.

12.3 Explore the relationship of the history of early Japanese art and architecture to changing systems of government and patterns of religion.

12.4 Learn to characterize the significant distinctions between the art of the refined Heian court and the dynamic Kamakura shogunate.

((•—[Listen** to the chapter audio on myartslab.com

PREHISTORIC JAPAN

Human habitation in Japan dates to around 30,000 years ago (**MAP 12-1**). Sometime after 15,000 years ago Paleolithic peoples gave way to Neolithic hunter-gatherers, who gradually developed the ability to make and use ceramics. Recent scientific dating methods have shown that some works of Japanese pottery date to earlier than 10,000 BCE, making them the oldest now known (see Chapter 1).

JOMON PERIOD

The early potters lived during the Jomon ("cord markings") period (c. 12,000–400 BCE), named for the patterns on much of the pottery they produced. They made functional earthenware vessels, probably originally imitating reed baskets, by building them up with coils of clay, then firing them in bonfires at relatively low temperatures (see FIG. 1-24). They also created small humanoid figures known as **dogu**, which were probably effigies that manifested a kind of sympathetic magic. Around 5000 BCE agriculture emerged with the planting and harvesting of beans and gourds.

YAYOI PERIOD

During the succeeding Yayoi era (c. 400 BCE–300 CE), the introduction of rice cultivation by immigrants from Korea helped transform Japan into an agricultural nation. As it did elsewhere in the world, this shift to agriculture brought larger permanent settlements, class structure with the division of labor into agricultural and nonagricultural tasks, and more hierarchical forms of social organization. Korean settlers also brought metal technology. Bronze was used to create weapons as well as ceremonial objects such as bells. Iron metallurgy developed later in this period, eventually replacing stone tools in everyday life.

KOFUN PERIOD

Centralized government developed during the ensuing Kofun ("old tombs") period (c. 300–552 CE), named for its large royal tombs. With the emergence of a more complex social order, the veneration of leaders grew into the beginnings of an imperial system. Still in existence today in Japan, this system eventually explained that the emperor (or, very rarely, empress) descended directly from Shinto deities. When an emperor died, chamber tombs were constructed following Korean examples. Various grave goods were placed inside the tomb chambers, including large amounts of pottery, presumably to pacify the spirits of the dead and to serve them in their next life. As part of a general cultural transfer from China through Korea, fifth-century potters in Japan gained knowledge of finishing techniques and improved kilns, and began to produce high-fired ceramic ware.

The Japanese government has never allowed the major sacred tombs to be excavated, but much is known about the mortuary practices of Kofun-era Japan. Some huge tombs of the fifth and

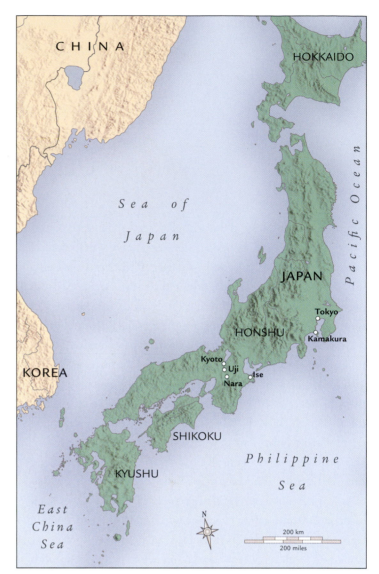

MAP 12-1 • JAPAN

Melting glaciers at the end of the Ice Age in Japan 15,000 years ago raised the sea level and formed the four main islands of Japan: Hokkaido, Honshu, Shikoku, and Kyushu.

sixth centuries were constructed in a shape resembling a large keyhole and surrounded by moats dug to protect the sacred precincts. Tomb sites might extend over more than 400 acres, with artificial hills built over the tombs themselves. On the top of the hills were placed ceramic sculptures called **haniwa**.

HANIWA The first *haniwa* were simple cylinders that may have held jars with ceremonial offerings. By the fifth century, these cylinders came to be made in the shapes of ceremonial objects, houses, and boats. Gradually, living creatures were added to the repertoire of *haniwa* subjects, including birds, deer, dogs, monkeys, cows, and horses. By the sixth century, **HANIWA** in human shapes were crafted, including males and females of various types, professions, and classes (**FIG. 12-2**).

12-2 • HANIWA
Kyoto. Kofun period, 6th century CE. Earthenware, height 27″ (68.5 cm). Collection of the Tokyo National Museum. Important Cultural Property.

There have been many theories on the function of *haniwa*. The figures seem to have served as some kind of link between the world of the dead, over which they were placed, and the world of the living, from which they could be viewed. This figure has been identified as a seated female shaman, wearing a robe, belt, and necklace and carrying a mirror at her waist. In early Japan, shamans acted as agents between the natural and the supernatural worlds, just as *haniwa* figures were links between the living and the dead.

Haniwa embody aesthetic characteristics that we will encounter again in Japanese art. *Haniwa* were left with their clay bodies unglazed; they do not show a preoccupation with technical virtuosity. Instead, their makers explored the expressive potentials of simple and bold forms. *Haniwa* are never perfectly symmetrical; their slightly off-center eye-slits, irregular cylindrical bodies, and unequal arms seem to impart the idiosyncrasy of life and individuality.

SHINTO As described at the beginning of this chapter, Shinto is Japan's indigenous religious belief system. It encompasses a variety of ritual practices that center around family, village, and devotion to *kami*. The term Shinto was not coined until after the arrival of Buddhism in the sixth century CE, and as *kami* worship was influenced by and incorporated into Buddhism it became more systematized, with shrines, a hierarchy of deities, and more strictly regulated ceremonies.

THE ISE SHRINE One of the great Shinto monuments is the Grand Shrine of Ise, on the coast southwest of Tokyo (**FIG. 12-3**), where the main deity worshiped is the sun goddess Amaterasu-o-mi-*kami*, the legendary progenitor of Japan's imperial family. Japan's earliest written historical texts recorded by the imperial court in the eighth century claim that the Ise Shrine dates to the first century CE. Although we do not know for certain if this is true, it is known that it has been ritually rebuilt, alternately on two adjoining sites at 20-year intervals with few breaks since the year 690, a time when the imperial family was solidifying its hegemony. Its most recent rebuilding took place in 1993, by carpenters who train for the task from childhood. After the *kami* is ceremonially escorted to the freshly copied shrine, the old shrine is dismantled. Thus—like Japanese culture itself—this exquisite shrine is both ancient and constantly renewed. In this sense it embodies one of the most important characteristics of Shinto faith—ritual purification—derived from respect for the cycle of the seasons in

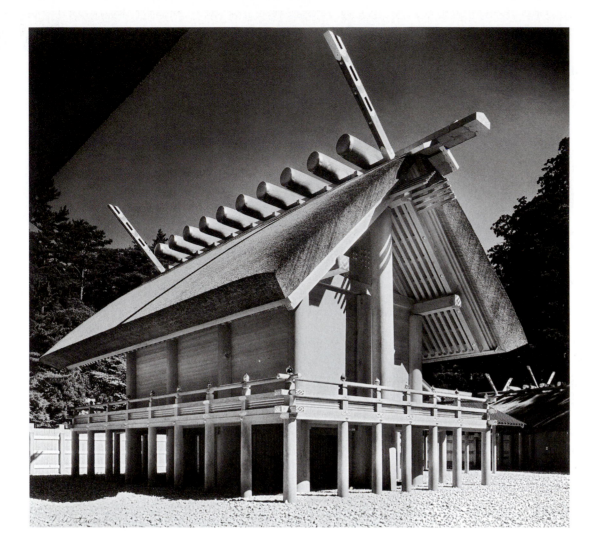

12-3 • MAIN HALL, INNER SHRINE, ISE
Mie Prefecture. Last rebuilt 1993. Photograph by Watanabe Yoshio (1907–2000), 1953. National Treasure.

◉— **Watch** a video about the rebuilding of the Ise Shrine on myartslab.com

which pure new life emerges in springtime and gives way to death in winter, yet is reborn again in the following year.

Although Ise is visited by millions of pilgrims each year, only members of the imperial family and a few Shinto priests are allowed within the enclosure that surrounds its inner shrine. Detailed documents on its appearance date back to the tenth century, but shrine authorities denied photographers access to its inner compound until 1953, when the iconic photograph of it reproduced in FIGURE 12-3 was taken by a photographer officially engaged by a quasi-governmental cultural relations agency. The reluctance of shrine officials to permit photography even then may stem from beliefs that such intimate pictures would violate the privacy of the shrine's most sacred spaces.

Many aspects of the Ise Shrine are typical of Shinto architecture, including the wooden piles that elevate the building above the ground, a thatched roof held in place by horizontal logs, the use of unpainted cypress wood, and the overall feeling of natural simplicity rather than overwhelming size or elaborate decoration. The building's shape seems indebted to early raised granaries known from drawings on bronze artifacts of the Yayoi period. The sensitive use of unornamented natural materials in the Ise Shrine

suggests an early origin for an aspect of Japanese taste that persists to the present day.

ASUKA PERIOD

During the single century of the Asuka period (552–645 CE), new forms of philosophy, medicine, music, food, clothing, agriculture, city planning, religion, visual art, and architecture entered Japan from Korea and China at an astonishing pace. Most significant among these were the Buddhist religion, a centralized governmental structure, and a system of writing. Each was adopted and gradually modified to suit local Japanese conditions, and each has had an enduring legacy.

Buddhism reached Japan in Mahayana form, with its many buddhas and bodhisattvas (see "Buddhism," page 301). After being accepted by the imperial family, it was soon adopted as a state religion. Buddhism represented not only different gods from Shinto but an entirely new concept of religion. Worship of Buddhist deities took place inside worship halls of temples situated in close proximity to imperial cities. The Chinese-influenced temples looked nothing like previous Japanese buildings. They housed

Chinese culture enjoyed great prestige in east Asia. Written Chinese served as an international language of scholarship and cultivation, much as Latin did in medieval Europe. Educated Koreans, for example, wrote almost exclusively in Chinese until the fifteenth century. In Japan, Chinese continued to be used for certain kinds of writing, such as Buddhist *sutras*, philosophical and legal texts, and Chinese poetry (by Japanese writers), into the nineteenth century.

When it came to writing their own language, the Japanese initially borrowed Chinese characters, or *kanji*. Differences between the Chinese and Japanese languages made this system extremely unwieldy, so during the ninth century they developed two syllabaries, or *kana*, from simplified Chinese characters. (A syllabary is a system of lettering in which each symbol stands for a syllable.) *Katakana*, consisting of angular symbols, was developed to aid pronunciation of Chinese Buddhist texts and now is generally used for foreign words. *Hiragana*, comprised of graceful, cursive symbols, was the written language the Japanese first used to write native poetry and prose. Eventually it came to be used to represent only the grammatical portions of the written Japanese language in conjunction with Chinese characters that convey meaning. Japanese written in *hiragana* was once called "women's hand" because

its rounded forms looked feminine. During the Heian period *hiragana* were used to create a large body of literature, written either by women or sometimes for women by men.

A charming poem originated in Heian times to teach the new writing system. In two stanzas of four lines each, it uses almost all of the syllable sounds of spoken Japanese and thus almost every *kana* symbol. It was memorized as we would recite our abcs. The first stanza translates as:

> Although flowers glow with color
> They are quickly fallen,
> And who in this world of ours
> Is free from change?
> (Translation by Earl Miner)

Like Chinese, Japanese is written in columns from top to bottom and across the page from right to left. (Following this logic, Chinese and Japanese handscrolls also read from right to left.) Below is the stanza written three ways. At the right, it appears in *katakana* glossed with the original phonetic value of each symbol. In the center, the stanza appears in flowing *hiragana*. To the left is the mixture of *kanji* and *hiragana* that eventually became standard.

kanji hiragana mixed	hiragana	katakana

常ならむ　我世誰ぞ　散りぬるを　色は匂へど
つねならむ　わかよたれそ　ちりぬるを　いろはにほへと

イロハニホヘト I-ro-ha-ni-he-to
チリヌルヲ Chi-ri-nu-ru-wo
ワカヨタレソ Wa-ka-yo-ta-re-so
ツネナラム Tsu-ne-na-ra-mu

anthropomorphic and elaborately symbolic Buddhist icons (see "Buddhist Symbols," page 368) at a time when *kami* were not portrayed in human form. Yet Buddhism attracted followers because it offered a rich cosmology with profound teachings of meditation and enlightenment. The protective powers of its deities enabled the ruling elites to justify their own power, through association with Buddhism, and they called upon Buddhist deities to nurture and protect the populace over whom they ruled. Many highly

developed aspects of continental Asian art traveled to Japan with the new religion, including new methods of painting and sculpture.

HORYUJI

The most significant surviving early Japanese temple is Horyuji, located on Japan's central plains not far from Nara. The temple was founded in 607 by Prince Shotoku (574–622), who ruled Japan as a regent and became the most influential early proponent

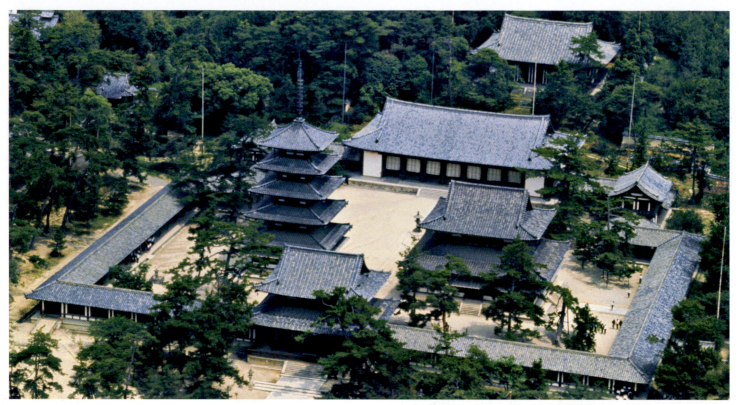

12-4 • AERIAL VIEW OF HORYUJI COMPOUND
Pagoda to the west (left), golden hall (*kondo*) to the east (right). Nara
Prefecture. Asuka period, 7th century CE. UNESCO World Heritage Site,
National Treasure.

of Buddhism. Rebuilt after a fire in 670, Horyuji is the oldest
wooden temple in the world. The just proportions and human
scale of its buildings, together with the artistic treasures it houses,
make Horyuji a beautiful as well as important monument to Bud-
dhist faith in early Japan.

The main compound of Horyuji consists of a rectangular
courtyard surrounded by covered corridors, one of which contains
a gateway. Within the compound are two buildings: the **kondo**
(golden hall) and a five-story pagoda. Within a simple asymmetri-
cal layout, the large *kondo* balances the tall, slender pagoda (**FIG.
12-4**). The *kondo*, filled with Buddhist images, is used for wor-
ship and ceremonies, while the pagoda serves as a **reliquary** and
is not entered. Other monastery buildings lie outside the main
compound, including an outer gate, a lecture hall, a repository for
sacred texts, a belfry, and dormitories for monks.

Among the many treasures still preserved in Horyuji is a port-
able shrine decorated with paintings in lacquer. It is known as
the Tamamushi Shrine after the *tamamushi* beetle, whose iridescent

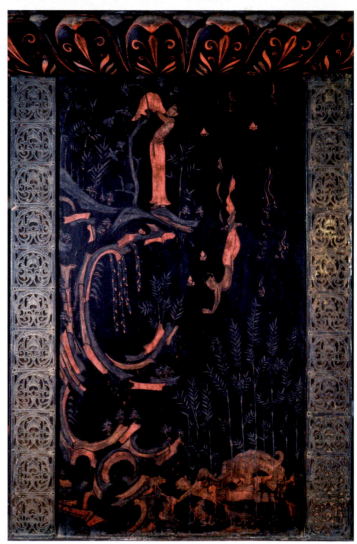

12-5 • HUNGRY TIGRESS JATAKA
Panel of the Tamamushi Shrine, Horyuji. Asuka period, c. 650 CE.
Lacquer on wood, height of shrine 7'7½" (2.33 m). Horyuji Treasure
House, Nara. National Treasure.

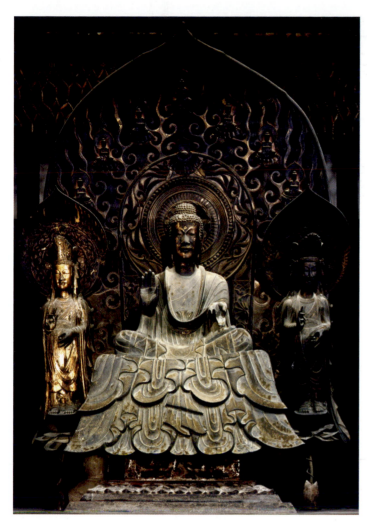

12-6 • Tori Busshi **BUDDHA SHAKA AND ATTENDANT BODHISATTVAS IN THE HORYUJI KONDO**
Asuka period, c. 623 CE. Gilt bronze, height of seated figure 34½"
(87.5 cm). Horyuji, Nara. National Treasure.

wings were originally affixed to the shrine to make it glitter, much like mother-of-pearl. Its architectural form replicates an ancient palace-form building type that pre-dates Horyuji itself.

HUNGRY TIGRESS JATAKA Paintings on the sides of the Tamamushi Shrine are among the few two-dimensional works of art to survive from the Asuka period. Most celebrated among them are two that illustrate Jataka tales, stories about former lives of the Buddha. One depicts the future Buddha nobly sacrificing his life in order to feed his body to a starving tigress and her cubs (**FIG. 12-5**). Since the tigers are at first too weak to eat him, he jumps off a cliff to break open his flesh. The painter has created a full narrative within a single frame. The graceful form of the Buddha appears three times in three sequential stages of the story, harmonized by the curves of the rocky cliff and tall wands of bamboo. First, he hangs his shirt on a tree, then he dives downward onto the rocks, and finally the starving animals devour his body. The elegantly slender renditions of the figure and the stylized treatment of the cliff, trees, and bamboo represent an

international Buddhist style that was transmitted to Japan via China and Korea. Such illustrations of Jataka tales helped popularize Buddhism in Japan.

SHAKA TRIAD Another example of the international style of early Buddhist art at Horyuji is the sculpture called the Shaka Triad, traditionally attributed to sculptor Tori Busshi (**FIG. 12-6**). (Shaka is the Japanese name for Shakyamuni, the historical Buddha.) Tori Busshi (Busshi means Buddhist image-maker) may have been a descendant of Korean craftsmakers who emigrated to Japan as part of an influx of Buddhists and artisans from Korea. The Shaka Triad reflects the strong influence of Chinese art of the Northern Wei dynasty (see FIG. 11-12). The frontal pose, the outsized face and hands, and the linear treatment of the drapery all suggest that the maker of this statue was well aware of earlier continental models, while the fine bronze casting of the figures shows his advanced technical skill.

NARA PERIOD

The Nara period (645–794) is named for Japan's first permanent imperial capital, founded in 710. Previously, an emperor's death was thought to taint his entire capital city, so for reasons of purification (and perhaps also of politics), his successor usually selected a new site. As the government adopted ever more complex aspects of the Chinese political system, necessitating construction of huge administrative complexes, it abandoned this custom in the eighth century when Nara was founded. During this period, divisions of the imperial bureaucracy grew exponentially and hastened the swelling of the city's population to perhaps 200,000 people.

One result of the strong central authority was the construction in Nara of magnificent Buddhist temples and Shinto shrines that dwarfed those built previously. The expansive park in the center of Nara today is the site of the largest and most important of these, including the Shinto Kasuga Shrine depicted in FIGURE 12-1. The grandest of the Buddhist temples in Nara Park is Todaiji, which the deeply religious Emperor Shomu (r. 724–749) conceived as the headquarters of a vast network of branch temples throughout the nation. Todaiji served as both a state-supported central monastic training center and as the setting for public religious ceremonies. The most spectacular of these took place in 752 and celebrated the consecration of the main Buddhist statue of the temple in a traditional "eye-opening" ceremony, in its newly constructed Great Buddha Hall (*Daibutsuden*; see "The Great Buddha Hall," page 370). The statue, a giant gilt-bronze image of the Buddha Birushana (Vairochana in Sanskrit), was inspired by the Chinese tradition of erecting monumental stone Buddhist statues in cave-temples (see FIG. 11-12).

The ceremony, which took place in the vast courtyard in front of the Great Buddha Hall, was presided over by an illustrious Indian monk and included *sutra* chanting by over 10,000 Japanese Buddhist monks and sacred performances by 4,000 court musicians

A few of the most important Buddhist symbols, which have myriad variations, are described here in their most generalized forms.

Lotus flower: Usually shown as a white waterlily, the lotus (Sanskrit, *padma*) symbolizes spiritual purity, the wholeness of creation, and cosmic harmony. The flower's stem is an *axis mundi* ("axis of the world").

Lotus throne: Buddhas are frequently shown seated on an open lotus, either single or double, a representation of *nirvana* (see FIG. 12–12).

Chakra: An ancient sun symbol, the *chakra* (wheel) symbolizes both the various states of existence (the Wheel of Life) and the Buddhist doctrine (the Wheel of the Law). A *chakra*'s exact meaning depends on how many spokes it has.

Marks of a buddha: A buddha is distinguished by 32 physical attributes (*lakshanas*). Among them are a bulge on top of the head (*ushnisha*), a tuft of hair between the eyebrows (*urna*), elongated earlobes, and 1,000-spoked *chakras* on the soles of the feet.

Mandala: *Mandalas* are diagrams of cosmic realms, representing order and meaning within the spiritual universe. They may be simple or complex, three- or two-dimensional, and in a wide array of forms—such as an Indian stupa (see FIG. 10–8) or a Womb World *mandala* (see FIG. 12–10), an early Japanese type.

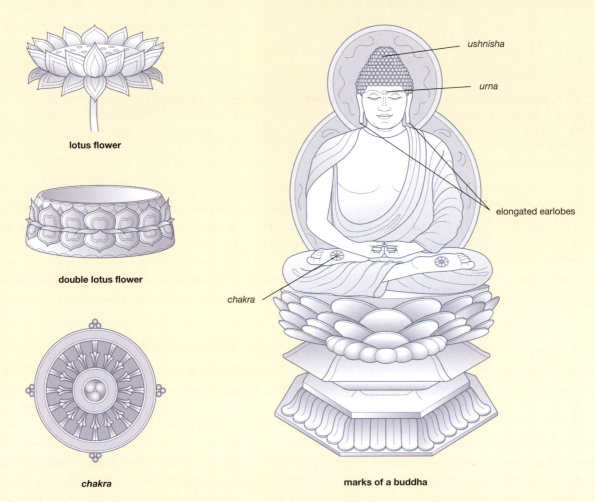

lotus flower

double lotus flower

chakra

ushnisha

urna

elongated earlobes

chakra

marks of a buddha

and dancers. Vast numbers of Japanese courtiers and emissaries from the Asian continent comprised the audience. Numerous ritual objects used in the ceremony came from exotic Asian and Near Eastern lands. The resulting cosmopolitan atmosphere reflected the position Nara then held as the eastern terminus of the Central Asian Silk Road.

Many of these treasures have been preserved in the Shosoin Imperial Repository at Todaiji, which today contains some 9,000 objects. The Shosoin came into being in the year 756, when Emperor Shomu died and his widow Empress Komyo, a devout Buddhist, donated some 600 of his possessions to the temple, including a number of objects used during the Great Buddha's consecration ceremony. Many years later, objects used in Buddhist rituals and previously stored elsewhere at Todaiji were incorporated into the collection. The objects formerly owned by Emperor Shomu consisted mainly of his personal possessions, such

12-7 • FIVE-STRINGED LUTE (BIWA) WITH DESIGN OF A CENTRAL ASIAN MAN PLAYING A BIWA ATOP A CAMEL
Chinese. Tang dynasty, 8th century CE. Red sandalwood and chestnut inlaid with mother-of-pearl, amber, and tortoiseshell. Length 42½″ (108.1 cm), width 12″ (30.9 cm), depth 3½″ (9 cm). Shosoin, Todaiji.

as documents, furniture, musical instruments, games, clothing, medicine, weapons, food and beverage vessels of metal, glass, and lacquer, and some Buddhist ritual objects. Some of these were made in Japan while others came from as far away as China, India, Iran, Greece, Rome, and Egypt. They reflect the vast international trade network that existed at this early date.

One of the items Empress Komyo donated in 756 is a magnificently crafted five-stringed lute (*biwa*) made of lacquered red sandalwood and chestnut, and inlaid with mother-of-pearl, amber, and tortoiseshell. Its plectrum guard features the portrayal of a central Asian musician (his ethnicity apparent from his clothing and physical features) sitting on a camel and playing a lute (**FIG. 12–7**). This is the only existing example of an ancient five-stringed lute, an instrument invented in India and transmitted to China and Japan via the Silk Road. The Shosoin piece is generally identified as Chinese, but, as with many of the objects preserved in the Shosoin, the location of its manufacture is not absolutely certain. While it was most likely crafted in China and imported to Japan for use in the consecration ceremony (researchers have recently conclusively determined that it was indeed played), it is also plausible that Chinese (or Japanese) craftsmakers made it in Japan using imported materials. Its meticulous workmanship is characteristic of the high level of craft production achieved by artists of this era.

Influenced by Emperor Shomu, the Buddhist faith permeated all aspects of Nara court society. Indeed, in 749 Shomu abdicated the throne to spend the remainder of his life as a monk. His daughter, also a devout Buddhist, succeeded him as empress but wanted to cede her throne to a Buddhist monk. This so dismayed her advisors that they moved the capital city away from Nara, where they felt Buddhist influence had become overpowering, and establish a new one in Kyoto, within whose bounds, at first, only a few Buddhist temples would be allowed. The move of the capital to Kyoto marked the end of the Nara period.

HEIAN PERIOD

During the Heian period (794–1185) the Japanese fully absorbed and transformed their cultural borrowings from China and Korea. Generally peaceful conditions contributed to a new air of self-reliance, and the imperial government severed ties to China in the ninth century, a time when the power of related aristocratic families increased. An efficient method of writing the Japanese language was developed, and the rise of vernacular literature generated such prose masterpieces as Lady Murasaki's *The Tale of Genji*. During these four centuries of splendor and refinement, two major streams of Buddhism emerged—esoteric sects and, later, those espousing salvation in the Pure Land Western Paradise of the Buddha Amida.

ESOTERIC BUDDHIST ART

With the removal of the capital to Kyoto, the older Nara temples lost their influence. Soon two new Esoteric sects of Buddhism, Tendai and Shingon, grew to dominate Japanese religious life. Strongly influenced by polytheistic religions such as Hinduism, Esoteric Buddhism (known as Tantric Buddhism in Nepal and

The Great Buddha Hall (*Daibutsuden*) is distinguished today as the largest wooden structure in the world. Yet the present **GREAT BUDDHA HALL** (**FIG. 12–8**), dating to a reconstruction of 1707, is 30 percent smaller than the original, which towered nearly 90 feet in height. Since it was first erected in 752 CE, natural disasters and intentional destruction by foes of the imperial family have necessitated its reconstruction four times. It was first destroyed during civil wars in the twelfth century and rebuilt in 1203, then destroyed in yet another civil war in 1567. Reconstruction did not next occur until the late seventeenth century under the direction of a charismatic monk who solicited funds not from the government, which was then impoverished, but through popular subscription. This building, completed in 1707, is essentially the structure that stands on the site today. However, by the late nineteenth century its condition had deteriorated so profoundly that restoration finally undertaken between 1906 and 1913 entailed completely dismantling it and putting it back together, this time utilizing steel (imported from England) and concrete to provide invisible support to the roof, which had nearly collapsed. Architects adopted this nontraditional solution mainly because no trees of sufficiently large dimensions could be found, and no traditional carpenters then living possessed knowledge of ancient construction techniques. This project occurred only after laws were enacted in 1897 to preserve ancient architecture. Another major restoration of the building took place between 1973 and 1980.

Like the building, the Great Buddha (*Daibutsu*) statue has not survived intact. Its head was completely destroyed in the late sixteenth century and replaced as part of the hall's reconstruction in the late seventeenth century, when its torso and lotus petal throne also required extensive restoration. The present statue, though impressive in scale, appears stiff and rigid. Its more lyrical original appearance may have approximated engraved images of seated Buddhist deities found on a massive cast-bronze lotus petal from the original statue that has survived in fragmentary form (**FIG. 12–9**). The petal features a buddha with a narrow waist, broad shoulders, and elegantly flowing robes that characterize the style of contemporaneous buddha images of the Tang dynasty (see, for example, the central buddha in **FIG. 11–14**).

12-9 • THE BUDDHA SHAKA, DETAIL OF A PARADISE SCENE
Engraved bronze lotus petal from the original Great Buddha (*Daibutsu*) statue of the Buddha Birushana. 8th century CE. Height of petal 79" (200 cm). *Daibutsuden*, Todaiji. National Treasure.

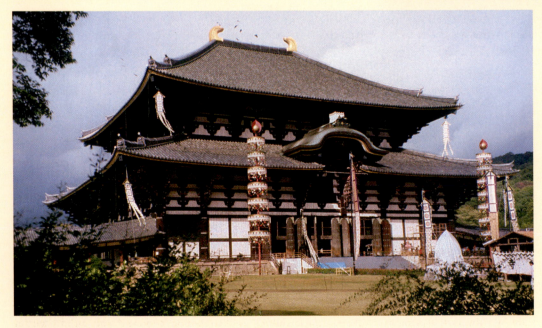

12-8 • GREAT BUDDHA HALL (DAIBUTSUDEN), TODAIJI, NARA
Original structure completed in 752 CE; twice destroyed; rebuilt in 1707; extensively restored 1906–1913, 1973–1980. UNESCO World Heritage Site, National Treasure.

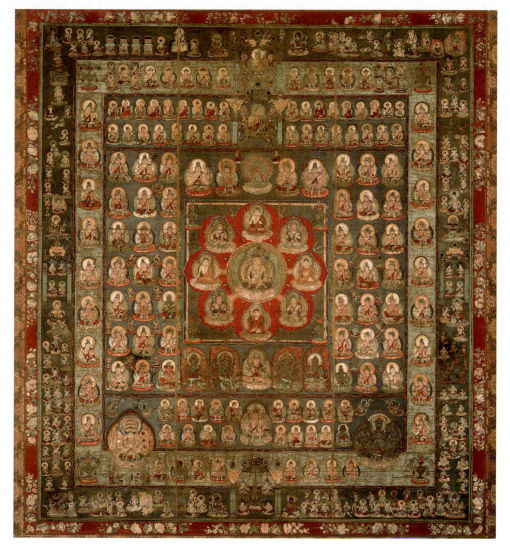

12-10 • WOMB WORLD MANDALA
Heian period, late 9th century CE. Hanging scroll with colors on silk, 6′ × 5′1½″ (1.83 × 1.54 m).
Toji, Kyoto. National Treasure.

Mandalas are used not only in teaching, but also as vehicles for practice. A monk, initiated into secret teachings, may meditate upon and assume the gestures of each deity depicted in the *mandala*, gradually working out from the center, so that he absorbs some of each deity's powers. The monk may also recite magical phrases, called mantras, as an aid to meditation. The goal is to achieve enlightenment through the powers of the different forms of the Buddha. *Mandalas* are created in sculptural and architectural forms as well as in paintings (see FIG. 10–34). Their integration of the two most basic shapes, the circle and the square, is an expression of the principles of ancient geomancy (divining by means of lines and figures) as well as Buddhist cosmology.

schematic order. The **WOMB WORLD MANDALA** from Toji, for example, is entirely filled with depictions of gods. Dainichi is at the center, surrounded by buddhas of the four directions (**FIG. 12–10**). Other deities, including some with multiple heads and limbs, branch out in diagrammatical order, each with a specific symbol of power and targeted to various levels of potential worshipers, some of whom needed to be frightened to awaken to Buddhist teaching. To believers, the *mandala* represents an ultimate reality beyond the visible world.

Perhaps the most striking attribute of many Esoteric Buddhist images is their sense of spiritual force and potency, especially in depictions of the wrathful deities, which are often surrounded by flames, like those visible in the Womb World *mandala* just below the main circle of Buddhas. Esoteric Buddhism, with its intricate theology and complex doctrines, was a religion for the educated aristocracy, not for the masses. Its elaborate network of deities, hierarchy, and ritual, found parallels in the elaborate social divisions of the Heian court.

PURE LAND BUDDHIST ART

Rising militarism, political turbulence, and the excesses of the imperial court marked the beginning of the eleventh century in Japan. To many, the unsettled times seemed to confirm the coming of *Mappo*, the Buddhist concept of a long-prophesied dark age of spiritual degeneration. Japanese of all classes reacted by increasingly turning to the promise of salvation after death through simple faith in the existence of a Buddhist realm

Tibet) included a daunting number of deities, each with magical powers. The historical Buddha was no longer very important. Instead, most revered was the universal Buddha, called Dainichi ("Great Sun" in Japanese), who was believed to preside over the universe. He was accompanied by buddhas and bodhisattvas, as well as guardian deities who formed fierce counterparts to the more benign gods.

Esoteric Buddhism is hierarchical, and its deities have complex relationships to one another. Learning all the different gods and their interrelationships was assisted greatly by paintings, especially *mandalas*, cosmic diagrams of the universe that portray the deities in

known as the Western Paradise of the Pure Land, a resplendent place filled with divine flowers and music. Amida (Amithaba in Sanskrit) and his attendant bodhisattvas preside there as divine protectors who compassionately accept into their land of bliss all who submit wholeheartedly to their benevolent powers. Pure Land beliefs had spread to Japan from China by way of Korea, where they also enjoyed great popularity. They offered a more immediate and easy means to achieve salvation than the elaborate rituals of the Esoteric sects. Pure Land Buddhism held that merely by chanting *Namu Amida Butsu* ("Hail to Amida Buddha"), the faithful would be reborn into the Western Paradise.

Wood is a temperamental material because fluctuations in moisture content cause it to swell and shrink. Cut from a living, sap-filled tree, it takes many years to dry to a state of stability. While the outside of a piece of wood dries fairly rapidly, the inside yields its moisture only gradually, causing a difference in the rates of shrinkage between the inside and the outside, which induces the wood to crack. Consequently, a large statue carved from a single log must inevitably crack as it ages. Natural irregularities in wood, such as knots, further accentuate this problem. Thus, wood with a thinner cross section and fewer irregularities is less susceptible to cracking because it can dry more evenly. (This is the logic behind sawing logs into boards before drying.)

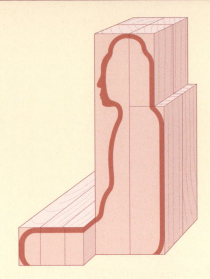

Japanese sculptors developed an ingenious and unique method, the joined-block technique, to reduce cracking in heavy wooden statues. This allowed them to create larger statues in wood than ever before, enabled standardization of body proportions, and encouraged division of labor among teams of carvers, some of whom became specialists in certain parts, such as hands or crossed legs or lotus thrones. To create large statues seated in the lotus pose, sculptors first put four blocks together vertically two by two in front and back, to form the main body, then added several blocks horizontally at what would become the front of the statue for the lap and knees. After carving each part, they assembled the figure and hollowed out the interior. This cooperative approach also had the added benefit of enabling workshops to produce large statues more quickly to meet a growing demand. Jocho is credited as the master sculptor who perfected this technique. The diagram shows how he assembled the Amida Buddha at the Byodoin (see FIG. 12–12).

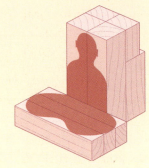

Diagram of the joined-block wood sculpture technique used on the Amida statue by Jocho.

👁—**Watch** an architectural simulation about the joined-block technique on myartslab.com

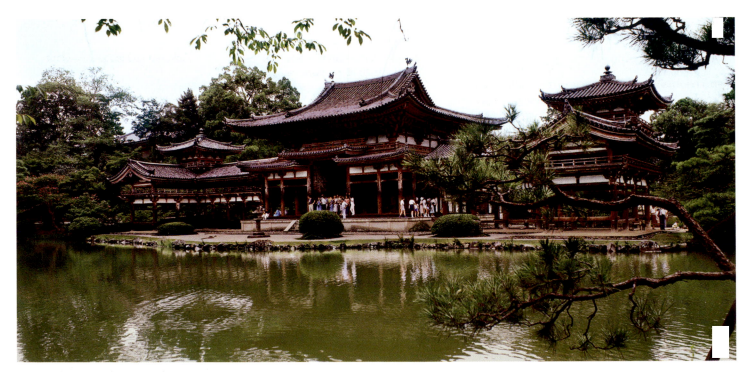

12–11 • PHOENIX HALL, BYODOIN, UJI
Kyoto Prefecture. Heian period, c. 1053 CE. UNESCO World Heritage Site, National Treasure.

BYODOIN One of the most beautiful temples of Pure Land Buddhism is the Byodoin, located in the Uji Mountains not far from central Kyoto (**FIG. 12-11**). The temple itself was originally a secular villa whose form was intended to suggest the appearance of the palatial residence of Amida in his Western Paradise (see FIG. 11-14). It was built for a member of the powerful Fujiwara family who served as the leading counselor to the emperor. After the counselor's death in the year 1052, his descendants converted the palace into a memorial temple to honor his spirit. The Byodoin is often called the Phoenix Hall, not only for the pair of phoenix images on its roof, but also because the shape of the building itself suggests the mythical bird. Its thin columns give the Byodoin a sense of airiness, as though the entire temple could easily rise up through the sky to Amida's Western Paradise. The hall rests gently in front of an artificial pond created in the shape of the Sanskrit letter A, the sacred symbol for Amida.

The Byodoin's central image of Amida, carved by the master sculptor Jocho (d. 1057), exemplifies the serenity and compassion of this Buddha (**FIG. 12-12**). When reflected in the water of the pond before it, the Amida image seems to shimmer in its private mountain retreat. The figure was not carved from a single block of wood like earlier sculpture, but from several blocks in Jocho's new **joined-block** method of construction (see "Joined-Block Wood Sculpture," opposite). This technique allowed sculptors to create larger and lighter statuary. It also reflects the growing importance of wood as the medium of choice for Buddhist sculpture, reflecting a long-standing Japanese love for this natural material.

Surrounding the Amida on the walls of the Byodoin are smaller wooden figures of bodhisattvas and angels, some playing musical instruments. Everything about the Byodoin was designed to simulate the appearance of the paradise that awaits the believer after death. Its remarkable state of preservation after more than 900 years allows visitors to experience the late Heian religious ideal at its most splendid.

SECULAR PAINTING AND CALLIGRAPHY

Parallel with the permeation of Buddhism during the Heian era (794–1185) was a refined secular culture that developed at court. Gradually, over the course of these four centuries, the pervasive influence of Chinese culture in aristocratic society gave rise to new, uniquely Japanese developments. Above all, Heian court culture greatly valued refinement; pity any man or woman at court who was not accomplished in several forms of art. A woman would be admired for the way she arranged the 12 layers of her robes by color, or a man for knowing which kind of incense was being burned. Concurrently, court life became preoccupied by the

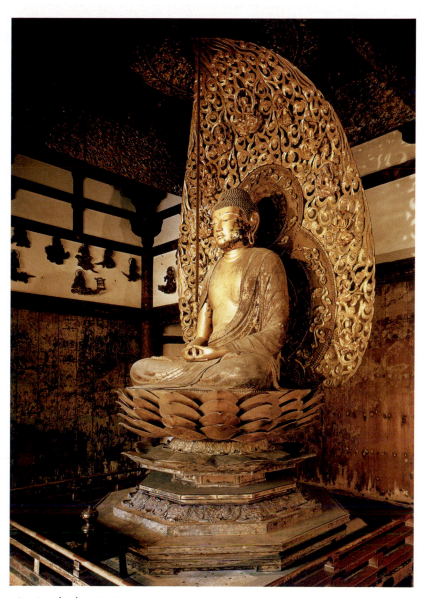

12-12 • Jocho AMIDA BUDDHA
Phoenix Hall, Byodoin. Heian period, c. 1053 CE. Gold leaf and lacquer on wood, height 9'8" (2.95 m). National Treasure.

poetical expression of human love. In this climate, women became a vital force in Heian society. Although the status of women was to decline in later periods, they contributed greatly to art at the Heian court and became famous for their prose and poetry.

Although male courtiers continued to be required to read and write Chinese, both men and women of court society wrote prose and poetry in their native Japanese language using the newly devised *kana* script (see "Writing, Language, and Culture," page 365). They also used *kana* on text portions of new types of small-scale secular paintings—handscrolls or folding albums designed to be appreciated in private settings.

At the beginning of the eleventh century, the lady-in-waiting Lady Murasaki transposed the lifestyle of Heian aristocrats into fiction for the amusement of her fellow court ladies in *The Tale of Genji*, which some consider the world's first novel. Still today the Japanese admire this tale of 54 chapters as the pinnacle of Japanese

A CLOSER LOOK | *The Tale of Genji*

Scene from the Kashiwagi chapter.
Heian period, 12th century CE. Handscroll with ink and colors on paper, 8⅝″ × 18⅞″ (21.9 × 47.9 cm).
Tokugawa Art Museum, Nagoya. National Treasure.

Only 19 illustrated scenes from this earliest known example of an illustrated handscroll of *The Tale of Genji*, created about 100 years after the novel was written, have been preserved. Scholars assume that it once contained illustrations from the entire novel of 54 chapters, approximately 100 pictures in all. Each scroll seems to have been produced by a team of artists. One was the calligrapher, most likely a member of the nobility. Another was the master painter, who outlined two or three illustrations per chapter in fine brushstrokes and indicated the color scheme. Next, colorists went to work, applying layer after layer of color to build up patterns and textures. After they had finished, the master painter returned to reinforce outlines and apply the finishing touches, among them the details of the faces.

Thickly applied mineral colors are now cracking and flaking.

A "line for an eye, hook for a nose" style is used for facial features.

The building interior is seen from a bird's-eye perspective via a "blown-away roof".

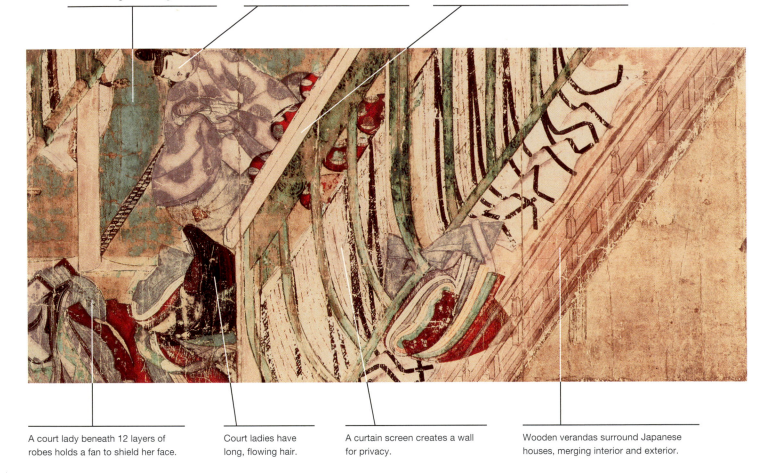

A court lady beneath 12 layers of robes holds a fan to shield her face.

Court ladies have long, flowing hair.

A curtain screen creates a wall for privacy.

Wooden verandas surround Japanese houses, merging interior and exterior.

View the Closer Look for *The Tale of Genji* on myartslab.com

literary achievement (in 2009, the official 1,000-year anniversary of its completion, numerous exhibitions and celebrations took place throughout Japan). Underlying the story of the love affairs of Prince Genji and his companions is the Heian conception of fleeting pleasures and ultimate sadness in life, an echo of the Buddhist view of the vanity of earthly pleasures.

YAMATO-E HANDSCROLLS—*THE TALE OF GENJI* One of the earliest extant examples of secular painting from Japan in a new native style called **yamato-e** (native Japanese-style pictures; Yamato is the old Japanese word for Japan) is an illustrated handscroll depicting a series of scenes from *The Tale of Genji*, painted in the twelfth century. The handscroll alternates sections of text with illustrations of scenes from the story and features delicate lines, strong (but sometimes muted) mineral colors, and asymmetrical compositions. The *Genji* paintings have a refined, subtle emotional impact. They generally show court figures in architectural settings, with the frequent addition of natural elements, such as sections of gardens, that help to convey the mood of the scene. Thus a blossoming cherry tree appears in a scene of happiness, while unkempt weeds appear in a depiction of loneliness. Such correspondences between nature and human

emotion are an enduring theme of Japanese poetry and art. The figures in *The Tale of Genji* paintings do not show their emotions directly on their faces, which are rendered with a few simple lines. Instead, their feelings are conveyed by colors, poses, the fluttering of curtains, and the overall composition of the scenes.

One scene evokes the seemingly happy Prince Genji holding a baby boy borne by his wife, Nyosan. In fact, the baby was fathered by another court noble. Since Genji himself has not been faithful to Nyosan—whose appearance is only implied by the edge of her clothing seen to Genji's left—he cannot complain; meanwhile the true father of the child has died, unable to acknowledge his only son (see "A Closer Look," opposite). Thus, what should be a joyful scene has undercurrents of irony and sorrow. The irony is even greater because Genji himself is the illegitimate son of an emperor.

Steeped in the Western tradition, we might expect a painting of such an emotional scene to focus on the people involved. Instead, the human participants are rendered here rather small in size, and the scene is dominated by a wall hung with curtains and blinds that effectively squeezes Genji and his wife into a corner, their space even further restricted at the top by the frame. It is the composition, not facial expression or bodily posture, that conveys how their positions in courtly society have forced them into this unfortunate situation.

12–13 • BOOK PAGE FROM THE ISHIYAMA-GIRE (DISPERSED VOLUMES, ONCE OWNED BY THE ISHIYAMA TEMPLE, OF THE ANTHOLOGY OF THE THIRTY-SIX IMMORTAL POETS)

Heian period, early 12th century CE. Ink with gold and silver on decorated and collaged paper, 8″ × 6⅜″ (20.6 × 16.1 cm). Freer Gallery of Art, Smithsonian Institution, Washington, DC. (F1969.4)

CALLIGRAPHY IN JAPANESE The text portions of the *The Tale of Genji* handscroll were written in *kana* script, which was also used to write poetry in Japanese. In the Heian period, the most significant form of native poetry was a 31-syllable format known as *waka*, which had first been composed earlier than the eighth century. During the Heian era, the finest *waka* by various writers were collected together and hand-copied in albums, the most popular of which featured writers collectively known as the Thirty-Six Immortal Poets, an anthology still appreciated by educated Japanese today. The earliest of many surviving examples of this iconic collection originally contained 39 volumes of poems. Two volumes were taken apart and sold in 1929, and now survive in single-page sections (**FIG. 12–13**). Collectively these separated volumes are known as the *Ishiyama-gire* (Ishiyama fragments, named after Ishiyamadera, the temple that originally owned the volumes).

With its simple, flowing letters, characters, or syllables, interspersed occasionally with more complex Chinese characters, this style of writing gave a distinctive asymmetrical balance to the appearance of the written words. In these pages, the poems seem to float elegantly on fine dyed papers decorated with painting, block printing, scattered sheets and particles of gold and silver, and

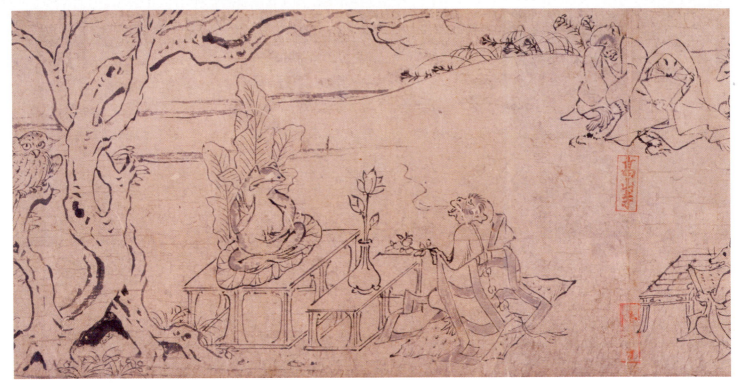

12-14 • Attributed to Toba Sojo SCENE FROM FROLICKING ANIMALS
Heian period, 12th century CE. Handscroll with ink on paper, height 12" (30.5 cm). Kozanji, Kyoto. National Treasure.

sometimes paper collage. Often, as in FIGURE 12-13, the irregular pattern of torn paper edges adds a serendipitous element. The page shown here reproduces two verses by the eighth-century courtier Ki no Tsurayuki that express melancholy emotions. One reads:

> Until yesterday
> I could meet her,
> But today she is gone—
> Like clouds over the mountain
> She has been wafted away.

The spiky, flowing calligraphy and the patterning of the papers, the rich use of gold, and the suggestions of natural imagery match the elegance of the poetry, epitomizing courtly Japanese taste.

YAMATO-E HANDSCROLLS—*FROLICKING ANIMALS* In its sedate and sophisticated portrayal of courtly life, *The Tale of Genji* scroll represents one side of *yamato-e*. But another style of native painting emerged contemporaneously. Characterized by bold, confident strokes of the brush, and little if any use of color, it depicted subjects outside the court, in playful and irreverent activities. One of the early masterpieces of this style is a set of handscrolls known as *Frolicking Animals* (*Choju Giga*) that satirizes human behavior through animal antics. Freely executed entirely in black ink, the humorous parodies are attributed to Toba Sojo (1053–1140), abbot of a Buddhist monastery.

In one particularly amusing scene, a monkey—robed as a monk preoccupied with the passionate incantations that emerge

from his gaping mouth like wisps of smoke—offers a peach branch on an altar, behind which is a frog, posed as a buddha enthroned on a lotus leaf (**FIG. 12-14**). Behind this monkey-monk is an assembly of animals—rabbits, monkey, foxes, and frog—representing monastic and secular worshipers, some bored and distracted, others focusing on their prayers, which are either read from texts or guided by the Buddhist prayer beads clutched in their hands. Although unlike the *Genji* scroll there is no accompanying text to *Frolicking Animals*, making it difficult to know exactly what was being satirized, the universality of the humorous antics portrayed has made it continually engaging to viewers everywhere.

KAMAKURA PERIOD

The courtiers of the Heian era seem to have become so engrossed in their own refinement that they neglected their responsibilities for governing the country. At the same time clans of warriors—samurai—from outside the capital grew increasingly strong. Two of these, the Taira and Minamoto, were especially powerful and took opposing sides in the factional conflicts of the imperial court, in order to control the weakened emperor and take charge of the government.

The Kamakura era (1185–1333) began when the head of the Minamoto clan, Yoritomo (1147–1199), defeated the Taira family and ordered the emperor to appoint him as shogun (general-in-chief). To resist what he perceived as the softening effects of courtly life in Kyoto, he established his military capital in Kamakura, while

Battles such as the one depicted in *Night Attack on the Sanjo Palace* (see FIG. 12–15) were fought largely by archers on horseback. Samurai archers charged the enemy at full gallop and loosed their arrows just before they wheeled away. The scroll clearly shows their distinctive bow, with its asymmetrically placed handgrip. The lower portion of the bow is shorter than the upper so it can clear the horse's neck. The samurai wear long, curved swords at their waists.

By the tenth century, Japanese swordsmiths had perfected techniques for crafting their legendarily sharp swords. Sword-makers face a fundamental difficulty: steel hard enough to hold a razor-sharp edge is brittle and breaks easily, but steel resilient enough to withstand rough use is too soft to hold a keen edge. The Japanese ingeniously forged a blade which laminated a hard cutting edge within less brittle support layers.

The earliest form of samurai armor, illustrated here, known as *yoroi*, was intended for use by warriors on horseback, as seen in FIGURE 12–15. It was made of overlapping iron and lacquered leather scales, punched with holes and laced together with leather thongs and brightly colored silk braids. The principal piece wrapped around the chest, left side, and back. Padded shoulder straps hooked it together back to front. A separate piece of armor was tied to the body to protect the right side. The upper legs were protected by a four-sided skirt that attached to the body armor, while two large rectangular panels tied on with cords guarded the arms. The helmet was made of iron plates riveted together. From it hung a neckguard flared sharply outward to protect the face from arrows shot at close range as the samurai wheeled away from an attack.

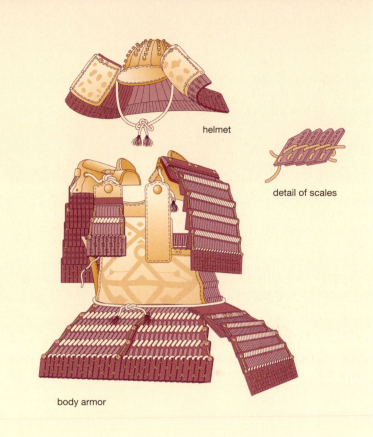

helmet

detail of scales

body armor

the emperor continued to reside in Kyoto. Although Yoritomo's newly invented title of shogun nominally respected the authority of the emperor, at the same time it assured him of supreme military and political power. The shogunate initiated by Yoritomo endured in various forms until 1868.

A BATTLE HANDSCROLL The battles for domination between the Minamoto and the Taira became famous not only in medieval Japanese history but also as subjects in literature and art. One of the great painted handscrolls depicting these battles is **NIGHT ATTACK ON THE SANJO PALACE** (**FIG. 12-15**). Though it was painted perhaps a century after the actual event, the artist conveyed the sense of eye-witness reporting even though imagining the scene from verbal—at best semifactual—descriptions. The style of the painting includes some of the brisk and lively linework of *Frolicking Animals* and also aspects of the more refined brushwork, use of color, and bird's-eye viewpoint of *The Tale of Genji* scroll. The relentless focus, however, is on the dynamic depiction of the savagery of warfare across expansive lateral compositions (see "Arms and Armor," above). Unlike the *Genji* scroll, *Night Attack* is full of action: flames engulf the palace, horses charge, warriors behead their enemies, court ladies try to hide. The sense of energy and violence is pervasive, conveyed with sweeping power. There

is no trace here of courtly poetic refinement and melancholy; the new world of the samurai is dominating the secular arts.

PURE LAND BUDDHIST ART

By the beginning of the Kamakura period, Pure Land Buddhist beliefs had swept throughout Japan, and several charismatic priests founded new sects to promote this ideology. They traveled throughout the country, spreading the new gospel in ways that appealed to people of all levels of education and sophistication. They were so successful that since the Kamakura period, Pure Land Buddhist sects have remained the most popular form of Buddhism in Japan.

A PORTRAIT SCULPTURE The itinerant monk Kuya (903–972), famous for urging country folk to join him in singing chants in praise of the Buddha Amida, was one of the early proponents of Pure Land practices. Kamakura-period Pure Land Buddhist followers—who regarded this Heian-period monk as a founder of their religious tradition—would have immediately recognized Kuya in this thirteenth-century portrait statue by Kosho (**FIG. 12-16**). The traveling clothes, the small gong, the staff topped by deer horns (it was after slaying a deer that he was converted to Buddhism), are attributes that clearly identify the monk, whose

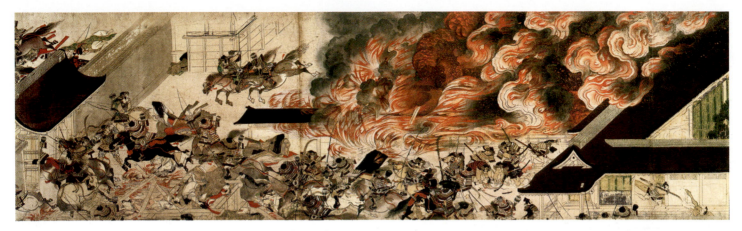

12–15 • SECTION OF NIGHT ATTACK ON THE SANJO PALACE
Kamakura period, late 13th century CE. Handscroll with ink and colors on paper, 16¼″ × 23′ (41.3 cm × 7 m). Museum of Fine Arts, Boston. Fenollosa-Weld Collection (11.4000)

The battles between the Minamoto and Taira clans were fought primarily by mounted and armored warriors, who used both bows and arrows, and the finest swords. In the year 1160, some 500 Minamoto rebels opposed to the retired emperor Go-Shirakawa carried out a daring raid on the Sanjo Palace. In a surprise attack in the middle of the night, they abducted the emperor. The scene was one of great carnage, much of it caused by the burning of the wooden palace. Despite the drama of the scene, this was not the decisive moment in the war. The Minamoto rebels would eventually lose more important battles to their Taira enemies. Yet the Minamoto heirs to those who carried out this raid would eventually prove victorious, destroying the Taira clan in 1185.

sweetly intense expression gives this sculpture a radiant sense of faith. As for Kuya's chant, Kosho's solution to the challenge of putting words into sculptural form was simple but brilliant: He carved six small buddhas emerging from Kuya's mouth, one for each of the six syllables of *Na-mu-A-mi-da-Bu(tsu)* (the final syllable *tsu* is not articulated). Believers would have understood that these six small buddhas embodied the Pure Land chant.

RAIGO PAINTINGS Pure Land Buddhism taught that even one sincere invocation of the sacred chant could lead the most wicked sinner to the Western Paradise. Popular paintings called **raigo** ("welcoming approach") depicted the Amida Buddha, accompanied by bodhisattvas, coming down to earth to welcome the soul of the dying believer. Golden cords were often attached to these paintings, which were taken to the homes of the dying. A person near death held onto these cords, hoping that Amida would escort the soul directly to paradise.

Raigo paintings differ significantly in style from the complex *mandalas* and fierce guardian deities of Esoteric Buddhism. The earliest-known example of this subject is found on the walls and doors of the Phoenix Hall, surrounding Jocho's sculpture of Amida (see FIG. 12–12). Like that statue, they radiate warmth and compassion. In the Kamakura period, *raigo* paintings were made in great numbers, reflecting the popularity of Pure Land Buddhism at

12–16 • Kosho KUYA PREACHING
Kamakura period, before 1207 CE. Painted wood with inlaid eyes, height 46½″ (117.5 cm). Rokuhara Mitsuji, Kyoto. Important Cultural Property.

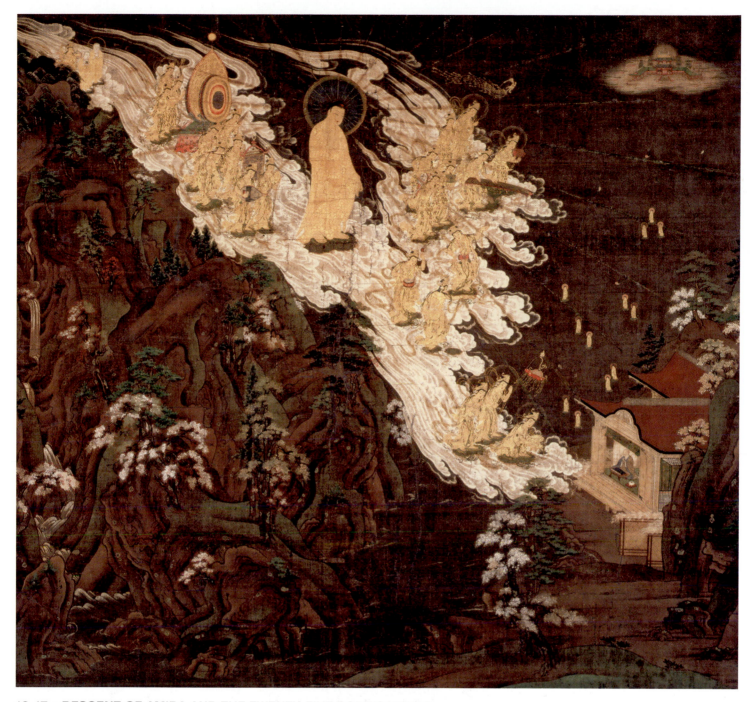

12–17 • DESCENT OF AMIDA AND THE TWENTY-FIVE BODHISATTVAS
Kamakura period, 13th century CE. Hanging scroll with colors and gold on silk, 57¼″ × 61½″ (145 × 155.5 cm).
Chionin, Kyoto. National Treasure.

that time. One magnificent example portrays Amida Buddha and 25 bodhisattvas swiftly descending over mountains (**FIG. 12–17**). The artist used gold paint and thin slivers of gold leaf cut in elaborate patterning to suggest the divine radiance of the deities. This painstaking cut-gold leaf technique, known as *kirikane*, is one of the great achievements of early Japanese Buddhist artists. It originated in China, but Japanese artists refined and perfected it. In this painting, the darkened silk behind the figures heightens the sparkle of their golden aura. In the flickering light of oil lamps and torches,

raigo paintings would have appeared magical, whether in a temple or in a dying person's home.

One of the most remarkable aspects of this painting is its sensitive rendering of the landscape, full of rugged peaks and flowering trees. Perhaps this emphasis on the natural setting derives from a traditional Japanese appreciation for the beautiful land in which they dwelled, an appreciation that may stem from Shinto beliefs. In fact, Shinto pictures portraying the landscape of Japan as divine first appeared in the Kamakura period, just when Pure Land

Chan (called Zen in Japan) monks modeled their behavior on that of the patriarch or founder of their lineage, the mythical Indian Buddhist sage Daruma (Bodhidharma in Sanskrit), who emigrated to China in the sixth century CE and famously transmitted his teachings to a Chinese disciple, who became the second Chan patriarch. This portrait of **DARUMA** (**FIG. 12–18**) is one of the earliest surviving examples of a Japanese Zen painting. Using fine ink outlines and a touch of color for the robe and the figure's sandals, the artist portrays the Chan master seated meditating atop a rock, with an unwavering, focused gaze that is intended to convey his inner strength and serenity. At the top of the scroll is an inscription in Chinese by Yishan Yining (1247–1317), one of several influential early Chinese Chan masters to emigrate to Japan. He had actually planned only to visit Japan in his role as head of an official diplomatic delegation from China in 1299, but he stayed for the remainder of his life. Although the Japanese were wary of him at first, his sincere intentions to teach Chan and his erudite abilities quickly attracted influential supporters, to whom he taught Chinese religious practices and cultural traditions. Thus soon after arrival, Yishan was appointed as the tenth head abbot of the large Zen temple of Kenchoji in Kamakura, a post he held briefly before moving on to head several other Zen temples.

Kenchoji had been founded in 1253 by another emigrant Chan master, Lanxi Daolong (1213–1278). Lanxi had been the first Chan master to travel to Japan. There, he was warmly received by the fifth Minamoto shogun who helped him plan construction of Kenchoji where, for the first time, authentic Chinese Chan Buddhism was to be taught in Japan. Kenchoji remains one of the most important Zen monasteries in Japan today. The temple owns many formal portraits of its founder, including this one (**FIG. 12–19**), considered by many to be the best, in that it seems to capture Daolong's inner spirit as well as his outer form. This type of painting is peculiar to Chan and Zen sects and is known as *chinso*. These paintings were often gifts given by a master to disciples when they completed their formal training and departed his presence to officiate at their own temples. They served as personal reminders of their master's teachings and tangible evidence (like a diploma) of their right to transmit Zen teachings to their own pupils. Lanxi Daolong dedicated the inscription of this painting to an important regent (samurai official), a confidant of the shogun, and not an ordained Zen monk. This shows that Zen, from its early days in Japan, also strove to attract followers from among those in power who could not abandon their secular life for the rigorous, cloistered existence required of Zen monks who lived in temples.

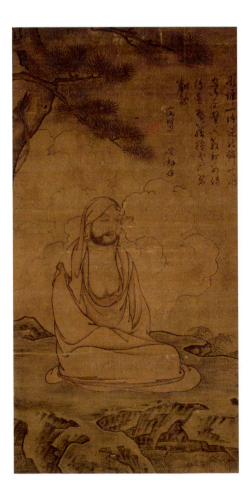

12–18 • DARUMA
Artist unknown, inscription by Chinese Chan (Zen) master Yishan Yining (1247–1317). Kamakura period, early 14th century CE. Hanging scroll with ink and colors on silk, 39⅝″ × 20″ (100.8 × 50.8 cm). Tokyo National Museum. Important Cultural Property.

12–19 • PORTRAIT OF THE CHINESE CHAN MASTER LANXI DAOLONG
Inscription by Lanxi Daolong. Kamakura period, dated 1271 CE. Hanging scroll with colors on silk, 41⅓″ × 18″ (105 × 46.1 cm). Kenchoji, Kamakura. National Treasure.

Buddhism grew in popularity. One of these paintings is the Kasuga Shrine *mandala* of FIGURE 12-1, demonstrating how Kamakura artists represented the merging of the two faiths of Buddhism and Shinto. The artist of this work made the shrine buildings resemble those of the palatial abode of Amida in his Western Paradise and rendered the landscape details with the radiant charm of Amida's heaven.

ZEN BUDDHIST ART

Toward the latter part of the Kamakura period, Zen Buddhism was introduced to Japan from China where it was already highly developed and known as Chan. Zen had been slow to reach Japan because of the interruption of relations between the two countries during the Heian period. But during the Kamakura era, both emigrant Chinese (see "Daruma, Founder of Zen," opposite) and Japanese monks—who went to China to study Buddhism and returned home enthused about the new teachings they learned there—brought Zen to Japan. The monk Kuya, represented in the statue by Kosho (see FIG. 12-16), epitomized the itinerant life of a Pure Land Buddhist monk who wandered the countryside and relied on the generosity of believers to support him. Zen monks lived very differently. They secluded themselves in monasteries, leading an austere life of simplicity and self-responsibility.

In some ways, Zen resembles the original teachings of the historical Buddha: it emphasizes individual enlightenment through meditation, without the help of deities or magical chants. It especially appealed to the self-disciplined spirit of samurai warriors, who were not satisfied with the older forms of Buddhism connected with the Japanese court. Zen was the last major form of Buddhism to reach Japan from the Asian mainland and it had a profound and lasting impact on Japanese arts and culture.

Just as the *Night Attack* (see FIG. 12-15) reveals a propensity for recording the consequences of political turbulence by representing gruesome and detailed battle scenes in vivid colors, Kamakura-era Buddhist sculpture and painting also emphasized realism. Various factors account for this new taste. Society was dominated by samurai warriors, who possessed a more pragmatic outlook on the world than the Heian-period courtiers, who had lived a dream-like, insular existence at court. In addition, renewed contacts with China introduced new styles for Buddhist art that also emphasized lifelike portrayal. Finally, forging personal connections with heroic exploits and individuals—both past and present, political and religious—greatly concerned the people of the Kamakura period. Representing these figures in arresting pictorial and sculpted images helped reinforce legends and perpetuate their influence, which accounts for the predominance of these subjects at this time.

As the Kamakura era ended, the seeds of the future were planted both politically and culturally. The coming age witnessed the nation's continued dominance by the warrior class and the establishment of Zen as the religion of choice among those warriors who wielded power at the highest levels. As before, the later history of Japanese art continued to be marked by an intriguing interplay between native traditions and imported foreign tendencies.

THINK ABOUT IT

12.1 Discuss the influence of Chinese art on the early Japanese Buddhist complex at Horyuji, referring to Chapter 11 as necessary.

12.2 Compare the Heian-period Womb World *Mandala* (FIG. 12-10) with the Kamakura-period *Descent of Amida and the Twenty-Five Bodhisattvas* (FIG. 12-17). How do these pictures embody the specific type of Buddhism from which each emerged? How would they have been used by believers?

12.3 Discuss a work of art in this chapter that combines aspects of the foreign traditions of Buddhism with native Shinto traditions. How do the artists blend the disparate traditions? How would the blending affect the way the work functioned within a religious context?

12.4 Characterize and compare one representative secular work of art from Heian courtly culture with one from the warrior culture that replaced it during the Kamakura period. How do these works relate to the political climates of these two distinct eras in early Japanese history?

CROSSCURRENTS

FIG. 6–48

These two works of art proclaim political power by documenting military conquest, but they chose vastly different media and contexts to accomplish this goal. How do the distinctions between these battle narratives relate to the cultural context that gave rise to each? Be sure to consider the viewing context when forming your answer.

FIG. 12–15

✓—**Study** and review on myartslab.com

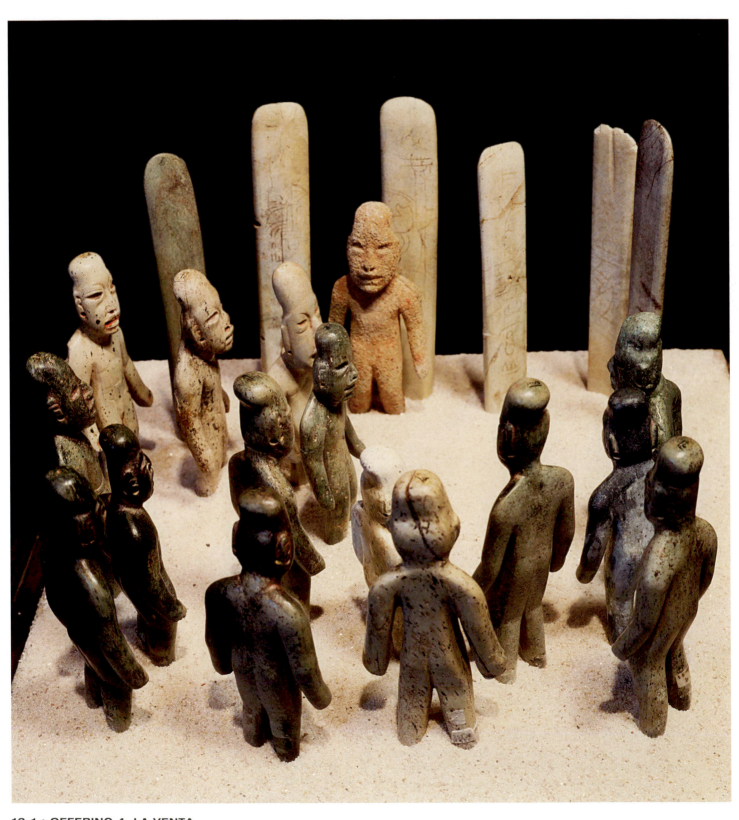

13–1 • OFFERING 4, LA VENTA
Mexico. Olmec culture, c. 900–400 BCE. Jade, greenstone, granite, and sandstone, height of figures 6¼″–7″ (16–18 cm).
Museo Nacional de Antropología, Mexico City.

Art of the Americas before 1300

The scene hints at a story in progress (**FIG. 13-1**). Fifteen figures of precious greenstone converge on a single figure made of a baser, more porous stone. The tall oblong stones (**celts**) in the background evoke an architectural space, perhaps a location within the Olmec center of La Venta (Mexico), where this tableau was created sometime between 900 and 400 BCE. The figures have the slouching bodies, elongated heads, almond-shaped eyes, and down-turned mouths characteristic of Olmec art. Holes for earrings and the simple lines of the bodies suggest that these sculptures may originally have been dressed and adorned with perishable materials. The poses of the figures, with their knees slightly bent and their arms flexed at their sides, lend a sense of arrested movement to this enigmatic scene. Is it a council? A trial? An initiation? Are the greenstone figures marching in front of the reddish granite figure as he reviews them, or moving to confront him? With no texts to explain the scene, the specific tale it narrates may never be known, but it is clear that this offering commemorates an important event.

And it was remembered. This tableau was set up in the earth and buried underneath a plaza at La Venta, one of a number of offerings of works of art and precious materials beneath the surface of the city. Colored sand and floors covered the offerings, each colored floor signifying a successive renovation of the plaza. Over a century after these sculptures were buried, a hole was dug directly over the offering and it was viewed once more. Pieces of the later floors fell into the hole, but the figures themselves were not disturbed. After this, the scene was buried once again. The precision of this later excavation suggests that the exact location of the tableau was remembered. The archaeological record assures us that this work of art, although hidden, still exerted tremendous power.

This extraordinary find demonstrates the importance of scientific archaeological excavations for understanding ancient art. Had these objects been torn out of the ground by looters and sold piecemeal on the black market, we might never have known how Olmec sculptures were used to create narrative installations or imagined that buried art could be remembered for so long. Instead, this discovery provides a context for isolated greenstone figures that have been found throughout Mesoamerica (modern Mexico, Guatemala, and Honduras). It provides evidence that all these sculptures were made by the Olmec, Mesoamerica's first great civilization, and suggests that these objects, scattered today, might have once been assembled in meaningful ways like the offering at La Venta.

LEARN ABOUT IT

13.1 Compare the various ways the ancient artists of the Americas represented the human figure.

13.2 Recognize themes and symbols specific to individual ancient American cultures as well as instances of commonalities across time and geography.

13.3 Explore how an understanding of the ritual use or practical function of an object is critical to evaluating its meaning in ancient American visual arts.

13.4 Recognize how differences in environmental conditions affected the urban planning and architectural design of Mesoamerican, South American, and North American communities.

((•—[**Listen** to the chapter audio on myartslab.com

THE NEW WORLD

In recent years the question of the original settlement of the Americas has become an area of debate. The traditional view has been that human beings arrived in North and South America from Asia during the last Ice Age, when glaciers trapped enough of the world's water to lower the level of the oceans and expose a land bridge across the Bering Strait. Although most of present-day Alaska and Canada was covered by glaciers at that time, an ice-free corridor along the Pacific coast would have provided access from Asia to the south and east. Thus, this theory holds that sometime before 12,000 years ago, perhaps as early as 20,000 to 30,000 years ago, Paleolithic hunter-gatherers emerged from this corridor and began to spread out into two vast, uninhabited continents. This view is now challenged by the early dates of some new archaeological finds and by evidence suggesting the possibility of early connections with Europe as well, perhaps along the Arctic coast of the North Atlantic. Recently, some have suggested that Pacific Islanders could have sailed to the coast of Chile and spread out from there. In any event, by between 10,000 and 12,000 years ago, bands of hunters roamed throughout the Americas, and after the ice had retreated, the peoples of the Western Hemisphere were essentially cut off from the rest of the world until they were overrun by European invaders, beginning at the end of the fifteenth century CE.

In this isolation, the peoples of the Americas experienced cultural transformations similar to those seen elsewhere around the world following the end of the Paleolithic era. In most regions they developed an agricultural way of life. A trio of native plants—corn, beans, and squash—was especially important, but people also cultivated potatoes, tobacco, cacao, tomatoes, and avocados. New World peoples also domesticated many animals: dogs, turkeys, guinea pigs, llamas, and their camelid cousins—alpacas, guanacos, and vicuñas.

As elsewhere, the shift to agriculture in the Americas was accompanied by population growth and, in some places, the rise of hierarchical societies, the appearance of ceremonial centers and towns with monumental architecture, and the development of sculpture, ceramics, and other arts. The people of Mesoamerica—the region that extends from central Mexico well into Central America—developed writing, astronomy, a complex and accurate calendar, and a sophisticated system of mathematics. Central and South American peoples had advanced metallurgy and produced exquisite gold, silver, and copper objects. The metalworkers of the Andes, the mountain range along the western coast of South America, began to produce metal jewelry, weapons, and agricultural implements in the first millennium CE, and people elsewhere in the Americas made tools, weapons, and art from other materials such as bone, ivory, stone, wood, and, where it was available, obsidian, a volcanic glass capable of a cutting edge 500 times finer than surgical steel. Basketry and weaving became major art forms. The inhabitants of the American Southwest built multi-storied, apartmentlike village and cliff dwellings, as well as elaborate irrigation systems with canals. Evidence of weaving in the American Southwest dates to about 7400 BCE.

Extraordinary artistic traditions flourished in many regions in the Americas before 1300 CE. This chapter explores the accomplishments of selected cultures in five of those areas: Mesoamerica, Central America, the central Andes of South America, the Southeastern Woodlands and great river valleys of North America, and the North American Southwest.

MESOAMERICA

Ancient Mesoamerica encompasses the area from north of the Valley of Mexico (the location of Mexico City) to present-day Belize, Honduras, and western Nicaragua in Central America (**MAP 13–1**). The region is one of great contrasts, ranging from tropical rainforest to semiarid mountains. The civilizations that arose in Mesoamerica varied, but they were linked by cultural similarities and trade. Among their shared features were a ballgame with religious and political significance (see "The Cosmic Ballgame," page 395), aspects of monumental building construction, and a complex system of multiple calendars including a 260-day divinatory cycle and a 365-day ritual and agricultural cycle. Many Mesoamerican societies were sharply divided into elite and commoner classes.

The transition to farming began in Mesoamerica between 7000 and 6000 BCE, and by 3000 to 2000 BCE settled villages were widespread. Customarily the region's subsequent history is divided into three broad periods: Formative or Preclassic (1500 BCE–250 CE), Classic (250–900 CE), and Postclassic (900–1521 CE). This chronology derives primarily from the archaeology of the Maya—the people of Guatemala, southern Mexico, and the Yucatan Peninsula—with the Classic period bracketing the era during which the Maya erected dated stone monuments. As with the study of ancient Greek art, the term "Classic" reflects the view of early scholars that this period was a kind of golden age. Although this view is no longer current—and the periods are only roughly applicable to other cultures of Mesoamerica—the terminology has endured.

THE OLMEC

The first major Mesoamerican art style, that of the Olmec, emerged during the Formative/Preclassic period, beginning around 1500 BCE. Many of the key elements of Mesoamerican art, including monumental stone sculpture commemorating individual rulers, finely carved jades, elegant ceramics, and architectural elements such as pyramids, plazas, and ballcourts, were first developed by the Olmec. In the fertile, swampy coastal areas of the present-day Mexican states of Veracruz and Tabasco, the Olmec raised massive earth mounds on which they constructed ceremonial centers. These centers probably housed an elite group of rulers and priests supported by a larger population of farmers who lived in villages of pole-and-thatch houses. The presence at Olmec sites of goods

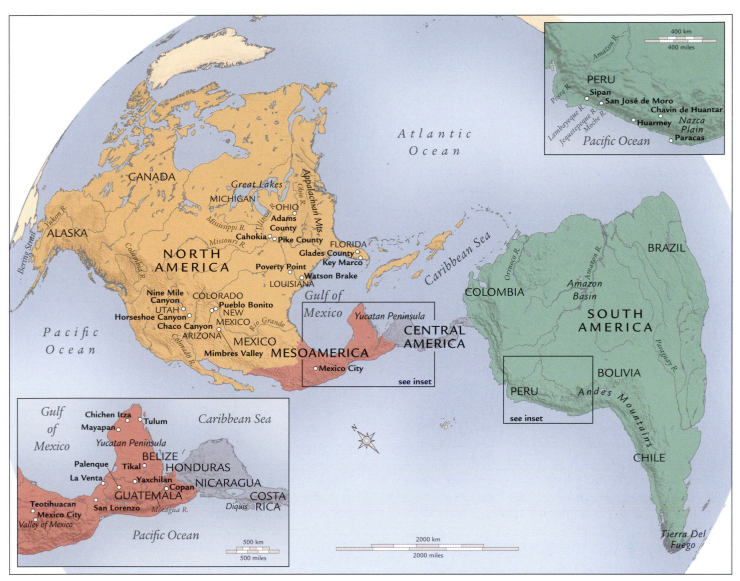

MAP 13–1 • THE AMERICAS BEFORE 1300

Human beings moved across North America, then southward through Central America until they eventually reached the Tierra del Fuego region of South America.

such as obsidian, iron ore, and jade that are not found in the Gulf of Mexico region but come from throughout Mesoamerica indicates that the Olmec participated in extensive long-distance trade. They went to especially great lengths to acquire jade, which was one of the most precious materials in ancient Mesoamerica.

The earliest Olmec ceremonial center (c. 1200–900 BCE), at San Lorenzo, was built atop a giant earthwork, nearly three-quarters of a mile long, with an elaborate stone drainage system running throughout the mound. Other architectural features included a palace with basalt columns, a possible ballcourt, and a stone-carving workshop. Another center, at La Venta, thriving from about 900 to 400 BCE, was built on high ground between rivers. Its most prominent feature, an earth mound known as the **GREAT PYRAMID**, still rises to a height of over 100 feet (**FIG. 13-2**), and, like ancient pyramids in Egypt, those in Mesoamerica seem to have been envisioned as artificial sacred mountains, linked

to creation stories and cultural cosmology. The La Venta pyramid stands at the south end of a large, open plaza arranged on a north–south axis and defined by long, low earth mounds. Many of the physical features of La Venta—including the symmetrical arrangement of earth mounds, platforms, and central open spaces along an axis that was probably determined by astronomical observations—are characteristic of later monumental and ceremonial architecture throughout Mesoamerica. What was buried beneath the surface of La Venta—massive stone mosaics, layers of colored clay, and greenstone figures like those in FIGURE 13-1, discussed at the beginning of the chapter—may have been as important as what was visible on the surface.

The Olmec produced an abundance of monumental basalt sculpture, including **COLOSSAL HEADS** (**FIG. 13-3**), altars, and seated figures. The huge basalt blocks for the large works of sculpture were quarried at distant sites and transported to San

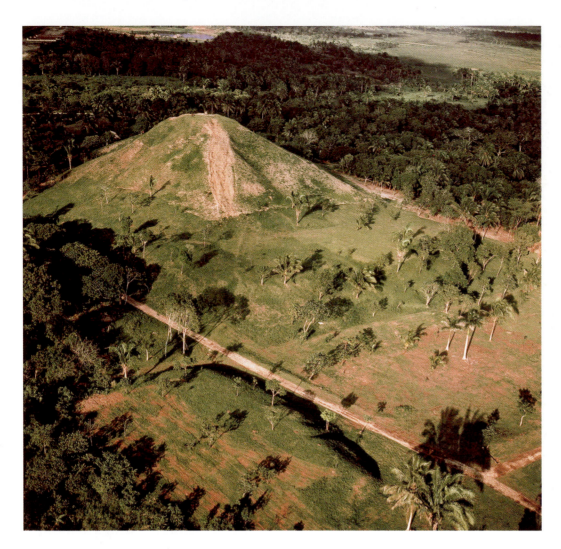

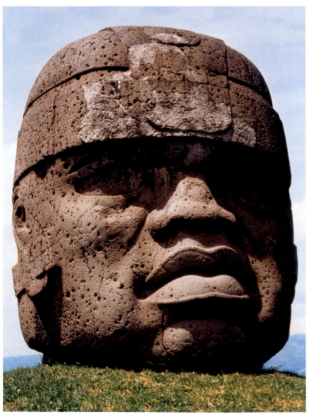

13-3 • COLOSSAL HEAD, SAN LORENZO
Mexico. Olmec culture, c. 1200–900 BCE. Basalt, height 7′5″ (2.26 m).

Lorenzo, La Venta, and other centers. Colossal heads ranged in height from 5 to 12 feet and weighed from 5 to more than 20 tons. The heads portray adult males wearing close-fitting caps with chin straps and large, round earspools (cylindrical earrings that pierce the earlobe). The fleshy faces have almond-shaped eyes, flat broad noses, thick protruding lips, and down-turned mouths. Since each face is different, they may represent specific individuals. Ten colossal heads were found at San Lorenzo, where many had been mutilated and buried by about 900 BCE, when the site went into decline. At La Venta, 102 basalt monuments have been found, including four more colossal heads, massive thrones or altars, tall stone stelae (upright slabs), and other kinds of figural sculpture. The colossal heads and the subjects depicted on other monumental sculpture suggest that the Olmec elite were interested in commemorating rulers and historic events.

In addition to these heavy basalt monuments, Olmec artists also made smaller, more portable jade and ceramic objects (see FIG. 13–1). Jade, available only from the Motagua River Valley in present-day Guatemala, was prized for its brilliant blue-green color and the smooth, shiny surfaces it could achieve with careful polishing. Its green hue and its natural appearance in

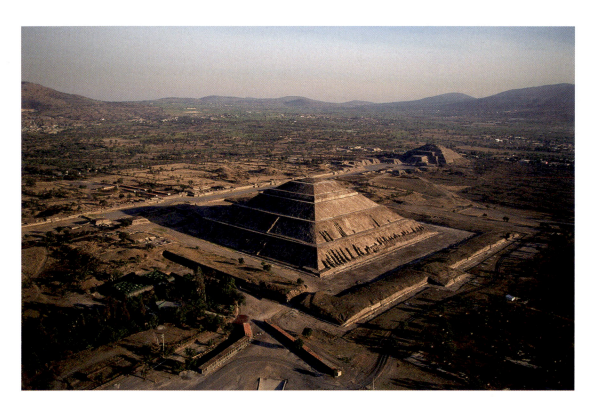

13-4 • CEREMONIAL CENTER OF THE CITY OF TEOTIHUACAN

Mexico. Teotihuacan culture, c. 100–650 CE. View from the southeast. The Pyramid of the Sun is in the foreground, and the Pyramid of the Moon is visible in the distance. The Avenue of the Dead, the north–south axis of the city, which connects the two pyramids, continues for over a mile.

👁 **Watch** an architectural simulation about the ceremonial center of Teotihuacan on myartslab.com

stream beds made it a symbol of fertility. Jade is one of the hardest materials in Mesoamerica, and, with only stone tools available, Olmec craftsmakers used jade tools and powdered jade dust as an abrasive to carve and polish these sculptures. Other figurines were made out of softer and more malleable greenstones, like serpentine, which occur in many parts of Mesoamerica. Olmec ceramics, including decorated vessels and remarkably lifelike clay babies, also appear to have been prized far beyond the Olmec heartland. Olmec greenstone and ceramic objects have been found throughout Mesoamerica, evidence of the extensive reach and influence of Olmec art and culture.

By 200 CE, forests and swamps had begun to reclaim Olmec sites, but since Olmec civilization had spread widely throughout Mesoamerica, it would have an enduring influence on its successors. As the Olmec centers of the Gulf Coast faded, the great Classic period centers in the Maya region and Teotihuacan area in the Valley of Mexico were beginning their ascendancy.

TEOTIHUACAN

Located some 30 miles northeast of present-day Mexico City, the city of Teotihuacan experienced a period of rapid growth early in the first millennium CE. By 200 CE, it had emerged as Mesoamerica's first truly urban settlement, a significant center of commerce and manufacturing. At its height, between 300 and 650, Teotihuacan covered nearly nine square miles and had a population of at least 125,000, making it the largest city in the Americas and one of the largest in the world at that time (FIG. 13-4). Its residents lived in walled "apartment compounds," and the entire city was organized on a grid (FIG. 13-5), its orientation chosen both for its calendrical significance and to respond to the surrounding landscape.

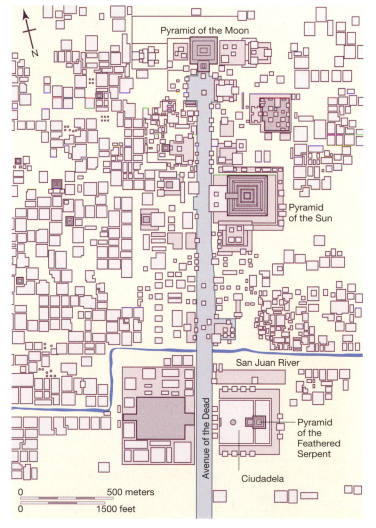

Pyramid of the Moon

Pyramid of the Sun

San Juan River

Avenue of the Dead

Pyramid of the Feathered Serpent

Ciudadela

0 500 meters
0 1500 feet

13-5 • PLAN OF THE CEREMONIAL CENTER OF TEOTIHUACAN

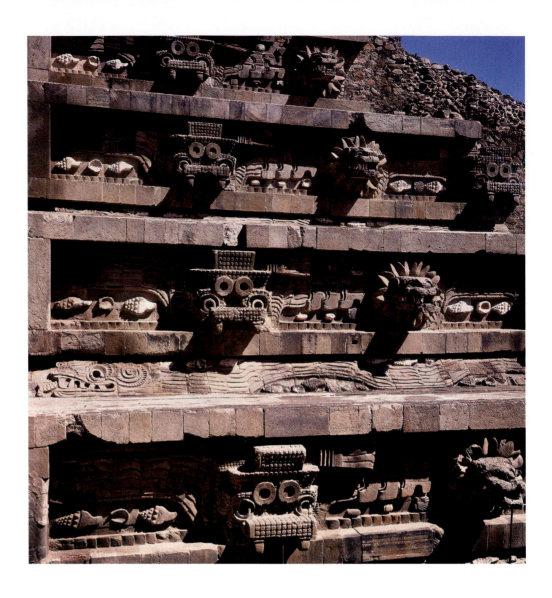

13-6 • PYRAMID OF THE FEATHERED SERPENT
The Ciudadela, Teotihuacan, Mexico.
Teotihuacan culture, c. 200 CE.

Although Teotihuacan declined in power after 650, it was never forgotten. Centuries later, it remained a legendary pilgrimage center. The much later Aztec people (c. 1300–1525) revered the site, believing it to be the place where the gods created the sun and the moon. In fact, Teotihuacan, a word indicating a place of divinity, is the Aztec name for the city. The names we use for its principal monuments are also Aztec names. We do not know what the original inhabitants of Teotihuacan called these buildings nor what they called their own city.

The center of the city is bisected by a broad processional thoroughfare laid out on a north–south axis, extending for more than a mile and in places as much as 150 feet wide, which the Aztecs called the Avenue of the Dead. At the center of the Teotihuacan grid, a series of canals forced the San Juan River to run perpendicular to the avenue. At the north end of this central axis stands the Pyramid of the Moon, facing a large plaza flanked by smaller, symmetrically placed platforms. It seems to echo the shape of the mountain behind it, and as one walks toward the pyramid, it looms above, eclipsing the mountain completely. The Pyramid of the Moon was enlarged several times, as were many Mesoamerican pyramids; each enlargement completely enclosed the previous structure and was accompanied by rich sacrificial offerings.

The largest of Teotihuacan's architectural monuments, the Pyramid of the Sun, located just to the east of the Avenue of the Dead, is slightly over 200 feet high and measures about 720 feet on each side at its base, similar in size to, but not as tall as, the largest Egyptian pyramid at Giza. It is built over a multi-chambered cave with a spring that may have been the original focus of worship at the site and its source of prestige. The pyramid rises in a series of sloping steps to a flat platform, where a small temple once stood. A monumental stone stairway led from level to level up the side of the pyramid to the temple platform. The exterior was faced with stone, which was then stuccoed and painted.

At the southern end of the ceremonial center, and at the heart of the city, is the Ciudadela (Spanish for a fortified city center), a vast sunken plaza surrounded by temple platforms. One of the city's principal religious and political centers, the plaza could accommodate an assembly of more than 60,000 people. Early in Teotihuacan's history, its focal point was the **PYRAMID OF THE FEATHERED SERPENT** (FIG. 13-6). This seven-tiered structure exhibits the *talud-tablero* (slope-and-panel) construction that is a

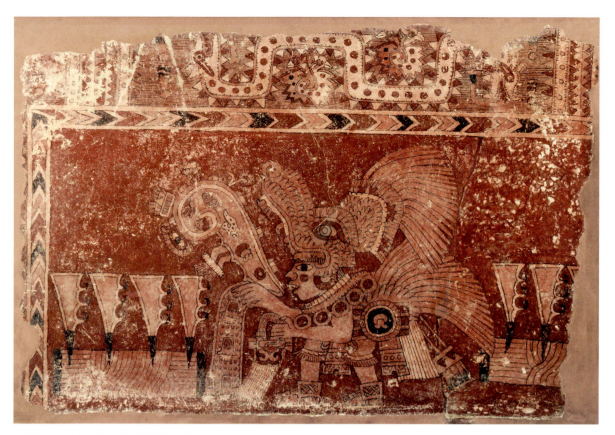

13-7 • BLOODLETTING RITUAL

Fragment of a fresco from Teotihuacan, Mexico. Teotihuacan culture, c. 550–650 CE. Pigment on lime plaster, 32¼″ × 45¼″ (82 × 116.1 cm). The Cleveland Museum of Art. Purchase from the J. H. Wade Fund (63.252)

The maguey (agave) plant supplied the people of Teotihuacan with food, with fiber for making clothing, rope, and paper, and with the precious drink pulque. As this painting indicates, priestly officials used its spikes in rituals to draw their own blood as a sacrifice.

hallmark of the Teotihuacan architectural style. The *talud* (sloping base) of each platform supports a *tablero* (entablature), that rises vertically and is surrounded by a frame.

Archaeological excavations of the temple's early phase have revealed reliefs portraying undulating feathered serpents floating in a watery space punctuated by aquatic shells. Their flat, angular, abstract style, typical of Teotihuacan art, is in marked contrast to the curvilinear, organic forms of Olmec art. While the bodies of the feathered serpents are rendered in low relief, in the vertical *tablero* sections three-dimensional sculptures of fanged serpent heads emerge from aureoles of stylized feathers. Each serpent carries on its body a squarish headdress with a protruding upper jaw, huge, round eyes originally inlaid with obsidian, and a pair of round goggles on its forehead between the eyes. These mosaic headdresses seem to represent an aspect of the Teotihuacan Storm God associated with warfare—other works of art at Teotihuacan and elsewhere in Mesoamerica show armed warriors wearing the same headdress. Inside the pyramid, this militaristic message was reinforced by the burials of dozens of sacrificial victims, some of them wearing necklaces made of human jawbones (or shell imitations thereof), their arms tied behind their backs. In the fourth century, the elaborate sculptural façade of the Pyramid of the Feathered Serpent was concealed behind a plainer *talud-tablero* structure tacked onto the front of the pyramid.

The residential sections of Teotihuacan fanned out from the city's center. The large and spacious palaces of the elite, with as many as 45 rooms and seven patios, stood nearest the ceremonial center. Artisans, foreign traders, and peasants lived farther away, in more crowded compounds, all aligned with the Teotihuacan grid. Palaces and more humble homes alike were rectangular one-story structures with high walls—plastered and covered with paintings—and suites of rooms arranged around open courtyards.

Teotihuacan's artists created wall paintings in a fresco technique, applying pigments directly on damp lime plaster. Once the paint was applied, the walls were polished to give a smooth, shiny, and durable surface. The style, like that of the sculpture, was flat, angular, and abstract, often featuring processions of similarly dressed figures, rows of mythological animals, or other kinds of repeating images. Teotihuacan painters worked in several different color schemes, including a bright polychrome and a more restricted palette emphasizing tones of red. A detached fragment of a wall painting, now in the Cleveland Museum of Art, depicts a **BLOODLETTING RITUAL** (**FIG. 13-7**) in which an elaborately dressed man enriches and revitalizes the earth with his own

Maya writing is logosyllabic—it consists of ideographs or logographs that represent entire words as well as a set of symbols that stand for the sound of each syllable in the Maya language. Thus, a word like *balam* (jaguar) could be written in many different ways: with the logograph "BALAM", a picture of the head of a jaguar (top right); with three syllables, "ba-la-ma," for the sounds of the word *balam* (bottom right); or a combination of the two systems—the logograph "BALAM" complemented with one or more phonetic syllables, to make it clear which logograph was represented (and avoid the possibility of confusing this logograph with the symbol for *hix*, another kind of feline, for example) (middle right). The combination of these two systems allowed Maya scribes extraordinary flexibility, and some calligraphers seem to have delighted in finding as many different ways as possible to write the same word. Many Maya logographs remained very pictorial, like the glyph for jaguar illustrated here, which meant that Maya writing was never too distant from other kinds of image making. In fact, the same word, *ts'ib*, signified both writing and painting in the Classic Maya language.

With major advances in the decipherment of Maya hieroglyphic writing—beginning in the 1950s and continuing to this day—it has become clear that the inscriptions on Maya architecture and stelae appear almost entirely devoted to a ceremonial recording of historical events. They document the dates of royal marriages, births of heirs,

alliances between cities, and great military victories, and they tie these events to astronomical events and propitious dates in the Maya calendar. We know that the Maya also wrote books, but only four of these fragile manuscripts—called codices—have survived, all of them from the Postclassic period.

BALAM

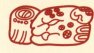

ba-BALAM

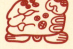

BALAM-ma

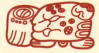

ba-BALAM-ma

ba-la-ma

blood. The man's large canine headdress, decorated with precious feathers from the quetzal bird, indicates his high status. He stands between rectangular plots of earth or bundles of grass pierced with bloody maguey (*Agave americana*) spines (used in bloodletting), and he scatters seeds or drops of blood from his right hand, as indicated by the stream of conventionalized symbols for blood, seeds, and flowers cascading downward. The sound scroll emerging from his open mouth symbolizes his ritual chant. The visual weight accorded the headdress and the sound scroll suggests that the man's priestly office and chanted words were essential elements of the ceremony. Such bloodletting rituals were widespread in Mesoamerica.

Teotihuacan was a wealthy and cosmopolitan city, home to people from all over Mesoamerica. One reason for its wealth was its control of a source of high-quality obsidian. Goods made at Teotihuacan, including obsidian tools and pottery, were distributed widely throughout Mesoamerica in exchange for luxury items such as the brilliant green feathers of the quetzal bird. Yet not all interactions between Teotihuacan and other Mesoamerican centers were peaceful—the threat of Teotihuacan military force, so clearly expressed at the Pyramid of the Feathered Serpent, was always present.

Sometime in the early seventh century disaster struck Teotihuacan. The ceremonial center was sacked and burned, and the city went into a permanent decline. Nevertheless, its influence continued as other centers throughout Mesoamerica, as far south as the

highlands of Guatemala, borrowed and transformed its imagery over the next several centuries.

THE MAYA

The ancient Maya are noted for a number of achievements. In densely populated cities they built imposing pyramids, temples, palaces, and administrative structures. They developed the most advanced hieroglyphic writing in Mesoamerica and perfected a sophisticated version of the Mesoamerican calendrical system (see "Maya Writing," above). Using these, they recorded the accomplishments of their rulers in sculpture, ceramic vessels, wall paintings, and books. They studied astronomy and the natural cycles of plants and animals, and used sophisticated mathematical concepts such as zero and place value.

An increasingly detailed picture of the Maya has been emerging from recent archaeological research and from advances in deciphering their writing. That picture shows a society divided into competing city-states in a near-constant state of war with each other. A hereditary ruler and an elite class of nobles and priests governed each city-state, supported by a large group of farmer-commoners. Rulers established their legitimacy, maintained links with their divine ancestors, commemorated important calendrical dates, and sustained the gods through elaborate rituals, including ballgames, bloodletting ceremonies, and human sacrifice. Rulers commemorated such events and their military exploits on carved stelae. A complex pantheon of deities presided over the Maya universe.

Maya civilization emerged during the Late Preclassic period (400 BCE–250 CE), reached its peak in the southern lowlands of Mexico and Guatemala during the Classic period (250–900 CE), and shifted to the northern Yucatan Peninsula during the Post-classic period (900–1521 CE). Throughout this time, the Maya maintained strong ties with other regions of Mesoamerica: They inherited many ideas and technologies from the Olmec, had trade and military interactions with Teotihuacan, and, centuries later, were in contact with the Aztec Empire.

TIKAL The monumental buildings of Maya cities were masterly examples of the use of architecture for public display and as the backdrop for social and sacred ritual. Tikal (in present-day Guatemala) was one of the largest Maya cities, with a population of up to 70,000 at its height. Unlike Teotihuacan, with its grid plan, Maya cities, including Tikal, conformed to the uneven terrain of the rainforest. Plazas, pyramid-temples, ballcourts, and other structures stood on high ground connected by wide elevated roads, or causeways.

Tikal was settled in the Late Preclassic period, in the fourth century BCE, and continued to flourish through the Early Classic period. The kings of Tikal were buried in funerary pyramids in the **NORTH ACROPOLIS**, visible on the left in **FIGURE 13-8**,

which was separated by a wide plaza from the royal palace to the south. Tikal suffered a major upheaval in 378 CE, recorded in texts from the city and surrounding centers, when some scholars believe the arrival of strangers from Teotihuacan precipitated the death of Tikal's king and the installation of a new ruler with ties to Central Mexico. Art from this period shows strong Teotihuacan influence in ceramic and architectural forms, though both were soon adapted to suit local Maya aesthetics. The city enjoyed a period of wealth and regional dominance until a military defeat led to a century of decline.

In the eighth century CE, the city of Tikal again flourished during the reign of Jasaw Chan K'awiil (nicknamed Ruler A before his name could be fully read; r. 682–734), who initiated an ambitious construction program and commissioned many stelae decorated with his own portrait. His building program culminated in the construction of Temple I (see FIG. 13-8), a tall pyramid that faces a companion pyramid, Temple II, across a large central plaza. Containing Jasaw Chan K'awiil's tomb in the limestone bedrock below, Temple I rises above the forest canopy to a height of more than 140 feet. Its base has nine layers, probably reflecting the belief that the underworld had nine levels. Priests climbed the steep stone staircase on the exterior to the temple on top, which consists of two narrow, parallel rooms covered with a steep roof supported

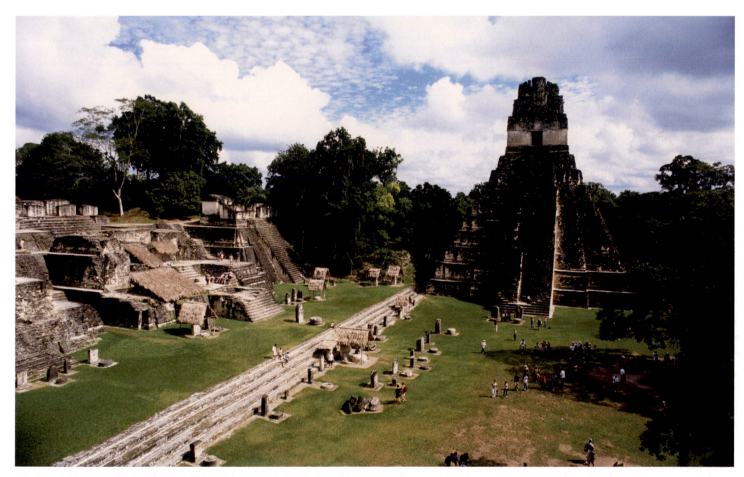

13-8 • BASE OF NORTH ACROPOLIS (LEFT) AND TEMPLE I, TIKAL
Guatemala. Maya culture. North Acropolis, 4th century BCE–5th century CE; Temple I (Tomb of Jasaw Chan K'awiil), c. 734 CE.

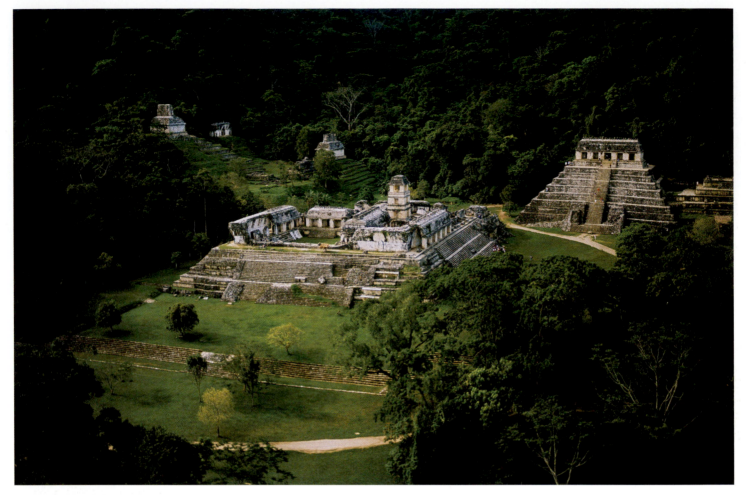

13-9 • PALACE (FOREGROUND) AND TEMPLE OF THE INSCRIPTIONS, PALENQUE
Mexico. Maya culture. Palace, 5th–8th century CE; Temple of the Inscriptions (Tomb of Pakal the Great), c. 683 CE.

by corbel vaults. The crest that rises over the roof of the temple, known as a **roof comb**, was originally covered with brightly painted sculpture. Ritual performances on the narrow platform at the top of the pyramid would have been visible throughout the plaza. Inspired by Jasaw Chan K'awiil's's building program, later kings of Tikal also built tall funerary pyramids that still tower above the rainforest canopy.

PALENQUE The small city-state of Palenque (in the present-day Mexican state of Chiapas) rose to prominence later than Tikal, during the Classic period. Hieroglyphic inscriptions record the beginning of its royal dynasty in 431 CE, but the city had only limited regional importance until the ascension of a powerful ruler, K'inich Janahb Pakal (*pakal* is Maya for "shield"), who ruled from 615 to 683. Known as Pakal the Great, he and his sons, who succeeded him, commissioned most of the structures visible at Palenque today. As at Tikal, urban planning responds to the landscape. Perched on a ridge over 300 feet above the swampy lowland plains, the buildings of Palenque are terraced into the mountains with a series of aqueducts channeling rivers through the urban core. The center of the city houses the palace, the Temple of

the Inscriptions, and other temples (**FIG. 13-9**). Still other temples, elite palaces, and a ballcourt surround this central group.

The palace was an administrative center as well as a royal residence. At its core was the throne room of Pakal the Great, a spacious structure whose stone roof imitated the thatched roofs of more humble dwellings. Over time, the palace grew into a complex series of buildings organized around four courtyards, where the private business of the court was transacted. From the outside, the palace presented an inviting façade of wide staircases and open colonnades decorated with stucco sculptures, but access to the interior spaces was tightly limited.

Next to the palace stands the Temple of the Inscriptions, Pakal the Great's funerary pyramid. Rising 75 feet above the plaza, it has nine levels like Temple I at Tikal (see **FIG. 13-8**). The shrine on the summit consists of a portico with five entrances and a vaulted inner chamber originally surmounted by a tall roof comb. Its façade still retains much of its stucco sculpture. The inscriptions that give the building its name consist of three large panels of text that line the back wall of the outer chamber at the top of the temple, linking Pakal's accomplishments to the mythical history of the city. A corbel-vaulted stairway beneath the summit shrine zigzags down

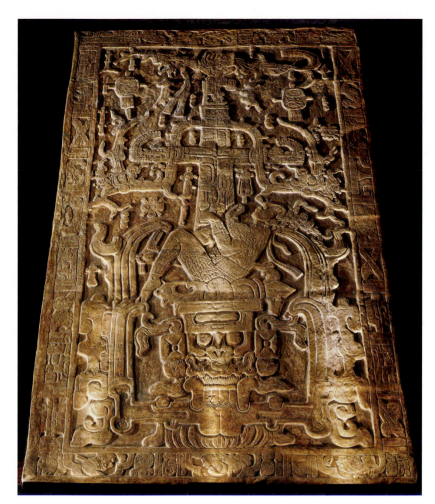

13-10 • LID OF THE SARCOPHAGUS OF PAKAL THE GREAT
From Pakal's tomb, Temple of the Inscriptions, Palenque, Mexico. Maya culture, c. 683 CE. Limestone, 12'1½" × 7'1½" (3.72 × 2.17 m).

skull (babies' heads were bound to produce this shape), large curved nose (enhanced by an ornamental bridge), full lips, and open mouth—are characteristic of the Maya ideal of beauty, also associated with the youthful Maize God, who represented—among other things—the cycle of death and rebirth, as in the constant cycle of planting and harvesting life-sustaining food. Pakal's long, narrow face and jaw, however, are individual characteristics that carry a sense of personal likeness into this symbolic portrait. Traces of pigment indicate that, like much Maya sculpture, this stucco head was once colorfully painted.

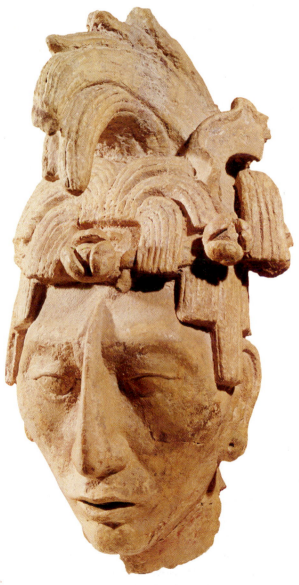

13-11 • PORTRAIT OF PAKAL THE GREAT
From Pakal's tomb, Temple of the Inscriptions, Palenque, Mexico. Maya culture, mid 7th century CE. Stucco and red paint, height 16⅞" (43 cm). Museo Nacional de Antropología, Mexico City.

80 feet to a small subterranean chamber that contained the undisturbed tomb of Pakal, which was discovered in the 1950s.

Pakal the Great—dressed as the Maya maize god and covered with pale green jade and brilliant red cinnabar—lay in a monolithic, uterus-shaped sarcophagus that represented him balanced between the underworld and the earth. His ancestors, carved on the sides of the sarcophagus, emerge from cracks in the earth to witness his death and descent into the underworld, the subject of an elaborate relief sculpture on the lid (**FIG. 13-10**). The reclining king appears here poised in relaxed resignation at the very moment of his death, falling into the jaws of the underworld as if consumed by the earth itself. Above him rises the World Tree, an *axis mundi*, with a fantastical bird representing the celestial realm perched at the top. The branches of this tree are filled with references to the bloodletting rituals that sustain royal power and maintain the continuity of human life.

Underneath the sarcophagus, archaeologists found a stucco portrait of Pakal, in the guise of the Maize God, with a headband of maize flowers and upswept hair that recall the leaves of the plant (**FIG. 13-11**). His features—sloping forehead and elongated

Lintel 24.
Yaxchilan, Mexico. Maya culture, 725 CE. Limestone, 43½″ × 31¾″ (110.5 × 80.6 cm).
British Museum, London.

Shield Jaguar's elaborate headgear includes the shrunken head of a sacrificial victim, proclaiming his past piety in another ritual pleasing to the gods.

The two inscriptions—almost acting as an internal frame for the standing figure—record the date and the nature of the ritual portrayed: bloodletting on October 28, 709. It also identifies the standing king as Shield Jaguar and the kneeling woman as Lady Xok.

The sharply outlined subjects, as well as the way they project forward from a deeply recessed, blank background, focus viewers' attention on the bodies of Lord Shield Jaguar and his kneeling wife, Lady Xok.

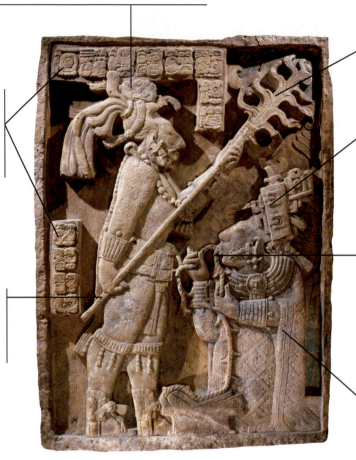

Shield Jaguar holds a huge torch, indicating that this ritual took place within a dark room or during the night.

Tasseled headdresses are associated with bloodletting rituals.

Lady Xok pulls a rope of thorns through her perforated tongue, while spiraling dotted lines show the blood she is sacrificing to the gods. The spiny rope falls to a basket with blood-spotted paper and a sting ray spine also sometimes used for bloodletting. This ritual of self-mutilation was required of royalty since it was believed to maintain royal rule and continuation of human life within the kingdom by gaining favor with the gods.

Lady Xok is lavishly dressed in a garment made of patterned fabric edged with a fringe. The mosaics on her cuffs and collar could be made of jade or shell.

 View the Closer Look for Shield Jaguar and Lady Xok on myartslab.com

YAXCHILAN Elite men and women, rather than gods, were the usual subjects of Maya sculpture, and most works show rulers performing religious rituals in elaborate costumes and headdresses. The Maya favored low relief for carving commemorative stelae and decorating buildings. One of the most outstanding examples is one of a series of carved lintels from a temple in the city of Yaxchilan, dedicated in 726 by Lady Xok, the principal wife and queen of the ruler nicknamed "Shield Jaguar the Great." In this retrospective image of a rite conducted when Shield Jaguar (r. 681–742) became the ruler of Yaxchilan in 681, Lady Xok pulls a rope of thorns through her perforated tongue in a bloodletting ritual while her husband stands with a torch to illuminate the scene (see "A Closer Look," above). The relief is unusually high, giving the sculptor ample opportunity to display a virtuoso carving technique, for example, in Lady Xok's garments and jewelry. The lintels were originally brightly painted as well. That the queen figures so prominently on the lintels of this temple is an indication of her importance at court, and of the status that elite Maya women could attain as important actors in the rituals that assured the power of Maya rulers and the survival of their subjects.

POSTCLASSIC PERIOD After warfare and environmental crisis led to the abandonment of the lowland Maya city-states around 800, the focus of Maya civilization shifted north to the Yucatan Peninsula. One of the principal cities of the Postclassic period was Chichen Itza, which means "at the mouth of the well of

The ritual ballgame was one of the defining characteristics of Mesoamerican society. It was generally played on a long, rectangular court with a large, solid, heavy rubber ball. Using their elbows, knees, or hips—but not their hands—heavily padded players directed the ball toward a goal or marker. The rules, size and shape of the court, the number of players on a team, and the nature of the goal varied. The largest surviving ballcourt, at Chichen Itza, is bigger than a modern football field. Large stone rings set in the walls of this court about 25 feet above the field served as goals. The **BALLCOURT** in **FIGURE 13–12** was constructed at the heart of the ceremonial center in the southernmost Maya city of Copan.

The game was a common subject in Mesoamerican art. This scene, painted on a **CYLINDRICAL VESSEL** (**FIG. 13–13**), shows four lords playing the ballgame, the architectural space of the ballcourt suggested by a few horizontal lines. The men wear elaborate headdresses and padded gear to protect them from the heavy rubber ball. The painter has chosen a moment of arrested movement: One player kneels to hit the ball—or has just hit it—while the others gesture and lean toward him.

The ballgame may have had religious and political significance: It features in creation stories and was sometimes associated with warfare. Captive warriors might have been forced to play the game, and when the stakes were high the game may have culminated in human sacrifice.

13-12 • BALLCOURT
Copan, Honduras. Maya culture, c. 711–736 CE.

13-13 • CYLINDRICAL VESSEL WITH BALLGAME SCENE
Maya culture, 600–800 CE. Painted ceramic, diameter 6⅜″ (15.9 cm), height 8⅛″ (20.5 cm). Dallas Museum of Art. Gift of Mr. and Mrs. Raymond Nasher 1983.148

This roll-out photograph shows the entire scene painted around the cylinder; a person holding the vessel would have to turn it to see what was happening. The text running around the rim is a standard dedicatory inscription, naming it as a vessel for drinking chocolate, and tests of residues inside such vessels have confirmed this use. Without sugar or milk, Maya chocolate was a very different drink from the one we are used to, a frothy and bitter beverage consumed on courtly and ritual occasions.

📖—**Read** the document related to the Maya civilization on myartslab.com

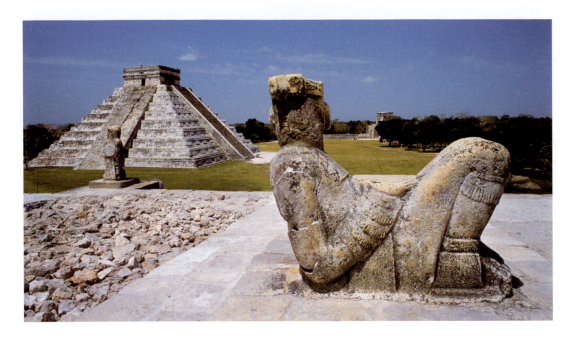

13-14 • PYRAMID ("EL CASTILLO") WITH CHACMOOL IN FOREGROUND

Chichen Itza, Yucatan, Mexico. Maya culture, 9th–12th century CE.

From the top of the Temple of the Warriors, where a reclining *chacmool* sculpture graces the platform, there is a clear view of the radial pyramid nicknamed "El Castillo."

Watch a video about the Chichen Itza site on myartslab.com

the Itza," and may refer to the deep *cenote* (sinkhole) at the site that was sacred to the Maya. The city flourished from the ninth to the thirteenth century, and at its height covered about 6 square miles.

One of Chichen Itza's most conspicuous structures is a massive nine-level pyramid in the center of a large plaza, nicknamed **EL CASTILLO** ("the castle" in Spanish) (**FIG. 13-14**). A stairway on each side of the radial pyramid leads to a square temple on the summit. At the spring and fall equinoxes, the setting sun casts undulating shadows on the stairway, forming bodies for the serpent heads carved at the base of the north balustrades, pointing toward the Sacred Cenote. Many prominent features of Chichen Itza are markedly different from earlier Maya sites and recall complexes in central Mexico, including long, colonnaded halls and inventive columns in the form of inverted, descending serpents. Brilliantly colored relief sculpture and painting covered the buildings of Chichen Itza. Many of the surviving works show narrative scenes that emphasize military conquests. Sculpture at Chichen Itza, including the serpent columns and balustrades, and the half-reclining figures known as **chacmools**, has the sturdy forms, proportions, and angularity of architecture, rather than the curving complexity and subtle modeling of Classic Maya sculpture. The *chacmools* may represent fallen warriors and were used to receive sacrificial offerings.

After Chichen Itza's decline, Mayapan, in the middle of the Yucatan Peninsula, became the principal Maya center. But by the time the Spanish arrived in the early sixteenth century, Mayapan, too, had declined (destroyed in the mid fifteenth century), and smaller cities like Tulum, located on the Caribbean coast, were all that remained. The Maya people and much of their culture would survive the devastation of the conquest, adapting to the imposition of Hispanic customs and beliefs. Many Maya continue to speak their own languages, to venerate traditional sacred places, and to follow traditional ways.

CENTRAL AMERICA

Unlike their neighbors in Mesoamerica, who lived in complex hierarchical societies, the people of Central America lived in extended family groups, in towns led by chiefs. A notable example of these small chiefdoms was the Diquis culture (located in present-day Costa Rica), which lasted from about 700 to 1500 CE. The Diquis occupied fortified villages and seem to have engaged in constant warfare with one another. Although they did not produce monumental architecture or the large-scale sculpture found in other parts of Costa Rica, they created fine featherwork, ceramics, textiles, and objects of gold and jade.

Metallurgy and the use of gold and copper-gold alloys were widespread in Central America. The technique of lost-wax casting probably first appeared in present-day Colombia between 500 and 300 BCE. From there it spread north to the Diquis. A small, exquisite pendant (**FIG. 13-15**) illustrates the style and technique of Diquis goldwork. The pendant depicts a male figure wearing bracelets, anklets, and a belt with a snake-headed penis sheath. He plays a drum while holding the tail of a snake in his teeth and its head in his left hand. The wavy forms with serpent heads emerging from his scalp suggest an elaborate headdress, and the creatures emerging from his legs suggest some kind of reptile costume. The inverted triangles on the headdress probably represent birds' tails.

In Diquis mythology, serpents and crocodiles inhabited a lower world, humans and birds a higher one. Diquis art depicts animals and insects as fierce and dangerous. The man in the pendant is clearly a performer, and some have interpreted him as a shaman transforming himself into a composite serpent-bird or enacting a ritual snake dance surrounded by serpents or crocodiles. The scrolls on the sides of his head may represent a shaman's power to hear and understand the speech of animals. Whatever its specific meaning, the pendant evokes a ritual of mediation between earthly and cosmic powers involving music, dance, and costume.

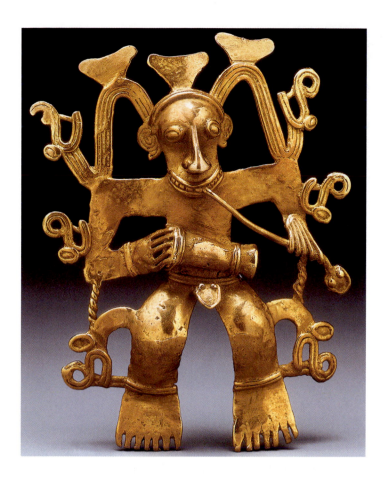

13-15 • SUPERNATURAL FIGURE WITH DRUM AND SNAKE
Costa Rica. Diquis culture, c. 13th–16th century CE. Gold, 4¼″ × 3¼″ (10.8 × 8.2 cm). Museos del Banco Central de Costa Rica, San José, Costa Rica.

Whether gold figures of this kind were protective amulets or signs of high status, they were certainly more than personal adornment. Shamans and warriors wore gold to inspire fear, perhaps because gold was thought to capture the energy and power of the sun. This energy was also thought to allow shamans to leave their bodies and travel into cosmic realms.

SOUTH AMERICA: THE CENTRAL ANDES

Like Mesoamerica, the central Andes of South America—primarily present-day Peru and Bolivia—saw the development of complex hierarchical societies with rich and varied artistic traditions. The area is one of dramatic contrasts. The narrow coastal plain, bordered by the Pacific Ocean on the west and the abruptly soaring

TECHNIQUE | Andean Textiles

Textiles were one of the most important forms of art and technology in Andean society. Specialized fabrics were developed for everything from ritual burial shrouds and ceremonial costumes to rope bridges and knotted cords for record keeping. Clothing indicated ethnic group and social status and was customized for certain functions, the most rarefied being royal ceremonial garments made for specific occasions and worn only once. Andean textiles are among the most technically complex cloths ever made, and their creation consumed a major portion of societal resources.

Andean textile artists used two principal materials: cotton and camelid fiber. (Camelid fiber—llama, alpaca, guanaco, or vicuña hair—is the Andean equivalent of wool.) Cotton grows on the coast, while llamas, alpacas, and other camelids thrive in the highlands. The presence of cotton fibers in the highlands and camelid fibers on the coast documents trade between the two regions from very early times and suggests that the production of textiles was an important factor in the domestication of both plants (cotton) and animals (llamas).

The earliest Peruvian textiles were made by twining, knotting, wrapping, braiding, and looping fibers. Those techniques continued to be used even after the invention of weaving looms in the early second millennium BCE. Most Andean textiles were woven on a simple, portable backstrap loom in which the undyed cotton warp (the lengthwise threads) was looped and stretched between two bars. One bar was tied

to a stationary object and the other strapped to the waist of the weaver. The weaver controlled the tension of the warp threads by leaning back and forth while threading a shuttle from side to side to insert the weft (crosswise threads). Changing the arrangement of the warp threads between each passage of the weft created a stable interlace of warp and weft: a textile.

Andean artists used a variety of different techniques to decorate their textiles, creating special effects that were prized for their labor-intensiveness and difficulty of manufacture as well as their beauty. In tapestry weaving, a technique especially suited to representational textiles, the weft does not run the full width of the fabric; each colored section is woven as an independent unit. **Embroidery** with needle and thread on an already woven textile allows even greater freedom from the rigid warp-and-weft structure of the loom, allowing the artist to create curvilinear forms with thousands of tiny stitches (see FIG. 13–17). As even more complex techniques developed, the production of a single textile might involve a dozen processes requiring highly skilled workers. Dyeing technology, too, was an advanced art form in the ancient Andes, with some textiles containing dozens of colors.

Because of their complexity, deciphering how these textiles were made can be a challenge, and investigators rely on contemporary Andean weavers—inheritors of this tradition—for guidance. Now, as then, fiber and textile arts are primarily in the hands of women.

Andes Mountains on the east, is one of the driest deserts in the world. Life here depends on the rich marine resources of the Pacific Ocean and the rivers that descend from the Andes, forming a series of valley oases. The Andes themselves are a region of lofty snowcapped peaks, high grasslands, steep slopes, and deep, fertile river valleys. The high grasslands are home to the Andean camelids that have served for thousands of years as beasts of burden and a source of wool and meat. The lush eastern slopes of the Andes descend to the tropical rainforest of the Amazon basin.

In contrast to developments in other parts of the world, Andean peoples developed monumental architecture and textiles long before ceramics and intensive agriculture, usually the two hallmarks of early civilization. Thus, the earliest period of monumental architecture, beginning around 3000 BCE, is called the Preceramic period. On the coast, sites with ceremonial mounds and plazas were located near the sea, while in the highlands early centers consisted of multi-roomed stone-walled structures with sunken central fire pits for burning ritual offerings. In the second millennium BCE (the Initial Period), as agriculture became more important both in the highlands and on the coast, the scale and pace of construction increased dramatically. Communities in the coastal valleys built massive U-shaped ceremonial complexes, while highland religious centers focused on sunken circular courtyards. By adding to these constructions bit by bit over generations, and using older constructions as the nucleus of new buildings, relatively small communities could generate mountain-size pyramids.

CHAVIN DE HUANTAR

Located on a trade route between the coast and the Amazon basin, the highland site of Chavin de Huantar was an important religious center between 900 and 200 BCE, home to a style of art that spread through much of the Andes. In Andean chronology, this era is known as the Early Horizon, the first of three so-called Horizon periods. The period was one of artistic and technical innovation in ceramics, metallurgy, and textiles.

The architecture of Chavin synthesizes coastal and highland traditions, combining the U-shaped pyramid typical of the coast with a sunken circular plaza lined with carved reliefs, a form common in the highlands. The often fantastical animals that adorn Chavin sculpture have features of jaguars, hawks, caimans, and other tropical Amazonian beasts.

Within the U-shaped Old Temple at Chavin is a mazelike system of narrow galleries, at the very center of which lies a sculpture called the **LANZÓN** (**FIG. 13–16**). Wrapped around a 15-foot-tall blade-shaped stone with a narrow projection at the top—a form that may echo the shape of traditional Andean planting sticks—this complex carving depicts a powerful creature with a humanoid body, clawed hands and feet, and enormous fangs. Its eyebrows and strands of hair terminate in snakes—a kind of composite and transformational imagery shared by many Chavin images. The creature is bilaterally symmetrical, except that it has one hand raised and the other lowered. Compact frontality, flat relief, curvilinear design,

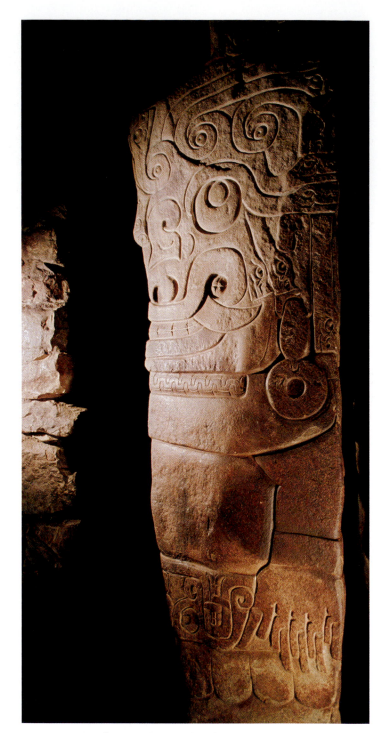

13–16 • LANZÓN, CHAVIN DE HUANTAR
Peru. Chavin culture, c. 900 BCE. Granite, height 15′ (4.5 m).

and the combination of human, animal, bird, and reptile parts characterize this early art.

It has been suggested that the Lanzón was an oracle (a chamber directly above the statue would allow priests' disembodied voices to filter into the chamber below), which would explain why people from all over the Andes made pilgrimages to Chavin, bringing exotic goods to the highland site and spreading the style of its art throughout the Andean region as they returned home.

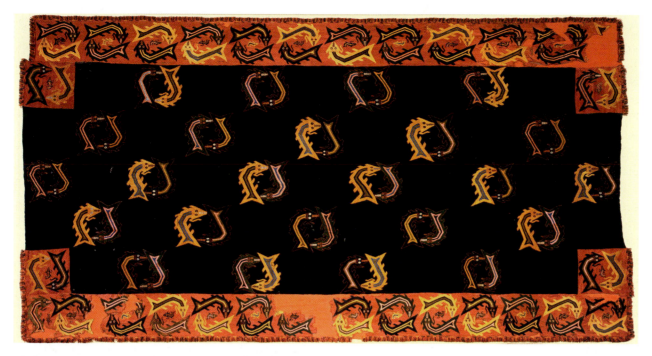

13–17 • MANTLE WITH DOUBLE FISH PATTERN

Paracas Necropolis, Peru. Paracas culture, 1st century CE. Cotton and camelid fiber, plain weave with stem-stitch embroidery, 118⅛″ × 63¾″ (3 × 1.62 m). Brooklyn Museum. Alfred W. Jenkins Fund (34.1560)

THE PARACAS AND NAZCA CULTURES

While Chavín de Huantar was flourishing as a highland center whose art was enormously influential throughout the Andes, different valleys on the Pacific coast developed distinctive art styles and cultures.

PARACAS The Paracas culture of the Peruvian south coast flourished from about 600 BCE to 200 CE, overlapping the Chavín period. It is best known for its stunning textiles, which were found in cemeteries as wrappings, in many layers, around the bodies of the dead. Some bodies were wrapped in as many as 200 pieces of cloth.

Weaving is of great antiquity in the central Andes and continues to be among the most prized arts in the region (see "Andean Textiles," page 397). Fine textiles were a source of prestige and wealth. The designs on Paracas textiles include repeated embroidered figures of warriors, dancers, composite creatures, and animals (**FIG. 13–17**). Tiny overlapping stitches on this example create a colorful, curvilinear pattern of paired fish—probably sharks, based on the placement of the gills—striking against the dark blue field and red border. Paracas embroiderers sometimes used as many as 22 different colors within a single figure, but only one simple stitch.

NAZCA The Nazca culture, which dominated portions of the south coast of Peru during the first seven centuries CE, overlapped the Paracas culture to the north. Nazca artisans wove fine fabrics, and also produced multicolored pottery with painted and modeled images reminiscent of those on Paracas textiles.

The Nazca are best known for their colossal earthworks, or **geoglyphs**, which dwarf even the most ambitious twentieth-century environmental sculpture. On great stretches of desert they literally drew in the earth. By removing dark, oxidized stones, they exposed the light underlying stones. In this way they created gigantic images—including a **HUMMINGBIRD** with a beak 120 feet long (**FIG. 13–18**), a killer whale, a monkey, a spider, a duck, and other birds—similar to those with which they decorated their pottery. They also made abstract patterns and groups of straight, parallel lines that extend for up to 12 miles. The purpose and meaning of the glyphs remain a mystery, but the "lines" of stone are wide enough to have been ceremonial pathways.

THE MOCHE CULTURE

The Moche culture dominated the north coast of Peru from the Piura Valley to the Huarmey Valley—a distance of some 370 miles—between about 100 and 700 CE. Moche lords ruled each valley in this region from a ceremonial-administrative center. The largest of these, in the Moche Valley (from which the culture takes its name), contained the so-called Huaca del Sol (Pyramid of the Sun) and Huaca de la Luna (Pyramid of the Moon), both built of **adobe** brick (sun-baked blocks of clay mixed with straw). The Huaca del Sol, one of the largest ancient structures in South America, was originally 1,100 feet long by 500 feet wide, rising in a series of terraces to a height of 59 feet. Much of this pyramid was destroyed in the seventeenth century, when a Spanish mining company diverted a river through it to wash out the gold contained in its many burials. Recent excavations at the Huaca de la

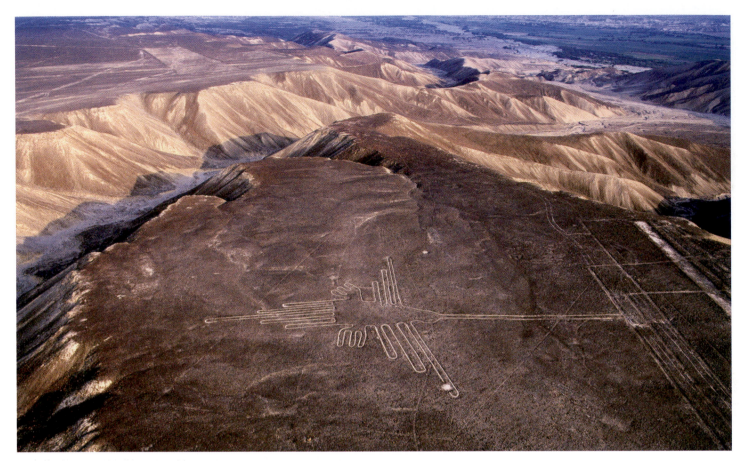

13-18 • EARTH DRAWING (GEOGLYPH) OF A HUMMINGBIRD, NAZCA PLAIN
Southwest Peru. Nazca culture, c. 1–700 CE. Length approx. 450′ (137 m); wingspan approx. 220′ (60.9 m).

⊙ **Watch** a video about the earth drawings on the Nazca Plain on myartslab.com

Luna have revealed brightly painted reliefs of deities, captives, and warriors, remade during successive renovations of the pyramid. This site had been thought to be the capital of the entire Moche realm, but the accumulating evidence indicates that the Moche maintained a decentralized social network.

The Moche were exceptional potters and metalsmiths. Vessels were made in the shapes of naturalistically modeled human beings, animals, and architectural structures, at times combined in complex figural scenes. They developed ceramic molds, which allowed them to mass-produce some forms. They also created **PORTRAIT VESSELS** that seem to preserve individual likenesses (**FIG. 13–19**) and recorded mythological narratives and ritual scenes in intricate fine-line painting. Similar scenes were painted on the walls of temples and administrative buildings. Moche metalsmiths, the most sophisticated in the central Andes, developed several innovative metal alloys.

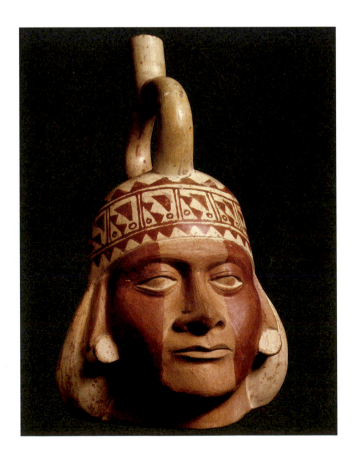

13-19 • MOCHE PORTRAIT VESSEL
Peru. Moche culture, c. 100–700 CE. Clay, height 11″ (28 cm).
Ethnologisches Museum, Staatliche Museen zu Berlin.

This is one of several portrait vessels, made from the same mold, that seems to show a particular individual.

THE TOMB OF THE WARRIOR PRIEST A central theme in Moche iconography is a ceremony in which prisoners captured in battle are sacrificed and several elaborately dressed figures then drink their blood. Archaeologists have labeled the principal figure in this sacrifice ceremony as the Warrior Priest and other important figures as the Bird Priest and the Priestess. The recent discovery of a number of spectacularly rich Moche tombs indicates that the sacrifice ceremony was an actual Moche ritual and that Moche lords and ladies assumed the roles of the principal figures. The occupant of a tomb at Sipán, in the Lambayeque Valley on the northwest coast, was buried with the regalia of the Warrior Priest. In tombs at the site of San José de Moro, just south of Sipán, several women were buried with the regalia of the Priestess.

Among the riches accompanying the Warrior Priest at Sipán was a pair of exquisite gold-and-turquoise **EARSPOOLS**, each of which depicts three Moche warriors (**FIG. 13–20**). The central figure bursts into three dimensions, while his companions are shown in profile, in a flat inlay technique. All three are adorned with tiny gold-and-turquoise earspools, simpler versions of the object they themselves adorn. They wear gold-and-turquoise headdresses topped with delicate sheets of gold that resemble the crescent-shaped knives used in sacrifices. The central figure has a crescent-shaped nose ornament and carries a removable gold club and shield. A necklace of owl's-head beads strung with gold thread hangs around his shoulders; similar objects have been found in other tombs at Sipán. These earspools illustrate two of the most notable features of Moche art: its capacity for naturalism and its close attention to detail.

NORTH AMERICA

Compared to the densely inhabited agricultural regions of Mesoamerica and South America, most of North America remained sparsely populated. Early people lived primarily by hunting, fishing, and gathering edible plants. Agriculture was developed on a limited scale with the cultivation of squash, sunflowers, and other plants to supplement a diet comprised largely of game, fish, and berries.

THE EAST

We are only beginning to understand the early culture of eastern North America. Archaeologists have discovered that people lived in communities that included both burial and ceremonial earthworks—mounds of earth-formed platforms that probably supported a chief's house and served as the shrines of ancestors and places for a sacred fire, tended by special guardians. Poverty Point, Louisiana, is one of the largest of the earthwork ceremonial centers (though not the earliest—this distinction goes to Watson Brake, Louisiana, dating to 3400–3000 BCE). Dated between 1800 and 500 BCE—essentially contemporary with Stonehenge in England (see FIG. 1–20) and with Olmec constructions in Mexico (see FIG. 13–2)—Poverty Point consisted of huge, concentric earthen arcs three-quarters of a mile wide.

THE WOODLAND PERIOD The Woodland period (300 BCE–1000 CE) saw the creation of impressive earthworks along the great river valleys of the Ohio and Mississippi, where people built monumental mounds and buried individuals with valuable grave goods. Objects discovered in these burials indicate that the people of the Mississippi, Illinois, and Ohio river valleys traded widely with other regions of North and Central America. For example, the burial sites of the Adena (c. 1100 BCE–200 CE) and the Hopewell (c. 100 BCE–550 CE) cultures contained objects made with copper from present-day Michigan's Upper Peninsula, and cut sheets of mica from the Appalachian Mountains, turtle shells and sharks' teeth from Florida, and obsidian from Wyoming and Idaho. The pipes for the ritual smoking of tobacco that the Hopewell people created from fine-grained pipestone have been found from Lake Superior to the Gulf of Mexico.

The Hopewell carved their pipes with representations of forest animals and birds, sometimes with inlaid eyes and teeth of freshwater pearls and bone. Combining realism and elegant

13-20 • EARSPOOL
From Sipán, Peru. Moche culture, c. 300 CE. Gold, turquoise, quartz, and shell, diameter approx. 3″ (9.4 cm). Bruning Archaeological Museum, Lambayeque, Peru.

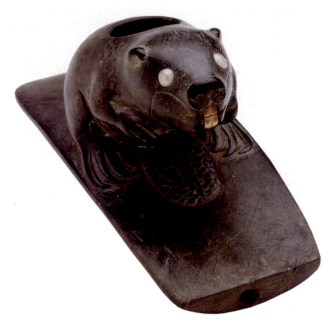

13-21 • BEAVER EFFIGY PLATFORM PIPE
From Bedford Mound, Pike County, Illinois. Hopewell culture, c. 100–400 CE. Pipestone, river pearls, and bone, 4⁹⁄₁₆″ × 1⅞″ × 2″. Gilcrease Museum, Tulsa, Oklahoma.

simplification, a beaver crouching on a platform forms the bowl of a pipe found in present-day Illinois (**FIG. 13–21**). As in a modern pipe, the bowl—a hole in the beaver's back—could be filled with tobacco or other dried leaves, the leaves lighted, and smoke drawn through the hole in the stem. Using the pipe in this way, the smoker would be face to face with the beaver, whose shining pearl eyes may suggest an association with the spirit world.

THE MISSISSIPPIAN PERIOD The Mississippian period (c. 700–1550 CE) is characterized by the widespread distribution of complex chiefdoms, both large and small, that proliferated throughout the region. The people of the Mississippian culture continued the mound-building tradition begun by the Adena, Hopewell, and others. From 1539 to 1543 Hernando de Soto encountered Mississippian societies while exploring the region, and this contact between native North American people and Europeans resulted in catastrophe. The Europeans introduced diseases, especially smallpox, to which native populations had had no previous exposure and hence no immunity. In short order, 80 percent of the native population perished, an extraordinary disruption of society, far worse than the Black Death in fourteenth-century Europe. By the time other Europeans reached the area, the great earthworks of the Mississippian culture had long been abandoned.

One of the most impressive Mississippian period earthworks is the **GREAT SERPENT MOUND** in present-day Adams County, Ohio (**FIG. 13-22**). Researchers using carbon-14 dating have recently proposed dating the mound to about 1070 CE. There have been many interpretations of the twisting snake form, especially the "head" at the highest point, a Y-shape and an oval enclosure that some see as the serpent opening its jaws to swallow a huge egg. Perhaps the people who built it were responding to the spectacular astronomical display of Halley's Comet in 1066.

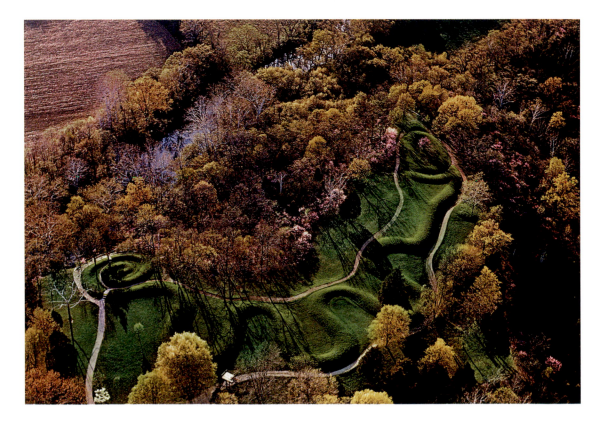

13-22 • GREAT SERPENT MOUND
Adams County, Ohio. Mississippian culture, c. 1070 CE. Length approx. 1,254′ (328.2 m).

East St. Louis, Illinois. Mississippian culture, c. 1000–1300 CE. East–west length approx. 3 miles (4.82 km), north–south length approx. 2¼ miles (3.6 km); base of great mound, 1,037′ × 790′ (316 × 241 m), height approx. 100′ (30 m). Monk's Mound is the large platform in the center of the image. Painting by William R. Iseminger. Courtesy of Cahokia Mounds Historic Site.

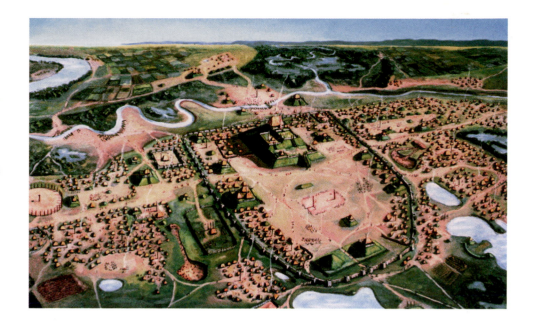

Mississippian peoples built a major urban center known as Cahokia, near the juncture of the Illinois, Missouri, and Mississippi rivers (now East St. Louis, Illinois). Although the site may have been inhabited as early as about 3000 BCE, most monumental construction at Cahokia took place between about 1000 and 1300 CE. At its height the city had a population of up to 15,000 people, with another 10,000 in the surrounding countryside (FIG. 13-23).

The most prominent feature of Cahokia—a feature also found at other Mississippian sites—is an enormous earth mound called Monk's Mound, covering 15 acres and originally 100 feet high. A small, rounded platform on its summit initially supported a wooden fence and a rectangular building. The mound is aligned with the sun at the equinox and may have had a special use during planting or harvest festivals. Smaller rectangular and rounded mounds in front of the principal mound surrounded a large, roughly rectangular plaza. The city's entire ceremonial center was protected by a stockade, or fence, of upright wooden posts. In all, the walled enclosure contained more than 100 mounds, platforms, wooden enclosures, and houses. The various earthworks functioned as tombs and bases for palaces and temples, and also served to make astronomical observations.

Postholes indicate that woodhenges (circles of wooden columns) were a significant feature of Cahokia. The largest (seen to the extreme left in FIGURE 13-23) had 48 posts forming a circle with a diameter of about 420 feet. Sight lines between a 49th post set east of the center of the enclosure and points on the perimeter enabled early astronomers to determine solstices and equinoxes.

FLORIDA GLADES CULTURE In 1895, excavators working in submerged mud and shell mounds off Key Marco on the west coast of Florida made a remarkable discovery: posts carved with birds and animals were preserved in the swamps. The large mound called Fort Center, in Glades Country, Florida, gives the Florida Glades culture its name.

At Key Marco, painted wooden animal and bird heads, a human mask, and the figure of a kneeling cat-human were found in circumstances that suggested a ruined shrine. Recently, carbon-14 dating of these items has confirmed a date of about 1000 CE. Although the heads are spare in details, the artists show a remarkable power of observation in reproducing the creatures they saw around them, such as the **PELICAN** in **FIGURE 13-24**. The surviving head, neck, and breast of the pelican are made of carved

13-24 • PELICAN FIGUREHEAD
Key Marco, Florida. Florida Glades culture, c. 1000 CE. Wood and paint, 4⅜″ × 2⅜″ × 3⅛″ (11.2 × 6 × 8 cm). The University Museum of Archaeology and Anthropology, Philadelphia.

wood, painted black, white, and gray (other images also had traces of pink and blue paint). The bird's outstretched wings were found nearby, but the wood shrank and disintegrated as it dried. Carved wooden wolf and deer heads were also found. Archaeologists think the heads might have been attached to ceremonial furniture or posts. Some see evidence here of a bird and animal cult or perhaps the use of birds and animals as clan symbols.

THE NORTH AMERICAN SOUTHWEST

Farming cultures were slower to arise in the arid American Southwest, which became home to three major early cultures. The Hohokam culture, centered in the central and southern parts of present-day Arizona, emerged around 200 BCE and endured until sometime around 1300 CE. The Hohokam built large-scale irrigation systems, multi-story residences, and ballcourts that demonstrate ties with Mesoamerica. The Mimbres/Mogollon culture, located in the mountains of west-central New Mexico and east-central Arizona, flourished from about 200 to about 1150 CE. Potters made deep bowls painted with lively, imaginative, and sometimes complex scenes of humans and animals (**FIG. 13–25**). Much of our knowledge of this ceramic tradition is based on examples excavated in burials under the floors of Mimbres dwellings, where food bowls—most of them intentionally punctured before burial—were inverted and placed over the head of the deceased. Some experts believe these perforated bowls could have represented the dome of the sky and embodied ideas about the transport of the dead from the earth into the spirit world.

13–26 • SEED JAR
Ancestral Puebloan culture, c. 1150 CE. Earthenware with black-and-white pigment, diameter 14½″ (36.9 cm). Saint Louis Art Museum.
Funds given by the Children's Art Festival (175:1981)

The third southwestern culture, the Ancestral Puebloans (formerly called Anasazi), emerged around 500 CE in the Four Corners region, where present-day Colorado, Utah, Arizona, and New Mexico meet. The Puebloans adopted the irrigation technology of the Hohokam and began building elaborate, multi-storied, apartmentlike "great houses" with many rooms for specialized purposes, including communal food storage and ritual.

As in Mimbres culture, Ancestral Puebloan people found aesthetic expression in their pottery, an ancient craft refined over generations. Women were the potters in ancient Pueblo society. They developed a functional, aesthetically pleasing, coil-built earthenware, or low-fired ceramic, initiating a tradition of ceramic production that continues to be important today among the Pueblo peoples of the Southwest. One type of vessel, a wide-mouthed **SEED JAR** with a globular body and holes near the rim (**FIG. 13–26**), would have been suspended from roof poles by thongs attached to the jar's holes, out of reach of voracious rodents. The example shown here is decorated with black-and-white dotted squares and zigzag patterns. The patterns conform to the body of the jar, enhancing its curved shape by focusing the energy of the design around its bulging expansion.

CHACO CANYON Chaco Canyon, covering about 30 square miles in present-day New Mexico with nine great houses, or pueblos, was an important center of Ancestral Puebloan civilization. The largest-known "great house" is **PUEBLO BONITO** (**FIG. 13–27**), which was built in stages between the tenth and mid thirteenth centuries. Eventually it comprised over 800 rooms in four or five stories, arranged in a D shape. Within the crescent

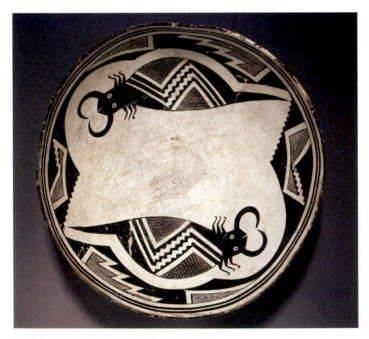

13–25 • BOWL WITH SCORPIONS
Swarts Ruin, Southwest New Mexico. Mimbres culture, c. 1000–1150 CE. Earthenware with white slip and black paint, height 4¾″ (12 cm), diameter 11⅝″ (29.5 cm). Courtesy of the Peabody Museum of Archaeology and Ethnology, Harvard University.

part of the D, 32 **kivas** recall the round, semisubmerged pit houses of earlier Southwestern cultures. Here men performed religious rituals and instructed youths in their responsibilities. Interlocking pine logs formed a shallow, domelike roof with a hole in the center through which the men entered by climbing down a ladder. Based on what we know of later Pueblo beliefs, a small indentation in the floor of the kiva, directly under the entrance and behind the fire pit, may have symbolized the "navel of the earth"—the place where ancestors of the Ancestral Pueblo themselves had emerged to settle on the earth in mythic "first times." The top of the kivas formed the floor of the communal plaza.

Pueblo Bonito stood at the hub of a network of wide, straight roads—almost invisible today, but discovered through aerial photography—that radiated out to some 70 other communities.

They make no detour to avoid topographic obstacles; when they encounter cliffs, they become stairs. Their undeviating course suggests that they were more than practical thoroughfares: They may have served as processional ways. Given its place at the intersection of this road system and the prominence of kivas in the design of great houses such as Pueblo Bonito, some have suggested that Chaco Canyon may have been a gathering place or pilgrimage site for people from the entire region at specific times of year.

Though no one knows for certain why Chaco Canyon was abandoned, the Ancestral Puebloan population declined during a severe drought in the twelfth century, and building at Pueblo Bonito ceased around 1250. Ancestral Puebloans may have moved to the Rio Grande and Mogollon River valleys, where they built new apartmentlike dwellings on ledges under sheltering cliffs

13-27 • PUEBLO BONITO
Chaco Canyon, New Mexico. 830–1250 CE.

The rock art of the American Southwest consists of pictographs, which are painted, and petroglyphs, which are pecked or engraved. While occurring in numerous distinctive styles, rock art images include humans, animals, and geometric figures, represented singly and in multi-figured compositions. Petroglyphs are often found in places where the dark brown bacterial growths and staining known as "**desert varnish**" streak down canyon walls (see FIG. 13–29). To create an image, the artist scrapes or pecks through the layer of varnish, exposing the lighter sandstone beneath.

In the Great Gallery of Horseshoe Canyon, Utah, the painted human figures have long, decorated rectangular bodies and knoblike heads (**FIG. 13-28**). One large, wide-eyed figure (popularly known as the "Holy Ghost") is nearly 8 feet tall. Archaeologists have dated these paintings to as early as 1900 BCE and as recently as 300 CE; rock art is very difficult to date with any precision.

In the petroglyphs of Nine Mile Canyon in central Utah—attributed to the Fremont people (800–1300 CE), agriculturists as well as hunters—a large human hunter draws his bow and arrow on a flock of bighorn sheep (**FIG. 13–29**). Other hunters and a large, rectangular armless figure wearing a horned headdress mingle with the animals. The scene gives rise to the same questions and arguments we have noted with regard to the prehistoric art discussed in Chapter 1: Is this a record of a successful hunt or is it part of some ritual activity to ensure success?

13-28 • ANTHROPOMORPHS, THE GREAT GALLERY, HORSESHOE (BARRIER) CANYON

Utah. c. 1900 BCE–300 CE. Largest figure about 8′ (2.44 m) tall.

These may represent holy or priestly figures and are often associated with snakes, dogs, and other small energetic creatures. Big-eyed anthropomorphs may be rain gods. Painters used their fingers and yucca-fiber brushes to apply the reddish pigment made from hematite (iron oxide).

13-29 • HUNTER'S MURAL
Nine Mile Canyon, Utah. Fremont people, 800–1300 CE.

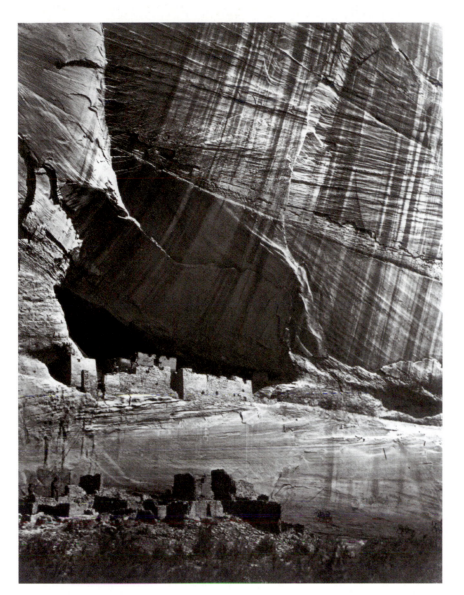

13-30 • Timothy O'Sullivan ANCIENT RUINS IN THE CANYON DE CHELLEY
Arizona. Albumen print. 1873. National Archives, Washington, DC.

While ostensibly a documentary photograph, Timothy O'Sullivan's picture of "The White House," built by twelfth-century Ancestral Puebloans, is both a valuable document for the study of architecture and an evocative art photograph, filled with the Romantic sense of sublime melancholy.

(**FIG. 13-30**). Difficult as it must have been to live high on canyon walls and commute to the farm the valley below, the cliff communities had the advantage of being relatively secure. The rock shelters in the cliffs also acted as insulation, protecting the dwellings from the extremes of heat and cold that characterize this part of the world. Like a modern apartment complex, the many rooms housed an entire community comfortably. Communal solidarity and responsibility became part of the heritage of the Pueblo peoples.

Throughout the Americas, for the next several hundred years, artistic traditions would continue to emerge, develop, and be transformed as the indigenous peoples of various regions interacted. But more than anything else, the sudden incursions of Europeans, beginning in the late fifteenth century, would have a dramatic and lasting impact on these civilizations and their art.

THINK ABOUT IT

13.1 Characterize and compare the differing figure styles of paintings from Teotihuacan and Maya culture as seen in FIGS. 13–7 and 13–13.

13.2 Discuss the significance of bloodletting as a recurring theme in early Mesoamerican art, focusing your answer on one specific work of art in this chapter.

13.3 Evaluate what we can learn about the broad cultural values of Olmec civilization from the figural group that was the subject of the opening discussion in this chapter.

13.4 Compare the architectural complexes of Teotihuacan and Chaco Canyon. Evaluate the arguments for understanding both of these early monuments of American art as ceremonial sites. What do we know of the rituals that would have been performed in each location?

CROSSCURRENTS

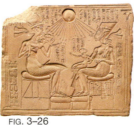

FIG. 3–26

Ch. 13 Closer Look, page 394

Both of these works, representing activities and relationships critical to royal power, were created in pictorial relief sculpture. Compare the two very different techniques of carving and figural styles. How are style and technique related to the cultural traditions of the time when and place where they were made?

✓—[**Study** and review on myartslab.com

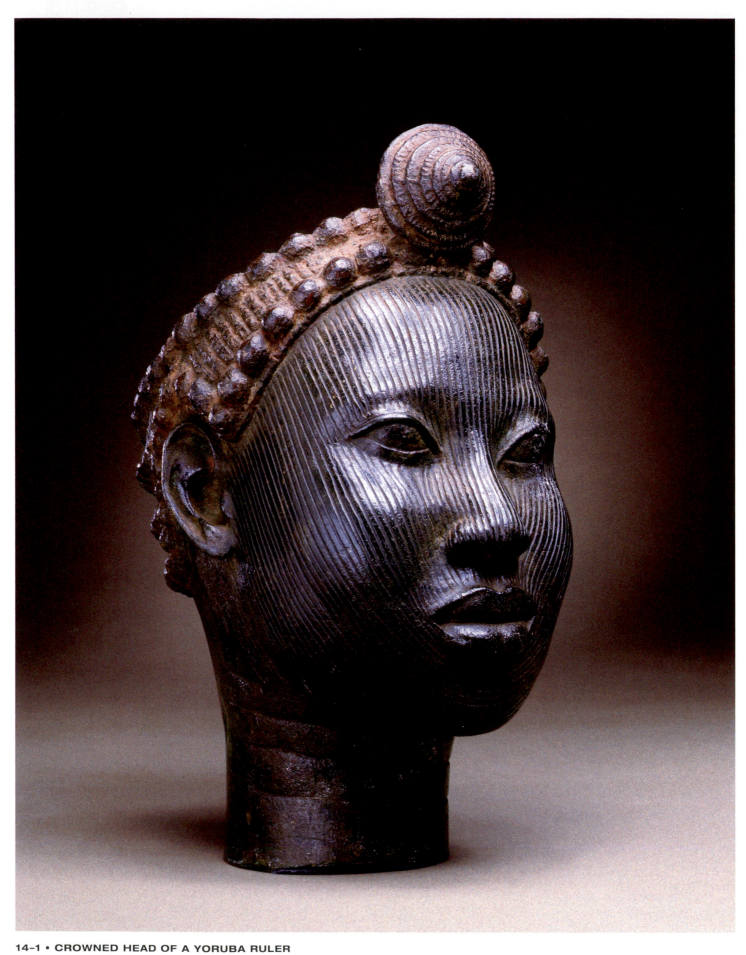

14–1 • CROWNED HEAD OF A YORUBA RULER
From Ife, Nigeria. Yoruba, 12th–15th century CE. Zinc brass, height 9⁷⁄₁₆" (24 cm). Museum of Ife Antiquities, Ife, Nigeria.

Early African Art

The Yoruba people of southwestern Nigeria regard the city of Ife (also known as Ile-Ife) as the "navel of the world," the site of creation, the place where Ife's first ruler—the *oni* Oduduwa—came down from heaven to create Earth and then to populate it. By the eleventh century CE, Ife was a lively metropolis, and, even today, every Yoruba city claims "descent" from Ife. It was, and remains, the sacred city of the Yoruba people.

A sculptural tradition of casting lifelike human heads, using the lost-wax process, began in Ife about 1050 CE and flourished over four centuries. Although the ancestral line of the Ife *oni* (king) has continued unbroken, knowledge of the precise purpose of these arresting works has been lost. The cast-bronze head in **FIGURE 14–1** demonstrates the extraordinary artistry that produced them. The modeling of the flesh—covered with thin, parallel **scarification** patterns (decorations made by scarring)—is remarkably sensitive, especially the subtle transitions around the nose and mouth. The full, delicate lips and expressive eyes bulge organically in ways that are strikingly similar to the faces of some modern Yoruba, underlining the sense of an individual likeness.

This head was cast with a crown, and its size and delicate features suggest it may represent a female *oni*. Although its precise use is not known, similar life-size heads have large holes in the neck, suggesting they may have been attached

to wooden figures, and mannequins with naturalistic facial features have been documented at memorial services for deceased individuals among contemporary Yoruba peoples. The Ife mannequin could have been dressed in the *oni*'s robes. But the head could also have been used to display an actual crown during annual purification and renewal rites.

The question of whether the Ife heads are true portraits has been debated, and their attention to the distinctive contours and features that provide individuality to human faces gives an impression that they could be. They all, however, seem to represent individuals of the same age and embody a similar concept of physical perfection, suggesting they are idealized images representing both physical beauty and moral character. As we have seen in the portraits of other cultures, however, idealization does not preclude the possibility that the faces describe the distinguishing characteristics of a specific human being.

The superb naturalism of Ife sculpture contradicted everything Europeans thought they knew about African art. The German scholar, Leo Frobenius, who "discovered" Ife sculpture in 1910 suggested that it was created not by Africans but by survivors from the legendary lost island of Atlantis. Later, there was speculation that influence from ancient Greece or Renaissance Europe must have reached Ife. Scientific study, however, finally put such prejudiced ideas to rest.

LEARN ABOUT IT

14.1 Compare the variety of figure styles used by the early artists of Africa and explore the relationship of style to technique, especially bronze casting.

14.2 Understand how African arts mediate and support communication between the temporal and the supernatural worlds of various spirit forces.

14.3 Explore how the arts of early Africa are fully realized and understood in the context of ritual and ceremony.

14.4 Recognize how contact with other cultures has affected the development and also threatened the very survival of early African art.

((•— **Listen** to the chapter audio on myartslab.com

THE LURE OF ANCIENT AFRICA

"I descended [the Nile] with three hundred asses laden with incense, ebony, grain, panthers, ivory, and every good product." Thus the Egyptian envoy Harkhuf described his return from Nubia, the African land to the south of Egypt, in 2300 BCE. The riches of Africa attracted merchants and envoys in ancient times, and trade brought the continent in contact with the rest of the world. Egyptian relations with the rest of the African continent continued through the Hellenistic era and beyond. Phoenicians and Greeks founded dozens of settlements along the Mediterranean coast of North Africa between 1000 and 300 BCE to extend trade routes across the Sahara to the peoples of Lake Chad and the bend of the Niger River (MAP 14–1). When the Romans took control of North Africa, they continued this lucrative trans-Saharan trade. In the seventh and eighth centuries CE, the expanding empire of Islam swept across North Africa, and thereafter Islamic merchants were regular visitors to Bilad al-Sudan (the Land of the Blacks—sub-Saharan Africa). Islamic scholars chronicled the great West African empires of Ghana, Mali, and Songhay, and West African gold financed the flowering of Islamic culture.

East Africa, meanwhile, had been drawn since at least the beginning of the Common Era into the maritime trade that ringed the Indian Ocean and extended east to Indonesia and the South China Sea. Arab, Indian, and Persian ships plied the coastline. A new language, Swahili, evolved from centuries of contact between Arabic-speaking merchants and Bantu-speaking Africans, and great port cities such as Kilwa, Mombasa, and Mogadishu arose.

In the fifteenth century, Europeans ventured by ship into the Atlantic Ocean and down the coast of Africa. Finally encountering the continent firsthand, they were often astonished by what they found (see "The Myth of 'Primitive' Art," page 412). "Dear King My Brother," wrote a fifteenth-century Portuguese king to his new trading partner, the king of Benin in west Africa. The Portuguese king's respect was well founded—Benin was vastly more powerful and wealthier than the small European country that had just stumbled upon it.

As we saw in Chapter 3, Africa was home to one of the world's earliest great civilizations, that of ancient Egypt, and as we saw in Chapter 9, Egypt and the rest of North Africa contributed prominently to the development of Islamic art and culture. This chapter examines the artistic legacy elsewhere in ancient Africa.

AFRICA—THE CRADLE OF ART AND CIVILIZATION

During the twentieth century, the sculpture of traditional African societies—wood carvings of astonishing formal inventiveness and power—found admirers the world over. While avidly collected, these works were much misunderstood. For the past 75 years, art historians and cultural anthropologists have studied African art firsthand, which has added to our overall understanding of art making in many African cultures. However, except for a few isolated examples (such as in Nigeria and Mali), the historical depth of our understanding is still limited by the continuing lack of systematic archaeological research. Our understanding of traditions that are more than 100 years old is especially hampered by the fact that most African art was made from wood, which decays rapidly in sub-Saharan Africa. Consequently, few examples of African masks and sculpture remain from before the nineteenth century, and for the most part it is necessary to rely on contemporary traditions and oral histories to help extrapolate backward in time to determine what may have been the types, styles, and meanings of art made in the past. Nevertheless, the few surviving ancient African artworks—in such durable materials as terra cotta, stone, and bronze, and an extensive record in rock art that has been preserved in sheltered places—bear eloquent witness to the skill of early African artists and the splendor of the civilizations in which they worked.

Twentieth-century archaeology has made it popular to speak of Africa as the cradle of human civilization. Certainly the earliest evidence for our human ancestors comes from southern Africa (see "Southern African Rock Art," page 414). Now evidence of the initial stirrings of artistic activity also comes from this region. Recently, quantities of ocher pigment thought to have been used for ceremonial or decorative purposes, and perforated shells thought to have been fashioned into beads and worn as personal adornment, have been found in Blombos Cave on the Indian Ocean coast of South Africa, dating to approximately 77,000 years ago. Also discovered together with these were two small, ocher blocks that had been smoothed and then decorated with geometric arrays of carved lines (see FIG. 1–4). These incised abstract patterns pre-date any other findings of ancient art by more than 30,000 years, and they suggest a far earlier development of modern human behavior than had been previously recognized.

The earliest-known figurative artworks from the African continent are animal figures dating to about 25,000 BCE, painted in red and black pigment on flat stones found in a cave designated as Apollo 11, located in the desert mountains of Namibia. These figures are comparable to the better-known European cave drawings such as those from the Chauvet Cave (c. 32,000–30,000 BCE) and Lascaux Cave (c. 15,000–13,000 BCE) discussed in Chapter 1.

AFRICAN ROCK ART

Like the Paleolithic inhabitants of Europe, early Africans painted and inscribed images on the walls of caves and rock shelters. Rock art is found throughout the African continent in places where the environment has been conducive to preservation—areas ranging from small, isolated shelters to great cavernous formations. Distinct geographic zones of rock art can be identified broadly, encompassing the northern, central, southern, and eastern regions of the continent. These rock paintings and engravings range in form from highly abstract geometric designs to abstract and naturalistic

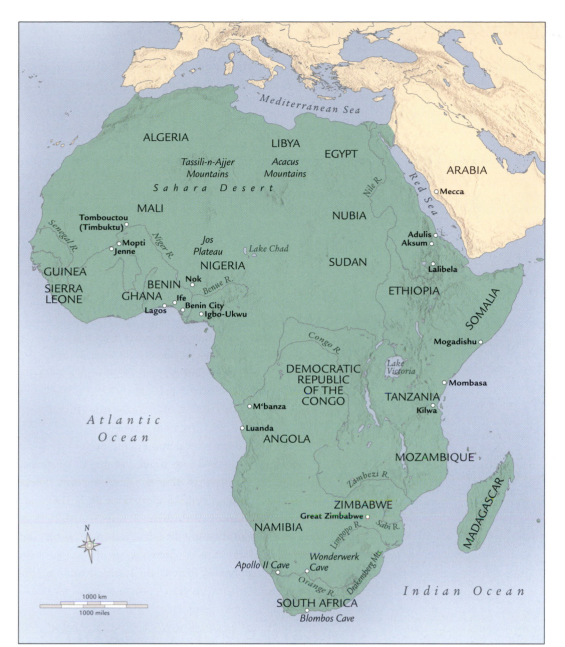

MAP 14–1 • ANCIENT AFRICA

Nearly 5,000 miles from north to south, Africa is the second-largest continent and was the home of some of the earliest and most advanced cultures of the ancient world.

representations of human and animal forms, including hunting scenes, scenes of domestic life, and costumed figures that appear to be dancing. The long record of rock art, extending over thousands of years in numerous places, charts dramatic environmental and social change in the deserts of Africa. Images depicting human subjects are also important evidence that the African artistic traditions of body decoration, mask making and performance spring from ancient African roots.

SAHARAN ROCK ART

The mountains of the central Sahara—principally the Tassili-n-Ajjer range in the south of present-day Algeria and the Acacus Mountains in present-day Libya—contain images that span a period of thousands of years. They record not only the artistic and cultural development of the peoples who lived in the region, but

also the transformation of the Sahara from a fertile grassland to the vast desert we know today.

The earliest Saharan rock art is thought to date from at least 8000 BCE, during the transition into a geological period known as the Makalian Wet Phase. At that time the Sahara was a grassy plain, perhaps much like the game-park reserves of modern east Africa. Vivid images of hippopotamuses, elephants, giraffes, antelopes, and other animals incised on rock surfaces attest to the abundant wildlife that roamed the region.

A variety of scenes found on rock walls in both southern Algeria and Libya depict men and women dancing or performing various ceremonial activities. The artists who created these works paid close attention to details of clothing, body decoration, and headdresses; in some examples the figures are depicted wearing masks that cover their faces. It is suggested that they are engaged in

The word "primitive" was once used by Western art historians to categorize the art of Africa, the art of the Pacific islands, and the indigenous art of the Americas. The term itself means "early" or "first of its kind," but its use was meant to imply that these cultures were crude, simple, backward, and stuck in an early stage of development.

This attitude was accepted by Christian missionaries and explorers, who often described the peoples among whom they worked as "heathen," "barbaric," "ignorant," "tribal," "primitive," and other terms rooted in racism and colonialism. Such usages were extended to these peoples' creations, and "primitive art" became the conventional label for their cultural products.

Criteria that have been used to label a people "primitive" include the use of so-called Stone Age technology, the absence of written histories, and the failure to build great cities. Even based on these criteria, however, the accomplishments of the peoples of Africa, to take just one example, contradict such prejudiced condescension: Africans south of the Sahara have smelted and forged iron since at least 500 BCE. Africans in many areas made and used high-quality steel for weapons and tools. Many African peoples have recorded their histories in Arabic since at least the tenth century CE. The first European visitors to Africa admired the style and sophistication of urban centers such as Benin

and Luanda, to name only two of the continent's great cities. Clearly, neither the cultures of ancient Africa nor the artworks they produced were "primitive."

Until quite recently, Westerners tended to see Africa as a single country and not as an immense continent of vastly diverse cultures. Moreover, they perceived artists working in Africa as craftsmakers bound to styles and images dictated by village elders and producing art that was anonymous and interchangeable. Over the past several decades, however, these misconceptions, too, have crumbled. Art historians and anthropologists have now identified numerous African cultures and artists and compiled catalogs of their work. For example, the well-known Yoruba artist Olowe of Ise (see Chapter 29) was commissioned by rulers throughout the Yoruba region in the early twentieth century to create prestige objects such as palace veranda posts and palace doors or *tour-de-force* carvings such as magnificent lidded bowls supported by kneeling figures. Certainly we will never know the names of the vast majority of African artists of the past, just as we do not know the names of the sculptors responsible for the portrait busts of ancient Rome or the monumental reliefs of the Hindu temples of South Asia. But, as elsewhere, the greatest artists in Africa were famous and sought after, while innumerable others labored honorably and not at all anonymously.

rituals intended to ensure adequate rainfall or success in hunting, or to honor their dead. Produced in a variety of styles, these images document the development of the complex ceremonial and ritual lives of the people who created them (**FIG. 14-2**).

By 4000 BCE the climate had become more arid, and hunting had given way to herding as the primary life-sustaining activity of the Sahara's inhabitants. Among the most beautiful and complex examples of Saharan rock art created in this period are scenes of sheep, goats, and cattle and of the daily lives of the people who tended them. Some scenes found at Tassili-n-Ajjer date from late in the herding period, about 5000–2000 BCE, and illustrate men and women gathered in front of round, thatched houses. As the men tend cattle, the women prepare a meal and care for children. Some scenes attempt to create a sense of depth and distance with overlapping forms, and the placement of near figures lower and distant figures higher in the picture plane.

By 2500–2000 BCE the Sahara was drying and the great game had disappeared, but other animals appear in the rock art. The horse was brought from Egypt by about 1500 BCE and is seen regularly in rock art over the ensuing millennium. The fifth-century BCE Greek historian Herodotus described a chariot-driving people called the Garamante, whose kingdom corresponds roughly to present-day Libya. Rock-art images of horse-drawn chariots bear out his account. Around 600 BCE the camel was introduced into the region from the east, and images of camels were painted on and incised into the rock.

The drying of the Sahara coincided with the rise of Egyptian civilization along the Nile Valley to the east. Similarities can be noted between Egyptian and Saharan motifs, among them images of rams with what appear to be disks between their horns. These similarities have been interpreted as evidence of Egyptian influence on the less-developed regions of the Sahara. Yet in light of the great age of Saharan rock art, it seems just as plausible that the influence flowed the other way, carried by people who had migrated into the Nile Valley when the grasslands of the Sahara disappeared.

SUB-SAHARAN CIVILIZATIONS

Saharan peoples presumably migrated southward as well, into the Sudan, the broad belt of grassland that stretches across Africa south of the Sahara Desert. They brought with them knowledge of settled agriculture and animal husbandry. The earliest evidence of settled agriculture in the Sudan dates from about 3000 BCE. Toward the middle of the first millennium BCE, at the same time that iron technology was being developed elsewhere in Africa, knowledge of ironworking spread across the Sudan as well, enabling its inhabitants to create more effective weapons and farming tools. In the wake of these developments, larger and more complex societies emerged, especially in the fertile basins of Lake Chad in the central Sudan and the Niger and Senegal rivers to the west.

NOK

Some of the earliest evidence of iron technology in sub-Saharan Africa comes from the so-called Nok culture, which arose in the western Sudan, in present-day Nigeria, as early as 500 BCE. The

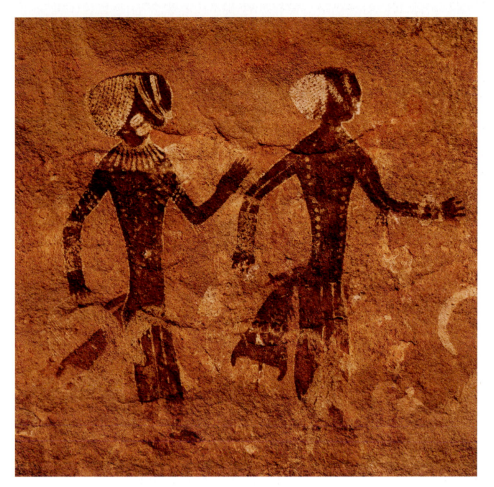

14-2 • DANCERS IN CEREMONIAL ATTIRE
Section of rock-wall painting, Tassili-n-Ajjer, Algeria. c. 5000–2000 BCE.

have since been found in numerous sites over a wide area.

The Nok **HEAD** in **FIGURE 14-3**, slightly larger than life-size, probably formed part of a complete figure. The triangular or D-shaped eyes are characteristic of Nok style and appear also on sculptures of animals. Holes in the pupils, nostrils, and mouth allowed air to pass freely as the figure was fired. Each of the large buns of its elaborate hairstyle is pierced with a hole that may have held ornamental feathers. Other Nok figures were created displaying beaded necklaces, armlets, bracelets, anklets, and other prestige ornaments. Nok sculpture may represent ordinary people dressed for special occasions or it may portray people of high status, thus reflecting social stratification in this early farming culture. In either case, the sculpture provides evidence of considerable technical accomplishment, which has led to speculation that Nok culture was built on the achievements of an earlier culture still to be discovered.

Nok people were farmers who grew grain and oil-bearing seeds, but they were also smelters with the technology for refining ore. Slag and the remains of furnaces have been discovered, along with clay nozzles from the bellows used to fan the fires. The Nok people created the earliest-known sculpture of sub-Saharan Africa, producing accomplished terra-cotta figures of human and animal subjects between about 500 BCE and 200 CE.

Nok sculpture was discovered in modern times by tin miners digging in alluvial deposits on the Jos plateau north of the confluence of the Niger and Benue rivers. Presumably, floods from centuries past had removed the sculptures from their original contexts, dragged and rolled them along, and then deposited them, scratched and broken, often leaving only the heads from what must have been complete human figures. Following archaeological convention, the name of a nearby village, Nok, was given to the culture that created these works. Nok-style works of sculpture

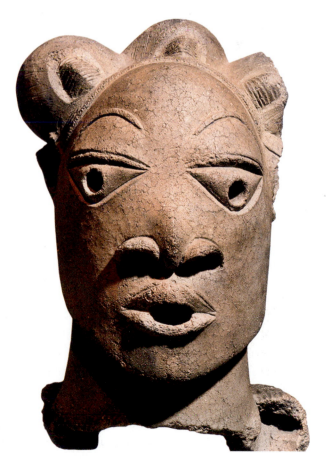

14-3 • HEAD
From Nok, Nigeria. c. 500 BCE–200 CE. Terra cotta, height 14³⁄₁₆″ (36 cm). National Museum, Lagos, Nigeria.

Rock painting (pictographs) and engraving (petroglyphs) from sites in southern Africa differ in style and date from those discussed for the Sahara region. Some works of art pre-date those found in the Sahara, while others continued to be produced into the modern era. Early works include an engraved fragment found in datable debris in Wonderwerk Cave, South Africa, which is about 10,000 years old. Painted stone flakes found at a site in Zimbabwe suggest dates between 13,000 and 8000 BCE.

Numerous examples of rock painting are also found in eastern South Africa in the region of the Drakensberg Mountains. Almost 600 sites have been located in rock shelters and caves, with approximately 35,000 individual images catalogued. It is believed the paintings were produced, beginning approximately 2,400 years ago, by the predecessors of San peoples. Ethnographic research among the San and related peoples in southern Africa suggest possible interpretations for some of the paintings. For example, rock paintings depicting groups of dancing figures may relate to certain forms of San rituals that are still performed today to heal individuals or to cleanse communities. These may have been created by San ritual specialists or shamans to record their curing dances or trance experiences of the spirit world. San rock artists continued to create rock paintings into the late nineteenth century. These latter works depict the arrival of Afrikaner pioneers in the region as well as British soldiers brandishing guns used to hunt eland (FIG. 14–4).

14–4 • SECTION OF SAN ROCK-WALL PAINTING San peoples, uncertain dates. Drakensberg Mountains, South Africa. Pigment and eland blood on rock.

IGBO-UKWU

A number of significant sites excavated in Nigeria in the mid twentieth century increase our understanding of the development of art and culture in west Africa. This includes the archaeological site of Igbo-Ukwu in eastern Nigeria where Igbo peoples reside, numerically one of Nigeria's largest populations. The earliest-known evidence for copper alloy or bronze casting in sub-Saharan Africa is found at Igbo-Ukwu. This evidence dates to the ninth and tenth centuries CE. Igbo-Ukwu is also the earliest-known site containing an elite burial and shrine complex yet found in sub-Saharan Africa. Three distinct archaeological sites have been excavated at Igbo-Ukwu—one containing a burial chamber, another resembling a shrine or storehouse containing ceremonial objects, and the third an ancient pit containing ceremonial and prestige objects.

The **BURIAL CHAMBER** (FIG. 14–5) contained an individual dressed in elaborate regalia, placed in a seated position, and surrounded by emblems of his power and authority. These included three ivory tusks, thousands of imported beads that originally formed part of an elaborate necklace, other adornments, and a cast-bronze representation of a leopard skull. Elephants and leopards remain symbols of temporal and spiritual leadership in Africa today. Ethnographic research among the Nri, an Igbo-related people currently residing in the region, suggests that the burial site is that of an important Nri king or ritual leader (*eze*).

The second excavation uncovered a shrine or storehouse complex containing ceremonial and prestige objects. These copper-alloy castings were made by the lost-wax technique (see "Lost-Wax Casting," page 418) in the form of elaborately decorated small bowls, fly-whisk handles, altar stands, staff finials (decorative tops), and ornaments. Igbo-Ukwu's unique style consists of the representation in bronze of natural objects such as gourd bowls and snail shells whose entire outer surface is covered with elaborate raised and banded decorations—including linear, spiral, circular, and granular designs, sometimes with the addition of small animals

IFE

The sculpture created by the artists of the city of Ife are among the most remarkable works in the history of art. Ancient Ife, which arose in the southwestern, forested part of Nigeria about 800 CE, was essentially circular in plan, with the *oni*'s palace at the center. Ringed by protective stone walls and moats, it was connected to other Yoruba cities by roads that radiated from the center, passing through the city walls at fortified gateways and decorated with mosaics created from stones and pottery shards. From these elaborately patterned pavement mosaics, which covered much of Ife's open spaces, comes the name for Ife's most artistically cohesive historical period (c. 1000–1400), the Pavement period.

Just as the *oni*'s palace was located in a large courtyard in the center of Ife, so too were ritual spaces elsewhere in Ife located in paved courtyards with altars. In the center of such a sacred courtyard, outlined by rings of pavement mosaic, archaeologists excavated an exceptional terra-cotta vessel (**FIG. 14–6**). The jar's bottom had been ritually broken before it was buried, so that liquid offerings (libations) poured into the neck opening would flow into the

14–5 • BURIAL CHAMBER
Igbo-Ukwu, Nigeria. Reconstruction showing the placement of the ruler and artifacts in the chamber in the 10th century. Painting by Caroline Sassoon.

or insects such as snakes, frogs, crickets, or flies applied to the decorated surface. Some castings are further enlivened with the addition of brightly colored beads.

A cast fly-whisk handle is topped with the representation of an equestrian figure whose face, like that of a pendant head also found during excavation, is scarified with patterning similar to that found on some of the terra-cotta and bronze heads of rulers at Ife. These markings resemble those called *ichi*, which are still used by Igbo men as a symbol of high achievement. Among the most technically sophisticated bronze castings found at Igbo-Ukwu is a roped vessel (see "A Closer Look," page 416) resembling a form of water-pot drum still used in this region of Nigeria. The vessel is filled with water and a flat mallet is struck across the surface of the water at the rim to create a percussive sound.

14–6 • RITUAL VESSEL
From Ife, Nigeria. Yoruba, 13th–14th century CE. Terra cotta, height 9¹³⁄₁₆″ (24.9 cm). University Art Museum, Obafemi, Awolowo University, Ife, Nigeria.

A CLOSER LOOK | Roped Pot on a Stand

From Igbo-Ukwu. 9th–10th century CE.
Leaded bronze, height 12¹¹⁄₁₆" (32.3 cm). National Museum, Lagos.

Like a number of other objects excavated at Igbo-Ukwu, this vessel is a skeuomorph—an object created in a different material from the original but made to resemble the original in form, shape, and texture.

The flaring neck of the vessel just below the rim and the lower half of the pot stand were both cast separately. Molten metal was then applied to the edges of the separate castings to join them together.

The knotted rope cage appears to be made from one continuous piece of "rope." Even the individual strands of the "rope" are replicated in leaded bronze.

Pot stands are used to support containers placed on sacred altars so that the water contained in the vessels will never touch the ground before its use in ritual ceremony.

The rope cage surrounding the pot and stand was cast separately and then positioned around the pot and upper part of the stand. The lower part of the knotted rope was then bent inward to grip the pot stand.

 View the Closer Look for the roped pot on a stand on myartslab.com

earth. The objects depicted in relief on the surface of the vessel include what looks like an altar platform with three heads under it, the outer two quite abstract and the middle one in the naturalistic tradition of free-standing Yoruba portrait heads. The abstraction of the two outside heads may have been a way of honoring or blessing the central portrait, a practice that survives among Yoruba royalty today.

BENIN

Ife was probably the artistic parent of the great city-state of Benin, which arose 150 miles to the southeast. According to oral histories, the earliest kings of Benin belonged to the Ogiso, or Skyking, dynasty. After a long period of misrule, however, the people of Benin asked the *oni* of Ife for a new ruler, and the *oni* sent Prince Oranmiyan, who founded a new dynasty in 1170. Some two centuries later, the fourth king, or *oba*, of Benin sent to Ife for a master metalcaster named Iguegha to start a tradition of memorial sculpture like that of Ife, and this tradition of casting memorial heads for the shrines of royal ancestors endures among the successors of Oranmiyan to this day (**FIG. 14–7**).

Benin established cordial relations with Portugal in 1485 and carried on an active trade, at first in ivory and forest products, but eventually in slaves. Benin flourished until 1897, when, in reprisal for the massacre of a party of trade negotiators, British troops sacked and burned the royal palace, sending the *oba* into an exile from which he did not return until 1914 (see Chapter 29).

14-7 • MEMORIAL HEAD OF AN OBA

From Benin, Nigeria. Early Period, c. 16th century CE. Brass, height 9″ (23 cm). The Nelson-Atkins Museum of Art, Kansas City, Missouri. Purchase: Nelson Trust through the generosity of Donald J. and Adele C. Hall, Mr. and Mrs. Herman Robert Sutherland, an anonymous donor, and the exchange of Nelson Gallery Foundation properties (87-7)

This belongs to a small group of rare Early Period sculptures called "rolled-collar" heads that are distinguished by the rolled collar that serves as a firm base for the exquisitely rendered head.

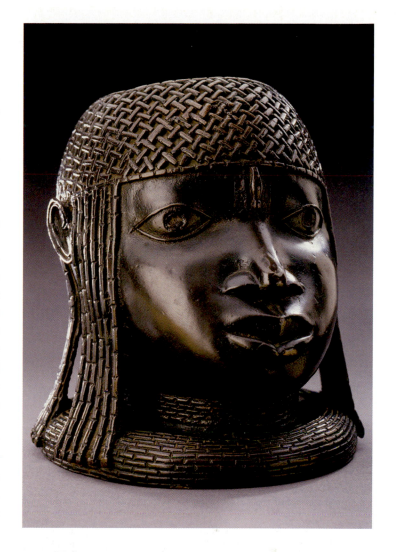

The palace was later rebuilt, and the present-day *oba* continues the dynasty started by Oranmiyan.

The British invaders discovered shrines to deceased *obas* covered with brass heads, bells, and figures. They also found wooden rattles and enormous ivory tusks carved with images of kings, court attendants, and sixteenth-century Portuguese soldiers. The British appropriated the treasure as war booty, making no effort to note which head came from which shrine, thus destroying evidence that would have helped establish the relative age of the heads and determine a chronology for the evolution of Benin style. Nevertheless, it has been possible to piece together a chronology from other evidence.

The Benin heads, together with other objects, were originally placed on a semicircular platform or **ALTAR** and surmounted by large elephant tusks, another symbol of power (**FIG. 14–8**). Benin brass heads range from small, thinly cast, and lifelike to large, thickly cast, and highly stylized. Many scholars have concluded

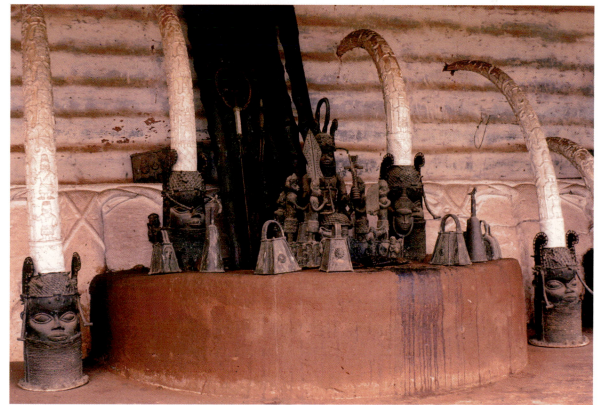

14-8 • PHOTOGRAPH OF AN ALTAR
Edo culture, Nigeria. c. 1959. The National Museum of African Art, Smithsonian Institution, Washington, DC. Eliot Elisofon Photographic Archives (7584)

TECHNIQUE | Lost-Wax Casting

In the lost-wax casting process a metal copy is produced from an original image made of wax. The usual metals for this casting process are bronze, an alloy of copper and tin, and brass, an alloy of copper and zinc. First, the sculptor models a wax original. Then the wax is invested in a heat-resistant mold, usually of clay. Next, the wax is melted, leaving an empty cavity into which molten metal is poured. After the metal cools and solidifies, the mold is broken away and the metal copy is chased and polished.

The progression of drawings here shows the steps used by the Benin sculptors of Africa. A heat-resistant "core" of clay (A) approximating the shape of the sculpture-to-be (and eventually becoming the hollow inside the sculpture) was covered by a layer of wax that had the thickness of the final sculpture. The sculptor carved or modeled (B) the details in the wax. Rods and a pouring cup made of wax were attached (C) to the model. A thin layer of fine, damp sand was pressed very firmly into the surface of the wax model, and then model, rods, and cup were encased (D) in thick layers of clay. When the clay was completely dry, the mold was heated (E) to melt out the wax. The mold was then placed upside down in the ground to receive (F) the molten metal. When the metal was completely cool, the outside clay cast and the inside core were broken up and removed (G), leaving the cast-brass sculpture. Details were polished to finish the piece, which could not be duplicated because the mold had been destroyed.

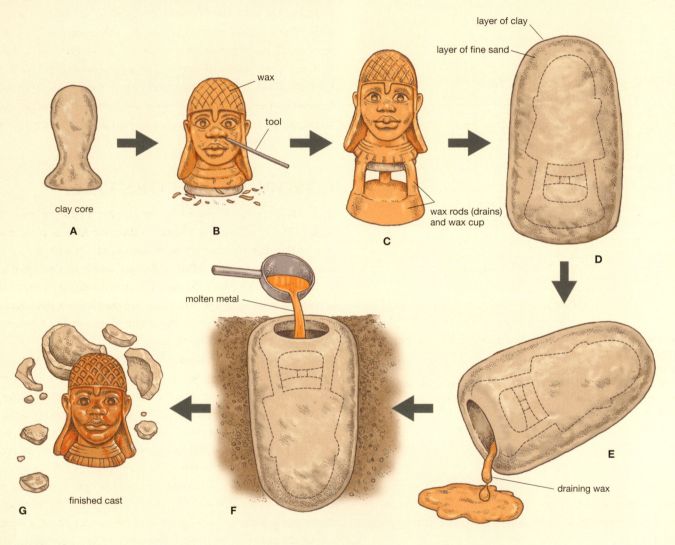

Watch a video about the process of lost-wax casting on myartslab.com

that the smallest, most naturalistic heads with only a few strands of beads around the neck were created during a so-called Early Period (1400–1550), when Benin artists were still heavily influenced by Ife. Heads grew heavier and increasingly stylized, and the strands of beads increased in number until they concealed the chin during the Middle Period (1550–1700). Heads from the ensuing Late Period (1700–1897) are very large and heavy, with angular, stylized features, elaborate beaded crowns, and numerous necklaces forming a tall, cylindrical mass. In addition, broad, horizontal flanges, or projecting edges, bearing small images cast in low relief

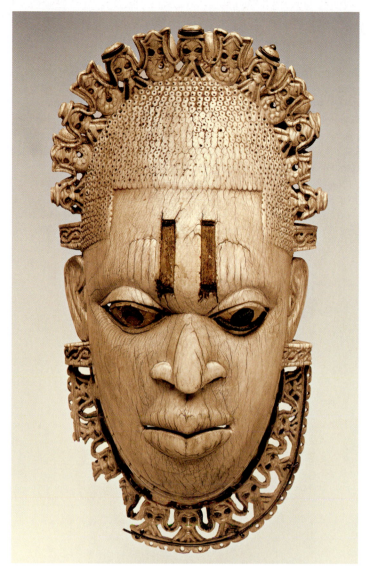

14-9 • HIP PENDANT REPRESENTING AN IYOBA ("QUEEN MOTHER")

From Benin City, Nigeria. Middle Period, c. 1550 CE. Ivory, iron, and copper, height 9⅜″ (23.4 cm). Metropolitan Museum of Art, New York. The Michael C. Rockefeller Memorial Collection, Gift of Nelson A. Rockefeller (1978.412.323)

ring the base of the Late Period heads. The increase in size and weight of Benin memorial heads over time may reflect the growing power and wealth flowing to the *oba* from Benin's expanding trade with Europe.

At Benin, as in many other African cultures, the head is the symbolic center of a person's intelligence, wisdom, and ability to succeed in this world or to communicate with spiritual forces in the ancestral world. One of the honorifics used for the king is "Great Head": The head leads the body as the king leads the people. All memorial heads include representations of coral-beaded caps and necklaces and royal costume. Coral, enclosing the head and displayed on the body, is still the ultimate symbol of the *oba*'s power and authority.

The art of Benin is a royal art; only the *oba* could commission works in brass (see "A Warrior Chief Pledging Loyalty," page 420). Artisans who served the court were organized into **guilds** and lived in a separate quarter of the city. *Obas* also commissioned important works in ivory. One example is a beautiful ornamental pendant (**FIG. 14-9**) representing an *iyoba* (queen mother—the *oba*'s mother), the senior female member of the royal court. The pendant was carved as a belt ornament and was worn at the *oba*'s hip. Its pupils were originally inlaid with iron, as were the scarification patterns on the forehead. This particular belt ornament may represent Idia, who was the mother of Esigie, a powerful *oba* who ruled from 1504 to 1550. Idia is particularly remembered for raising an army and using magical powers to help her son defeat his enemies. Like Idia, the Portuguese helped Esigie expand his kingdom. The necklace represents heads of Portuguese soldiers with beards and flowing hair. In the crown, more Portuguese heads alternate with figures of mudfish, which symbolize Olokun, the Lord of the Great Waters. Mudfish live near river banks, mediating between water and land, just as the *oba*, who is viewed as semi-divine, mediates between the human world and the supernatural world of Olokun.

OTHER URBAN CENTERS

Ife and Benin were only two of the many cities that arose in ancient Africa. The first European visitors to the west African coast at the end of the fifteenth century were impressed not only by Benin, but also by the city of Mbanza Kongo, south of the mouth of the Congo River. Along the east African coastline, Europeans also happened upon cosmopolitan cities that had been busily carrying on long-distance trade across the Indian Ocean and as far away as China and Indonesia for hundreds of years.

Important centers also existed in the interior, especially across the central and western Sudan. There, cities and the states that developed around them grew wealthy from the trans-Saharan trade that had linked west Africa to the Mediterranean since at least the first millennium BCE. Indeed, the routes across the desert were probably as old as the desert itself. Among the most significant goods exchanged in this trade were salt from the north and gold from west Africa. Such fabled cities as Mopti, Timbuktu, and Jenné arose in the vast area of grasslands along the Niger River in the region known as the Niger Bend (present-day Mali), a trading crossroads as early as the first century BCE. They were great centers of commerce, where merchants from all over west Africa met caravans arriving from the Mediterranean. Eventually the trading networks extended across Africa from the Sudan in the east to the Atlantic coast in the west. In the twelfth century CE a Mande-speaking people formed the kingdom of Mali (Manden). The rulers adopted Islam, and by the fourteenth century they controlled the oases on which the traders' caravans depended. Mali prospered, and wealthy cities like Timbuktu and Jenné became famed as centers of Islamic learning.

Produced during the sixteenth and seventeenth centuries, approximately 900 brass plaques, each averaging about 16 to 18 inches in height, once decorated the walls and pillars of the royal palace of the kingdom of Benin. Like the brass memorial heads and figure sculpture, the plaques were made using the lost-wax casting process. They illustrate a variety of subjects including ceremonial scenes at court, showing the *oba*, other court functionaries, and (at times) Portuguese soldiers. Modeled in relief,

the plaques depict one or more figures, with precise details of costume and regalia. Some figures are modeled in such high relief that they appear almost free-standing as they emerge from a textured surface background that often includes foliate patterning.

This **PLAQUE** (**FIG. 14–10**) features a warrior chief in ceremonial attire. His rank is indicated by a necklace of leopard's teeth and a coral-decorated cap and collar. He also wears an elaborate skirt with a leopard mask

on his hip and holds a spear in one hand and an *eben* sword raised above his head in the other hand. The *eben* sword, with its distinctive leaf-shaped blade made of iron with openwork surface decoration is a principal symbol of high rank in Benin City even today (**FIGS. 14–11, 14–12**).

The plaque is organized in a hierarchal order with the warrior chief larger in size and in the center of the composition. The chief is flanked by two warriors holding shields and

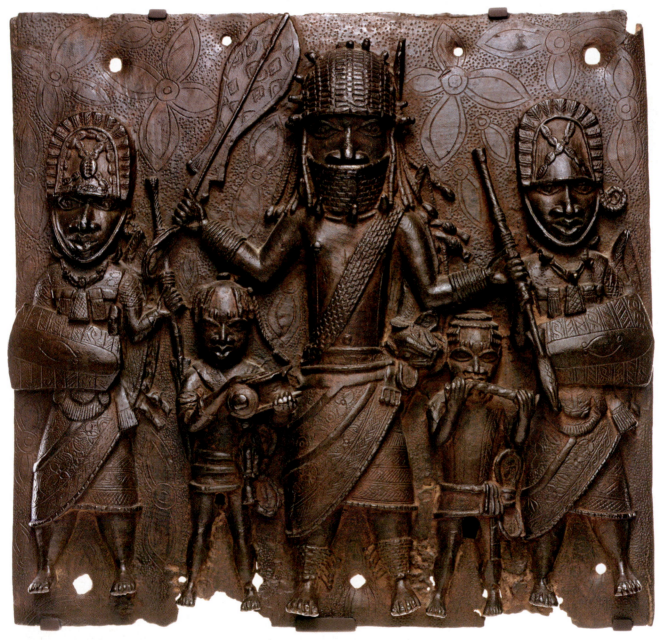

14–10 • PLAQUE: WARRIOR CHIEF FLANKED BY WARRIORS AND ATTENDANTS
From Benin City, Nigeria. Middle Period, c. 1550–1650 CE. Brass, height 14¾″ × 15½″ (37.5 × 39.4 cm).
The Nelson-Atkins Museum of Art, Kansas City, Missouri. Purchase: William Rockhill Nelson Trust (58–3)

14–11 • SENIOR TOWN CHIEF
Supported by two attendants, one of them carrying his *eben* sword.

spears, and two smaller figures representing court attendants. One attendant plays a side-blown horn that announces the warrior chief's presence, while the other attendant carries a ceremonial box for conveying gifts to the *oba*. The scene is a ceremony of obeisance to the *oba*, and the warrior chief's gesture of raising the *eben* sword is still performed at annual ceremonies in which chiefs declare their allegiance and loyalty to the *oba* by raising the sword and spinning it in the air to add drama, conviction, and authority to the ceremony.

14–12 • *OBA* EREDIAUWA
Wearing coral-beaded regalia and seated on a dais.

At a site near Jenné known as Jenné-Jeno or Old Jenné, excavations (by both archaeologists and looters) have uncovered hundreds of terra-cotta figures dating from the thirteenth to the sixteenth centuries. The figures were polished, covered with a red clay slip, and fired at a low temperature. A **HORSEMAN**, armed with quiver, arrows, and a dagger, is a good example of the technique (**FIG. 14–13**). Man and horse are formed of rolls of clay on which details of the face, clothing, and harness are carved, engraved, and painted. The rider has a long oval head and jutting chin, pointed oval eyes set in multiple framing lids, and a long straight nose. He wears short pants and a helmet with a chin strap, and his horse has an ornate bridle. Such elaborate trappings suggest that the horseman could be a guardian figure, hero, or even a deified ancestor. Similar figures have been found in sanctuaries. But, as urban life declined, so did the arts. The long tradition of ceramic sculpture came to an end in the fifteenth and sixteenth centuries, when rivals began to raid the Manden cities.

JENNÉ

In 1655, the Islamic writer al-Sadi wrote this description of Jenné:

> This city is large, flourishing, and prosperous; it is rich, blessed, and favoured by the Almighty.... Jenne [Jenné] is one of the great markets of the Muslim world. There one meets the salt merchants from the mines of Teghaza and merchants carrying gold from the mines of Bitou.... Because of this blessed city, caravans flock to Timbuktu from all points of the horizon.... The area around Jenne is fertile and well populated; with numerous markets held there on all the days of the week. It is certain that it contains 7,077 villages very near to one another.
>
> (Translated by Graham Connah in *African Civilizations*, page 108)

By the time al-Sadi wrote his account, Jenné already had a long history. Archaeologists have determined that the city was established by the third century CE, and that by the middle of the ninth century it had become a major urban center. Also by the ninth century, Islam was becoming an economic and religious force in west and north Africa, and the northern terminals of the trans-Saharan trade routes had already been incorporated into the Islamic realm.

When Koi Konboro, the 26th king of Jenné, converted to Islam in the thirteenth century, he transformed his palace into the first of three successive mosques in the city. Like the two that followed, the first mosque was built of adobe brick, a sun-dried mixture of clay and straw. With its great surrounding wall and tall towers, it was said to have been more beautiful and more lavishly decorated than the Kaaba, the central shrine of Islam, at Mecca. The mosque eventually attracted the attention of austere Muslim rulers who objected to its sumptuous furnishings. Among these was the early nineteenth-century ruler Sekou Amadou, who had it razed and a far more humble structure erected on a new site. This

14-13 • HORSEMAN
From Old Jenné, Mali. 13th–15th century CE. Terra cotta, height 27¾″ (70.5 cm). National Museum of African Art, Smithsonian Institution, Washington, DC. Museum Purchase (86-12-2)

second mosque was in turn replaced by the current grand mosque, constructed between 1906 and 1907 on the ancient site in the style of the original. The reconstruction was supervised by the architect Ismaila Traoré, the head of the Jenné guild of masons.

The mosque's eastern, or "marketplace," façade boasts three tall towers, the center one containing the *mihrab* (**FIG. 14-14**). The finials, or crowning ornaments, at the top of each tower bear ostrich eggs, symbols of fertility and purity. The façade and sides of the mosque are distinguished by tall, narrow, engaged columns, which act as buttresses. These columns are characteristic of west African mosque architecture, and their cumulative rhythmic effect is one of great verticality and grandeur. The most unusual features of west African mosques are the **torons**, wooden beams projecting from the walls. Torons provide permanent supports for the scaffolding erected each year so that the exterior can be replastered.

Traditional houses resemble the mosque on a small scale. Adobe walls, reinforced by buttresses, rise above the roofline in conical turrets, emphasizing the entrance. Rooms open inward onto a courtyard. Extended upper walls mask a flat roof terrace that gives more private space for work and living.

14–14 • GREAT FRIDAY MOSQUE

Jenné, Mali. Showing the eastern and northern façades. Rebuilding of 1907, in the style of 13th-century original.

The plan of the mosque is not quite rectangular. Inside, nine rows of heavy adobe columns, 33′ (10 m) tall and linked by pointed arches, support a flat ceiling of palm logs. An open courtyard on the west side (not seen here) is enclosed by a great double wall only slightly lower than the walls of the mosque itself. The main entrances to the prayer hall are in the north wall (to the right in the photograph).

👁—**Watch** an architectural simulation explaining adobe-brick construction on myartslab.com

GREAT ZIMBABWE

Thousands of miles from Jenné, in southeastern Africa, an extensive trade network developed along the Zambezi, Limpopo, and Sabi rivers. Its purpose was to funnel gold, ivory, and exotic skins to the coastal trading towns that had been built by Arabs and Swahili-speaking Africans. There, the gold and ivory were exchanged for prestige goods, including porcelain, beads, and other manufactured items. Between 1000 and 1500 CE, this trade was largely controlled from a site that was called Great Zimbabwe, home of the Shona people.

The word *zimbabwe* derives from the Shona term *dzimba dza mabwe* ("venerated houses" or "houses of stone"). The stone buildings at Great Zimbabwe were constructed by the ancestors of the present-day people of this region. The earliest construction at the site took advantage of the enormous boulders abundant in the vicinity. Masons incorporated the boulders and used the uniform granite blocks that split naturally from them to build a series of tall enclosing walls high on a hilltop. Each enclosure defined a family's living space and housed dwellings made of adobe with conical, thatched roofs.

The largest building complex at Great Zimbabwe is located in a broad valley below the hilltop enclosures. Known as Imba Huru (the Great Enclosure), the complex is ringed by a masonry wall more than 800 feet long, up to 32 feet tall, and 17 feet thick at the base. Inside the great outer wall are numerous smaller stone enclosures and adobe platforms (**FIG. 14–15**). The buildings at Great Zimbabwe were built without mortar; for stability the walls are battered, or built so that they slope inward toward the top. Although some of the enclosures at Great Zimbabwe were built on hilltops, there is no evidence that they were constructed as fortresses. There are neither openings for weapons to be thrust through, nor battlements for warriors to stand on. Instead, the walls and structures seem intended to reflect the wealth and power of the city's rulers. The Imba Huru was probably a royal residence, or palace complex, and other structures housed members of the ruler's family and court. The complex formed the nucleus of a city that radiated for almost a mile in all directions. Over the centuries, the builders grew more skillful, and the later additions are distinguished by dressed, or smoothly finished, stones, laid in fine, even, level courses. One of these later additions is a structure known

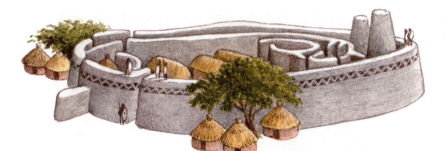

14-16 • CONICAL TOWER, GREAT ENCLOSURE

Great Zimbabwe Shona, Zimbabwe. c. 1350–1450 CE. Stone, height of tower 30′ (9.1 m).

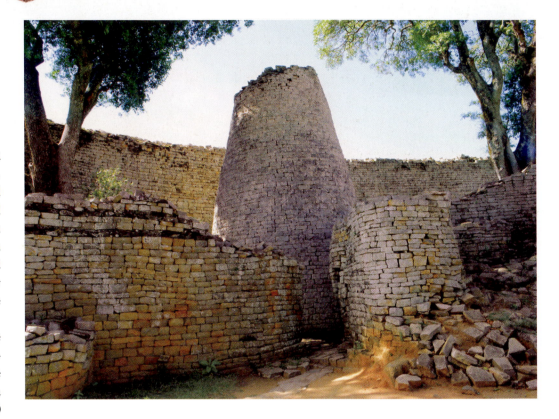

simply as the **CONICAL TOWER** (**FIG. 14-16**), 18 feet in diameter, 30 feet tall, and originally capped with three courses of ornamental stonework. Constructed between the two walls and resembling a granary, it may have represented the good harvest and prosperity believed to result from allegiance to the ruler of Great Zimbabwe.

It is estimated that at the height of its power, in the fourteenth century, Great Zimbabwe and its surrounding city housed a population of more than 10,000 people. A large cache of goods containing items of such far-flung origin as Portuguese medallions, Persian pottery, and Chinese porcelain testify to the extent of its trade. Yet beginning in the mid fifteenth century Great Zimbabwe was gradually abandoned as control of the lucrative southeast African trade network passed to the Mwene Mutapa and Khami empires a short distance away.

AKSUM AND LALIBELA

In the second century BCE Aksumite civilization increased in importance in the Ethiopian highlands through the control of trade routes from the African interior to the Red Sea port of Adulis. Its exports included ivory, gold, slaves, frankincense, myrrh, and salt. In the mid fourth century CE the Aksumite king Ezana converted to Christianity, and soon gold and silver coinage minted at Aksum bore the Christian cross.

The archaeological remains at Aksum and Gondar speak of the splendor of the ancient kingdom. By the third century CE a series of stone palaces were built at Aksum. The elites also erected a number of monolithic granite stelai which date from the third and fourth centuries, the largest over 95 feet in height. Their outer surfaces were decorated with such carved architectural details as false doors, inset windows, and timber beams. The stelai served as commemorative markers among the tombs and burial sites of the elite.

The power and influence of the Aksumite state were diminished by the displacement of the Red Sea trade routes after the Persian conquest of south Arabia, and Aksum was conquered by the Zagwe from Ethiopia's western highlands. After Aksum's demise and abandonment, a new capital arose, the influence and prestige of which lasted until near the end of the thirteenth century.

The Zagwe king Lalibela, wishing to create a "new" Jerusalem (the holy city revered by Christians, Jews, and Muslims) in Ethiopia, founded a holy site named after himself in the highlands south of Aksum. The cultural embrace of Christianity by the populace during the thirteenth century is evidenced by the numerous rock-hewn sanctuaries that were created in Lalibela at this time. Rather than being built from the ground up, the churches and other structures were hewn from the living rock. A wide trench was first cut around the four sides of a block of volcanic tuff that would become the church. Stonemasons then carved out the exterior and

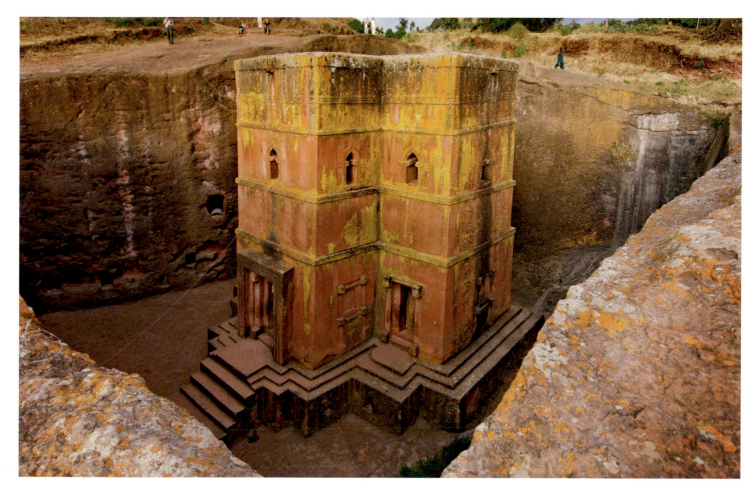

14-17 • BET GIORGIS (CHURCH OF ST. GEORGE), LALIBELA
Ethiopia. 13th century. Volcanic rock.

Explore the architectural panoramas of Bet Giorgis on myartslab.com

interior of the sanctuaries with hammers and chisels. Each aspect of the structure had to be planned with precision before work could begin. The interior of the church was created with a hemispherical domed ceiling in the style of the Byzantine churches that Ethiopian priests would have seen during pilgrimages to Jerusalem.

The largest of the 11 churches is **BET GIORGIS (CHURCH OF ST. GEORGE)** which was cut 40 feet down within the rock in the form of a modified cross (**FIG. 14-17**). Most rock-cut sanctuaries have architectural details that appear to have been modeled in part from earlier Aksum palaces. However, Bet Giorgis has window details that are similar to the organic tendril forms found in later Ethiopian painted manuscripts. The origins of the rock-cut church are unknown. The churches at Lalibela may have been modeled on earlier Aksumite cave sanctuaries, but it has also been suggested that they have their origins in central and southern India where Buddhist and Hindu temples, shrines, and monasteries have been excavated from the living rock for over 2,000 years.

KONGO KINGDOM

As in other parts of sub-Saharan Africa, art-making traditions in the Kongo cultural region developed over thousands of years.

However, as elsewhere on the African continent, the climate here is often not conducive to the survival of objects made from wood. Among the earliest-known wooden artworks from central Africa is a wood carving unearthed in Angola in 1928 (**FIG. 14-18**). This zoomorphic head may have been created for use as a headdress or mask. Its elongated snout, pointed ears, and geometric surface patterning resemble some masking traditions and sculptural practices that survived in the region well into the twentieth century.

The Portuguese first encountered Kongo culture in 1482 at approximately the same time that contact was made with the royal court of Benin in present-day western Nigeria. They visited the capital of Mbanza Kongo (present-day M'banza Congo) and met the *manikongo* ("king"), who ruled over a kingdom that was remarkable in terms of its complex political organization and artistic sophistication. The kingdom, divided into six provinces, encompassed over 100,000 square miles of present-day northwestern Angola and the western part of the Democratic Republic of the Congo. In 1491, King Nzinga aNkuwa converted to Christianity, as did his son and successor Afonso I, who established Christianity as the state religion. The conversions helped to solidify trade relations with the Portuguese, and trade in copper, salt, ivory, cloth,

14–18 • ZOOMORPHIC HEAD
Angola. c. 750 CE. Wood, 19⅞″ × 6⅛″ (50.5 × 15.5 cm). Royal Museum of Central Africa, Tervuren, Belgium.

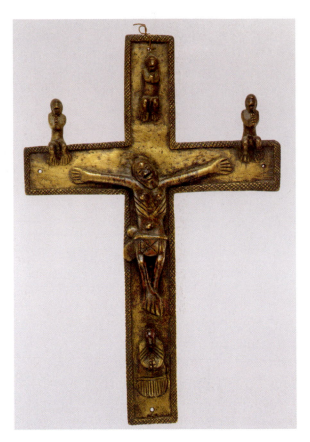

14–20 • CRUCIFIX
Kongo. Early 17th century CE. Bronze, height 10½″ (26.7 cm). Metropolitan Museum of Art, New York. Collection of Ernst Anspach. (1999.295.7)

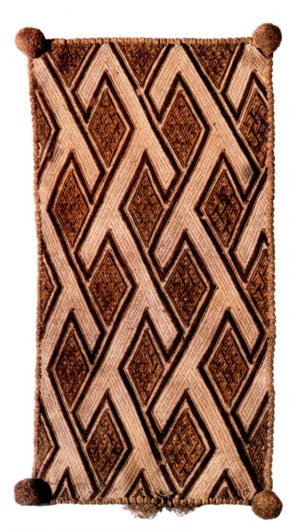

14–19 • DECORATED TEXTILE
Kongo. Before 1400 CE. Raffia, 9½″ × 18½″ (24 × 47 cm). Pitt Rivers Museum, University of Oxford, England. (1886.1.254.1)

and, later, slaves brought increased prosperity to the kingdom. Kongo's influence expanded until the mid seventeenth century when its trading routes were taken over by neighboring peoples, including the Lunda and Chokwe.

The increase in wealth brought a corresponding increase in the production of specialty textiles, baskets, and regalia for the nobility. Textiles in central Africa, as elsewhere in Africa, are highly valued and were used as forms of currency before European contact. They figure prominently in funerary rituals even to the present day. Kongo **DECORATED TEXTILES** were lauded by the Portuguese from first contact and were accepted as gifts or collected, eventually finding their way into European museum collections (**FIG. 14–19**).

Following Portuguese contact in the fifteenth century and Nzinga aNkuwa's conversion, Kongolese art increasingly absorbed Western influences. Catholic missionaries brought with them various religious objects, including monstrances (highly decorated vessels used to display the consecrated Eucharistic host) and figures of the Virgin Mary and various saints. The **CRUCIFIX** became especially popular as a potent symbol of both conversion and political authority. Cast in brass and copper alloy, locally produced examples (**FIG. 14–20**) mirror their European prototypes, but are often restated in African terms. The features of the crucified Christ, as

well as his hands and feet and those of the supporting figures, are stylized in ways that suggest local African art, as does the placement of supporting figures above and below the central figure. Although the supporting figures appear to be praying, they are actually clapping their hands—a common central African gesture of respect for another person.

EXPORTING TO THE WEST

Shortly after initial contact with European explorers, merchants, and traders, African artists not only continued to fashion objects for their own consumption but also began to produce them for export to Europe. For example, by the late fifteenth century, carvers residing in present-day Sierra Leone (called Sapi by the Portuguese) and Nigeria (Bini) began to produce ivory objects such as saltcellars, powder flasks, spoons, and forks, as well as exquisitely carved oliphants, or horns (**FIG. 14–21**) for European patrons.

The form of this Sapi-Portuguese oliphant and virtually all its decorative motifs are European-inspired. The mouthpiece is at the narrow end rather than on the side as is typical for African horns. The carvings, including the coat of arms of Portugal and Spain, the motto of Spain's Ferdinand V, and heraldic emblems and hunting scenes, were derived from illustrations found in European prayer books and other publications that were given to the artists as source material. However, not all of the designs found on some export ivories are derived from European sources. For example, some saltcellars depicting human subjects were carved in a style that resembles local stone figures that pre-date Portuguese contact with the west African coast. As we will see in Chapter 29, the synthesis of African traditions and Western influences continued to affect African art in both subtle and overt ways in the modern period.

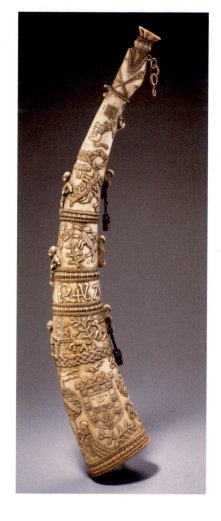

14–21 • SAPI-PORTUGUESE STYLE HUNTING HORN
Sierra Leone. Late 15th century CE. Ivory, length 25″ (63.5 cm). National Museum of African Art, Smithsonian Institution, Washington, DC. Gift of Walt Disney World Co., a subsidiary of the Walt Disney Company (2005–6–9)

THINK ABOUT IT

14.1 Analyze the formal characteristics of the human heads in FIGURES 14–7 and 14–9. What is the relationship between style and medium, as well as style and function?

14.2 What is the spiritual role of the *oba* in Benin? What is his relationship to the spirit world, and how is that relationship represented in one work discussed in the chapter?

14.3 Explain the original purpose of the Benin royal plaque (see "A Warrior Chief Pledging Loyalty," page 420). How do the identity and presentation of the individuals on the plaque relate to hierarchy at the royal court and the glorification of Benin kingship?

14.4 Evaluate the effect of Portuguese influence on African art by discussing the works in FIGURES 14–20 and 14–21. Which aspects of these works derive from local traditions and which are the result of European contact?

CROSSCURRENTS

FIG. 6–12 FIG. 14–1

Both of these works in bronze represent important people with heightened descriptive detail that suggests they may portray specific individuals. Discuss the similarities and differences in technique, style, and use. How does each work represent the culture that produced it?

 Study and review on myartslab.com

Glossary

abacus (p. 108) The flat slab at the top of a **capital**, directly under the **entablature**.

abbey church (p. 239) An abbey is a monastic religious community headed by an abbot or abbess. An abbey church often has an especially large **choir** to provide space for the monks or nuns.

absolute dating (p. 12) A method, especially in archaeology, of assigning a precise historical date at which, or span of years during which, an object was made. Based on known and recorded events in the region, as well as technically extracted physical evidence (such as carbon-14 disintegration). See also **radiometric dating**, **relative dating**.

abstract (p. 7) Of art that does not attempt to describe the appearance of visible forms but rather to transform them into stylized patterns or to alter them in conformity to ideals.

academy (p. 926) An institution established for the training of artists. Academies date from the Renaissance and after; they were particularly powerful, state-run institutions in the seventeenth and eighteenth centuries. In general, academies replaced **guild**s as the venues where students learned the craft of art and were educated in art theory. Academies helped the recognition of artists as trained specialists, rather than craftsmakers, and promoted their social status. An academician is an academy-trained artist.

acanthus (p. 110) A Mediterranean plant whose leaves are reproduced in Classical architectural ornament used on **molding**s, **frieze**s, and **capital**s.

acroterion (*pl.* **acroteria**) (p. 110) An ornament at the corner or peak of a roof.

Action painting (p. 1074) Using broad gestures to drip or pour paint onto a pictorial surface. Associated with mid-twentieth-century American Abstract Expressionists, such as Jackson Pollock.

adobe (p. 399) Sun-baked blocks made of clay mixed with straw. Also: buildings made with this material.

aedicula (p. 609) A decorative architectural frame, usually found around a niche, door, or window. An aedicula is made up of a **pediment** and **entablature** supported by **columns** or **pilaster**s.

aerial perspective (p. 626) See under **perspective**.

agora (p. 137) An open space in a Greek town used as a central gathering place or market. Compare **forum**.

aisle (p. 225) Passage or open corridor of a church, hall, or other building that parallels the main space, usually on both sides, and is delineated by a row, or **arcade**, of **columns** or **pier**s. Called side aisles when they flank the **nave** of a church.

akropolis (p. 128) The citadel of an ancient Greek city, located at its highest point and housing temples, a treasury, and sometimes a royal palace. The most famous is the Akropolis in Athens.

album (p. 796) A book consisting of a series of paintings or prints (album leaves) mounted into book form.

allegory (p. 627) In a work of art, an image (or images) that symbolizes an idea, concept, or principle, often moral or religious.

alloy (p. 23) A mixture of metals; different metals melted together.

altarpiece (p. xl) A painted or carved panel or ensemble of panels placed at the back of or behind and above an altar. Contains religious imagery (often specific to the place of worship for which it was made) that viewers can look at during liturgical ceremonies (especially the **Eucharist**) or personal devotions.

amalaka (p. 302) In Hindu architecture, the circular or square-shaped element on top of a spire (*shikhara*), often crowned with a **finial**, symbolizing the cosmos.

ambulatory (p. 224) The passage (walkway) around the **apse** in a church, especially a **basilica**, or around the central space in a **central-plan building**.

amphora (*pl.* **amphorae**) (p. 101) An ancient Greek or Roman jar for storing oil or wine, with an egg-shaped body and two curved handles.

animal style or **interlace** (p. 433) Decoration made of interwoven animals or serpents, often found in early medieval Northern European art.

ankh (p. 51) A looped cross signifying life, used by ancient Egyptians.

appropriation (p. xxviii) The practice of some Postmodern artists of adopting images in their entirety from other works of art or from visual culture for use in their own art. The act of recontextualizing the appropriated image allows the artist to critique both it and the time and place in which it was created.

apse (p. 192) A large semicircular or polygonal (and usually **vaulted**) recess on an end wall of a building. In a Christian church, it often contains the altar. "Apsidal" is the adjective describing the condition of having such a space.

arabesque (p. 267) European term for a type of linear surface decoration based on foliage and calligraphic forms, thought by Europeans to be typical of Islamic art and usually characterized by flowing lines and swirling shapes.

arcade (p. 170) A series of **arch**es, carried by **columns** or **pier**s and supporting a common wall or **lintel**. In a blind arcade, the arches and supports are **engaged** and have a purely decorative function.

arch (p. 95) In architecture, a curved structural element that spans an open space. Built from wedge-shaped stone blocks called **voussoir**s placed together and held at the top by a trapezoidal **keystone**. It forms an effective space-spanning and weight-bearing unit, but requires **buttress**es at each side to contain the outward **thrust** caused by the weight of the structure. *Corbeled arch*: an arch or **vault** formed by **courses** of stones, each of which projects beyond the lower course until the space is enclosed; usually finished with a **capstone**. *Horseshoe arch*: an arch of more than a half-circle; typical of western Islamic architecture. *Round arch*: an arch that displaces most of its weight, or downward thrust along its curving sides, transmitting that weight to adjacent supporting uprights (door or window **jamb**s, **column**s, or **pier**s). *Ogival arch*: a sharply pointed arch created by S-curves. *Relieving arch*: an arch built into a heavy wall just above a **post-and-lintel** structure (such as a gate, door, or window) to help support the wall above by transferring the load to the side walls. *Transverse arch*: an arch that connects the wall **pier**s on both sides of an interior space, up and over a stone **vault**.

Archaic smile (p. 114) The curved lips of an ancient Greek statues in the period c. 600–480 BCE, usually interpreted as a way of animating facial features.

architrave (p. 107) The bottom element in an **entablature**, beneath the **frieze** and the **cornice**.

archivolt (p. 478) A band of **molding** framing an **arch**, or a series of stone blocks that form an arch resting directly on flanking **column**s or **pier**s.

ashlar (p. 99) A highly finished, precisely cut block of stone. When laid in even **course**s, ashlar masonry creates a uniform face with fine joints. Often used as a facing on the visible exterior of a building, especially as a veneer for the **façade**. Also called **dressed stone**.

assemblage (p. 1026) Artwork created by gathering and manipulating two- and/or three-dimensional found objects.

astragal (p. 110) A thin convex decorative **molding**, often found on a Classical **entablature**, and usually decorated with a continuous row of beadlike circles.

atelier (p. 946) The studio or workshop of a master artist or craftsmaker, often including junior associates and apprentices.

atmospheric perspective (p. 183) See under **perspective**.

atrial cross (p. 943) A cross placed in the **atrium** of a church. In Colonial America, used to mark a gathering and teaching place.

atrium (p. 158) An unroofed interior courtyard or room in a Roman house, sometimes having a pool or garden, sometimes surrounded by **column**s. Also: the open courtyard in front of a Christian church; or an entrance area in modern architecture.

automatism (p. 1057) A technique in which artists abandon the usual intellectual control over their brushes or pencils to allow the subconscious to create the artwork without rational interference.

avant-garde (p. 972) Term derived from the French military word meaning "before the group," or "vanguard." Avant-garde denotes those artists or concepts of a strikingly new, experimental, or radical nature for their time.

axis (p. xxxii) In pictures, an implied line around which elements are composed or arranged. In buildings, a dominant line around which parts of the structure are organized and along which human movement or attention is concentrated.

axis mundi (p. 300) A concept of an "axis of the world," which marks sacred sites and denotes a link between the human and celestial realms. For example, in Buddhist art, the axis mundi can be marked by monumental free-standing decorative pillars.

baldachin (p. 472) A canopy (whether suspended from the ceiling, projecting from a wall, or supported by columns) placed over an honorific or sacred space such as a throne or church altar.

bar tracery (p. 510) See under **tracery**.

barbarian (p. 149) A term used by the ancient Greeks and Romans to label all foreigners outside their cultural orbit (e.g., Celts, Goths, Vikings). The word derives from an imitation of what the "barblings" of their language sounded like to those who could not understand it.

barrel vault (p. 187) See under **vault**.

bas-relief (p. 325) Another term for low relief ("bas" is the French word for "low"). See under **relief sculpture**.

basilica (p. 191) A large rectangular building. Often built with a **clerestory**, side **aisles** separated from the center **nave** by **colonnades**, and an **apse** at one or both ends. Originally Roman centers for administration, later adapted to Christian church use.

bay (p. 170) A unit of space defined by architectural elements such as **columns**, **piers**, and walls.

beehive tomb (p. 98) A **corbel-vaulted** tomb, conical in shape like a beehive, and covered by an earthen mound.

Benday dots (p. 1095) In modern printing and typesetting, the individual dots that, together with many others, make up lettering and images. Often machine- or computer-generated, the dots are very small and closely spaced to give the effect of density and richness of tone.

bilum (p. 865) Netted bags made mainly by women throughout the central highlands of New Guinea. The bags can be used for everyday purposes or even to carry the bones of the recently deceased as a sign of mourning.

biomorphic (p. 1058) Denoting the biologically or organically inspired shapes and forms that were routinely included in abstracted Modern art in the early twentieth century.

black-figure (p. 105) A technique of ancient Greek **ceramic** decoration in which black figures are painted on a red clay ground. Compare **red-figure**.

blackware (p. 855) A **ceramic** technique that produces pottery with a primarily black surface with **matte** and glossy patterns on the surface.

blind arcade (p. 780) See under **arcade**.

bodhisattva (p. 311) In Buddhism, a being who has attained enlightenment but chooses to remain in this world in order to help others advance spiritually. Also defined as a potential Buddha.

Book of Hours (p. 549) A prayer book for private use, containing a calendar, services for the canonical hours, and sometimes special prayers.

boss (p. 556) A decorative knoblike element that can be found in many places, e.g. at the intersection of a Gothic **rib vault** or as a buttonlike projection on metalwork.

bracket, bracketing (p. 341) An architectural element that projects from a wall to support a horizontal part of a building, such as beams or the eaves of a roof.

buon fresco (p. 87) See under **fresco**.

burin (p. 592) A metal instrument used in **engraving** to cut lines into the metal plate. The sharp end of the burin is trimmed to give a diamond-shaped cutting point, while the other end is finished with a wooden handle that fits into the engraver's palm.

buttress, buttressing (p. 170) A projecting support built against an external wall, usually to counteract the lateral **thrust** of a **vault** or **arch** within. In Gothic church architecture, a **flying buttress** is an arched bridge above the **aisle** roof that extends from the upper **nave** wall, where the lateral thrust of the main vault is greatest, down to a solid **pier**.

cairn (p. 17) A pile of stones or earth and stones that served both as a prehistoric burial site and as a marker for underground tombs.

calligraphy (p. 275) Handwriting as an art form.

calyx krater (p. 119) See under **krater**.

calotype (p. 969) The first photographic process utilizing negatives and paper positives; invented by William Henry Fox Talbot in the late 1830s.

came (*pl.* **cames**) (p. 501) A lead strip used in the making of leaded or **stained-glass** windows. Cames have an indented groove on the sides into which individual pieces of glass are fitted to make the overall design.

cameo (p. 172) Gemstone, clay, glass, or shell having layers of color, carved in low relief (see under **relief sculpture**) to create an image and ground of different colors.

camera obscura (p. 750) An early cameralike device used in the Renaissance and later for recording images from the real world. It consists of a dark box (or room) with a hole in one side (sometimes fitted with a lens). The camera obscura operates when bright light shines through the hole, casting an upside-down image of an object outside onto the inside wall of the box.

canon of proportions (p. 64) A set of ideal mathematical ratios in art based on measurements, as in the proportional relationships between the basic elements of the human body.

canopic jar (p. 53) In ancient Egyptian culture, a special jar used to store the major organs of a body before embalming.

capital (p. 110) The sculpted block that tops a **column**. According to the **convention**s of the orders, capitals include different decorative elements (see **order**). A *historiated capital* is one displaying a figural composition and/or narrative scenes.

capriccio (*pl.* *capricci*) (p. 915) A painting or print of a fantastic, imaginary landscape, usually with architecture.

capstone (p. 17) The final, topmost stone in a **corbeled arch** or **vault**, which joins the sides and completes the structure.

cartoon (p. 501) A full-scale drawing of a design that will be executed in another **medium**, such as wall painting, **tapestry**, or **stained glass**.

cartouche (p. 187) A frame for a **hieroglyphic** inscription formed by a rope design surrounding an oval space. Used to signify a sacred or honored name. Also: in architecture, a decorative device or plaque, usually with a plain center used for inscriptions or epitaphs.

caryatid (p. 107) A sculpture of a draped female figure acting as a **column** supporting an **entablature**.

cassone (*pl.* *cassoni*) (p. 616) An Italian dowry chest often highly decorated with carvings, paintings, inlaid designs, and gilt embellishments.

catacomb (p. 215) An underground cemetery consisting of tunnels on different levels, having niches for urns and **sarcophagi** and often incorporating rooms (**cubicula**).

cathedral (p. 220) The principal Christian church in a diocese, the bishop's administrative center and housing his throne (*cathedra*).

celadon (p. 358) A high-fired, transparent **glaze** of pale bluish-green hue whose principal coloring agent is an oxide of iron. In China and Korea, such glazes were typically applied over a pale gray **stoneware** body, though Chinese potters sometimes applied them over **porcelain** bodies during the Ming (1368–1644) and Qing (1644–1911) dynasties. Chinese potters invented celadon glazes and initiated the continuous production of celadon-glazed wares as early as the third century CE.

cella (p. 108) The principal interior room at the center of a Greek or Roman temple within which the cult statue was usually housed. Also called the **naos**.

celt (p. 383) A smooth, oblong stone or metal object, shaped like an axe-head.

cenotaph (p. 771) A funerary monument commemorating an individual or group buried elsewhere.

centering (p. 170) A temporary structure that supports a masonry **arch**, **vault**, or **dome** during construction until the mortar is fully dried and the masonry is self-sustaining.

central-plan building (p. 225) Any structure designed with a primary central space surrounded by symmetrical areas on each side, e.g., a **rotunda**.

ceramics (p. 20) A general term covering all types of wares made from fired clay.

chacmool (p. 396) In Maya sculpture, a half-reclining figure probably representing an offering bearer.

chaitya (p. 305) A type of Buddhist temple found in India. Built in the form of a hall or **basilica**, a *chaitya* hall is highly decorated with sculpture and usually is carved from a cave or natural rock location. It houses a sacred shrine or **stupa** for worship.

chamfer (p. 780) The slanted surface produced when an angle is trimmed or beveled, common in building and metalwork.

chasing (p. 432) Ornamentation made on metal by incising or hammering the surface.

château (*pl.* *châteaux*) (p. 693) A French country house or residential castle. A *château fort* is a military castle incorporating defensive works such as towers and battlements.

chattri (p. 780) In Indian architecture, a decorative pavilion with an umbrella-shaped **dome**.

chevron (p. 357) A decorative or heraldic motif of repeated Vs; a zigzag pattern.

chiaroscuro (p. 636) An Italian word designating the contrast of dark and light in a painting, drawing, or print. *Chiaroscuro* creates spatial depth and volumetric forms through gradations in the intensity of light and shadow.

choir (p. 225) The part of a church reserved for the clergy, monks, or nuns, either between the **transept** crossing and the **apse** or extending farther into the **nave**; separated from the rest of the church by screens or walls and fitted with stalls (seats).

cista (*pl.* *cistae*) (p. 157) Cylindrical containers used in antiquity by wealthy women as a case for toiletry articles such as a mirror.

clerestory (p. 57) In a **basilica**, the topmost zone of a wall with windows, extending above the **aisle** roofs. Provides direct light into the **nave**.

cloisonné (p. 257) An **enamel**ing technique in which artists affix wires or strips to a metal surface to delineate designs and create compartments (*cloisons*) that they subsequently fill with enamel.

cloister (p. 448) An enclosed space, open to the sky, especially within a monastery, surrounded by an **arcade**d walkway, often having a fountain and garden. Since the most important monastic buildings (e.g., dormitory, refectory, church) open off the cloister, it represents the center of the monastic world.

codex (*pl.* **codices**) (p. 245) A book, or a group of **manuscript** pages (folios), held together by stitching or other binding along one edge.

coffer (p. 197) A recessed decorative panel used to decorate ceilings or **vault**s. The use of coffers is called coffering.

coiling (p. 848) A technique in basketry. In coiled baskets a spiraling coil, braid, or rope of material is held in place by stitching or interweaving to create a permanent shape.

collage (p. 1025) A composition made of cut and pasted scraps of materials, sometimes with lines or forms added by the artist.

colonnade (p. 69) A row of **column**s, supporting a straight **lintel** (as in a **porch** or **portico**) or a series of **arch**es (an **arcade**).

colophon (p. 438) The data placed at the end of a book listing the book's author, publisher, illuminator, and other information related to its production. In East Asian **handscroll**s, the inscriptions which follow the painting are also called colophons.

column (p. 110) An architectural element used for support and/or decoration. Consists of a rounded or polygonal vertical **shaft** placed on a **base** and topped by a decorative **capital**. In Classical architecture, columns are built in accordance with the rules of one of the architectural **orders**. They can be free-standing or attached to a background wall (**engaged**).

combine (p. 1087) Combination of painting and sculpture using nontraditional art materials.

complementary color (p. 995) The primary and secondary colors across from each other on the color wheel (red and green, blue and orange, yellow and purple). When juxtaposed, the intensity of both colors increases. When mixed together, they negate each other to make a neutral gray-brown.

Composite order (p. 161) See under **order**.

composite pose or **image** (p. 10) Combining different viewpoints within a single representation.

composition (p. xxix) The overall arrangement, organizing design, or structure of a work of art.

conch (p. 236) A halfdome.

connoisseur (p. 289) A French word meaning "an expert," and signifying the study and evaluation of art based primarily on formal, visual, and stylistic analysis. A connoisseur studies the style and technique of an object to assess its relative quality and identify its maker through visual comparison with other works of secure authorship. See also **Formalism**.

continuous narrative (p. 245) See under **narrative image**.

contrapposto (p. 120) Italian term meaning "set against," used to describe the Classical convention of representing human figures with opposing alternations of tension and relaxation on either side of a central **axis** to imbue figures with a sense of the potential for movement.

convention (p. 31) A traditional way of representing forms.

corbel, corbeling (p. 19) An early roofing and arching technique in which each **course** of stone projects slightly beyond the previous layer (a corbel) until the uppermost corbels meet; see also under **arch**. Also: **bracket**s that project from a wall.

corbeled vault (p. 99) See under **vault**.

Corinthian order (p. 108) See under **order**.

cornice (p. 110) The uppermost section of a Classical **entablature**. More generally, a horizontally projecting element found at the top of a building wall or **pedestal**. A *raking cornice* is formed by the junction of two slanted cornices, most often found in **pediment**s.

course (p. 99) A horizontal layer of stone used in building.

crenellation, crenellated (p. 44) Alternating high and low sections of a wall, giving a notched appearance and creating permanent defensive shields on top of fortified buildings.

crocket (p. 587) A stylized leaf used as decoration along the outer angle of spires, pinnacles, gables, and around **capital**s in Gothic architecture.

cruciform (p. 228) Of anything that is cross-shaped, as in the cruciform plan of a church.

cubiculum (*pl.* **cubicula**) (p. 220) A small private room for burials in a **catacomb**.

cuneiform (p. 28) An early form of writing with wedge-shaped marks impressed into wet clay with a **stylus**, primarily used by ancient Mesopotamians.

curtain wall (p. 1045) A wall in a building that does not support any of the weight of the structure.

cyclopean (p. 93) A method of construction using huge blocks of rough-hewn stone. Any large-scale, monumental building project that impresses by sheer size. Named after the Cyclopes (sing. Cyclops), one-eyed giants of legendary strength in Greek myths.

cylinder seal (p. 35) A small cylindrical stone decorated with **incised** patterns. When rolled across soft clay or wax, the resulting raised pattern or design served in Mesopotamian and Indus Valley cultures as an identifying signature.

dado (*pl.* **dadoes**) (p. 161) The lower part of a wall, differentiated in some way (by a **molding** or different coloring or paneling) from the upper section.

daguerreotype (p. 969) An early photographic process that makes a positive print on a light-sensitized copperplate; invented and marketed in 1839 by Louis-Jacques-Mandé Daguerre.

dendrochronology (p. xxxvi) The dating of wood based on the patterns of the tree's growth rings.

dentils (p. 110) A row of projecting rectangular blocks forming a **molding** or running beneath a **cornice** in Classical architecture.

desert varnish (p. 406) A naturally occurring coating that turns rock faces into dark surfaces. Artists would draw images by scraping through the dark surface and revealing the color of the underlying rock. Extensively used in southwest North America.

diptych (p. 212) Two panels of equal size (usually decorated with paintings or reliefs) hinged together.

dogu (p. 362) Small human figurines made in Japan during the Jomon period. Shaped from clay, the figures have exaggerated expressions and are in contorted poses. They were probably used in religious rituals.

dolmen (p. 17) A prehistoric structure made up of two or more large upright stones supporting a large, flat, horizontal slab or slabs.

dome (p. 187) A rounded **vault**, usually over a circular space. Consists of curved masonry and can vary in shape from hemispherical to bulbous to ovoidal. May use a supporting vertical wall (**drum**), from which the vault springs, and may be crowned by an open space (**oculus**) and/or an exterior **lantern**. When a dome is built over a square space, an intermediate element is required to make the transition to a circular drum. There are two systems. A dome on **pendentives** incorporates arched, sloping intermediate sections of wall that carry the weight and **thrust** of the dome to heavily **buttress**ed supporting **pier**s. A dome on **squinch**es uses an arch built into the wall (squinch) in the upper corners of the space to carry the weight of the dome across the corners of the square space below. A halfdome or **conch** may cover a semicircular space.

domino construction (p. 1045) System of building construction introduced by the architect Le Corbusier in which reinforced concrete floor slabs are floated on six free-standing posts placed as if at the positions of the six dots on a domino playing piece.

Doric order (p. 108) See **order**.

dressed stone (p. 84) Another term for **ashlar**.

drillwork (p. 188) The technique of using a drill for the creation of certain effects in sculpture.

drum (p. 110) The circular wall that supports a **dome**. Also: a segment of the circular **shaft** of a **column**.

drypoint (p. 748) An **intaglio** printmaking process by which a metal (usually copper) plate is directly inscribed with a pointed instrument (**stylus**). The resulting design of scratched lines is inked, wiped, and printed. Also: the print made by this process.

earthenware (p. 20) A low-fired, opaque **ceramic** ware, employing humble clays that are naturally heat-resistant and remain porous after firing unless **glaze**d. Earthenware occurs in a range of earth-toned colors, from white and tan to gray and black, with tan predominating.

earthwork (p. 1102) Usually very large-scale, outdoor artwork that is produced by altering the natural environment.

echinus (p. 110) A cushionlike circular element found below the **abacus** of a Doric **capital**. Also: a similarly shaped **molding** (usually with egg-and-dart motifs) underneath the **volute**s of an Ionic capital.

electronic spin resonance (p. 12) Method that uses magnetic field and microwave irradiation to date material such as tooth enamel and its surrounding soil.

elevation (p. 108) The arrangement, proportions, and details of any vertical side or face of a building. Also: an architectural drawing showing an exterior or interior wall of a building.

embroidery (p. 397) Stitches applied in a decorative pattern on top of an already-woven fabric ground.

en plein air (p. 987) French term (meaning "in the open air") describing the Impressionist practice of painting outdoors so artists could have direct access to the fleeting effects of light and atmosphere while working.

enamel (p. 255) Powdered, then molten, glass applied to a metal surface, and used by artists to create designs. After firing, the glass forms an opaque or transparent substance that fuses to the metal background. Also: an object created by the enameling technique. See also *cloisonné*.

encaustic (p. 246) A painting **medium** using pigments mixed with hot wax.

engaged (p. 171) Of an architectural feature, usually a **column**, attached to a wall.

engraving (p. 592) An **intaglio** printmaking process of inscribing an image, design, or letters onto a metal or wood surface from which a print is made. An engraving is usually drawn with a sharp implement (**burin**) directly onto the surface of the plate. Also: the print made from this process.

entablature (p. 107) In the Classical **order**s, the horizontal elements above the **column**s and **capital**s. The entablature consists of, from bottom to top, an **architrave**, a **frieze**, and a **cornice**.

entasis (p. 108) A slight swelling of the **shaft** of a Greek **column**. The optical illusion of entasis makes the column appear from afar to be straight.

esquisse (p. 946) French for "sketch." A quickly executed drawing or painting conveying the overall idea for a finished painting.

etching (p. 748) An **intaglio** printmaking process in which a metal plate is coated with acid-resistant resin and then inscribed with a **stylus** in a design, revealing the plate below. The plate is then immersed in acid, and the exposed metal of the design is eaten away by the acid. The resin is removed, leaving the design etched permanently into the metal and the plate ready to be inked, wiped, and printed.

Eucharist (p. 220) The central rite of the Christian Church, from the Greek word for "thanksgiving." Also known as the Mass or Holy Communion, it reenacts Christ's sacrifice on the cross and commemorates the Last Supper. According to traditional Catholic Christian belief, consecrated bread and wine become the body and blood of Christ; in Protestant belief, bread and wine symbolize the body and blood.

exedra (*pl.* **exedrae**) (p. 197) In architecture, a semicircular niche. On a small scale, often used as decoration, whereas larger exedrae can form interior spaces (such as an **apse**).

expressionism (p. 149) Artistic styles in which aspects of works of art are exaggerated to evoke subjective emotions rather than to portray objective reality or elicit a rational response.

façade (p. 52) The face or front wall of a building.

faience (p. 88) Type of **ceramic** covered with colorful, opaque glazes that form a smooth, impermeable surface. First developed in ancient Egypt.

fang ding (p. 334) A square or rectangular bronze vessel with four legs. The *fang ding* was used for ritual offerings in ancient China during the Shang dynasty.

fête galante (p. 910) A subject in painting depicting well-dressed people at leisure in a park or country setting. It is most often associated with eighteenth-century French Rococo painting.

filigree (p. 90) Delicate, lacelike ornamental work.

fillet (p. 110) The flat ridge between the carved-out **flutes** of a **column shaft**.

finial (p. 780) A knoblike architectural decoration usually found at the top point of a spire, pinnacle, canopy, or gable. Also found on furniture. Also the ornamental top of a staff.

flutes (p. 110) In architecture, evenly spaced, rounded parallel vertical grooves incised on **shaft**s of **column**s or on columnar elements such as **pilaster**s.

flying buttress (p. 503) See under **buttress**.

flying gallop (p. 88) A non-naturalistic pose in which animals are depicted hovering above the ground with legs fully extended backwards and forwards to signify that they are running.

foreshortening (p. xxxi) The illusion created on a flat surface by which figures and objects appear to recede or project sharply into space. Accomplished according to the rules of **perspective**.

formal analysis (p. xxix) An exploration of the visual character that artists bring to their works through the expressive use of elements such as line, form, color, and light, and through its overall structure or composition.

Formalism (p. 1073) An approach to the understanding, appreciation, and valuation of art based almost solely on considerations of form. The Formalist's approach tends to regard an artwork as independent of its time and place of making.

forum (p. 176) A Roman town center; site of temples and administrative buildings and used as a market or gathering area for the citizens.

fresco (p. 81) A painting technique in which water-based pigments are applied to a plaster surface. If the plaster is painted when wet, the color is absorbed by the plaster, becoming a permanent part of the wall (*buon fresco*). *Fresco secco* is created by painting on dried plaster, and the color may eventually flake off. Murals made by both these techniques are called frescos.

frieze (p. 107) The middle element of an **entablature**, between the **architrave** and the **cornice**. Usually decorated with sculpture, painting, or **molding**s. Also: any continuous flat band with **relief sculpture** or painted decoration.

frottage (p. 1057) A design produced by laying a piece of paper over a textured surface and rubbing with charcoal or other soft **medium**.

fusuma (p. 820) Sliding doors covered with paper, used in traditional Japanese construction. *Fusuma* are often highly decorated with paintings and colored backgrounds.

gallery (p. 236) A roofed passageway with one or both of its long sides open to the air. In church architecture, the story found above the side **aisles** of a church or across the width at the end of the **nave** or **transept**s, usually open to and overlooking the area below. Also: a building or hall in which art is displayed or sold.

garbhagriha (p. 302) From the Sanskrit word meaning "womb chamber," a small room or shrine in a Hindu temple containing a holy image.

genre painting (p. 714) A term used to loosely categorize paintings depicting scenes of everyday life, including (among others) domestic interiors, parties, inn scenes, and street scenes.

geoglyph (p. 399) Earthen design on a colossal scale, often created in a landscape as if to be seen from an aerial viewpoint.

gesso (p. 546) A ground made from glue, gypsum, and/or chalk, used as the ground of a wood panel or the priming layer of a canvas. Provides a smooth surface for painting.

gilding (p. 90) The application of paper-thin gold leaf or gold pigment to an object made from another **medium** (for example, a sculpture or painting). Usually used as a decorative finishing detail.

giornata (*pl. giornate*) (p. 539) Adopted from the Italian term meaning "a day's work," a *giornata* is the section of a **fresco** plastered and painted in a single day.

glazing (p. 600) In **ceramics**, an outermost layer of vitreous liquid (**glaze**) that, upon firing, renders the ware waterproof and forms a decorative surface. In painting, a technique used with oil **media** in which a transparent layer of paint (glaze) is laid over another, usually lighter, painted or glazed area. In architecture, the process of filling openings in a building with windows of clear or **stained glass**.

gold leaf (p. 47) Paper-thin sheets of hammered gold that are used in **gilding**. In some cases (such as Byzantine **icon**s), also used as a ground for paintings.

gopura (p. 775) The towering gateway to an Indian Hindu temple complex.

Grand Manner (p. 923) An elevated style of painting popular in the eighteenth century in which the artist looked to the ancients and to the Renaissance for inspiration; for portraits as well as history painting, the artist would adopt the poses, compositions, and attitudes of Renaissance and antique models.

Grand Tour (p. 913) Popular during the eighteenth and nineteenth centuries, an extended tour of cultural sites in France and Italy intended to finish the education of a young upper-class person primarily from Britain or North America.

granulation (p. 90) A technique of decoration in which metal granules, or tiny metal balls, are fused onto a metal surface.

graphic arts (p. 698) A term referring to those arts that are drawn or printed and that utilize paper as the primary support.

grattage (p. 1057) A pattern created by scraping off layers of paint from a canvas laid over a textured surface. Compare **frottage**.

grid (p. 65) A system of regularly spaced horizontally and vertically crossed lines that gives regularity to an architectural plan or in the composition of a work of art. Also: in painting, a grid is used to allow designs to be enlarged or transferred easily.

grisaille (p. 540) A style of monochromatic painting in shades of gray. Also: a painting made in this style.

groin vault (p. 187) See under **vault**.

grozing (p. 501) Chipping away at the edges of a piece of glass to achieve the precise shape needed for inclusion in the composition of a **stained-glass** window.

guild (p. 419) An association of artists or craftsmakers. Medieval and Renaissance guilds had great economic power, as they controlled the marketing of their members' products and provided economic protection, political solidarity, and training in the craft to its members. The painters' guild was usually dedicated to St. Luke, their patron saint.

hall church (p. 521) A church with **nave** and **aisle**s of the same height, giving the impression of a large, open hall.

halo (p. 215) A circle of light that surrounds and frames the heads of emperors and holy figures to signify their power and/or sanctity. Also known as a nimbus.

handscroll (p. 343) A long, narrow, horizontal painting or text (or combination thereof) common in Chinese and Japanese art and of a size intended for individual use. A handscroll is stored wrapped tightly around a wooden pin and is unrolled for viewing or reading.

hanging scroll (p. 796) In Chinese and Japanese art, a vertical painting or text mounted within sections of silk. At the top is a semicircular rod; at the bottom is a round dowel. Hanging scrolls are kept rolled and tied except for special occasions, when they are hung for display, contemplation, or commemoration.

haniwa (p. 362) Pottery forms, including cylinders, buildings, and human figures, that were placed on top of Japanese tombs or burial mounds during the Kofun period (300–552 CE).

Happening (p. 1087) An art form developed by Allan Kaprow in the 1960s, incorporating performance, theater, and visual images. A Happening was organized without a specific narrative or intent; with audience participation, the event proceeded according to chance and individual improvisation.

hemicycle (p. 512) A semicircular interior space or structure.

henge (p. 17) A circular area enclosed by stones or wood posts set up by Neolithic peoples. It is usually bounded by a ditch and raised embankment.

hierarchic scale (p. 27) The use of differences in size to indicate relative importance. For example, with human figures, the larger the figure, the greater her or his importance.

hieratic (p. 484) Highly stylized, severe, and detached, often in relation to a strict religious tradition.

hieroglyph (p. 52) Picture writing; words and ideas rendered in the form of pictorial symbols.

high relief (p. 307) See under **relief sculpture**.

historiated capital (p. 484) See under **capital**.

historicism (p. 965) The strong consciousness of and attention to the institutions, themes, styles, and forms of the past, made accessible by historical research, textual study, and archaeology.

history paintings (p. 926) Paintings based on historical, mythological, or biblical narratives. Once considered the noblest form of art, history paintings generally convey a high moral or intellectual idea and are often painted in a grand pictorial style.

horizon line (p. 569) A horizontal "line" formed by the implied meeting point of earth and sky. In **linear perspective**, the **vanishing point** or points are located on this "line."

horseshoe arch (p. 272) See under **arch**.

hue (p. 77) Pure color. The saturation or intensity of the hue depends on the purity of the color. Its value depends on its lightness or darkness.

hydria (p. 139) A large ancient Greek or Roman jar with three handles (horizontal ones at both sides and one vertical at the back), used for storing water.

hypostyle hall (p. 66) A large interior room characterized by many closely spaced **column**s that support its roof.

icon (p. 246) An image representing a sacred figure or event in the Byzantine (later the Orthodox) Church. Icons are venerated by the faithful, who believe their prayers are transmitted through them to God.

iconic image (p. 215) A picture that expresses or embodies an intangible concept or idea.

iconoclasm (p. 248) The banning and/or destruction of images, especially **icon**s and religious art. Iconoclasm in eighth- and ninth-century Byzantium and sixteenth- and seventeenth-century Protestant territories arose from differing beliefs about the power, meaning, function, and purpose of imagery in religion.

iconography (p. xxxiii) Identifying and studying the subject matter and **conventional** symbols in works of art.

iconology (p. xxxv) Interpreting works of art as embodiments of cultural situation by placing them within broad social, political, religious, and intellectual contexts.

iconophile (p. 247) From the Greek for "lover of images." In periods of **iconoclasm**, iconophiles advocate the continued use of sacred images.

idealization (p. 134) A process in art through which artists strive to make their forms and figures attain perfection, based on pervading cultural values and/or their own personal ideals.

illumination (p. 431) A painting on paper or parchment used as an illustration and/or decoration in a **manuscript** or **album**. Usually richly colored, often supplemented by gold and other precious materials. The artists are referred to as illuminators. Also: the technique of decorating manuscripts with such paintings.

impasto (p. 749) Thick applications of pigment that give a painting a palpable surface texture.

impluvium (p. 178) A pool under a roof opening that collected rainwater in the **atrium** of a Roman house.

impost block (p. 170) A block of masonry imposed between the top of a **pier** or above the **capital** of a **column** in order to provide extra support at the springing of an **arch**.

incising (p. 118) A technique in which a design or inscription is cut into a hard surface with a sharp instrument. Such a surface is said to be incised.

ink painting (p. 812) A monochromatic style of painting developed in China, using black ink with gray washes.

inlay (p. 30) To set pieces of a material or materials into a surface to form a design. Also: material used in or decoration formed by this technique.

installation, installation art (p. 1051) Contemporary art created for a specific site, especially a gallery or outdoor area, that creates a complete and controlled environment.

intaglio (p. 592) A technique in which the design is carved out of the surface of an object, such as an engraved seal stone. In the **graphic arts**, intaglio includes **engraving**, **etching**, and **drypoint**—all processes in which ink transfers to paper from incised, ink-filled lines cut into a metal plate.

intarsia (p. 618) Technique of **inlay** decoration using variously colored woods.

intuitive perspective (p. 182) See under **perspective**.

Ionic order (p. 107) See under **order**.

iwan (p. 277) In Islamic architecture, a large, vaulted chamber with a monumental arched opening on one side.

jamb (p. 478) In architecture, the vertical element found on both sides of an opening in a wall, and supporting an **arch** or **lintel**.

Japonisme (p. 996) A style in French and American nineteenth-century art that was highly influenced by Japanese art, especially prints.

jasperware (p. 919) A fine-grained, unglazed, white **ceramic** developed in the eighteenth century by Josiah Wedgwood, often with raised designs remaining white above a background surface colored by metallic oxides.

Jataka **tales** (p. 303) In Buddhism, stories associated with the previous lives of Shakyamuni, the historical Buddha.

joggled voussoirs (p. 268) Interlocking **voussoirs** in an **arch** or **lintel**, often of contrasting materials for colorful effect.

joined-block sculpture (p. 373) Large-scale wooden sculpture constructed by a method developed in Japan. The entire work is made from smaller hollow blocks, each individually carved, and assembled when complete. The joined-block technique allowed production of larger sculpture, as the multiple joints alleviate the problems of drying and cracking found with sculpture carved from a single block.

kantharos (p. 117) A type of ancient Greek goblet with two large handles and a wide mouth.

keep (p. 477) The innermost and strongest structure or central tower of a medieval castle, sometimes used as living quarters, as well as for defense. Also called a donjon.

kente (p. 892) A woven cloth made by the Ashanti peoples of West Africa. *Kente* cloth is woven in long, narrow pieces featuring complex and colorful patterns, which are then sewn together.

key block (p. 828) The master block in the production of a colored **woodblock print**, which requires different blocks for each color. The key block is a flat piece of wood upon which the outlines for the entire design of the print were first drawn on its surface and then all but these outlines were carved away with a knife. These outlines serve as a guide for the accurate **registration** or alignment of the other blocks needed to add colors to specific parts of a print.

keystone (p. 170) The topmost **voussoir** at the center of an **arch**, and the last block to be placed. The pressure of this block holds the arch together. Often of a larger size and/or decorated.

kiln (p. 20) An oven designed to produce enough heat for the baking, or firing, of clay, for the melting of the glass used in **enamel** work, and for the fixing of vitreous paint on **stained glass**.

kiva (p. 405) A subterranean, circular room used as a ceremonial center in some Native American cultures.

kondo (p. 366) The main hall inside a Japanese Buddhist temple where the images of Buddha are housed.

korambo (p. 865) A ceremonial or spirit house in Pacific cultures, reserved for the men of a village and used as a meeting place as well as to hide religious artifacts from the uninitiated.

kore (*pl.* **kourai**) (p. 114) An Archaic Greek statue of a young woman.

koru (p. 872) A design depicting a curling stalk with a bulb at the end that resembles a young tree fern; often found in Maori art.

kouros (*pl.* **kouroi**) (p. 114) An Archaic Greek statue of a young man or boy.

kowhaiwhai (p. 872) Painted curvilinear patterns often found in Maori art.

krater (p. 99) An ancient Greek vessel for mixing wine and water, with many subtypes that each have a distinctive shape. *Calyx krater*: a bell-shaped vessel with handles near the base that resembles a flower calyx. *Volute krater*: a krater with handles shaped like scrolls.

Kufic (p. 275) An ornamental, angular Arabic script.

kylix (p. 120) A shallow ancient Greek cup, used for drinking, with a wide mouth and small handles near the rim.

lacquer (p. 824) A type of hard, glossy surface varnish, originally developed for use on objects in East Asian cultures, made from the sap of the Asian sumac or from shellac, a resinous secretion from the lac insect. Lacquer can be layered and manipulated or combined with pigments and other materials for various decorative effects.

lakshana (p. 306) The 32 marks of the historical Buddha. The *lakshana* include, among others, the Buddha's golden body, his long arms, the wheel impressed on his palms and the soles of his feet, and his elongated earlobes.

lamassu (p. 42) Supernatural guardian-protector of ancient Near Eastern palaces and throne rooms, often represented sculpturally as a combination of the bearded head of a man, powerful body of a lion or bull, wings of an eagle, and the horned headdress of a god, usually possessing five legs.

lancet (p. 505) A tall, narrow window crowned by a sharply pointed arch, typically found in Gothic architecture.

lantern (p. 464) A turretlike structure situated on a roof, vault, or dome, with windows that allow light into the space below.

lekythos (*pl.* **lekythoi**) (p. 141) A slim ancient Greek oil vase with one handle and a narrow mouth.

linear perspective (p. 595) See under **perspective**.

linga shrine (p. 315) A place of worship centered on an object or representation in the form of a phallus (the lingam), which symbolizes the power of the Hindu god Shiva.

lintel (p. 18) A horizontal element of any material carried by two or more vertical supports to form an opening.

literati painting (p. 793) A style of painting that reflects the taste of the educated class of East Asian intellectuals and scholars. Characteristics include an appreciation for the antique, small scale, and an intimate connection between maker and audience.

lithography (p. 953) Process of making a print (lithograph) from a design drawn on a flat stone block with greasy crayon. Ink is applied to the wet stone and adheres only to the greasy areas of the design.

loggia (p. 534) Italian term for a **gallery**. Often used as a corridor between buildings or around a courtyard, a loggia usually features an **arcade** or **colonnade**.

longitudinal-plan building (p. 225) Any structure designed with a rectangular shape and a longitudinal axis. In a cross-shaped building, the main arm of the building would be longer than any arms that cross it. For example, a **basilica**.

lost-wax casting (p. 36) A method of casting metal, such as bronze. A wax mold is covered with clay and plaster, then fired, thus melting the wax and leaving a hollow form. Molten metal is then poured into the hollow space and slowly cooled. When the hardened clay and plaster exterior shell is removed, a solid metal form remains to be smoothed and polished.

low relief (p. 40) See under **relief sculpture**.

lunette (p. 221) A semicircular wall area, framed by an **arch** over a door or window. Can be either plain or decorated.

lusterware (p. 277) Pottery decorated with metallic **glaze**s.

madrasa (p. 277) An Islamic institution of higher learning, where teaching is focused on theology and law.

maenad (p. 104) In ancient Greece, a female devotee of the wine god Dionysos who participated in orgiastic rituals. Often depicted with swirling drapery to indicate wild movement or dance. Also called a Bacchante, after Bacchus, the Roman equivalent of Dionysos.

majolica (p. 573) Pottery painted with a tin **glaze** that, when fired, gives a lustrous and colorful surface.

mandala (p. 302) An image of the cosmos represented by an arrangement of circles or concentric geometric shapes containing diagrams or images. Used for meditation and contemplation by Buddhists.

mandapa (p. 302) In a Hindu temple, an open hall dedicated to ritual worship.

mandorla (p. 479) Light encircling, or emanating from, the entire figure of a sacred person.

manuscript (p. 244) A hand-written book or document.

maqsura (p. 272) An enclosure in a Muslim **mosque**, near the *mihrab*, designated for dignitaries.

martyrium (*pl.* **martyria**) (p. 238) A church, chapel, or shrine built over the grave of a Christian martyr.

mastaba (p. 53) A flat-topped, one-story structure with slanted walls built over an ancient Egyptian underground tomb.

matte (p. 573) Of a smooth surface that is without shine or luster.

mausoleum (p. 175) A monumental building used as a tomb. Named after the tomb of King Mausolos erected at Halikarnassos around 350 BCE.

medallion (p. 222) Any round ornament or decoration. Also: a large medal.

medium (*pl.* **media**) (p. xxix) The material from which a work of art is made.

megalith (*adj.* **megalithic**) (p. 16) A large stone used in some prehistoric architecture.

megaron (p. 93) The main hall of a Mycenaean palace or grand house.

memento mori (p. 909) From Latin for "remember that you must die." An object, such as a skull or extinguished candle, typically found in a *vanitas* image, symbolizing the transience of life.

menorah (p. 186) A Jewish lampstand with seven or nine branches; the nine-branched menorah is used during the celebration of Hanukkah. Representations of the seven-branched menorah, once used in the Temple of Jerusalem, became a symbol of Judaism.

metope (p. 110) The carved or painted rectangular panel between the **triglyph**s of a Doric **frieze**.

mihrab (p. 265) A recess or niche that distinguishes the wall oriented toward Mecca (*qibla*) in a **mosque**.

millefiori (p. 434) A glassmaking technique in which rods of differently colored glass are fused in a long bundle that is subsequently sliced to produce disks or beads with small-scale, multicolor patterns. The term derives from the Italian for "a thousand flowers."

minaret (p. 274) A tower on or near a **mosque** from which Muslims are called to prayer five times a day.

minbar (p. 265) A high platform or pulpit in a **mosque**.

miniature (p. 245) Anything small. In painting, miniatures may be illustrations within **album**s or **manuscript**s or intimate portraits.

mirador (p. 280) In Spanish and Islamic **palace** architecture, a very large window or room with windows, and sometimes balconies, providing views to interior courtyards or the exterior landscape.

mithuna (p. 305) The amorous male and female couples in Buddhist sculpture, usually found at the entrance to a sacred building. The *mithuna* symbolizes the harmony and fertility of life.

moai (p. 875) Statues found in Polynesia, carved from tufa, a yellowish brown volcanic stone, and depicting the human form. Nearly 1,000 of these statues have been found on the island of Rapa Nui but their significance has been a matter of speculation.

modeling (p. xxix) In painting, the process of creating the illusion of three-dimensionality on a two-dimensional surface by use of light and shade. In sculpture, the process of molding a three-dimensional form out of a malleable substance.

module (p. 346) A segment or portion of a repeated design. Also: a basic building block.

molding (p. 319) A shaped or sculpted strip with varying contours and patterns. Used as decoration on architecture, furniture, frames, and other objects.

mortise-and-tenon (p. 18) A method of joining two elements. A projecting pin (tenon) on one element fits snugly into a hole designed for it (mortise) on the other.

mosaic (p. 145) Image formed by arranging small colored stone or glass pieces (**tesserae**) and affixing them to a hard, stable surface.

mosque (p. 265) A building used for communal Islamic worship.

Mozarabic (p. 439) Of an eclectic style practiced in Christian medieval Spain when much of the Iberian peninsula was ruled by Islamic dynasties.

mudra (p. 307) A symbolic hand gesture in Buddhist art that denotes certain behaviors, actions, or feelings.

mullion (p. 510) A slender straight or curving bar that divides a window into subsidiary sections to create **tracery**.

muqarna (p. 280) In Islamic architecture, one of the nichelike components, often stacked in tiers to mark the transition between flat and rounded surfaces and often found on the **vault** of a **dome**.

naos (p. 236) The principal room in a temple or church. In ancient architecture, the **cella**. In a Byzantine church, the **nave** and **sanctuary**.

narrative image (p. 215) A picture that recounts an event drawn from a story, either factual (e.g. biographical) or fictional. In **continuous narrative**, multiple scenes from the same story appear within a single compositional frame.

narthex (p. 220) The vestibule or entrance porch of a church.

nave (p. 191) The central space of a church, two or three stories high and usually flanked by **aisle**s.

necropolis (p. 53) A large cemetery or burial area; literally a "city of the dead."

nemes headdress (p. 51) The royal headdress of ancient Egypt.

niello (p. 90) A metal technique in which a black sulfur **alloy** is rubbed into fine lines engraved into metal (usually gold or silver). When heated, the alloy becomes fused with the surrounding metal and provides contrasting detail.

oculus (*pl.* **oculi**) (p. 187) In architecture, a circular opening. Usually found either as windows or at the apex of a **dome**. When at the top of a dome, an oculus is either open to the sky or covered by a decorative exterior **lantern**.

odalisque (p. 952) Turkish word for "harem slave girl" or "concubine."

oil painting (p. 575) Any painting executed with pigments suspended in a **medium** of oil. Oil paint has particular properties that allow for greater ease of working: among others, a slow drying time (which allows for corrections), and a great range of relative opaqueness of paint layers (which permits a high degree of detail and luminescence).

oinochoe (p. 126) An ancient Greek jug used for wine.

olpe (p. 105) Any ancient Greek vessel without a spout.

one-point perspective (p. 259) See under **perspective**.

orant (p. 220) Of a standing figure represented praying with outstretched and upraised arms.

oratory (p. 228) A small chapel.

order (p. 110) A system of proportions in Classical architecture that includes every aspect of the building's plan, elevation, and decorative system. *Composite*: a combination of the Ionic and the Corinthian orders. The **capital** combines **acanthus** leaves with **volute** scrolls. *Corinthian*: the most ornate of the orders, the Corinthian includes a **base**, a **fluted column shaft** with a capital elaborately decorated with acanthus leaf carvings. Its **entablature** consists of an **architrave** decorated with **moldings**, a **frieze** often containing **relief sculpture**, and a **cornice** with **dentils**. *Doric*: the column shaft of the Doric order can be fluted or smooth-surfaced and has no base. The Doric capital consists of an undecorated **echinus** and **abacus**. The Doric entablature has a plain architrave, a frieze with **metope**s and **triglyph**s, and a simple cornice. *Ionic*: the column of the Ionic order has a base, a fluted shaft, and a capital decorated with volutes. The Ionic entablature consists of an architrave of three panels and moldings,

a frieze usually containing sculpted relief ornament, and a cornice with dentils. *Tuscan*: a variation of Doric characterized by a smooth-surfaced column shaft with a base, a plain architrave, and an undecorated frieze. *Colossal* or *giant*: any of the above built on a large scale, rising through two or more stories in height and often raised from the ground on a **pedestal**.

Orientalism (p. 968) A fascination with Middle Eastern cultures that inspired eclectic nineteenth-century European fantasies of exotic life that often formed the subject of paintings.

orthogonal (p. 138) Any line running back into the represented space of a picture perpendicular to the imagined **picture plane**. In **linear perspective**, all orthogonals converge at a single **vanishing point** in the picture and are the basis for a **grid** that maps out the internal space of the image. An orthogonal plan is any plan for a building or city that is based exclusively on right angles, such as the grid plan of many major cities.

pagoda (p. 347) An East Asian **reliquary** tower built with successively smaller, repeated stories. Each story is usually marked by an elaborate projecting roof.

painterly (p. 253) A style of painting which emphasizes the techniques and surface effects of brushwork (also color, light, and shade).

palace complex (p. 41) A group of buildings used for living and governing by a ruler and his or her supporters, usually fortified.

palazzo (p. 602) Italian term for palace, used for any large urban dwelling.

palette (p. 183) A hand-held support used by artists for arranging colors and mixing paint during the process of painting. Also: the choice of a range of colors used by an artist in a particular work, as typical of his or her style. In ancient Egypt, a flat stone used to grind and prepare makeup.

panel painting (p. xli) Any painting executed on a wood support, usually planed to provide a smooth surface. A panel can consist of several boards joined together.

parchment (p. 245) A writing surface made from treated skins of animals. Very fine parchment is known as **vellum**.

parterre (p. 761) An ornamental, highly regimented flowerbed; especially as an element of the ornate gardens of a seventeenth-century palace or **château**.

passage grave (p. 17) A prehistoric tomb under a **cairn**, reached by a long, narrow, slab-lined access passageway or passageways.

pastel (p. 914) Dry pigment, chalk, and gum in stick or crayon form. Also: a work of art made with pastels.

pedestal (p. 107) A platform or base supporting a sculpture or other monument. Also: the block below the base of a Classical **column** (or **colonnade**), serving to raise the entire element off the ground.

pediment (p. 107) A triangular gable found over major architectural elements such as Classical Greek **portico**s, windows, or doors. Formed by an **entablature** and the ends of a sloping roof or a raking **cornice**. A similar architectural element is often used decoratively above a door or window, sometimes with a curved upper **molding**. A *broken pediment* is a variation on the traditional pediment, with an open space at the center of the topmost angle and/or the horizontal cornice.

pendant (also **pendent**) (p. 640) One of a pair of artworks meant to be seen in relation to each other as a set.

pendentive (p. 236) The concave triangular section of a **vault** that forms the transition between a square or polygonal space and the circular base of a **dome**.

Performance art (p. 1087) A contemporary artwork based on a live, sometimes theatrical performance by the artist.

peristyle (p. 66) In Greek architecture, a surrounding **colonnade**. A peristyle building is surrounded on the exterior by a colonnade. Also: a peristyle court is an open colonnaded courtyard, often having a pool and garden.

perspective (p. xxvii) A system for representing three-dimensional space on a two-dimensional surface. *Atmospheric* or *aerial perspective*: a method of rendering the effect of spatial distance by subtle variations in color and clarity of representation. *Intuitive perspective*: a method of giving the impression of recession by visual instinct, not by the use of an overall system or program. *Oblique perspective*: an intuitive spatial system in which a building or room is placed with one corner in the **picture plane**, and the other parts of the structure recede to an imaginary **vanishing point** on its other side. Oblique perspective is not a comprehensive, mathematical system. *One-point* and multiple-point perspective (also called linear, scientific, or mathematical perspective): a method of creating the illusion of three-dimensional space on a two-dimensional surface by delineating a **horizon line** and multiple **orthogonal** lines. These recede to meet at one or more points on the horizon (vanishing point), giving the appearance of spatial depth. Called scientific or mathematical because its use requires some knowledge of geometry and mathematics, as well as optics. *Reverse perspective*: a Byzantine perspective theory in which the orthogonals or rays of sight do not converge on a vanishing point in the picture, but are thought to originate in the viewer's eye in front of the picture. Thus, in reverse perspective the image is constructed with orthogonals that diverge, giving a slightly tipped aspect to objects.

photomontage (p. 1039) A photographic work created from many smaller photographs arranged (and often overlapping) in a composition, which is then rephotographed.

pictograph (p. 337) A highly stylized depiction serving as a symbol for a person or object. Also: a type of writing utilizing such symbols.

picture plane (p. 575) The theoretical plane corresponding with the actual surface of a painting, separating the spatial world evoked in the painting from the spatial world occupied by the viewer.

picturesque (p. 919) Of the taste for the familiar, the pleasant, and the agreeable, popular in the eighteenth and nineteenth centuries in Europe. Originally used to describe the "picturelike" qualities of some landscape scenes. When contrasted with the **sublime**, the picturesque stood for the interesting but ordinary domestic landscape.

piece-mold casting (p. 334) A casting technique in which the mold consists of several sections that are connected during the pouring of molten metal, usually bronze. After the cast form has hardened, the pieces of the mold are disassembled, leaving the completed object.

pier (p. 270) A masonry support made up of many stones, or rubble and concrete (in contrast to a column **shaft** which is formed from a single stone or a series of **drums**), often square or rectangular in plan, and capable of carrying very heavy architectural loads.

pietà (p. 230) A devotional subject in Christian religious art. After the Crucifixion the body of Jesus was laid across the lap of his grieving mother, Mary. When other mourners are present, the subject is called the Lamentation.

pietra serena (p. 602) A gray Tuscan sandstone used in Florentine architecture.

pilaster (p. 158) An **engaged** columnlike element that is rectangular in format and used for decoration in architecture.

pilgrimage church (p. 239) A church that attracts visitors wishing to venerate **relic**s as well as attend religious services.

pinnacle (p. 503) In Gothic architecture, a steep pyramid decorating the top of another element such as a **buttress**. Also: the highest point.

plate tracery (p. 505) See under **tracery**.

plein air (p. 989) See under *en plein air*.

plinth (p. 161) The slablike base or **pedestal** of a **column**, statue, wall, building, or piece of furniture.

pluralism (p. 1107) A social structure or goal that allows members of diverse ethnic, racial, or other groups to exist peacefully within the society while continuing to practice the customs of their own divergent cultures. Also: an adjective describing the state of having a variety of valid contemporary styles available at the same time to artists.

podium (p. 138) A raised platform that acts as the foundation for a building, or as a platform for a speaker.

poesia (*pl.* *poesie*) (p. 656) Italian Renaissance paintings based on Classical themes, often with erotic overtones, notably in the mid-sixteenth-century works of the Venetian painter Titian.

polychromy (p. 524) Multicolored decoration applied to any part of a building, sculpture, or piece of furniture. This can be accomplished with paint or by the use of multicolored materials.

polyptych (p. 566) An **altarpiece** constructed from multiple panels, sometimes with hinges to allow for movable wings.

porcelain (p. 20) A type of extremely hard and fine white **ceramic** first made by Chinese potters in the eighth century CE. Made from a mixture of kaolin and petuntse, porcelain is fired at a very high temperature, and the final product has a translucent surface.

porch (p. 108) The covered entrance on the exterior of a building. With a row of **column**s or **colonnade**, also called a **portico**.

portal (p. 40) A grand entrance, door, or gate, usually to an important public building, and often decorated with sculpture.

portico (p. 63) In architecture, a projecting roof or porch supported by **column**s, often marking an entrance. See also **porch**.

post-and-lintel (p. 19) An architectural system of construction with two or more vertical elements (posts) supporting a horizontal element (**lintel**).

potassium-argon dating (p. 12) Archaeological method of **radiometric dating** that measures the decay of a radioactive potassium isotope into a stable isotope of argon, and inert gas.

potsherd (p. 20) A broken piece of **ceramic** ware.

poupou (p. 873) In Pacific cultures, a house panel, often carved with designs.

Prairie Style (p. 1046) Style developed by a group of Midwestern architects who worked together using the aesthetic of the prairie and indigenous prairie plants for landscape design to create mostly domestic homes and small public buildings.

predella (p. 550) The base of an **altarpiece**, often decorated with small scenes that are related in subject to that of the main panel or panels.

primitivism (p. 1022) The borrowing of subjects or forms, usually from non-European or prehistoric sources by Western artists, in an attempt to infuse their work with the expressive qualities they attributed to other cultures, especially colonized cultures.

pronaos (p. 108) The enclosed vestibule of a Greek or Roman temple, found in front of the **cella** and marked by a row of **column**s at the entrance.

proscenium (p. 148) The stage of an ancient Greek or Roman theater. In a modern theater, the area of the stage in front of the curtain. Also: the framing **arch** that separates a stage from the audience.

psalter (p. 256) In Jewish and Christian scripture, a book of the Psalms (songs) attributed to King David.

psykter (p. 126) An ancient Greek vessel with an extended base to allow it to float in a larger **krater**; used to chill wine.

putto (*pl.* *putti*) (p. 224) A plump, naked little boy, often winged. In Classical art, called a cupid; in Christian art, a cherub.

pylon (p. 66) A massive gateway formed by a pair of tapering walls of oblong shape. Erected by ancient Egyptians to mark the entrance to a temple complex.

qibla (p. 274) The **mosque** wall oriented toward Mecca; indicated by the *mihrab*.

quatrefoil (p. 508) A four-lobed decorative pattern common in Gothic art and architecture.

quillwork (p. 847) A Native American technique in which the quills of porcupines and bird feathers are dyed and attached to materials in patterns.

radiometric dating (p. 12) Archaeological method of **absolute dating** by measuring the degree to which radioactive materials have degenerated over time. For dating organic (plant or animal) materials, one radiometric method measures a carbon isotope called radiocarbon, or carbon-14.

raigo (p. 378) A painted image that depicts the Amida Buddha and other Buddhist deities welcoming the soul of a dying believer to paradise.

raku (p. 823) A type of **ceramic** made by hand, coated with a thick, dark **glaze**, and fired at a low heat. The resulting vessels are irregularly shaped and glazed and are highly prized for use in the Japanese tea ceremony.

readymade (p. 1038) An object from popular or material culture presented without further manipulation as an artwork by the artist.

red-figure (p. 119) A technique of ancient Greek **ceramic** decoration characterized by red clay-colored figures on a black background. The figures are reserved against a painted ground and details are drawn, not engraved; compare **black-figure**.

register (p. 30) A device used in systems of spatial definition. In painting, a register indicates the use of differing groundlines to differentiate layers of space within an image. In **relief sculpture**, the placement of self-contained bands of reliefs in a vertical arrangement.

registration marks (p. 828) In Japanese **woodblock prints**, two marks carved on the blocks to indicate proper alignment of the paper during the printing process. In multicolor printing, which used a separate block for each color, these marks were essential for achieving the proper position or registration of the colors.

relative dating (p. 12) Archaeological process of determining relative chronological relationships among excavated objects. Compare **absolute dating**.

relic (p. 239) Venerated object or body part associated with a holy figure, such as a saint, and usually housed in a **reliquary**.

relief sculpture (p. 5) A three-dimensional image or design whose flat background surface is carved away to a certain depth, setting off the figure. Called *high* or *low* (*bas-*) *relief* depending upon the extent of projection of the image from the background. Called *sunken relief* when the image is carved below the original surface of the background, which is not cut away.

reliquary (p. 366) A container, often elaborate and made of precious materials, used as a repository for sacred relics.

repoussé (p. 90) A technique of pushing or hammering metal from the back to create a protruding image. Elaborate reliefs are created by pressing or hammering metal sheets against carved wooden forms.

rhyton (p. 88) A vessel in the shape of a figure or an animal, used for drinking or pouring liquids on special occasions.

rib vault (p. 499) See under **vault**.

ridgepole (p. 16) A longitudinal timber at the apex of a roof that supports the upper ends of the rafters.

roof comb (p. 392) In a Maya building, a masonry wall along the apex of a roof that is built above the level of the roof proper. Roof combs support the highly decorated false **façade**s that rise above the height of the building at the front.

rose window (p. 505) A round window, often filled with stained glass set into tracery patterns in the form of wheel spokes, found in the **façade**s of the **nave**s and **transept**s of large Gothic churches.

rosette (p. 105) A round or oval ornament resembling a rose.

rotunda (p. 195) Any building (or part thereof) constructed in a circular (or sometimes polygonal) shape, usually producing a large open space crowned by a **dome**.

round arch (p. 170) See under **arch**.

roundel (p. 158) Any ornamental element with a circular format, often placed as a decoration on the exterior of a building.

rune stone (p. 442) In early medieval northern Europe, a stone used as a commemorative monument and carved or inscribed with runes, a writing system used by early Germanic peoples.

rustication (p. 602) In architecture, the rough, irregular, and unfinished effect deliberately given to the exterior facing of a stone edifice. Rusticated stones are often large and used for decorative emphasis around doors or windows, or across the entire lower floors of a building.

sacra conversazione (p. 630) Italian for "holy conversation." Refers to a type of religious painting developed in fifteenth-century Florence in which a central image of the Virgin and Child is flanked by standing saints of comparable size who stand within the same spatial setting and often acknowledge each other's presence.

salon (p. 907) A large room for entertaining guests or a periodic social or intellectual gathering, often of prominent people, held in such a room. Also: a hall or **gallery** for exhibiting works of art.

sanctuary (p. 102) A sacred or holy enclosure used for worship. In ancient Greece and Rome, consisted of one or more temples and an altar. In Christian architecture, the space around the altar in a church called the chancel or presbytery.

sarcophagus (*pl.* **sarcophagi**) (p. 49) A stone coffin. Often rectangular and decorated with **relief sculpture**.

scarab (p. 51) In ancient Egypt, a stylized dung beetle associated with the sun and the god Amun.

scarification (p. 409) Ornamental decoration applied to the surface of the body by cutting the skin for cultural and/or aesthetic reasons.

school of artists or **painting** (p. 285) An art-historical term describing a group of artists, usually working at the same time and sharing similar styles, influences, and ideals. The artists in a particular school may not necessarily be directly associated with one another, unlike those in a workshop or **atelier**.

scriptorium (*pl.* **scriptoria**) (p. 244) A room in a monastery for writing or copying **manuscript**s.

scroll painting (p. 347) A painting executed on a flexible support with rollers at each end. The rollers permit the horizontal scroll to be unrolled as it is studied or the vertical scroll to be hung for contemplation or decoration.

sculpture in the round (p. 5) Three-dimensional sculpture that is carved free of any background or block. Compare **relief sculpture**.

serdab (p. 53) In ancient Egyptian tombs, the small room in which the *ka* statue was placed.

sfumato (p. 636) Italian term meaning "smoky," soft, and mellow. In painting, the effect of haze in an image. Resembling the color of the atmosphere at dusk, *sfumato* gives a smoky effect.

sgraffito (p. 604) Decoration made by incising or cutting away a surface layer of material to reveal a different color beneath.

shaft (p. 110) The main vertical section of a **column** between the **capital** and the base, usually circular in cross section.

shaft grave (p. 97) A deep pit used for burial.

shikhara (p. 302) In the architecture of northern India, a conical (or pyramidal) spire found atop a Hindu temple and often crowned with an *amalaka*.

shoin (p. 821) A term used to describe the various features found in the most formal room of upper-class Japanese residential architecture.

shoji (p. 821) A standing Japanese screen covered in translucent rice paper and used in interiors.

siapo (p. 876) A type of **tapa** cloth found in Samoa and still used as an important gift for ceremonial occasions.

silkscreen printing (p. 1092) A technique of printing in which paint or ink is pressed through a stencil and specially prepared cloth to reproduce a design in multiple copies.

sinopia (*pl.* **sinopie**) (p. 539) Italian word taken from Sinope, the ancient city in Asia Minor that was famous for its red-brick pigment. In **fresco** paintings, a full-sized, preliminary sketch done in this color on the first rough coat of plaster or *arriccio*.

site-specific (p. 1102) Of a work commissioned and/or designed for a particular location.

slip (p. 118) A mixture of clay and water applied to a **ceramic** object as a final decorative coat. Also: a solution that binds different parts of a vessel together, such as the handle and the main body.

spandrel (p. 170) The area of wall adjoining the exterior curve of an **arch** between its **springing** and the **keystone**, or the area between two arches, as in an **arcade**.

spolia (p. 471) Fragments of older architecture or sculpture reused in a secondary context. Latin for "hide stripped from an animal."

springing (p. 170) The point at which the curve of an **arch** or **vault** meets with and rises from its support.

squinch (p. 238) An **arch** or **lintel** built across the upper corners of a square space, allowing a circular or polygonal **dome** to be securely set above the walls.

stained glass (p. 287) Glass stained with color while molten, using metallic oxides. Stained glass is most often used in windows, for which small pieces of different colors are precisely cut and assembled into a design, held together by lead **came**s. Additional details may be added with vitreous paint.

stave church (p. 443) A Scandinavian wooden structure with four huge timbers (staves) at its core.

stele (*pl.* **stelai**), also **stela** (*pl.* **stelae**) (p. 27) A stone slab placed vertically and decorated with inscriptions or reliefs. Used as a grave marker or commemorative monument.

stereobate (p. 110) In Classical architecture, the foundation upon which a temple stands.

still life (*pl.* **still lifes**) (p. xxxv) A type of painting that has as its subject inanimate objects (such as food and dishes) or fruit and flowers taken out of their natural contexts.

stoa (p. 107) In Greek architecture, a long roofed walkway, usually having **column**s on one long side and a wall on the other.

stoneware (p. 20) A high-fired, vitrified, but opaque **ceramic** ware that is fired in the range of 1,100 to 1,200 degrees Celsius. At that temperature, particles of silica in the clay bodies fuse together so that the finished vessels are impervious to liquids, even without glaze. Stoneware pieces are glazed to enhance their aesthetic appeal and to aid in keeping them clean. Stoneware occurs in a range of earth-toned colors, from white and tan to gray and black, with light gray predominating. Chinese potters were the first in the world to produce stoneware, which they were able to make as early as the Shang dynasty.

stringcourse (p. 503) A continuous horizontal band, such as a **molding**, decorating the face of a wall.

stucco (p. 72) A mixture of lime, sand, and other ingredients made into a material that can easily be molded or modeled. When dry, it produces a durable surface used for covering walls or for architectural sculpture and decoration.

stupa (p. 302) In Buddhist architecture, a bell-shaped or pyramidal religious monument, made of piled earth or stone, and containing sacred **relic**s.

style (p. xxxvi) A particular manner, form, or character of representation, construction, or expression that is typical of an individual artist or of a certain place or period.

stylobate (p. 110) In Classical architecture, the stone foundation on which a temple **colonnade** stands.

stylus (p. 28) An instrument with a pointed end (used for writing and printmaking), which makes a delicate line or scratch. Also: a special writing tool for **cuneiform** writing with one pointed end and one triangular.

sublime (p. 955) Of a concept, thing, or state of greatness or vastness with high spiritual, moral, intellectual, or emotional value; or something awe-inspiring. The sublime was a goal to which many nineteenth-century artists aspired in their artworks.

sunken relief (p. 71) See under **relief sculpture**.

symposium (p. 119) An elite gathering of wealthy and powerful men in ancient Greece that focused principally on wine, music, poetry, conversation, games, and love making.

syncretism (p. 220) A process whereby artists assimilate and combine images and ideas from different cultural traditions, beliefs, and practices, giving them new meanings.

taotie (p. 334) A mask with a dragon or animal-like face common as a decorative motif in Chinese art.

tapa (p. 876) A type of cloth used for various purposes in Pacific cultures, made from tree bark stripped and beaten, and often bearing subtle designs from the mallets used to work the bark.

tapestry (p. 292) Multicolored decorative weaving to be hung on a wall or placed on furniture. Pictorial or decorative motifs are woven directly into the supporting fabric, completely concealing it.

tatami (p. 821) Mats of woven straw used in Japanese houses as a floor covering.

temenos (p. 108) An enclosed sacred area reserved for worship in ancient Greece.

tempera (p. 141) A painting **medium** made by blending egg yolks with water, pigments, and occasionally other materials, such as glue.

tenebrism (p. 723) The use of strong *chiaroscuro* and artificially illuminated areas to create a dramatic contrast of light and dark in a painting.

terra cotta (p. 114) A **medium** made from clay fired over a low heat and sometimes left unglazed. Also: the orange-brown color typical of this medium.

tessera (*pl.* **tesserae**) (p. 145) A small piece of stone, glass, or other object that is pieced together with many others to create a **mosaic**.

thatch (p. 16) Plant material such as reeds or straw tied over a framework of poles to make a roof, shelter, or small building.

thermo-luminescence dating (p. 12) A method of **radiometric dating** that measures the irradiation of the crystal structure of material such as flint or pottery and the soil in which it is found, determined by luminescence produced when a sample is heated.

tholos (p. 98) A small, round building. Sometimes built underground, e.g. as a Mycenaean tomb.

thrust (p. 170) The outward pressure caused by the weight of a **vault** and supported by **buttressing**. See also under **arch**.

tondo (*pl.* **tondi**) (p. 126) A painting or **relief sculpture** of circular shape.

torana (p. 302) In Indian architecture, an ornamented gateway arch in a temple, usually leading to the **stupa**.

torc (p. 149) A circular neck ring worn by Celtic warriors.

toron (p. 422) In West African **mosque** architecture, the wooden beams that project from the walls. Torons are used as support for the scaffolding erected annually for the replastering of the building.

tracery (p. 503) Stonework or woodwork forming a pattern in the open space of windows or applied to wall surfaces. In *plate tracery*, a series of openings are cut through the wall. In *bar tracery*, **mullion**s divide the space into segments to form decorative patterns.

transept (p. 225) The arm of a **cruciform** church perpendicular to the **nave**. The point where the nave and transept intersect is called the crossing. Beyond the crossing lies the **sanctuary**, whether **apse**, **choir**, or chevet.

transverse arch (p. 463) See under **arch**.

trefoil (p. 298) An ornamental design made up of three rounded lobes placed adjacent to one another.

triforium (p. 505) The element of the interior elevation of a church found directly below the **clerestory** and consisting of a series of arched openings in front of a passageway within the thickness of the wall.

triglyph (p. 110) Rectangular block between the **metope**s of a Doric **frieze**. Identified by the three carved vertical grooves, which approximate the appearance of the end of wooden beams.

triptych (p. 566) An artwork made up of three panels. The panels may be hinged together in such a way that the side segments (wings) fold over the central area.

trompe l'oeil (p. 618) A manner of representation in which artists faithfully describe the appearance of natural space and forms with the express intention of fooling the eye of the viewer, who may be convinced momentarily that the subject actually exists as three-dimensional reality.

trumeau (p. 478) A **column**, **pier**, or post found at the center of a large **portal** or doorway, supporting the **lintel**.

tugra (p. 288) A calligraphic imperial monogram used in Ottoman courts.

tukutuku (p. 872) Lattice panels created by women from the Maori culture and used in architecture.

Tuscan order (p. 158) See under **order**.

twining (p. 848) A basketry technique in which short rods are sewn together vertically. The panels are then joined together to form a container or other object.

tympanum (p. 478) In medieval and later architecture, the area over a door enclosed by an **arch** and a **lintel**, often decorated with sculpture or mosaic.

ukiyo-e (p. 828) A Japanese term for a type of popular art that was favored from the sixteenth century, particularly in the form of color **woodblock print**s. *Ukiyo-e* prints often depicted the world of the common people in Japan, such as courtesans and actors, as well as landscapes and myths.

undercutting (p. 212) A technique in sculpture by which the material is cut back under the edges so that the remaining form projects strongly forward, casting deep shadows.

underglaze (p. 800) Color or decoration applied to a **ceramic** piece before glazing.

upeti (p. 876) In Pacific cultures, a carved wooden design tablet, used to create patterns in cloth by dragging the fabric across it.

uranium-thorium dating (p. 12) Technique used to date prehistoric cave paintings by measuring the decay of uranium into thorium in the deposits of calcium carbinate that cover the surfaces of cave walls, to determine the minimum age of the paintings under the crust.

urna (p. 306) In Buddhist art, the curl of hair on the forehead that is a characteristic mark of a buddha. The *urna* is a symbol of divine wisdom.

ushnisha (p. 306) In Asian art, a round turban or tiara symbolizing royalty and, when worn by a buddha, enlightenment.

vanishing point (p. 610) In a **perspective** system, the point on the **horizon line** at which **orthogonals** meet. A complex system can have multiple vanishing points.

vanitas (p. xxxvi) An image, especially popular in Europe during the seventeenth century, in which all the objects symbolize the transience of life. *Vanitas* paintings are usually of **still lifes** or genre subjects.

vault (p. 17) An arched masonry structure that spans an interior space. *Barrel* or *tunnel vault*: an elongated or continuous semicircular vault, shaped like a half-cylinder. *Corbeled vault*: a vault made by projecting **course**s of stone; see also under **corbel**. *Groin* or *cross vault*: a vault created by the intersection of two barrel vaults of equal size which creates four side compartments of identical size and shape. *Quadrant vault*: a half-barrel vault. *Rib vault*: a groin vault with ribs (extra masonry) demarcating the junctions. Ribs may function to reinforce the groins or may be purely decorative.

veduta (*pl.* **vedute**) (p. 915) Italian for "vista" or "view." Paintings, drawings, or prints, often of expansive city scenes or of harbors.

vellum (p. 245) A fine animal skin prepared for writing and painting. See also **parchment**.

verism (p. 168) Style in which artists concern themselves with describing the exterior likeness of an object or person, usually by rendering its visible details in a finely executed, meticulous manner.

vihara (p. 305) From the Sanskrit term meaning "for wanderers." A *vihara* is, in general, a Buddhist monastery in India. It also signifies monks' cells and gathering places in such a monastery.

volute (p. 110) A spiral scroll, as seen on an Ionic **capital**.

votive figure (p. 31) An image created as a devotional offering to a deity.

voussoir (p. 170) Wedge-shaped stone block used to build an **arch**. The topmost voussoir is called a **keystone**. See also **joggled voussoirs**.

warp (p. 292) The vertical threads in a weaver's loom. Warp threads make up a fixed framework that provides the structure for the entire piece of cloth, and are thus often thicker than **weft** threads.

wattle and daub (p. 16) A wall construction method combining upright branches, woven with twigs (wattles) and plastered or filled with clay or mud (daub).

weft (p. 292) The horizontal threads in a woven piece of cloth. Weft threads are woven at right angles to and through the **warp** threads to make up the bulk of the decorative pattern. In carpets, the weft is often completely covered or formed by the rows of trimmed knots that form the carpet's soft surface.

westwork (p. 446) The monumental, west-facing entrance section of a Carolingian, Ottonian, or Romanesque church. The exterior consists of multiple stories between two towers; the interior includes an entrance vestibule, a chapel, and a series of **galleries** overlooking the **nave**.

white-ground (p. 141) A type of ancient Greek pottery in which the background color of the object was painted with a **slip** that turns white in the firing process. Figures and details were added by painting on or incising into this slip. White-ground wares were popular in the Classical period as funerary objects.

woodblock print (p. 591) A print made from one or more carved wooden blocks. In Japan, woodblock prints were made using multiple blocks carved in relief, usually with a block for each color in the finished print. See also **woodcut**.

woodcut (p. 592) A type of print made by carving a design into a wooden block. The ink is applied to the block with a roller. As the ink touches only on the surface areas and lines remaining between the carved-away parts of the block, it is these areas that make the print when paper is pressed against the inked block, leaving the carved-away parts of the design to appear blank. Also: the process by which the woodcut is made.

yaksha, yakshi (p. 301) The male (*yaksha*) and female (*yakshi*) nature spirits that act as agents of the Hindu gods. Their sculpted images are often found on Hindu temples and other sacred places, particularly at the entrances.

yamato-e (p. 374) A native style of Japanese painting developed during the twelfth and thirteenth centuries, distinguished from Japanese painting styles that emulate Chinese traditions.

ziggurat (p. 28) In ancient Mesopotamia, a tall stepped tower of earthen materials, often supporting a shrine.

Bibliography

Susan V. Craig, updated by **Carrie L. McDade**

This bibliography is composed of books in English that are suggested "further reading" titles. Most are available in good libraries, whether college, university, or public. Recently published works have been emphasized so that the research information would be current. There are three classifications of listings: general surveys and art history reference tools, including journals and Internet directories; surveys of large periods that encompass multiple chapters (ancient art in the Western tradition, European medieval art, European Renaissance through eighteenth-century art, modern art in the West, Asian art, and African and Oceanic art, and art of the Americas); and books for individual Chapters 1 through 33.

General Art History Surveys and Reference Tools

Adams, Laurie Schneider. *Art Across Time*. 4th ed. New York: McGraw-Hill, 2011.

Barnet, Sylvan. *A Short Guide to Writing about Art*. 10th ed. Upper Saddle River, NJ: Pearson/Prentice Hall, 2010.

Bony, Anne. *Design: History, Main Trends, Main Figures*. Edinburgh: Chambers, 2005.

Boström, Antonia. *Encyclopedia of Sculpture*. 3 vols. New York: Fitzroy Dearborn, 2004.

Broude, Norma, and Mary D. Garrard, eds. *Feminism and Art History: Questioning the Litany*. Icon Editions. New York: Harper & Row, 1982.

Chadwick, Whitney. *Women, Art, and Society*. 4th ed. New York: Thames & Hudson, 2007.

Chilvers, Ian, ed. *The Oxford Dictionary of Art*. 4th ed. New York: Oxford Univ. Press, 2009.

Curl, James Stevens. *A Dictionary of Architecture and Landscape Architecture*. 2nd ed. Oxford: Oxford Univ. Press, 2006.

Davies, Penelope J.E., et al. *Janson's History of Art: The Western Tradition*. 8th ed. Upper Saddle River, NJ: Prentice Hall, 2010.

The Dictionary of Art. Ed. Jane Turner. 34 vols. New York: Grove's Dictionaries, 1996.

Frank, Patrick, Duane Preble, and Sarah Preble. *Prebles' Artforms*. 10th ed. Upper Saddle River, NJ: Pearson/Prentice Hall, 2011.

Gaze, Delia, ed. *Dictionary of Women Artists*. 2 vols. London: Fitzroy Dearborn, 1997.

Griffiths, Antony. *Prints and Printmaking: An Introduction to the History and Techniques*. 2nd ed. London: British Museum Press, 1996.

Hadden, Peggy. *The Quotable Artist*. New York: Allworth Press, 2002.

Hall, James. *Dictionary of Subjects and Symbols in Art*. 2nd ed. Boulder, CO: Westview Press, 2008.

Holt, Elizabeth Gilmore, ed. *A Documentary History of Art*. 3 vols. New Haven: Yale Univ. Press, 1986.

Honour, Hugh, and John Fleming. *The Visual Arts: A History*. 7th ed. rev. Upper Saddle River, NJ: Pearson/Prentice Hall, 2010.

Johnson, Paul. *Art: A New History*. New York: HarperCollins, 2003.

Kemp, Martin, ed. *The Oxford History of Western Art*. Oxford: Oxford Univ. Press, 2000.

Kleiner, Fred S. *Gardner's Art through the Ages*. Enhanced 13th ed. Belmont, CA: Thomson/Wadsworth, 2011.

Kostof, Spiro. *A History of Architecture: Settings and Rituals*. 2nd ed. Revised Greg Castillo. New York: Oxford Univ. Press, 1995.

Mackenzie, Lynn. *Non-Western Art: A Brief Guide*. 2nd ed. Upper Saddle River, NJ: Pearson/Prentice Hall, 2001.

Marmor, Max, and Alex Ross, eds. *Guide to the Literature of Art History 2*. Chicago: American Library Association, 2005.

Onians, John, ed. *Atlas of World Art*. New York: Oxford Univ. Press, 2004.

Sayre, Henry M. *Writing about Art*. 6th ed. Upper Saddle River, NJ: Pearson/Prentice Hall, 2009.

Sed-Rajna, Gabrielle. *Jewish Art*. Trans. Sara Friedman and Mira Reich. New York: Abrams, 1997.

Slatkin, Wendy. *Women Artists in History: From Antiquity to the Present*. 4th ed. Upper Saddle River, NJ: Pearson/Prentice Hall, 2001.

Sutton, Ian. *Western Architecture: From Ancient Greece to the Present*. World of Art. New York: Thames & Hudson, 1999.

Trachtenberg, Marvin, and Isabelle Hyman. *Architecture, from Prehistory to Postmodernity*. 2nd ed. Upper Saddle River, NJ: Pearson/Prentice Hall, 2002.

Watkin, David. *A History of Western Architecture*. 4th ed. New York: Watson-Guptill, 2005.

Art History Journals: A Select List of Current Titles

African Arts. Quarterly. Los Angeles: Univ. of California at Los Angeles, James S. Coleman African Studies Center, 1967–.

American Art: The Journal of the Smithsonian American Art Museum. 3/year. Chicago: Univ. of Chicago Press, 1987–.

American Indian Art Magazine. Quarterly. Scottsdale, AZ: American Indian Art Inc., 1975–.

American Journal of Archaeology. Quarterly. Boston: Archaeological Institute of America, 1885–.

Antiquity: A Periodical of Archaeology. Quarterly. Cambridge: Antiquity Publications Ltd., 1927–.

Apollo: The International Magazine of the Arts. Monthly. London: Apollo Magazine Ltd., 1925–.

Architectural History. Annually. Farnham, UK: Society of Architectural Historians of Great Britain, 1958–.

Archives of American Art Journal. Quarterly. Washington, DC: Archives of American Art, Smithsonian Institution, 1960–.

Archives of Asian Art. Annually. New York: Asia Society, 1945–.

Ars Orientalis: The Arts of Asia, Southeast Asia, and Islam. Annually. Ann Arbor: Univ. of Michigan Dept. of Art History, 1954–.

Art Bulletin. Quarterly. New York: College Art Association, 1913–.

Art History: Journal of the Association of Art Historians. 5/year. Oxford: Blackwell Publishing Ltd., 1978–.

Art in America. Monthly. New York: Brant Publications Inc., 1913–.

Art Journal. Quarterly. New York: College Art Association, 1960–.

Art Nexus. Quarterly. Bogota, Colombia: Arte en Colombia Ltda, 1976–.

Art Papers Magazine. Bimonthly. Atlanta: Atlanta Art Papers Inc., 1976–.

Artforum International. 10/year. New York: Artforum International Magazine Inc., 1962–.

Artnews. 11/year. New York: Artnews LLC, 1902–.

Bulletin of the Metropolitan Museum of Art. Quarterly. New York: Metropolitan Museum of Art, 1905–.

Burlington Magazine. Monthly. London: Burlington Magazine Publications Ltd., 1903–.

Dumbarton Oaks Papers. Annually. Locust Valley, NY: J.J. Augustin Inc., 1940–.

Flash Art International. Bimonthly. Trevi, Italy: Giancarlo Politi Editore, 1980–.

Gesta. Semiannually. New York: International Center of Medieval Art, 1963–.

History of Photography. Quarterly. Abingdon, UK: Taylor & Francis Ltd., 1976–.

International Review of African American Art. Quarterly. Hampton, VA: International Review of African American Art, 1976–.

Journal of Design History. Quarterly. Oxford: Oxford Univ. Press, 1988–.

Journal of Egyptian Archaeology. Annually. London: Egypt Exploration Society, 1914–.

Journal of Hellenic Studies. Annually. London: Society for the Promotion of Hellenic Studies, 1880–.

Journal of Roman Archaeology. Annually. Portsmouth, RI: Journal of Roman Archaeology LLC, 1988–.

Journal of the Society of Architectural Historians. Quarterly. Chicago: Society of Architectural Historians, 1940–.

Journal of the Warburg and Courtauld Institutes. Annually. London: Warburg Institute, 1937–.

Leonardo: Art, Science, and Technology. 6/year. Cambridge, MA: MIT Press, 1968–.

Marg. Quarterly. Mumbai, India: Scientific Publishers, 1946–.

Master Drawings. Quarterly. New York: Master Drawings Association, 1963–.

October. Cambridge, MA: MIT Press, 1976–.

Oxford Art Journal. 3/year. Oxford: Oxford Univ. Press, 1978–.

Parkett. 3/year. Zürich, Switzerland: Parkett Verlag AG, 1984–.

Print Quarterly. Quarterly. London: Print Quarterly Publications, 1984–.

Simiolus: Netherlands Quarterly for the History of Art. Quarterly. Apeldoorn, Netherlands: Stichting voor Nederlandse Kunsthistorische Publicaties, 1966–.

Woman's Art Journal. Semiannually. Philadelphia: Old City Publishing Inc., 1980–.

Internet Directories for Art History Information: A Selected List

ARCHITECTURE AND BUILDING,
http://www.library.unlv.edu/arch/rsrce/webresources/
A directory of architecture websites collected by Jeanne Brown at the Univ. of Nevada at Las Vegas. Topical lists include architecture, building and construction, design, history, housing, planning, preservation, and landscape architecture. Most entries include a brief annotation and the last date the link was accessed by the compiler.

ART HISTORY RESOURCES ON THE WEB,
http://witcombe.sbc.edu/ARTHLinks.html
Authored by Professor Christopher L.C.E. Witcombe of Sweet Briar College in Virginia, since 1995, the site includes an impressive number of links for various art-historical eras as well as links to research resources, museums, and galleries. The content is frequently updated.

ART IN FLUX: A DIRECTORY OF RESOURCES FOR RESEARCH IN CONTEMPORARY ART,
http://www.boisestate.edu/art/artinflux/intro.html
Cheryl K. Shurtleff of Boise State Univ. in Idaho has authored this directory, which includes sites selected according to their relevance to the study of national or international contemporary art and artists. The subsections include artists, museums, theory, reference, and links.

ARTCYCLOPEDIA: THE GUIDE TO GREAT ART ON THE INTERNET,
http://www.artcyclopedia.com
With more than 2,100 art sites and 75,000 links, this is one of the most comprehensive Web directories for artists and art topics. The primary search is by artist's name but access is also available by title of artwork, artistic movement, museums and galleries, nationality, period, and medium.

MOTHER OF ALL ART AND ART HISTORY LINKS PAGES,
http://umich.edu/~motherha
Maintained by the Dept. of the History of Art at the Univ. of Michigan, this directory covers art history departments, art museums, fine arts schools and departments, as well as links to research resources. Each entry includes annotations.

VOICE OF THE SHUTTLE,
http://vos.ucsb.edu
Sponsored by Univ. of California, Santa Barbara, this directory includes more than 70 pages of links to humanities and humanities-related resources on the Internet. The structured guide includes specific subsections on architecture, on art (modern and contemporary), and on art history. Links usually include a one-sentence explanation and the resource is frequently updated with new information.

ARTBABBLE,
http://www.artbabble.org/
An online community created by staff at the Indianapolis Museum of Art to showcase art-based video content, including interviews with artists and curators, original documentaries, and art installation videos. Partners and contributors to the project include Art21, Los Angeles County Museum of Art, The Museum of Modern Art, The New York Public Library, San Francisco Museum of Modern Art, and Smithsonian American Art Museum.

YAHOO! ARTS>ART HISTORY,
http://dir.yahoo.com/Arts/Art_History/
Another extensive directory of art links organized into subdivisions with one of the most extensive being "Periods and Movements." Links include the name of the site as well as a few words of explanation.

Asian Art, General

Addiss, Stephen, Gerald Groemer, and J. Thomas Rimer, eds. *Traditional Japanese Arts and Culture: An Illustrated Sourcebook.* Honolulu: Univ. of Hawai'i Press, 2006.

Barnhart, Richard M. *Three Thousand Years of Chinese Painting.* New Haven: Yale Univ. Press, 1997.

Blunden, Caroline, and Mark Elvin. *Cultural Atlas of China.* 2nd ed. New York: Checkmark Books, 1998.

Brown, Kerry, ed. *Sikh Art and Literature.* New York: Routledge in collaboration with the Sikh Foundation, 1999.

Chang, Léon Long-Yien, and Peter Miller. *Four Thousand Years of Chinese Calligraphy.* Chicago: Univ. of Chicago Press, 1990.

Chang, Yang-mo. *Arts of Korea.* Ed. Judith G. Smith. New York: Metropolitan Museum of Art, 1998.

Clark, John. *Modern Asian Art.* Honolulu: Univ. of Hawai'i Press, 1998.

Clunas, Craig. *Art in China.* 2nd ed. Oxford History of Art. Oxford: Oxford Univ. Press, 2009.

Coaldrake, William H. *Architecture and Authority in Japan.* London: Routledge, 1996.

Collcutt, Martin, Marius Jansen, and Isao Kumakura. *Cultural Atlas of Japan.* New York: Facts on File, 1988.

Craven, Roy C. *Indian Art: A Concise History.* Rev. ed. World of Art. New York: Thames & Hudson, 1997.

Dehejia, Vidya. *Indian Art. Art & Ideas.* London: Phaidon Press, 1997.

Fisher, Robert E. *Buddhist Art and Architecture.* World of Art. New York: Thames & Hudson, 1993.

Fu, Xinian. *Chinese Architecture.* Ed. & exp., Nancy S. Steinhardt. New Haven: Yale Univ. Press, 2002.

Hearn, Maxwell K., and Judith G. Smith, eds. *Arts of the Sung and Yüan: Papers Prepared for an International Symposium.* New York: Dept. of Asian Art, Metropolitan Museum of Art, 1996.

Heibonsha Survey of Japanese Art. 31 vols. New York: Weatherhill, 1972–80.

Hertz, Betti-Sue. *Past in Reverse: Contemporary Art of East Asia.* San Diego: San Diego Museum of Art, 2004.

Japanese Arts Library. 15 vols. New York: Kodansha International, 1977–87.

Kerlogue, Fiona. *Arts of Southeast Asia.* World of Art. New York: Thames & Hudson, 2004.

Khanna, Balraj, and George Michell. *Human and Divine: 2000 Years of Indian Sculpture.* London: Hayward Gallery, 2000.

Lee, Sherman E. *A History of Far Eastern Art.* 5th ed. Ed. Naomi Noble Richards. New York: Abrams, 1994.

———. *China, 5000 Years: Innovation and Transformation in the Arts.* New York: Solomon R. Guggenheim Museum, 1998.

Liu, Cary Y., and Dora C.Y. Ching, eds. *Arts of the Sung and Yüan: Ritual, Ethnicity, and Style in Painting.* Princeton, NJ: Art Museum, Princeton Univ., 1999.

McArthur, Meher. *The Arts of Asia: Materials, Techniques, Styles.* New York: Thames & Hudson, 2005.

———. *Reading Buddhist Art: An Illustrated Guide to Buddhist Signs and Symbols.* New York: Thames & Hudson, 2002.

Mason, Penelope. *History of Japanese Art.* 2nd ed. Upper Saddle River, NJ: Pearson/Prentice Hall, 2005.

Michell, George. *Hindu Art and Architecture.* World of Art. London: Thames & Hudson, 2000.

———. *The Penguin Guide to the Monuments of India.* 2 vols. New York: Viking, 1989.

Mitter, Partha. *Indian Art.* Oxford History of Art. Oxford: Oxford Univ. Press, 2001.

Murase, Miyeko. *Bridge of Dreams: The Mary Griggs Burke Collection of Japanese Art.* New York: Metropolitan Museum of Art, 2000.

Nickel, Lukas, ed. *Return of the Buddha: The Qingzhou Discoveries.* London: Royal Academy of Arts, 2002.

Pak, Youngsook, and Roderick Whitfield. *Buddhist Sculpture.* Handbook of Korean Art. London: Laurence King Publishing, 2003.

Sullivan, Michael. *The Arts of China.* 5th ed., rev. & exp. Berkeley: Univ. of California Press, 2008.

Thorp, Robert L., and Richard Ellis Vinograd. *Chinese Art & Culture.* New York: Abrams, 2001.

Topsfield, Andrew, ed. *In the Realm of Gods and Kings: Arts of India.* London: Philip Wilson, 2004.

Tucker, Jonathan. *The Silk Road: Art and History.* Chicago: Art Media Resources, 2003.

Tregear, Mary. *Chinese Art.* Rev. ed. World of Art. New York: Thames & Hudson, 1997.

Vainker, S.J. *Chinese Pottery and Porcelain: From Prehistory to the Present.* New York: Braziller, 1991.

African and Oceanic Art and Art of the Americas, General

Anderson, Richard L., and Karen L. Field, eds. *Art in Small-Scale Societies: Contemporary Readings.* Upper Saddle River, NJ: Pearson/Prentice Hall, 1993.

Bacquart, Jean-Baptiste. *The Tribal Arts of Africa.* New York: Thames & Hudson, 1998.

Bassani, Ezio, ed. *Arts of Africa: 7000 Years of African Art.* Milan: Skira, 2005.

Benson, Elizabeth P. *Retratos: 2,000 Years of Latin American Portraits.* San Antonio, TX: San Antonio Museum of Art, 2004.

Berlo, Janet Catherine, and Lee Anne Wilson. *Arts of Africa, Oceania, and the Americas: Selected Readings.* Upper Saddle River, NJ: Prentice Hall, 1993.

Calloway, Colin G. *First Peoples: A Documentary Survey of American Indian History.* 3rd ed. Boston: Bedford/St. Martin's, 2008.

Coote, Jeremy, and Anthony Shelton, eds. *Anthropology, Art, and Aesthetics.* New York: Oxford Univ. Press, 1992.

Drewal, Henry, and John Pemberton III. *Yoruba: Nine Centuries of African Art and Thought.* New York: Center for African Art, 1989.

Evans, Susan Toby. *Ancient Mexico & Central America: Archaeology and Culture History.* 2nd ed. New York: Thames & Hudson, 2008.

———, and David L. Webster, eds. *Archaeology of Ancient Mexico and Central America: An Encyclopedia.* New York: Garland, 2001.

———, and Joanne Pillsbury, eds. *Palaces of the Ancient New World: A Symposium at Dumbarton Oaks, 10th and 11th October, 1998.* Washington, DC: Dumbarton Oaks Research Library and Collection, 2004.

Geoffroy-Schneiter, Bérénice. *Tribal Arts.* New York: Vendome Press, 2000.

Hiller, Susan, ed. & compiled. *The Myth of Primitivism: Perspectives on Art.* London: Routledge, 1991.

Mack, John, ed. *Africa, Arts and Cultures.* London: British Museum Press, 2000.

Mexico: Splendors of Thirty Centuries. New York: Metropolitan Museum of Art, 1990.

Nunley, John W., and Cara McCarty. *Masks: Faces of Culture.* New York: Abrams in assoc. with the Saint Louis Art Museum, 1999.

Perani, Judith, and Fred T. Smith. *The Visual Arts of Africa: Gender, Power, and Life Cycle Rituals.* Upper Saddle River, NJ: Pearson/Prentice Hall, 1998.

Phillips, Tom, ed. *Africa: The Art of a Continent.* New York: Prestel, 1995.

Price, Sally. *Primitive Art in Civilized Places.* 2nd ed. Chicago: Univ. of Chicago Press, 2001.

Rabineau, Phyllis. *Feather Arts: Beauty, Wealth, and Spirit from Five Continents.* Chicago: Field Museum of Natural History, 1979.

Schuster, Carl, and Edmund Carpenter. *Patterns that Connect: Social Symbolism in Ancient & Tribal Art.* New York: Abrams, 1996.

Scott, John F. *Latin American Art: Ancient to Modern.* Gainesville: Univ. Press of Florida, 1999.

Stepan, Peter. *Africa.* Trans. John Gabriel and Elizabeth Schwaiger. London: Prestel, 2001.

Visonà, Monica Blackmun, et al. *A History of Art in Africa.* 2nd ed. Upper Saddle River, NJ: Pearson/Prentice Hall, 2008.

Chapter 9 Islamic Art

Al-Faruqi, Isma'il R., and Lois Ibsen Al-Faruqi. *Cultural Atlas of Islam.* New York: Macmillan, 1986.

Atil, Esin. *The Age of Sultan Suleyman the Magnificent.* Washington, DC: National Gallery of Art, 1987.

Baker, Patricia L. *Islam and the Religious Arts.* London: Continuum, 2004.

Barry, Michael A. *Figurative Art in Medieval Islam and the Riddle of Bihzâd of Herât (1465–1535).* Paris: Flammarion, 2004.

Blair, Sheila S., and Jonathan Bloom. *The Art and Architecture of Islam 1250–1800.* Pelican History of Art. New Haven: Yale Univ. Press, 1995.

Dodds, Jerrilynn D., ed. *Al-Andalus: The Art of Islamic Spain.* New York: Metropolitan Museum of Art, 1992.

Ecker, Heather. *Caliphs and Kings: The Art and Influence of Islamic Spain.* Washington, DC: Arthur M. Sackler Gallery, 2004.

Ettinghausen, Richard, Oleg Grabar, and Marilyn Jenkins-Madina. *Islamic Art and Architecture, 650–1250.* 2nd ed. Pelican History of Art. New Haven: Yale Univ. Press, 2001.

Frishman, Martin, and Hasan-Uddin Khan. *The Mosque: History, Architectural Development and Regional Diversity.* London: Thames & Hudson, 1994.

Grabar, Oleg. *The Formation of Islamic Art.* Rev. and enl. New Haven: Yale Univ. Press, 1987.

———. *The Great Mosque of Isfahan.* New York: New York Univ. Press, 1990.

———. *Islamic Visual Culture, 1100–1800.* Burlington, VT: Ashgate, 2006.

———. *Mostly Miniatures: An Introduction to Persian Painting.* Princeton, NJ: Princeton Univ. Press, 2000.

———, Mohammad Al-Asad, Abeer Audeh, and Said Nuseibeh. *The Shape of the Holy: Early Islamic Jerusalem.* Princeton, NJ: Princeton Univ. Press, 1996.

Hillenbrand, Robert. *Islamic Art and Architecture.* World of Art. London: Thames & Hudson, 1999.

Irwin, Robert. *The Alhambra.* Cambridge, MA: Harvard Univ. Press, 2004.

Khalili, Nasser D. *Visions of Splendour in Islamic Art and Culture.* London: Worth Press, 2008.

Komaroff, Linda, and Stefano Carboni, eds. *The Legacy of Genghis Khan: Courtly Art and Culture in Western Asia, 1256–1353.* New York: Metropolitan Museum of Art, 2002.

Lentz, Thomas W., and Glenn D. Lowry. *Timur and the Princely Vision: Persian Art and Culture in the Fifteenth Century.* Los Angeles: Los Angeles County Museum of Art, 1989.

Necipolu, Gülru. *The Age of Sinan: Architectural Culture in the Ottoman Empire.* Princeton, NJ: Princeton Univ. Press, 2005.

Petruccioli, Attilio, and Khalil K. Pirani, eds. *Understanding Islamic Architecture.* New York: Routledge Curzon, 2002.

Roxburgh, David J., ed. *Turks: A Journey of a Thousand Years, 600–1600.* London: Royal Academy of Arts, 2005.

Sims, Eleanor, B.I. Marshak, and Ernst J. Grube. *Peerless Images: Persian Painting and Its Sources.* New Haven: Yale Univ. Press, 2002.

Stanley, Tim, Mariam Rosser-Owen, and Stephen Vernoit. *Palace and Mosque: Islamic Art from the Middle East.* London: V&A Publications, 2004.

Stierlin, Henri. *Islamic Art and Architecture.* New York: Thames & Hudson, 2002.

Tadgell, Christopher. *Four Caliphates: The Formation and Development of the Islamic Tradition.* London: Ellipsis, 1998.

Ward, R.M. *Islamic Metalwork.* New York: Thames & Hudson, 1993.

Watson, Oliver. *Ceramics from Islamic Lands.* New York: Thames & Hudson in assoc. with the al-Sabah Collection, Dar al-Athar al-Islamiyyah, Kuwait National Museum, 2004.

Chapter 10 Art of South and Southeast Asia before 1200

Atherton, Cynthia Packert. *The Sculpture of Early Medieval Rajasthan.* Studies in Asian Art and Archaeology, vol. 21. New York: Brill, 1997.

Behl, Benoy K. *The Ajanta Caves: Artistic Wonder of Ancient Buddhist India.* New York: Abrams, 1998.

Behrendt, Kurt A. *The Buddhist Architecture of Gandhara.* Handbook of Oriental Studies: Section Two: India, vol. 17. Boston: Brill, 2004.

Chakrabarti, Dilip K. *India, an Archaeological History: Palaeolithic Beginnings to Early Historic Foundations.* 2nd ed. New York: Oxford Univ. Press, 2009.

Craven, Roy C. *Indian Art: A Concise History.* Rev. ed. World of Art. New York: Thames & Hudson, 1997.

Czuma, Stanislaw J. *Kushan Sculpture: Images from Early India.* Cleveland: Cleveland Museum of Art, 1985.

Dehejia, Vidya. *Art of the Imperial Cholas.* New York: Columbia Univ. Press, 1990.

———. *The Sensuous and the Sacred: Chola Bronzes from South India.* New York: American Federation of Arts, 2002.

Dessai, Vishakha N., and Darielle Mason, eds. *Gods, Guardians, and Lovers: Temple Sculptures from North India, A.D. 700–1200.* New York: Asia Society Galleries, 1993.

Dhavalikar, Madhukar Keshav. *Ellora.* New York: Oxford Univ. Press, 2003.

Girard-Geslan, Maud. *Art of Southeast Asia.* Trans. J.A. Underwood. New York: Abrams, Inc., 1998.

Heller, Amy. *Early Himalayan Art.* Oxford: Ashmolean Museum, 2008.

Huntington, Susan L. *The Art of Ancient India: Buddhist, Hindu, Jain.* New York: Weatherhill, 1985.

———. *Leaves from the Bodhi Tree: The Art of Pala India (8th–12th Centuries) and Its International Legacy.* Dayton, OH: Dayton Art Institute, 1990.

Hutt, Michael. *Nepal: A Guide to the Art and Architecture of the Kathmandu Valley.* Boston: Shambhala, 1995.

Knox, Robert. *Amaravati: Buddhist Sculpture from the Great Stupa.* London: British Museum Press, 1992.

Khanna, Sucharita. *Dancing Divinities in Indian Art: 8th–12th Century A.D.* Delhi: Sharada Pub. House, 1999.

Kramrisch, Stella. *The Art of Nepal.* New York: Abrams, 1964.

———. *The Presence of Siva.* Princeton, NJ: Princeton Univ. Press, 1981.

Meister, Michael, ed. *Encyclopedia of Indian Temple Architecture.* 2 vols. in 7. Philadelphia: Univ. of Pennsylvania Press, 1983.

Michell, George. *Elephanta.* Bombay: India Book House, 2002.

———. *Hindu Art and Architecture.* World of Art. London: Thames & Hudson, 2000.

Mitter, Partha. *Indian Art.* Oxford History of Art. Oxford: Oxford Univ. Press, 2001.

Neumayer, Erwin. *Lines on Stone: The Prehistoric Rock Art of India.* New Delhi: Manohar, 1993.

Pal, Pratapaditya, ed. *The Ideal Image: The Gupta Sculptural Tradition and Its Influence.* New York: Asia Society, 1978.

Poster, Amy G. *From Indian Earth: 4,000 Years of Terracotta Art.* Brooklyn, NY: Brooklyn Museum, 1986.

Skelton, Robert, and Mark Francis. *Arts of Bengal: The Heritage of Bangladesh and Eastern India.* London: Whitechapel Art Gallery, 1979.

Stierlin, Henri. *Hindu India: From Khajuraho to the Temple City of Madurai.* Taschen's World Architecture. New York: Taschen, 1998.

Tadgell, Christopher. *India and South-East Asia: The Buddhist and Hindu Tradition.* London: Whitney Library of Design, 1998.

Williams, Joanna G. *Art of Gupta India, Empire and Province.* Princeton, NJ: Princeton Univ. Press, 1982.

Chapter 11 Chinese and Korean Art before 1279

Ciarla, Roberto, ed. *The Eternal Army: The Terracotta Soldiers of the First Chinese Emperor.* Vercelli: White Star, 2005.

Fong, Wen, ed. *Beyond Representation: Chinese Painting and Calligraphy, 8th–14th Century.* Princeton Monographs in Art and Archaeology, 48. New York: Metropolitan Museum of Art, 1992.

Fraser, Sarah Elizabeth. *Performing the Visual: The Practice of Buddhist Wall Painting in China and Central Asia, 618–960.* Stanford, CA: Stanford Univ. Press, 2004.

James, Jean M. *A Guide to the Tomb and Shrine Art of the Han Dynasty 206 B.C.–A.D. 220.* Chinese Studies, 2. Lewiston, NY: Mellen Press, 1996.

Karetzky, Patricia Eichenbaum. *Court Art of the Tang.* Lanham, MD: Univ. Press of America, 1996.

Kim, Kumja Paik. *Goryeo Dynasty: Korea's Age of Enlightenment, 918–1392.* San Francisco: Asian Art Museum—Chong-Moon Lee Center for Asian Art and Culture in cooperation with the National Museum of Korea and the Nara National Museum, 2003.

Li, Jian, ed. *The Glory of the Silk Road: Art from Ancient China.* Dayton, OH: Dayton Art Institute, 2003.

Little, Stephen, and Shawn Eichman. *Taoism and the Arts of China.* Chicago: Art Institute of Chicago, 2000.

Liu, Cary Y., Dora C.Y. Ching, and Judith G. Smith, eds. *Character & Context in Chinese Calligraphy.* Princeton, NJ: Art Museum, Princeton Univ., 1999.

Luo, Zhewen. *Ancient Pagodas in China.* Beijing, China: Foreign Languages Press, 1994.

Ma, Chengyuan. *Ancient Chinese Bronzes.* Ed. Hsio-Yen Shih. Hong Kong: Oxford Univ. Press, 1986.

Murck, Alfreda. *Poetry and Painting in Song China: The Subtle Art of Dissent.* Harvard-Yenching Institute Monograph Series. Cambridge, MA: Harvard Univ. Asia Center for the Harvard-Yenching Institute, 2000.

Ortiz, Valérie Malenfer. *Dreaming the Southern Song Landscape: The Power of Illusion in Chinese Painting.* Studies in Asian Art and Archaeology, vol. 22. Boston: Brill, 1999.

Paludan, Ann. *Chinese Tomb Figurines.* Hong Kong: Oxford Univ. Press, 1994.

Portal, Jane. *Korea: Art and Archaeology.* New York: Thames & Hudson, 2000.

Rawson, Jessica. *Mysteries of Ancient China: New Discoveries from the Early Dynasties.* London: British Museum Press, 1996.

Rhie, Marylin M. *Early Buddhist Art of China and Central Asia.* 2 vols in 3. Handbuch der Orientalistik. Vierte Abteilung; China, 12. Leiden: Brill, 1999.

Scarpari, Maurizio. *Splendours of Ancient China.* London: Thames & Hudson, 2000.

So, Jenny F. ed. *Noble Riders from Pines and Deserts: The Artistic Legacy of the Qidan.* Hong Kong: Art Museum, Chinese Univ. of Hong Kong, 2004.

Sturman, Peter Charles. *Mi Fu: Style and the Art of Calligraphy in Northern Song.* New Haven: Yale Univ. Press, 1997.

Wang, Eugene Y. *Shaping the Lotus Sutra: Buddhist Visual Culture in Medieval China.* Seattle: Univ. of Washington Press, 2005.

Watson, William. *The Arts of China to A.D. 900.* Pelican History of Art. New Haven: Yale Univ. Press, 1995.

———. *The Arts of China 900–1620.* Pelican History of Art. Reissue ed. 2003. New Haven: Yale Univ. Press, 2000.

Watt, James C.Y. *China: Dawn of a Golden Age, 200–750 A.D.* New York: Metropolitan Museum of Art, 2004.

Whitfield, Susan, and Ursula Sims-Williams, eds. *The Silk Road: Trade, Travel, War and Faith.* Chicago: Serindia Publications, 2004.

Wu Hung. *Monumentality in Early Chinese Art and Architecture.* Stanford, CA: Stanford Univ. Press, 1995.

Yang, Xiaoneng, ed. *The Golden Age of Chinese Archaeology: Celebrated Discoveries from the People's Republic of China.* Washington, DC: National Gallery of Art, 1999.

Chapter 12 Japanese Art before 1333

Cunningham, Michael R. *Buddhist Treasures from Nara.* Cleveland: Cleveland Museum of Art, 1998.

Harris, Victor, ed. *Shinto: The Sacred Art of Ancient Japan.* London: British Museum Press, 2001.

Izutsu, Shinryu, and Shoryu Omori. *Sacred Treasures of Mount Koya: The Art of Japanese Shingon Buddhism.* Honolulu: Koyasan Reihokan Museum, 2002.

Kurata, Bunsaku. *Horyu-ji, Temple of the Exalted Law: Early Buddhist Art from Japan.* New York: Japan Society, 1981.

Levine, Gregory P.A., and Yukio Lippit. *Awakenings: Zen Figure Painting in Medieval Japan.* New York: Japan Society, 2007.

McCallum, Donald F. *The Four Great Temples: Buddhist Archaeology, Architecture, and Icons of Seventh-Century Japan.* Honolulu: Univ. of Hawai'i Press, 2009.

Mino, Yutaka. *The Great Eastern Temple: Treasures of Japanese Buddhist Art from Todai-ji.* Chicago: Art Institute of Chicago, 1986.

Mizoguchi, Koji. *An Archaeological History of Japan: 30,000 B.C. to A.D. 700.* Philadelphia: Univ. of Pennsylvania Press, 2002.

Murase, Miyeko. *The Tale of Genji: Legends and Paintings.* New York: Braziller, 2001.

Nishiwara, Kyotaro, and Emily J. Sano. *The Great Age of Japanese Buddhist Sculpture, A.D. 60–1300.* Fort Worth, TX: Kimbell Art Museum, 1982.

Pearson, Richard J. *Ancient Japan.* Washington, DC: Arthur M. Sackler Gallery, 1992.

Ten Grotenhuis, Elizabeth. *Japanese Mandalas: Representations of Sacred Geography.* Honolulu: Univ. of Hawai'i Press, 1999.

Washizuka, Hiromitsu, Park Youngbok, and Kang Woo-bang. *Transmitting the Forms of Divinity: Early Buddhist Art from Korea and Japan.* Ed. Naomi Noble Richard. New York: Japan Society, 2003.

Wong, Dorothy C., and Eric M. Field, eds. *Horyuji Reconsidered.* Newcastle: Cambridge Scholars, 2008.

Chapter 13 Art of the Americas before 1300

Benson, Elizabeth P., and Beatriz de la Fuente. *Olmec Art of Ancient Mexico.* Washington, DC: National Gallery of Art, 1996.

Berrin, Kathleen, ed. *Feathered Serpents and Flowering Trees: Reconstructing the Murals of Teotihuacan.* San Francisco: Fine Arts Museums of San Francisco, 1988.

Brody, J.J. *Anasazi and Pueblo Painting.* Albuquerque: Univ. of New Mexico Press, 1991.

Burger, Richard L. *Chavin and the Origins of Andean Civilization.* New York: Thames & Hudson, 1992.

Clark, John E., and Mary E. Pye, eds. *Olmec Art and Archaeology in Mesoamerica.* Studies in the History of Art, 58: Symposium Papers, 35. Washington, DC: National Gallery of Art, 2000.

Clayton, Lawrence A., Vernon J. Knight, and Edward Moore, eds. *The De Soto Chronicles: The Expedition of Hernando de Soto to North America, 1539–1543.* 2 vols. Tuscaloosa: Univ. of Alabama Press, 1993.

Coe, Michael D. and Rex Koontz. *Mexico: From the Olmecs to the Aztecs.* 5th ed. New York: Thames & Hudson, 2005.

———. *Breaking the Maya Code.* Rev. ed. New York: Thames & Hudson, 1999.

Donnan, Christopher. *Moche Portraits from Ancient Peru.* Austin: Univ. of Texas Press, 2003.

Fagan, Brian M. *Chaco Canyon: Archaeologists Explore the Lives of an Ancient Society.* New York: Oxford Univ. Press, 2005.

Hall, Robert L. *An Archaeology of the Soul: North American Indian Belief and Ritual.* Urbana: Univ. of Illinois Press, 1997.

Heyden, Doris, and Paul Gendrop. *Pre-Columbian Architecture of Mesoamerica.* Trans. Judith Stanton. History of World Architecture. New York: Electa/Rizzoli, 1988.

Korp, Maureen. *The Sacred Geography of the American Mound Builders.* Native American Studies. Lewiston, NY: Mellen Press, 1990.

Kubler, George. *The Art and Architecture of Ancient America: The Mexican, Maya, and Andean Peoples.* 3rd ed. with updated bib. Pelican History of Art. New Haven: Yale Univ. Press, 1993.

Labbé, Armand J. *Shamans, Gods, and Mythic Beasts: Colombian Gold and Ceramics in Antiquity.* New York: American Federation of Arts, 1998.

LeBlanc, Steven A. *Painted by a Distant Hand: Mimbres Pottery from the American Southwest.* Cambridge, MA: Peabody Museum Press, 2004.

Loendorf, Lawrence L., Christopher Chippindale, and David S. Whitley, eds. *Discovering North American Rock Art.* Tucson: Univ. of Arizona Press, 2005.

Martin, Simon, and Nikolai Grube. *Chronicle of the Maya Kings and Queens: Deciphering the Dynasties of the Ancient Maya.* 2nd ed. New York: Thames & Hudson, 2008.

Miller, Mary Ellen. *The Art of Mesoamerica: From Olmec to Aztec.* 4th ed. World of Art. London: Thames & Hudson, 2006.

———. *Maya Art and Architecture.* World of Art. London: Thames & Hudson, 1999.

———, and Simon Martin. *Courtly Art of the Ancient Maya.* San Francisco: Fine Arts Museums of San Francisco, 2004.

———, and Karl Taube. *The Gods and Symbols of Ancient Mexico and the Maya: An Illustrated Dictionary of Mesoamerican Religion.* London: Thames & Hudson, 1993.

Milner, George R. *The Moundbuilders: Ancient Peoples of Eastern North America.* Ancient Peoples and Places, 110. London: Thames & Hudson, 2004.

Noble, David Grant. *In Search of Chaco: New Approaches to an Archaeological Enigma.* Santa Fe, NM: School of American Research Press, 2004.

O'Connor, Mallory McCane. *Lost Cities of the Ancient Southeast.* Gainesville: Univ. Press of Florida, 1995.

Pasztory, Esther. *Teotihuacan: An Experiment in Living.* Norman: Univ. of Oklahoma Press, 1997.

Pillsbury, Joanne, ed. *Moche Art and Archaeology in Ancient Peru.* Studies in the History of Art: Center for Advanced Study in the Visual Arts, 63: Symposium Papers, 40. Washington, DC: National Gallery of Art, 2001.

Power, Susan C. *Early Art of the Southeastern Indians: Feathered Serpents & Winged Beings.* Athens: Univ. of Georgia Press, 2004.

Rohn, Arthur H., and William M. Ferguson. *Puebloan Ruins of the Southwest*. Albuquerque: Univ. of New Mexico Press, 2006.

Sharer, Robert J., and Loa P. Traxler. *The Ancient Maya*. 6th ed. Stanford, CA: Stanford Univ. Press, 2006.

Stierlin, Henri. *The Maya: Palaces and Pyramids of the Rainforest*. Cologne: Taschen, 2001.

Stone-Miller, Rebecca. *Art of the Andes: From Chavín to Inca*. 2nd ed. World of Art. New York: Thames & Hudson, 2002.

———. *To Weave for the Sun: Ancient Andean Textiles*. New York: Thames & Hudson 1994.

Townsend, Richard F., and Robert V. Sharp, eds. *Hero, Hawk, and Open Hand: American Indian Art of the Ancient Midwest and South*. Chicago: Art Institute of Chicago, 2004.

Von Hagen, Adriana, and Craig Morris. *The Cities of the Ancient Andes*. New York: Thames & Hudson, 1998.

Chapter 14 Early African Art

Ben-Amos, Paula. *The Art of Benin*. Rev. ed. Washington, DC: Smithsonian Institution Press, 1995.

Berzock, Kathleen Bickford. *Benin: Royal Arts of a West African Kingdom*. Chicago: Art Institute of Chicago, 2008.

Blier, Suzanne Preston. *The Royal Arts of Africa: The Majesty of Form*. Perspectives. New York: Abrams, 1998.

Cole, Herbert M. *Igbo Arts: Community and Cosmos*. Los Angeles: Fowler Museum of Cultural History, Univ. of California, 1984.

Connah, Graham. *African Civilizations: An Archaeological Perspective*, 2nd ed. New York: Cambridge Univ. Press, 2001.

———. *Forgotten Africa: An Introduction to Its Archaeology*. New York: Routledge, 2004.

Darish, Patricia J. "Memorial Head of an Oba: Ancestral Time in Benin Culture." In *Tempus Fugit, Time Flies*. Ed. Jan Schall. Kansas City, MO: Nelson-Atkins Museum of Art, 2000: 290–297.

Eyo, Ekpo, and Frank Willett. *Treasures of Ancient Nigeria*. Ed. Rollyn O. Kirchbaum. New York: Knopf, 1980.

Garlake, Peter S. *Early Art and Architecture of Africa*. Oxford History of Art. Oxford: Oxford Univ. Press, 2002.

Grunne, Bernard de. *The Birth of Art in Africa: Nok Statuary in Nigeria*. Paris: A. Biro, 1998.

Huffman, Thomas N. *Symbols in Stone: Unravelling the Mystery of Great Zimbabwe*. Johannesburg: Witwatersrand Univ. Press, 1987.

LaViolette, Adria Jean. *Ethno-Achaeology in Jenné, Mali: Craft and Status among Smiths, Potters, and Masons*. Oxford: Archaeopress, 2000.

M'Bow, Babacar, and Osemwegie Ebohon. *Benin, a Kingdom in Bronze: The Royal Court Art*. Ft. Lauderdale, FL: African American Research Library and Cultural Center, Broward County Library, 2005.

Phillipson, D.W. *African Archaeology*. 3rd ed. Cambridge World Archaeology. New York: Cambridge Univ. Press, 2005.

Schädler, Karl-Ferdinand. *Earth and Ore: 2500 Years of African Art in Terra-Cotta and Metal*. Trans. Geoffrey P. Burwell. Munich: Panterra, 1997.

Credits

Chapter 9

9.1 Bibliothèque Nationale de France; 9.2 Kazuyoshi Nomachi/Corbis; 9.3a Zoonar GmbH/Alamy; 9.3b Dorling Kindersley; 9.4 The Art Archive/Gianni Dagli Orti; 9.5 Roger Wood/Corbis; 9.6 & 9.8 Raffaello Bencini Fotografo; 9.9 akg-images/Erich Lessing; 9.10 © 2012 The Metropolitan Museum of Art/Scala, Florence; 9.11 RMN/Thierry Ollivier; 9.13b After Robert Hillenbrand, *Islamic Architecture*, 1994, p.195; 9.14 Bernard O'Kane/Alamy; page 279 © 2012 Image The Metropolitan Museum of Art/Art Resource/Scala, Florence; 9.15 © Achim Bednorz, Cologne; 9.16 Peter Sanders Photography; 9.17 © 2012 The Metropolitan Museum of Art/Art Resource/Scala, Florence; 9.18 Digital Image Museum Associates/LACMA/Art Resource NY/Scala, Florence; 9.19 © 2012 Image The Metropolitan Museum of Art/Art Resource/Scala, Florence; 9.20 RMN (Musée du Louvre)/Franck Raux; 9.21 Courtesy of Alexandria Press; 9.22 akg-images/Gerard Degeorge; 9.23a Drawn by Christopher Woodward. From *A History of Ottoman Architecture* by Godfrey Goodwin, Thames & Hudson, London and New York; 9.23b Sonia Halliday Photographs; 9.24 & 9.25 Photo: Ayhan Altun; 9.26 © 2012 The Metropolitan Museum of Art/Art Resource/Scala, Florence; 9.28a Drawing by Keith Turner after Henri Stierlin © Aga Khan Visual Archive, MIT; 9.28b photo: Abbas Aminmansour/Magnum Photos; 9.29 © Culture and Sport Glasgow. CIC Glasgow Museums Collection; 9.31 Courtesy of the architect/Aga Khan Trust for Culture.

Chapter 10

10.1 Rick Asher; 10.2ab Giraudon/The Bridgeman Art Library; 10.2c, 10.2d, 10.2e, & 10.2f National Museum of Karachi, Karachi, Pakistan/The Bridgeman Art Library; 10.3 & 10.4 Copyright J.M. Kenoyer/Harappa.com, Courtesy Dept. of Archaeology and Museums, Govt. of Pakistan; 10.5 National Museum of New Delhi; 10.6 Borromeo/Art Resource, NY; 10.7 Rick Asher; 10.8 © Adam Woolfitt/Robert Harding World Imagery/Corbis; page 304 Dinodia Photo; 10.9 © Richard Ashworth/Robert Harding; 10.10 age fotostock/Dinodia Photo; 10.11 T. Paramjit/Ancient Art & Architecture Collection Ltd; 10.12 Richard Todd/National Museum of New Delhi; 10.13 & 10.14 Rick Asher; 10.15 akg-images; 10.16 Luca Tettoni/Robert Harding; 10.17 Asian Art Archives, University of Michigan (AAAUM); 10.18 Borromeo/Art Resource, NY; 10.19 Photo: Dominc Sansoni; 10.20 Kevin Schafer/Alamy; 10.21 & 10.22 Asian Art Archives, University of Michigan (AAAUM); 10.23 © Robert Gill; Papilio/CORBIS All Rights Reserved; 10.24 Rick Asher; 10.25 Photograph by John C. Huntington Courtesy of The Huntington Photographic Archive at The Ohio State University; 10.26 Photo: Srinivas Padma; 10.27 © David Cumming; Eye Ubiquitous/CORBIS All Rights Reserved; 10.28 © Richard Ashworth/Robert Harding World Imagery/Corbis; 10.30 Dinodia Photo; 10.29 Robert Harding World Imagery/Mrs. Holdsworth; 10.33 RMN-Grand Palais (Musée Guimet, Paris)/Thierry Ollivier; 10.34 © Luca Tettoni/Corbis; 10.35 akg-images/Gerard Degeorge; 10.36 Tibor Bognár/age fotostock/Dinodia Photo; 10.37 © 1983 Visual Resources Collections, Department of History of Art, Regents of the University of Michigan; 10.38 © Christophe Boisvieux/Corbis; 10.39 Photo: John Listopad; 10.40 Tim Hall/Robert Harding; 10.41 © Kevin R. Morris/Corbis.

Chapter 11

11.1 National Geographic Image Collection; 11.3 Line drawing illustrated in Michael Sullivan, *The Arts of China*, Berkeley: University of California Press, 2008, fig. 1-14, after Wenwu, no. 1 (1988), fig. 20; 11.5 Photo: Imaging Department © President and Fellows of Harvard College; 11.7 Asian Art & Archaeology, Inc./CORBIS; 11.8 Cultural Relics Publishing House; page 340 Courtesy of Fleming & Honour; 11.10 © The Trustees of the British Museum. All rights reserved; 11.11 National Palace Museum, Taipei, Taiwan, Republic of China; 11.12 © Corbis/Wolfgang Kaehler; 11.13 Photograph © 2013 Museum of Fine Arts, Boston; 11.14 dbimages/Alamy; 11.15 Photograph by John C. Huntington Courtesy of The Huntington Photographic Archive at The Ohio State University; 11.16 James Caldwell/Alamy; 11.17 Photograph © 2013 Museum of Fine Arts, Boston; 11.18 Photo: Imaging Department © President and Fellows of Harvard College; 11.19 Cultural Relics Publishing House; 11.21 National Palace Museum, Taipei, Taiwan, Republic of China; 11.23 Photo Courtesy of the Palace Museum, Beijing; 11.25 © The Trustees of the British Museum. All rights reserved; 11.26 National Museum of Korea, Seoul, Republic of Korea; 11.27 Photo: Imaging Department © President and Fellows of Harvard College; 11.28 National Museum of Korea; 11.30 Tokyo National Museum/TNM Image Archives/DNP; 11.31 Photo: Imaging Department © President and Fellows of Harvard College.

Chapter 12

12.1 Photo: Bruce Schwarz; 12.2 Collection of the Tokyo National Museum/TNM Image Archives/DNP; 12.3 Watanabe Yoshio/Pacific Press Service; 12.4 Getty/DAJ; 12.5 & 12.6 Photo: ASKAEN CO., LTD; 12.7 Shosoin, Todaiji, Nara; 12.8 Photo: Patricia J. Graham; 12.9 Z. Legacy. Images Resource Centers; 12.11 akg-images/Nimatallah; 12.12 Sakamoto Photo Research Laboratory/CORBIS; page 374 The Tokugawa Reimeikai Foundation/DNP Image Archives; 12.14 TNM Image Archives/DNP; 12.15 Photograph © 2013 Museum of Fine Arts, Boston; 12.16 Asanuma Photo Studios, Kyoto, Japan; 12.17 Photo Courtesy of Kyoto National Museum; 12.18 TNM Image Archives/DNP; 12.19 Kenchoji, Kamakura.

Chapter 13

13.1 The Art Archive/National Anthropological Museum Mexico/Gianni Dagli Orti; 13.2 Scala, Florence/Art Resource, NY/The Metropolitan Museum of Art, NY; 13.3 Werner Forman Archive; 13.4 © Yann Arthus-Bertrand/CORBIS; 13.6 The Art Archive/Gianni Dagli Orti; 13.8 © M.L. Sinibaldi/Corbis; 13.9 George Steinmetz/Corbis; 13.10 The Art Archive/National Anthropological Museum Mexico/Gianni Dagli Orti; 13.11 © 2012 Photo Scala, Florence; page 394 Rollout photograph © Justin Kerr, K2887; 13.12 The Art Archive/Gianni Dagli Orti; 13.13 Rollout photograph © Justin Kerr, K2803; 13.14 akg-images/Hedda Eid; 13.16 akg-images/Bildarchiv Steffens; 13.15 John Bigelow Taylor; 13.18 George Steinmetz/Corbis; 13.19 © 2005 Photo Scala, Florence/BPK, Bildagentur fuer Kunst, Kultur und Gechsichte, Berlin; 13.20 Photo: Dr. Chris Donnan; 13.21 © Gilcrease Museum, Tulsa; 13.22 Tony Linck/SuperStock; 13.23 William Iseminger, "Reconstruction of Central Cahokia Mounds." c. 1150 CE. Courtesy of Cahokia Mounds State Historic Site; 13.24 Courtesy of the Penn Museum, image #160303; 13.25 Peabody ID #24-15-10/94585; 13.26 Saint Louis Art Museum; 13.27 © Richard A. Cooke/Corbis; 13.28 Whit Richardson/Aurora Open/SuperStock; 13.29 Fred Hirschmann Photography; 13.30 National Archives photo no.10055.

Chapter 14

14.1 © 1980 Dirk Bakker; 14.2 © Kazuyoshi Nomachi/Corbis; 14.3 Werner Forman Archive/National Museum, Lagos, Nigeria. Location: 02; 14.4 Neil Lee/Ringing Rocks Digitizing Laboratory/www.SARADA.co.za/San Heritage Centre/Rock Art Research Centre/University of the Witwatersrand, Johannesburg; 14.5 From Thurstan Shaw, *Igbo-Ukwu: An Account of Archaeological Discoveries in Eastern Nigeria*. 2 vols. Evanston: Northwestern University Press, 1970; 14.6 Jerry L. Thompson/Art Resource, NY; page 416 © 1980 Dirk Bakker; 14.8 Photograph by Eliot Elisofon 1959; 14.9 © 2012 The Metropolitan Museum of Art/Art Resource/Scala, Florence; 14.11 & 14.12 Photograph by Joseph Nevadomsky, Benin, Nigeria, c. 1997. Joseph Nevadomsky Collection Eliot Elisofon Photographic Archives. National Museum of African Art Smithsonian Institution; 14.13 National Museum of African Art/Smithsonian Institution. Photo by Franko Khoury 14.14 Peter Adams/Getty; 14.15 Dorling Kindersley; 14.16 I. Vanderharst/Robert Harding World Imagery; 14.18 Heini Schneebeli/The Bridgeman Art Library; 14.19 The Pitt Rivers Museum/University of Oxford. Photo by Heini Schneebeli; 14.20 © 2008 Image copyright The Metropolitan Museum of Art/Art Resource/Scala, Florence; 14.21 Photograph by Frank Khoury.

Index